groundwaters

A CENTURY OF ART BY SELF-TAUGHT AND OUTSIDER ARTISTS

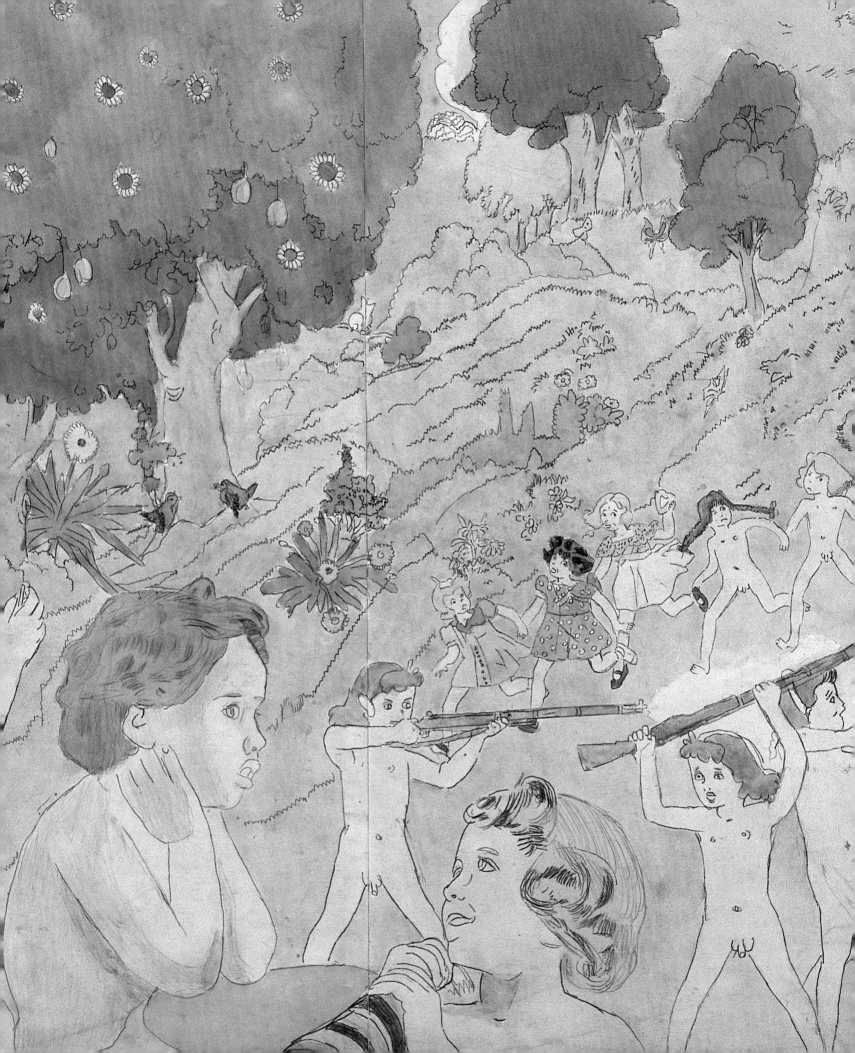

groundwaters
A CENTURY OF ART BY SELF-TAUGHT AND OUTSIDER ARTISTS

BY CHARLES RUSSELL

PRESTEL
LONDON MUNICH NEW YORK

Prestel, a member of Verlagsgruppe Random House GmbH

Prestel Verlag
Neumarkter Strasse 28
81673 Munich
Tel. +49 (0)89-4136-0
Fax +49 (0)89-4136-2335

Prestel Publishing Ltd.
4 Bloomsbury Place
London WC1A 2QA
Tel. +44 (0)20 7323-5004
Fax +44 (0)20 7636-8004

Prestel Publishing
900 Broadway, Suite 603
New York, NY 10003
Tel. +1 (212) 995-2720
Fax +1 (212) 995-2733

www.prestel.com

Prestel books are available worldwide. Please contact your nearest bookseller or
one of the above addresses for information concerning your local distributor.

Library of Congress Control Number: 2011933922
British Library Cataloguing-in-Publication Data: a catalogue record for this book
is available from the British Library; Deutsche Nationalbibliothek holds a record
of this publication in the Deutsche Nationalbibliografie; detailed bibliographical
data can be found under: http://dnb.d-nb.de

Editorial direction: Christopher Lyon
Copyediting: Betsy Stepina Zinn
Editorial assistance: Ryan Newbanks
Picture research: Monica Adame Davis
Design and layout: Rita Jules, Miko McGinty Inc.
Typesetting: Tina Henderson
Production: Karen Farquhar
Origination: Fine Arts Repro House Co., Ltd., Hong Kong
Printing and Binding: C&C Offset Printing, Hong Kong

Verlagsgruppe Random House FSC-DEU-0100
The FSC-certified paper 157gsm Chinese Golden Sun matte art has been
supplied by ShanDong Sun Paper Industry Joint Stock Co. Ltd., China

ISBN 978-3-7913-4490-4

Front cover: Detail of Bill Traylor's *Man with Yoke*, n.d. (p. 78)
Frontispiece: Detail of Henry Darger's *6 Episode 3 Place not mentioned…*,
n.d. (p. 109)
Page 6: Detail of Domenico Zindato's *Untitled*, 2009 (p. 222)
Back cover: Detail of Henry Darger's *Break out of concentration camp
killing and wounding enemy guards*, n.d. (p. 101)

Contents

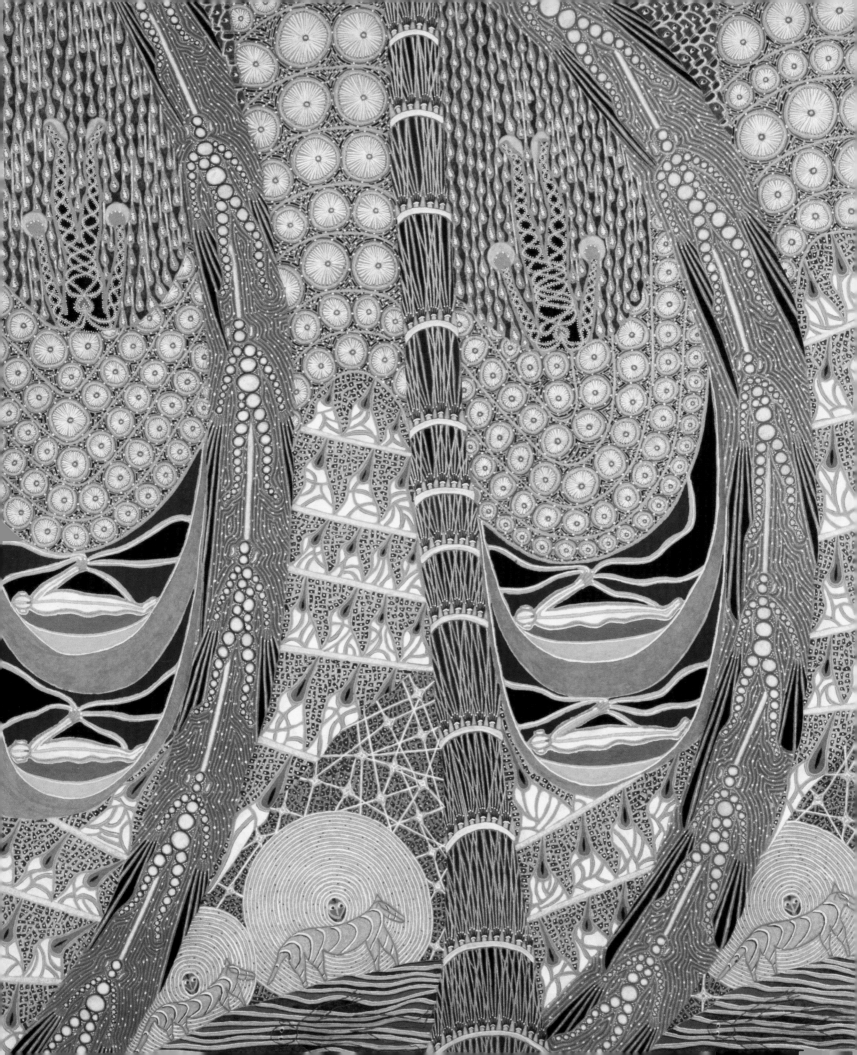

Acknowledgments

The art brought me to this point in my life. To all these artists and those I haven't been able to include in this work: thank you.

I did not know such profound work existed until some very wonderful, soulful, and wise people led me to it and taught me what I had been missing. They were followed by many others—too many to name—who helped me understand what I have seen.

I enjoyed the opportunity to acknowledge some of these friends and guides in my last two edited and co-edited books on the field: *Self-Taught Art: The Culture and Aesthetics of American Vernacular Art*; and, with Carol Crown, *Sacred and Profane: Voice and Vision in Southern Self-Taught Art*. I thank them here once again.

This book brought me back to many of those colleagues and mentors and also introduced me to a number of people to whom I am extremely grateful. They participate in the field as members of the museum and gallery world, as scholars within and outside the academy, as collectors and critics, and all as lovers of significant art.

I am especially indebted to: Jane Kallir, Luise Ross, Roger Ricco, Frank Maresca, Shari Cavin, Randall Morris, Andrew Edlin; Brooke Davis Anderson, Susan Crawley, Lucienne Peiry, Michel Thévoz, Daniel Baumann, Thomas Röske, Johann Feilacher, Nina Katschnig; Celine Muzelle, Valérie Rousseau; Roger Cardinal, John Maizels, Colin Rhodes; Bill Arnett; Jacqueline Porret-Forel.

Above all, I am indebted to Alison Weld who first introduced me to the art. With an artist's keen and loving eye and an intellect's insights, she expanded my vision and intensified my ability to see. I stood in her shadow in this field for years and now humbly offer the book to her and the light of day.

The final stages of writing this book were significantly helped by a sabbatical awarded by Rutgers University. I am particularly appreciative of the support of the Dean of the Faculty of Arts and Sciences of Rutgers Newark, Dr. Philip Yeagle.

Without the initial encouragement and constant support of the considerate and thoroughly professional people at Prestel Publishing this book would not have been written.

Ryan Newbanks ensured that every significant detail of the book's publication was attended to in a prompt, professional, and generous manner. Monica Davis assiduously tracked down the great and the obscure images so lavishly presented; Betsy Stepina Zinn transformed the rawest of prose into a readable text; and Rita Jules responded sensitively to the spirit of the visionary artists in her design of this beautiful book.

Guiding and supporting them all and, above all, challenging and encouraging this author has been the sharp and informed mind of Editor-in-Chief Christopher Lyon.

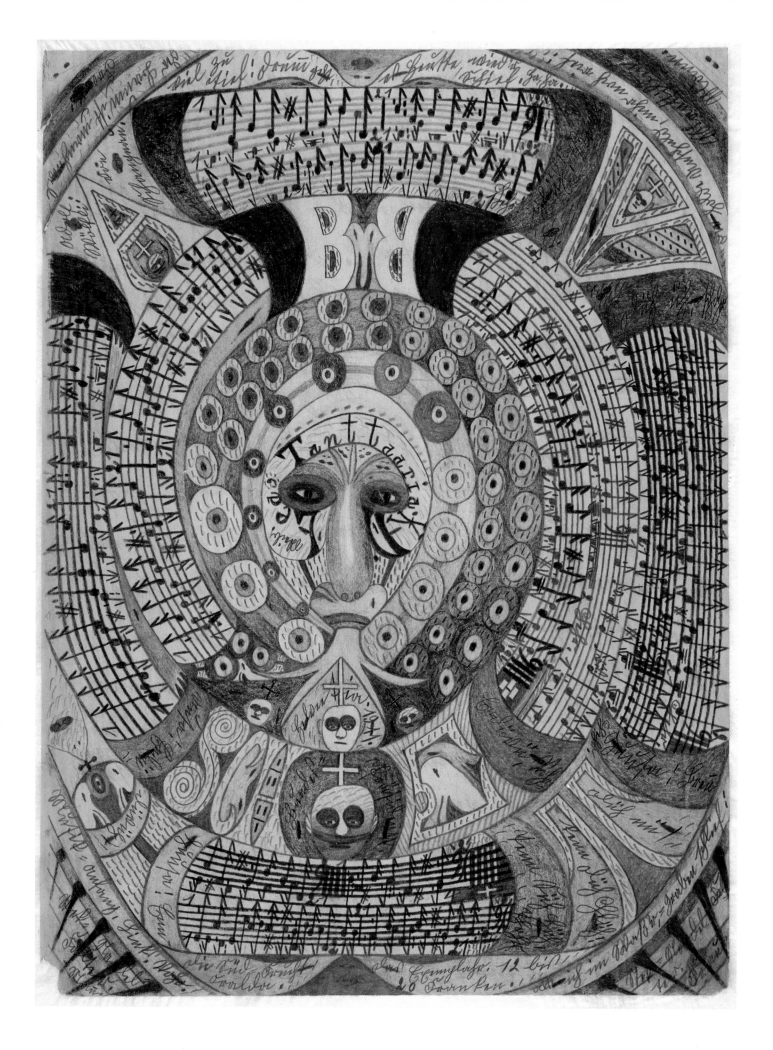

Introduction

The creative process, as realized in a contemporary work of art, is nourished by very different psychic springs, which do not always have to coalesce. . . . As groundwater seeps to the surface and flows toward the stream in many rivulets, many expressive impulses run in many creative paths into the great stream of art. Neither historically nor according to psychological theory does there exist a beginning point. Instead there are many springs which finally transcend all life.

—Hans Prinzhorn, *Artistry of the Mentally Ill* (1922)

Our understanding of self-taught and outsider art must account for two discordant facts: that works of significant visual achievement and meaning are created by individuals who are not trained as artists and may not even consider their creations to be *art*; and that some viewers—usually those familiar with our culture's "mainstream" tradition of art—see these unexpected objects as works of art but struggle to account for them within the customary art-world terms. Consequently, a study of the work of self-taught and outsider artists compels us to reflect on the nature, variety, and uses of creativity and to recognize its many sources—the many rivulets that contribute to the "great stream of art." Entertaining Prinzhorn's concept of the "great stream"—as opposed to the "mainstream"—of art forces us to question what the term *art* means in our society and how well it accounts for the existence and cultural significance of self-taught art. Hence, the following discussions of the works of

untrained artists will focus not only on the works themselves, but also on how those works were received by both the art world and the general viewer.

This book traces both how the works of twelve significant self-taught and outsider artists arose from their personal life experiences and their responses to a culture in which they were largely marginal figures and why their art nonetheless was discovered and found meaningful to that culture. Each chapter begins with an analysis of the individual artist's work and the immediate contexts of his or her creativity, followed by a discussion of the aesthetic and cultural issues within the mainstream art world and the relevant society. Finally, other artists responding to similar issues are introduced for comparison.

Several of the twelve artists featured here were first identified by psychiatrists and only subsequently by mainstream artists and the larger audience. Two groundbreaking studies of art created by institutionalized mental patients—Walter Morgenthaler's *A Mental Patient as Artist: Adolf Wölfi* (1921) and Hans Prinzhorn's *Artistry of the Mentally Ill* (1922)—analyzed the mental patients' creations in terms of not only the nature of their illness but also the insights they provided into the creative processes found in art of both the healthy and the ill. In addition, each psychiatrist explored the analogies to the vanguard art of their time. Morgenthaler's and Prinzhorn's work had great influence on generations of artists, from the German expressionists and artists associated with the Blaue Reiter to the dadaists and surrealists, especially. Both the physicians and the artists were fascinated by the visual achievements of the mentally ill and were convinced

OPPOSITE: Adolf Wölfli, *Lea Tanttaaria*, 1910. Pencil and colored pencil on newsprint, 19½ x 14⅝ in. (49.7 x 37.2 cm). Adolf Wölfli Foundation, Museum of Fine Arts, Bern, Switzerland

the medium's semiconscious behavior as analogous to their own efforts to tap into the subconscious creative sources through automatic writing and drawing.

No figure, however, has been more influential to the field of self-taught and outsider art than Jean Dubuffet. His deep appreciation of the artistic creations of mentally ill and of marginal individuals led him to develop the term *art brut* (raw art), and he declared that the artists' passion and original vision revealed the upswelling of authentic creation, unfettered by the conventions of the art world. Dubuffet's notion of art brut, later translated and broadened into the term *outsider art*, retroactively coalesced modernist interest in forms of European primitivism and expanded appreciation of artistic behavior that appeared on the various margins of society. For Dubuffet, art brut was essentially an expression of an antisocial or asocial spirit that belied the false legitimacy of culturally defined art.

Concurrent to the European artists' embrace of nontraditional creativity, American modernist artists, intellectuals, and members of the art world held the simple, authentic creativity expressed by the "common man" who exemplified the basic American spirit to be on the par with the works of mainstream artists. Whether created by "naive" painters, such as Morris Hirshfield, or by "folk" artists emerging from premodern rural cultures, as the ex-slave Bill Traylor seemed to be, the art of the self-taught was considered not to oppose the dominant culture but to share, from the margins, its deepest positive values.

Although American modernists found in folk art a type of authenticity and fresh abstract styles that their European colleagues sought in the art of non-Western primitive or the radically alienated mental patients, the American advocates of self-taught art had little of the European avant-garde anticultural zeal. Lacking a long history of religious and court art or established academies of art, American modernists had few rigid traditions against which to struggle.[1] They were also able to draw on a widely shared conception of a spirit of radical individualism in American life. American "outsiders," no mat-

that the paths to the origin of imaginative expression lay within the irrational subconscious tapped by the mad. The doctors' observations and theories spurred later European psychiatrists and mental asylum directors to study, support, and preserve the artistic work of their patients, as demonstrated in the late 1930s by Hans Steck with his patient Aloïse Corbaz, and, in the 1970s and later, by Leo Navratil with August Walla and numerous other artists associated with the Haus der Künstler (House of Artists) Navratil established at the mental hospital in Gugging, outside of Vienna.

Other European self-taught artists who emerged from or were associated with the quasi-metaphysical movement of spiritualism and the subcultural activities of mediums, such as Madge Gill, were also intriguing to the surrealists, who saw

Bill Traylor, *Untitled*, 1939–42. Poster paint on paper, 13¾ x 10¼ in. (34.9 x 26 cm)

ter how idiosyncratic, could also be seen as truly representative of a culture of nonconformists (itself a notion every bit as romantic as the European fantasies of the "primitive").

Nevertheless, in the American development of the field of self-taught and outsider art during the second half of the twentieth century, versions of the outsider were seen in isolates such as Henry Darger and in institutionalized mental patients such as Martín Ramírez, although both were deeply embedded in and drew on traditional and popular cultural imagery to shape their private artistic realms. And while the outsider or art brut paradigm has found use in the American context, the tradition of folk art remains strong, even as it has developed into more nuanced concepts of self-taught and vernacular creativity in the work of southern artists, such as Howard Finster and Thornton Dial.

As popular appreciation of the work of untrained artists has expanded significantly during the past thirty years, the conception—if not the terminology—of the nature and importance of their work has grown more complex. This was noted even by Dubuffet late in his life when he felt compelled to launch a new term, *neuve invention* (new invention), to designate the idiosyncratic creations of artists such as Michel Nedjar, who, though marginal to the established art world and to some extent to the culture in general, nonetheless conceived of themselves as practicing artists and were amenable to entering the art world and its market. Greater challenges to the previously Eurocentric and American field are presented by the West's growing receptivity to untrained artists from around the globe, whether highly motivated visionary individuals such as Nek Chand or those artists from Asia, Africa, and the Caribbean who unite elements of indigenous cultural traditions and personal visionary creativity. Indeed, recently the terms *visionary* and *vernacular* have become among the most frequently used words in the field.[2]

In this book, I primarily use the terms *outsider* and *self-taught* to suggest two general approaches to the art. *Outsider* is generally applied to artists on the psychological and social margins of the culture, often those deemed mentally ill or isolates at odds with cultural norms. As a concept, *self-taught* describes almost all the artists, since very few have received any formal artistic training. But it is used here as a term generally designating untrained artists whose highly individualistic work nonetheless resonates within broadly defined cultural contexts or freely adopts established cultural imagery.

The two terms reflect the historical contexts out of which discussions of outsider and self-taught art have been shaped: the first largely reflecting early-twentieth-century European considerations of psychological, sociological, and aesthetic bases of art and creativity in the high modernist era; the second arising from parallel but localized discussions in America from the 1930s into the 1970s concerning the cultural significance of artistic creations by untrained individuals. That these separate approaches have been joined in uneasy but stimulating international discourse during the last half of the twentieth century and into the present results in part from the polemical and visionary passion of Dubuffet and also from the dynamics of both the mainstream art world and the broader culture.

The Forms of Instinctual Expression

The concept of the outsider artist traces its origins largely to the work of creative individuals whose psychological or sociological conditions placed them on the margins of socially expected behavior. In the first decades of the twentieth century, the work of two psychiatrists—Walter Morgenthaler at the Waldau Mental Asylum in Bern, Switzerland, and Hans Prinzhorn at the psychiatric clinic at Heidelberg University in Germany—inquired into the sources and nature of creativity and its manifestation in the lives of ordinary people, artists, and the mentally ill.

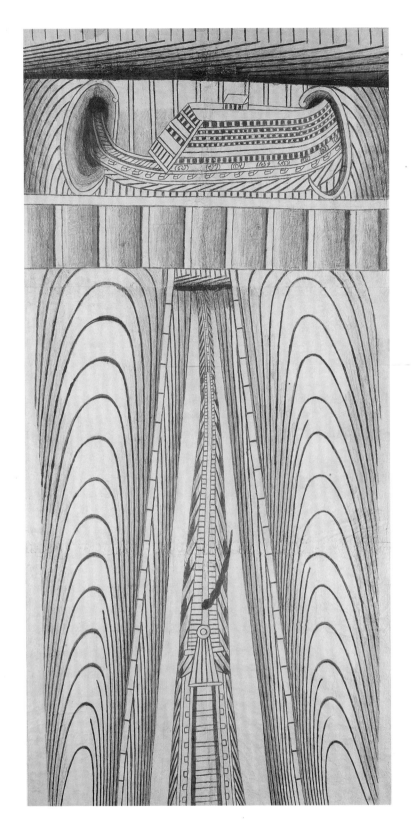

Morgenthaler and Prinzhorn were responding as individuals of their time—culturally aware, art-educated doctors. As psychiatrists, they contributed to early psychoanalytic studies of normative behavior through analysis of the psychopathological. Each was well-informed about artistic creativity and was familiar with the contemporary art world. In addition to his medical degree and psychiatric training, Prinzhorn held a doctorate in art history; Morgenthaler's brother was a professional artist. Both knew members of local artistic movements and were interested in how contemporary art reflected the spirit of their times. As art-historically astute intellectuals, they were intrigued by what mental patients' work could reveal about the "psycho"-pathology of the mentally ill artists and about the psychology of art in general. Both were alert to the possibility of art's primal connection to "primitive" and mythic thought, as were many vanguard artists and theorists at the time. Furthermore, both physicians sought to identify the connections and differences between the art produced by the patients and the modern art of their culture, even wondering whether the art of schizophrenics, in particular, might not be a historically significant expression of the era. Finally, both Morgenthaler and Prinzhorn recognized their projects had the potential to challenge and expand, if not change, their culture's conception of art.

Although Morgenthaler's study of a single patient, Adolf Wölfli, whom he had treated for thirteen years, is profoundly insightful about the relationship of aesthetic order to instinctive drives, Prinzhorn's work, *Artistry of the Mentally Ill*, had the greatest immediate influence. Based on his study of over five thousand artworks collected at Heidelberg that had been created by some 435 patients institutionalized in asylums across central Europe, his book focuses in large part on the significance of artistic form, or configuration, which Prinzhorn linked to an instinct for expression in response to our existential condition. He argued that artistic creation represents an effort of self-actualization that seeks to bridge the funda-

Martín Ramírez, *Untitled (Trains and Tunnels)*, c. 1950.
Crayon and pencil on pieced paper, 70 x 34¼ in. (178 x 87 cm).
abcd art brut collection, Paris

mental separation of the individual from others in the world. By forming an image that objectifies one's conception of the world, the psyche attempts "to escape into the expanse of common life from the restrictions of the individual."[3] Prinzhorn also suggested that in our response to works of art, we fulfill a corresponding instinctive need within our own being because we are able to directly apprehend their creator's psychical expression "without the interposition of any intellectual apparatus" (p. 13).

Across the thousands of works he studied, Prinzhorn identified six recurring patterns of configuration, which he ascribed to instinctive drives underlying all forms of visual expression. These are the drives for: self-expression; play; ornamentation; ordering and arranging; imitation; and creating symbolic meaning. Individual works of art may manifest any one or combination of these drives. Prinzhorn observed that none of these is a manifestation of psychopathological behavior; rather, these instinctive drives can be found in all forms of human artistic expression. They are the expression of "an inborn creative urge" shared by all humans (p. xvii), including mainstream and self-taught artists, as well as the mentally ill.

Focusing on the primacy of the expressive urge, Prinzhorn was less concerned with the artist's technical mastery of aesthetic conventions: "Configurative power has little in common with technical ability and is often missing in the presence of great virtuosity" (p. 34). Voicing the emerging modernist aesthetic, Prinzhorn held that too great an emphasis on form, as evident in academic art, depletes art of its instinctive expressive capacity and thus diminishes the experience of the viewer. Responding to the raw work stretched before him, he observed that "configurative power is easily underestimated when there is a lack of skill" (p. 34), but that apparent deficiency does not prevent the artist from achieving works of consummate expression.

Both Prinzhorn and Morgenthaler posited that while the basic patterns of human instinctive behavior are shared by the mentally healthy and the ill, they are especially exposed in the mentally ill, who are unable to adequately submit to social codes of modern civilization. Prinzhorn believed that insight into the universal configurative instincts is possible because they appear so directly and unguardedly in the patient's work: "The configurative process, instinctive and free of purpose, breaks through in these people without any demonstrable external stimulus or direction—they know not what they do. . . . Nowhere else do we find the components of the configurative process, which is subconsciously present in every man, in such an unadulterated state" (p. 269). Thus, we are able to understand our own deepest and obscured drives through the unwitting revelations provided by the mentally ill.

Although as psychiatrists they were well aware of the suffering of the mentally ill and did not romanticize their condition as numerous advocates of outsider art since Dubuffet have tended to do, Prinzhorn and Morgenthaler shared with many of the artists and intellectuals of their time a critical attitude toward the repressive forces inherent in modern society. Prinzhorn argued, for instance, that the "original configurative instinct intrinsic to all men . . . has been buried by the development of civilization" (p. 270). And Morgenthaler, comparing Adolf Wölfli's condition and the programmatic desires of contemporary artists to free themselves from the strictures of the academy, observed that "the moderns—for the most part hyperintellectuals, supersaturated with modern culture—seek to return to specific artistic fundamental elements through a systematic destruction of previously existing forms. In Wölfli's case, however, such fundamental elements were brought to light by the process of a sickness which destroyed the logical and other mental functions. . . . Parts of mighty foundation pillars of art are laid bare here, foundation pillars which certain modern trends are still looking for in their dismantling endeavors."[4] Many artists, envying the mentally ill individual's direct engagement with these creative sources, promulgated the romance of the primitive within

their culture and praised the "authenticity" of unbridled instinct supposedly enjoyed by the ill.

To what degree those pillars can be uncovered and built on by modern artists still operating comfortably within society is a question that has challenged vanguard artists throughout the twentieth century and that has animated much of the impassioned claims of partisans of outsider and self-taught art. Prinzhorn seemed to sympathize with artists who sought new forms of vision and expression when he challenged the existing criteria of artistic excellence, those "culturally supplementary perspectives which have made the word 'art' completely colorless," and when he asserted "Art" had to be freed from civilization's "extraneous ends" (p. 11). However, the issue—for the psychiatrists and many of the questing artists—went far beyond mere aesthetics. They wondered, without ever resolving the issue, what the destruction of cultural codes meant or forebode: was it initiated primarily by the artists as an act of renewal or was it a form of social collapse already abroad in a society of which the modern artist—and the mad—was but the most visibly evident sign.

Aware of German art historian Wilhelm Worringer's assertion in *Abstraction and Empathy* that abstraction and its challenge to representationalism were most evident during an age of anxiety, and having themselves experienced the cataclysm of World War I and its aftermath, Morgenthaler and Prinzhorn pondered the relationships among schizophrenia, modern art, and contemporary culture.[5] Morgenthaler cautiously ventured, "Our entire mental life seems in general to have approached schizophrenia in recent times, yet only inasmuch as the logical functions have receded somewhat in comparison with the emotional ones. In my opinion it is vain to want to predict whether this readjustment of the mental life is a definitive decline, a necessary transition, or already the beginning of a renewal."[6] What is especially notable is his uncertainty whether the cultural "approach" to schizophrenia could be a decline or a renewal, or even a *necessary* transition to either.

Subsequent events in European history provided further justification for artists and intellectuals to question the nature of their culture and its future, as well as their roles within it, what they might offer, and to whom. Whatever the mainstream and vanguard artists' answers for their own careers, the suspicion that those who stood outside the burdens of the cultural codes experienced a far richer reality continued to haunt them.

The Distinction of the Common Man

In the United States, a different type of nontraditional, untrained artist emerged, one who was also held to exemplify the sources of the creative impulse and to work independently of artistic conventions, but whose reception was shaped by significantly different aesthetic issues than those in Europe. The American self-taught artist was discussed neither in terms of psychopathology nor untrammeled instinctual expression. The nontraditional, untrained artist may have emerged independently of the mainstream art world and what was seen as "high" culture in the new world, but this "outsider" did not represent a challenge to American cultural values; rather he—occasionally she—was perceived as an authentic expression of the culture.

During the 1930s, in particular, discussions of self-taught artists took place within a crosshatching of discourses that reflected a developing concept of folk art, simultaneous with Depression-era evocations of the art of the "common man" and the mainstream art world's efforts to position American art within modern art movements based in the European art-historical tradition.

Self-taught artists such as Morris Hirshfield, John Kane, Joseph Pickett, Horace Pippin, and Anna Mary Robertson "Grandma" Moses, among others, were designated "naive" artists and "modern primitives." They were also seen as repre-

senting a natural extension of folk art, a recently emergent concept that had initially been applied to untutored craft and art production of pre-twentieth-century America. The "folk" had been loosely defined as ordinary citizens of a rural preindustrial economy, not strictly as members of distinct traditional or regional cultural groups, even though most collectors of "Americana" and museum exhibitions of early folk art privileged works of white, East Coast colonial culture. During the Great Depression, the concept of folk creativity was extended to twentieth-century work by self-taught artists who were praised as representative of the "common man." Holger Cahill, director of the Federal Art Project (FAP) of the Works Progress Administration, for instance, argued that contemporary folk art revealed the inherent creative spirit and strength of the American people. He proclaimed that the roots of the "popular" art of the "common man" tapped into the national character and embodied the centuries-old tradition of the "art of the people" from all walks of life and from all classes.

While the governments of certain European countries—including the Soviet Union and Germany—idolized the common man and national folk spirit for collectivist purposes, the American invocation of the common man focused more on an ideal of individualism. Because individualism is lauded as a national trait, this self-taught art symbolized and contributed to cultural identity, not opposition to it. Furthermore, the various terms used to describe the art of the common man—folk, naive, popular, and primitive—all assumed the inherent authenticity and fortitude of the American spirit. Art and artists were acclaimed for their innocence, simplicity, and natural upswelling of creativity. Sidney Janis, who organized the 1939 exhibition *Contemporary Unknown American Painters* at the Museum of Modern Art (MoMA) and published the landmark book *They Taught Themselves: American Primitive Painters of the Twentieth Century* (1942), spoke of the artists' "artless, ingenuous, refreshingly innocent" qualities.[7] None was seen as expressing deep psychological angst or autistic

tendencies. However unique in style or theme, the art was deemed positive and accessible to all Americans. Hence, in America, self-taught artists have generally been viewed as essentially affirmative of the social order, even if they come from the margins of mainstream culture.

It followed that from the archetypal self-made individuals should come strong expressions of great creative freedom, resulting, at times, in artistic works of significant accomplishment. Similar to the European modernists whose rejection of nineteenth-century conventions of naturalism led to appreciation of the visual languages of non-Western peoples, European folk traditions, and the art of the mentally ill, American modernist painters and some members of the art world believed that the individualistic inventiveness of self-taught artists could result in works of visual distinction. Janis and Alfred H. Barr, Jr., the first director of MoMA, believed that an individual who drew on these natural sources of creativity could produce strong art that was worthy of attention and appreciation. Barr asserted, in fact, that certain of "our self-taught painters can hold their own in the company of their best professionally trained compatriots."[8]

Barr held an expansive vision of modern art. He was responsible for MoMA's influential formalist reading of modern art. In two canon-making exhibitions of 1936—*Fantastic Art: Dada and Surrealism* and *Cubism and Abstract Art*—Barr identified two principal tendencies evident in the self-conscious innovations originating in recent European art: the conceptual and abstract mode, represented by cubism; and the psychologically charged, represented by surrealism. In addition, Barr identified a third tendency of equal significance: contemporary popular art, of which "primitive" or "naive" art could be seen as a nonacademic—as opposed to anti-academic—expression generally of untrained artists, especially those working in the American grain. In 1938 MoMA presented *Masters of Popular Painting: Modern Primitives of Europe and America*, an exhibition curated by Holger Cahill and mounted

Morris Hirshfield, *Stage Girls with Angels*, 1945.
Oil on canvas, 50 x 36⅛ in. (127 x 91.7 cm)

in collaboration with the Musée de Grenoble in France, which displayed works of European and American untrained artists who were contemporaries of the modernist and avant-garde artists exhibited in the two 1936 exhibitions.

Barr's belief in the aesthetic value of self-taught art, however, was not widely shared. At his museum and across the mainstream art world, there was little interest in either the art of the common man or nonacademic work displaying "independence of school or tradition."[9] Barr was made to realize this quite dramatically when Morris Hirshfield's 1943 solo exhibition at MoMA was harshly criticized, and, soon after, the board of trustees removed Barr from the position of director. Although Barr remained director of collections, MoMA has shown scant support for nonacademic art ever since. The subsequent narrative of modern art promulgated by MoMA focused almost exclusively on self-conscious formalist innovation within a Eurocentric tradition, a position that Barr supported throughout the remainder of his career.

Yet in the rejection of Barr's initial vision lies a story — and near history — of modern art. For a brief moment, art history might have taken a significantly different direction than it has, one that could have acknowledged the work of self-taught artists within the conception of modern art. Instead, the hegemony of a historically developmental version of modernist art history — which essentially sustains the fine art sensibility, despite putative vanguard attacks on class validation — has relegated to subsidiary positions all manifestations of outsider, self-taught, folk, and vernacular art.

An Art World of Their Own

The exclusion of self-taught artists from the mainstream art world signaled the growing hegemony of a formalist innovation as the marker of modernity, and subsequently postmodernity. The high modernist and avant-garde challenge to the strictures of the nineteenth-century academy had been partially successful. The faith of modernism was that there could be no "new" vision without "new" aesthetic form. Art is now judged appropriate to its time based on its ability to articulate in seemingly new aesthetic languages supposedly new cultural and historical conditions. Ezra Pound's dictum "Make it New," and his admonition "No good poetry is ever written in a manner twenty years old" (which applied equally to all other arts of the era) remain the bases of twentieth- and twenty-first-century art.[10] What has changed is the modernist and avant-garde belief that art could affect historical developments or could articulate a qualitatively new vision of human possibility.

Rather, modernism has become postmodernism; the avant-garde has become the neo-avant-garde. The voices of the "new" have become the new academy. Although it triumphed over the conventions of the nineteenth century, the art world of today acts like an academy. It is governed by a primary criterion of aesthetic value. In the place of established stylistic standards, it prizes formal innovation within a self-reflexive art-historical dialogue. Furthermore, it asserts its socially valid mission, not by depicting idealized or allegorical subjects of high culture, but by proffering cultural commentary from a presumed position of critical insight and ironic awareness. New forms do not announce new vision. Rather, new media repackage imagery appropriated from contemporary visual culture.

Although the academy sustains in form, though not in spirit, the former avant-garde claim to be critical of the dominant cultural values, it functions as an institution of cultural continuity, thoroughly at peace with a marketing sensibility of planned obsolescence and investment strategies based on the regular appearance of new products and product makers providing relatively inexpensive commodities for a brief time to a speculative market. Within this system, good artists and strong visual works of insight, wisdom, and even great beauty may appear periodically, proving that artists have always

been able to work within the systems of patronage and market support. But the successes seem almost beside the point.

Meanwhile, outside the academy, an art world specific to self-taught and outsider art has emerged, one that has defined itself largely in opposition to the mainstream. This development was greatly influenced by one man's actions: the voracious collecting and impassioned polemical advocacy of non-mainstream art by the avant-garde artist Jean Dubuffet. Although he rejected the avant-garde—and presciently recognized how complicit it was with the academy—his aesthetic and cultural positions fully embodied the avant-garde vision of an art that is at once passionately personal and socially challenging. And like the modernist and vanguard artists before him, he sought models of authentic creativity in artists outside the mainstream. In the 1930s, Dubuffet entertained the notion that the common man represented a spirit in opposition to dominant cultural modes, only to realize how generally submissive most popular cultural expressions were to the dominant discourse. He subsequently explored non-Western models, traveling to North Africa, and was briefly interested in the art of children. Finally seizing on the art of the mentally ill and works of socially marginalized individuals, Dubuffet argued that only those working without regard for or influenced by the official culture could create art in its purest, intuitive and expressive form. Calling the work *art brut*, Dubuffet stated:

> We understand by this term works produced by persons unscathed by artistic culture, where mimicry plays little or no part (contrary to the activities of intellectuals). These artists derive everything—subjects, choice of materials, means of transposition, rhythms, styles of writing, etc.—from their own depths, and not from the conventions of classical or fashionable art. We are witness here to a completely pure artistic operation, raw, brut, and entirely reinvented in all of its phases solely by means of the artists' own impulses. It is thus an art which manifests

an unparalleled inventiveness, unlike cultural art, with its chameleon- and monkey-like aspects.[11]

Yet however much in Dubuffet's eyes art brut was an anticultural expression, he viewed it through the familiar romantic tropes of the artist as uniquely sensitive and passionate visionary, an existential rebel against a false culture. In effect, art brut artists are unwitting avant-gardists; the outsiders, the most authentic primitives living among us. Nonetheless, Dubuffet was absolutely right in identifying them as strong artists who create powerful visual works that reveal their passionately engaged lives.

Dubuffet's collection of over five thousand art brut works—which became the Collection de l'Art Brut in Lausanne, Switzerland—had a formative role in identifying the wide range of creativity among untrained artists throughout Europe. Although his polemical definitions proved problematic (as he came to recognize), his writing and publication of a series of fascicules on many of the artists crystallized much of the discussions of nonmainstream art in the last half of the twentieth century, particularly in the post-1960s era of cultural rebellion in Europe and the United States. Dubuffet's ideas, most broadly promulgated by Roger Cardinal's 1972 book *Outsider Art*, struck a responsive chord in America and broadened the narrowly defined folk art perspectives of self-taught art in the United States. Correspondingly, Dubuffet's successors at the Collection de l'Art Brut proved receptive to American self-taught, vernacular, and isolate art, such as that of Bill Traylor, Martín Ramírez, and Henry Darger.

Who Speaks for the Culture?
Who Speaks for Us?

Although the confluence of European and American approaches to self-taught, nonmainstream creativity has

resulted in the emergence of a field loosely and awkwardly known as self-taught and outsider art, it remains to be seen whether this is or should be an enduring proposition. Certainly, many in the field who follow in the footsteps of Dubuffet insist that the significance of self-taught creation arises from its total independence from the academy, hence it should be valued as a superior and distinct form of artistic expression. Others, however, maintain that self-taught artists are grouped together merely by historical accident, reflecting the shifting aesthetic issues within the mainstream tradition, and, rather, they should be judged simply as individual creators by the standards we apply to any artist, even if those standards have been established by the mainstream tradition. Still others look to the day when the culture's recognition of the power and value of art embraces the works of self-taught and trained artists equally, when the breadth of the great stream of art will be apparent.

Nonetheless, the outsiders generally still remain outside the art world. They have not entered canonical art history. But they are artists. They are part of the culture and its history, as is too the field of cultural production called art history and the institutions which support it—the mainstream art world. Ulti-

mately, one need ask: Who speaks for our culture? Or, rather, what voices can be heard to speak for the most profound realities experienced by those who live within this culture?

Russell Bowman, former director of the Milwaukee Art Museum, has addressed the complexities of competing visions of artistic creation within our culture. He offered a "synthetic approach" to self-taught or folk art: "Because they incorporate a powerful and original formal vocabulary to express the artist's cultural or personal ideals, they are art. Despite being nonparticipants in the dialectical history of what defines art, they do participate in the dialectics of the broader culture and deserve to be seen on a par with any meaningful artistic expression."[12] Here, Bowman identified a criterion essential to modern art that is also readily evident in much self-taught and outsider art—developing a strong, original visual language that expresses the artist's individuality and cultural understanding. But because the outsiders' visual vocabulary does not develop in relation to the visual decisions of other artists who define their contribution within a shared art-historically-grounded dialogue, they have not been considered in the "dialectical history of what defines art."

Henry Darger, *Untitled (The Sacred Heart of Jesus)*, n.d. Watercolor, pencil, and carbon tracing on pieced paper, 19 x 49 in. (48.3 x 124.5 cm). Collection Kiyoko Lerner

Bowman is referring to the familiar tautological artifice known as the Institutional Theory of Art, which essentially holds that something is not art unless it is defined as such by the art world. Because self-taught or outsider art is created without concern for or possibly knowledge of the art world, it does not participate in the dialogue of that world, hence is not art. It may become art if someone in that world advances it as art and places it within the dialogue, but the artist seemingly remains without a voice, outside the dialectic.

Bowman's larger statement that nonacademic artists participate within the dialectics of the broader culture expands our perspective on art, arguing for a more complex understanding of the social role and definition of art. If self-taught and outsider artists create art outside the institution of art but within cultural history, we need also to ask where within the dialectics of culture does the self-referential art world stand? The historical conditions that led to the establishment of that world and the development of the philosophical tradition of aesthetics that sustains it have long been discussed. But the art world carries on as if the only operative forces of history are those manifest within its internal dialectic.

Experiencing the art of the self-taught and that of the mainstream, we ask once again: Who speaks for our culture? Who authorizes whom? The outsiders and the self-taught are almost universally unexpected speakers. They have previously been silent or perhaps just never heard — or listened to or seen — but they find voice through their works, which offer visual statements that can be as accomplished and profound as any art. Viewing their work frequently calls up echoes of the last spoken words of Ralph Ellison's Invisible Man: "Who knows but that, on the lower frequencies, I speak for you?" Do we authorize them to speak for our culture? For ourselves? Do they authorize themselves? If we authorize ourselves to listen for those deeper resonances, we allow them to speak and enter their monologue, perhaps finding dialogue.

If we choose, we have the ability to approach each work, each artist, as we do any work of art. Shaped by the art of the modern era, we look to art to expand consciousness and intensify awareness, to see what has not yet been seen, and to see the known differently, more intensely through new eyes. We seek art that embraces the unfamiliar, the marginal that challenges the center, the new vision that upsets the given, the codified, the old. However much self-taught and outsider art is declared a nonparticipant in the discourse of modern art, we, along with previous mainstream artists, have found our way to the self-taught precisely because they satisfy the most basic purposes of the art of our time.

Yet however consistent with our expectations of art, the experience of self-taught and outsider art can be more profoundly disorienting and illuminating than anticipated. This is in part because they are not participants in the known and predictable art world. Each artist defines his or her psychic and cultural terrain (although we may observe general cultural patterns and shared vocabularies among some vernacular artists). In great measure, the strongest and most unique self-taught artists draw us further out of our familiar realm of being and imagining into some other state of clarity and mystery.

We sense that we are encountering individuals who may be very much like us but who also seem to exist in another dimension of our world, suggesting degrees of intensity or estrangement that may be at once fascinating, desirable, and frightening. This sense of simultaneous closeness and estrangement can arise with those self-taught artists whose "cultural" vision demands that we see their home ground and our common culture from perspectives often suppressed, subaltern, or more knowing of us than we know ourselves. And the mystery of otherness and its closeness can loom forth even more strongly in the encounter with the work of outsider artists, whose inner journeys pull us deep into themselves and into ourselves.

The appeal and the challenge of these encounters is to hold in balance the sense of being expanded and penetrated by the Other who is both a stranger and our familiar. It is analogous to the demand that Clifford Geertz made of cultural anthropologists studying other cultures: "how the deeply different can be deeply known without becoming any less different, the enormously distant enormously close without becoming any less far away."[13]

If we are receptive viewers of self-taught and outsider art—if we are open to an alternate dialectics of culture and art—we find ourselves willing to stand at the edge of the known, open to the unknown beyond and within. It is a liminal state we enter, the condition of being on the threshold of the unknown, of possibly another dimension of being intuited, desired, and probably feared. More unsettling, perhaps, is the possibility that there are no clear borders. We may have just stepped further along a spectrum of cultural comfort or psychological stability without realizing how far we have gone or might still go. As Hans Prinzhorn declared, "neither the extremes of sick or healthy nor those of art and nonart are clearly distinguishable except dialectically" (p. 4).

Each borderline act of viewing or dialectic assessment of unclear distances calls up awareness of similarity and difference. How do we recognize the Other unless it is somehow, somewhat familiar or already imagined? How can we be true to the distinctiveness of difference if we slide too quickly into conceptual patterns of received meaning? Unlike the early-twentieth-century vision of the non-Western Other, here, throughout the experience of self-taught and outsider art, we encounter versions of the Other at home, within our culture. The psychological and social boundaries are more porous, the degrees of psychological estrangement, distortion, or intensity easily—perhaps too easily—imagined and felt. The world on which the vernacular or art brut artist looks appears strangely familiar, in all its strangeness. It is our very own.

Notes

Epigraph. Hans Prinzhorn, *Artistry of the Mentally Ill*, trans. Eric von Brockdorff, 2nd ed. (New York: Springer-Verlag, 1995), p. 15.

1. Barbara Rose, *American Art Since 1900* (New York: Praeger, 1975), p. 7.

2. See, for example: Paul Arnett and William Arnett, eds., *Souls Grown Deep: African American Vernacular Art of the South* (Atlanta: Tinwood Books, 2001); Annie Carlano, ed., *Vernacular Visionaries: International Outsider Art*, exh. cat. (New Haven: Yale University Press/Santa Fe: Museum of International Folk Art, 2003); and *Sublime Spaces and Visionary Worlds: Built Environments of Vernacular Artists*, exh. cat. (Princeton: Princeton Architectural Press/Sheboygan, WI: John Michael Kohler Arts Center, 2007).

3. Prinzhorn (epigraph), p. 107 n. 4. Subsequent page references to this source will be given in the text.

4. Walter Morgenthaler, *Madness and Art: The Life and Works of Adolf Wölfli*, trans. Aaron H. Esman (Lincoln: University of Nebraska, 1992), p. 108.

5. Wilhelm Worringer, "Abstraktion und Einfühlung: ein Beitrag zur Stilpsychologie" [Abstraction and Empathy: Essays in the Psychology of Style], (Ph.D. diss., Bern, 1907). See also Wilhelm Worringer, *Abstraction and Empathy*, trans. Michael Bullock (Chicago: Ivan R. Dee, Elephant Paperbacks, 1997).

6. Morgenthaler (note 4), p. 107.

7. Sidney Janis, *They Taught Themselves: American Primitive Painters of the Twentieth Century* (New York: Dial, 1942), p. 12.

8. Alfred H. Barr, Jr., foreword to ibid., p. xx.

9. Ibid., p. xix.

10. Ezra Pound, "A Retrospect," in *Pavannes and Divisions* (New York: Knopf, 1918), reprinted in *Ezra Pound: A Critical Anthology*, ed. J. P. Sullivan (Baltimore: Penguin, 1970), p. 85.

11. Jean Dubuffet, "L'art brut préféré aux arts culturels," in Jean Dubuffet, *Prospectus et tous écrits suivants*, vol. 1 (Paris: Gallimard, 1967), pp. 201–02. See also, Jean Dubuffet, "Art Brut in Preference to the Cultural Arts," in *Art Brut: Madness and Marginalia*, ed. Allen S. Weiss, trans. Paul Foss and Allen S. Weiss (Australia: Art and Text, 1988), p. 33.

12. Russell Bowman, "Introduction: A Synthetic Approach to Folk Art," in Jeffrey Russell Hayes, Lucy R. Lippard, and Kenneth L. Ames, *Common Ground/Uncommon Vision: The Michael and Julie Hall Collection of American Folk Art*, exh. cat. (Milwaukee: Milwaukee Art Museum, 1993), p. 18.

13. Clifford Geertz, "Found in Translation: On the Social History of the Moral Imagination" in *Local Knowledge: Further Essays in Interpretive Anthropology*, 3rd ed. (New York: Basic Books, 2000), p. 48.

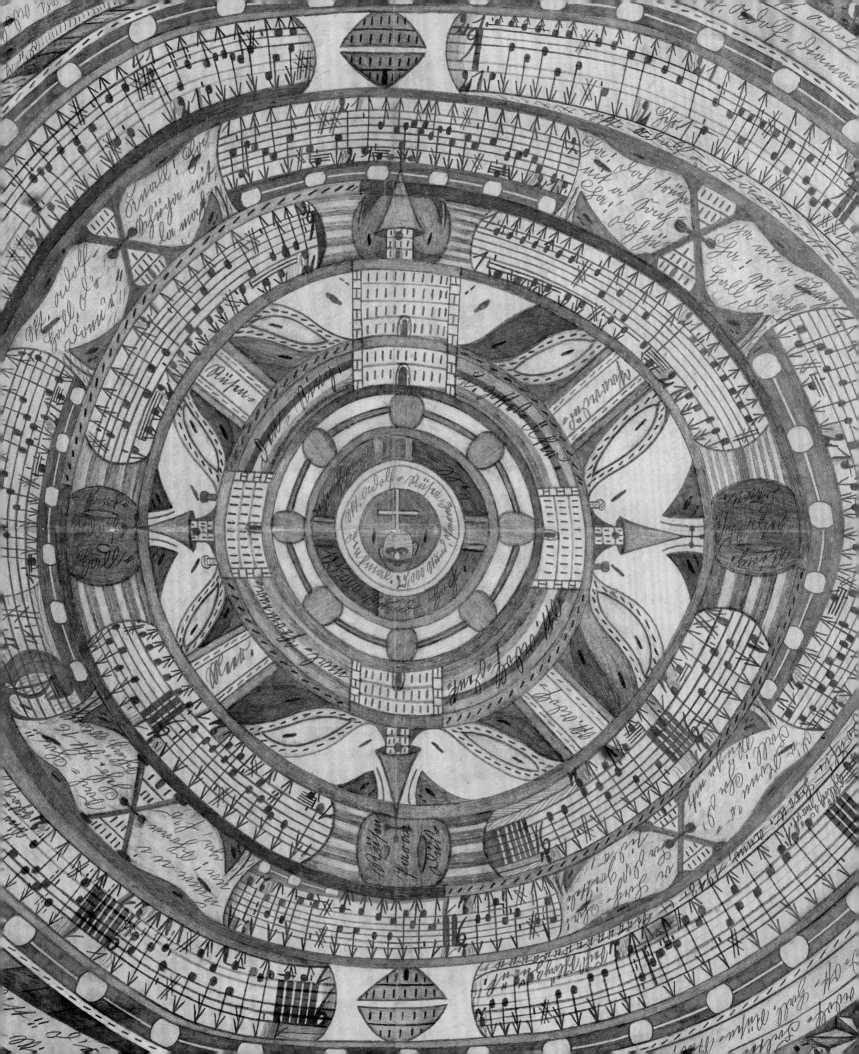

Adolf Wölfli

The life work of Adolf Wölfli (1864–1930) is a twenty-five-thousand-page, fictive autobiographical narrative filled with musical notation, poetry, and lyric songs, and illustrated with more than thirty-two hundred drawings and collages. There is something so exalted about Wölfli's grand narrative that it might claim the title of a total work of art, a Gesamtkunstwerk whose epic scope is not projected on an opera house stage as if it were a Wagnerian production, but manifest across thousands of beautifully composed pages meant to be seen, read, and sung.

The beauty and power of the visual work of this self-taught artist were immediately apparent to Walter Morgenthaler, a psychiatrist at the Waldau Mental Asylum in Bern, Switzerland, where Wölfli was confined for the last thirty-five years of his life. But the work also posed great challenges to Morgenthaler's conception of art and the creative processes. He struggled especially to understand the relationship between the evident formal achievement of the work and the disturbed mind of its creator, as well as how the experience of the art might challenge the viewer's aesthetic expectations. He remarked: "what surprises one at first is the real harmony of forms and colors. Closer attention to his work may yield some disappointment if one is put off by its delusional content. One must have a good sense of color and form if one is to avoid letting an intellectual critique erase the first impression."[1] Morgenthaler thus chose to focus on the pleasures and necessities of form in Wölfli's art and life, and on the viewer's ability to comprehend such eccentric compositions.

However challenging the content of Wölfli's drawings, we are struck, as Morgenthaler was, most immediately by their formal structure, color sense, and expressive power. Works such as *Felsenau, Bern* (1907; fig. 1) are characterized by a dense, rich weave of abstract and figurative elements brought into masterful order by a balanced geometric and rhythmic composition. While recognizably a landscape, this drawing depicts an imaginative realm of apparently deeply symbolic, if private, meaning to the artist, yet it is still mysteriously accessible to us. The scene is the Felsenau Cotton Mill and its surrounding hills and train tunnel, which Wölfli observed as a child but illustrated here through the constant merging of representational images with abstract and highly decorative forms. Fences, roads, and railings partition the landscape while establishing a fluid compositional structure. Faces, figures, biomorphic forms, and ornamental designs and symbols pack the interstices between the scenic references, transforming a representational landscape into a symbolic narrative. The road emerging from the tunnel becomes a lined ground for written text, and the smokestack's bricklike emission contributes to the decorative patterning evident throughout the composition.

Wölfli's visual sophistication is evident in his earliest surviving works (1904–07), which display the formal strategies and core imagery that he would call on throughout his life. From the start, his significant skill as a draftsman is seen in his assured line, precisely delineated figures, and tightly defined compositions, which he drew by hand without assistance from straight- or curved-edge tools. The earliest works,

OPPOSITE: Detail of Adolf Wölfli's *Skt. Adolf-Diamantt-Ring* (fig. 6)

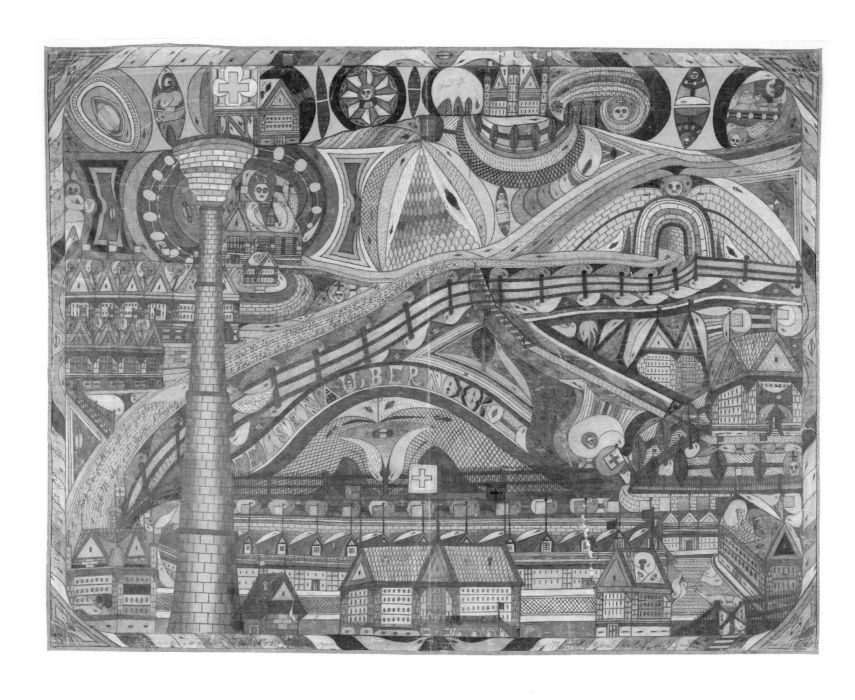

FIG. 1. Adolf Wölfli, *Felsenau, Bern*, 1907. Pencil and color pencil on newsprint, 29¼ x 39⅛ in. (74.3 x 99.3 cm). Adolf Wölfli Foundation, Museum of Fine Arts, Bern, Switzerland

on newsprint, are executed in graphite pencil, with which he achieved degrees of shading and tonality that generate both sharp contrasts and muted transitions. First given the opportunity in 1907 to work with colored pencils, he immediately exhibited an astonishing sense of color relationships and an ability to achieve both striking and subtle effects, as evidenced in *Felsenau, Bern*. Perhaps most notable, however, is Wölfli's assured sense of overall composition.

Throughout his artistic career, Wölfli employed a variety of formal strategies, many evident from the beginning. Some works, like *Glas-Perl-Egg* (1905; fig. 2), are centrally oriented, radiating out from a single circular or oval form. Wölfli developed this structure in other highly articulated drawings

whose rigorous yet sensuous symmetry and complex, multi-dimensional imagery often suggest mandalas. Other early drawings are defined by dominant horizontal frames and bands that are counterbalanced by prominent vertical oval or circular forms. Several complex works, such as *Sun-Ring* (1905; fig. 3), extend the lateral series of circular or oval forms across four conjoined panels unified by ornate frames ringing the work. The regularity of these drawings and their force of repetition in both "frame" and core establish a strong ornamental sense, yet one that moves well beyond the formulaic if satisfying pleasures of much decorative art. Instead of the familiar delights of mere repetition and symmetry and the predictable play of similarity and difference, Wölfli's abstrac-

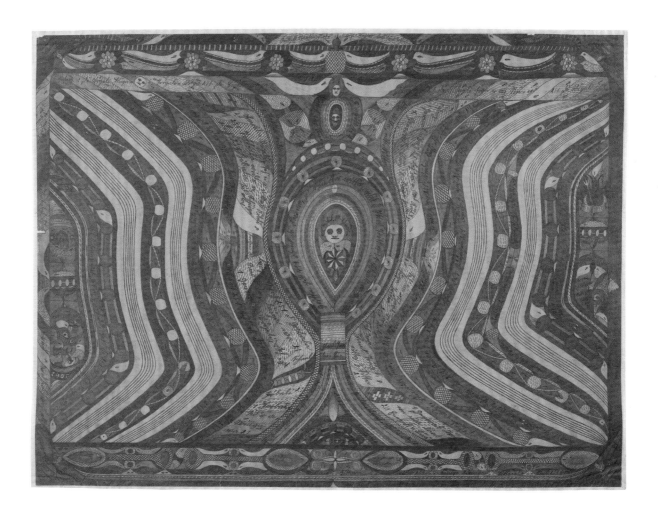

FIG. 2. Adolf Wölfli, *Glas-Perl-Egg*, 1905. Pencil on newsprint, 29 x 39¼ in. (73.5 x 99.6 cm). Adolf Wölfli Foundation, Museum of Fine Arts, Bern, Switzerland

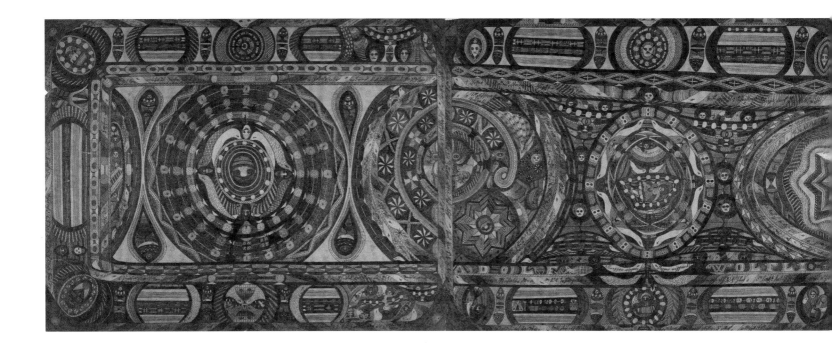

tion introduces surprising distortions, dislocations, shifting planes, and sinuous movements.

Within the ornate compositions we observe a distinctive repertoire of figurative and symbolic images, omnipresent musical notation, and extensive writing. Woven throughout the fluid forms or stable geometric fields, for instance, are small masked faces suggesting self-portraits, male and female figures depicting ambiguous relationships and narrative scenes, and occasional buildings and landscapes. The faces and figures are often centered within decorative circular or oval forms, as if formally framed. But frequently we stumble upon them unexpectedly, packed in the interstices of the composition.

The interpolated figures serve several functions. Their framing announces their importance as bearers of personal presence and, most likely, psychological drama. Occasionally, a figure appears to be pointing across the drawing to another individual, suggesting possible narrative connections in the work. Usually, however, the figures and scenes are compartmentalized within discrete frames, both constrained by and animating the ornately structured drawing and contributing

to the regularity of the patterning. This is especially true of the iconic "bird" and "snail-like" forms Wölfli called *Vögeli*, which he interwove in all but his very late works. At times they are a highlighted feature, as with the centered yellow *Vögeli* in *St. Adolf Brogar-Kitty* (1915; fig. 4) and especially in *At the Cradle of Frederic The Great* (1918; fig. 5). Like many of Wölfli's artistic elements, they structure the work, add a distinctive ornamental component, and, in their lyrically peaceful presence and phallic suggestiveness, bear psychological and symbolic resonance.

Wölfli's compositions also incorporate extensive musical notation, numbers, script writing, and collage, which, like the figurative images, serve as compositional devices, sometimes structuring the entire work or enriching its narrative meaning. Musical notation, texts of narration and songs, and cascading numerical columns and calculations may define the visual field, but they also signal Wölfli's expansive imagination, which could not find adequate expression in the ocular realm alone. (Indeed, as early as 1904 Wölfli signed a work "A.W.—Adolf Wölfli Composer.") In his earliest drawings, like *Glas-Perl-Egg*

FIG. 3. Adolf Wölfli, *Sun-Ring*, 1905. Pencil on newsprint, four panels; from left: *The Church Clock of Schangnau*, 29⅜ x 39⅛ in. (74.6 x 99.5 cm); *Sundial*, 29⅜ x 39⅛ in. (74.6 x 99.5 cm); *Berner Oberland*, 29½ x 39⅛ in. (75 x 99.4 cm); *Sunring*, 29⅜ x 39⅛ in. (74.6 x 99.4 cm). Adolf Wölfli Foundation, Museum of Fine Arts, Bern, Switzerland

FIG. 4. Adolf Wölfli, *St. Adolf Brogar-Kitty*, 1915. Page 145 of Book 13 from *Geographic and Algebraic Books*. Pencil and color pencil on newsprint, 28⅝ x 39⅝ in. (72.8 x 100.5 cm). Adolf Wölfli Foundation, Museum of Fine Arts, Bern, Switzerland

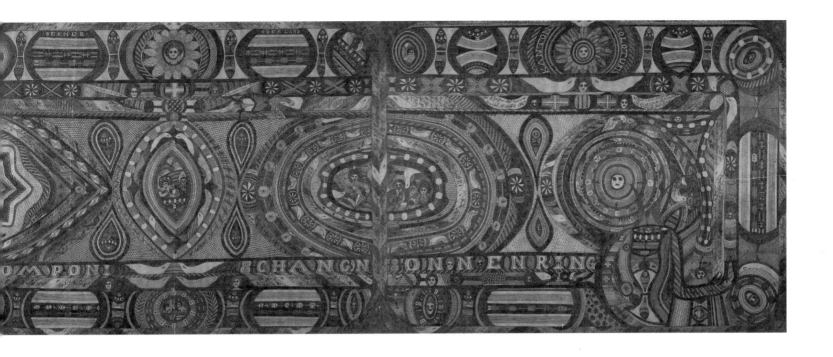

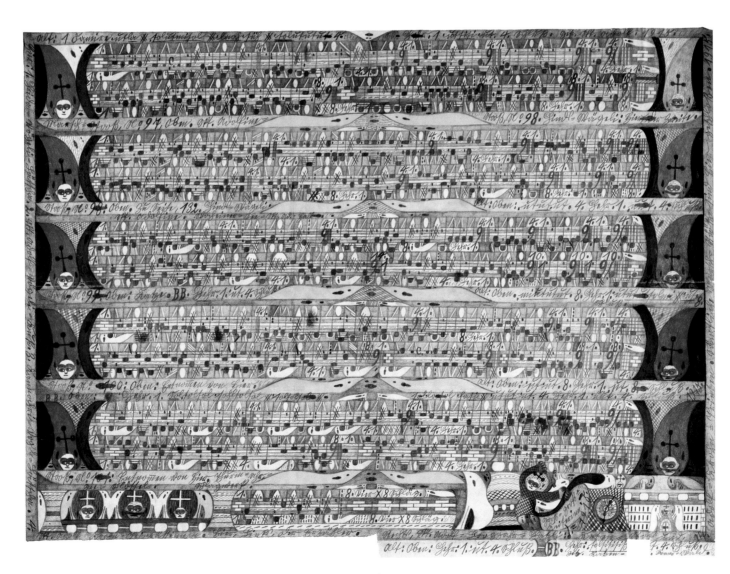

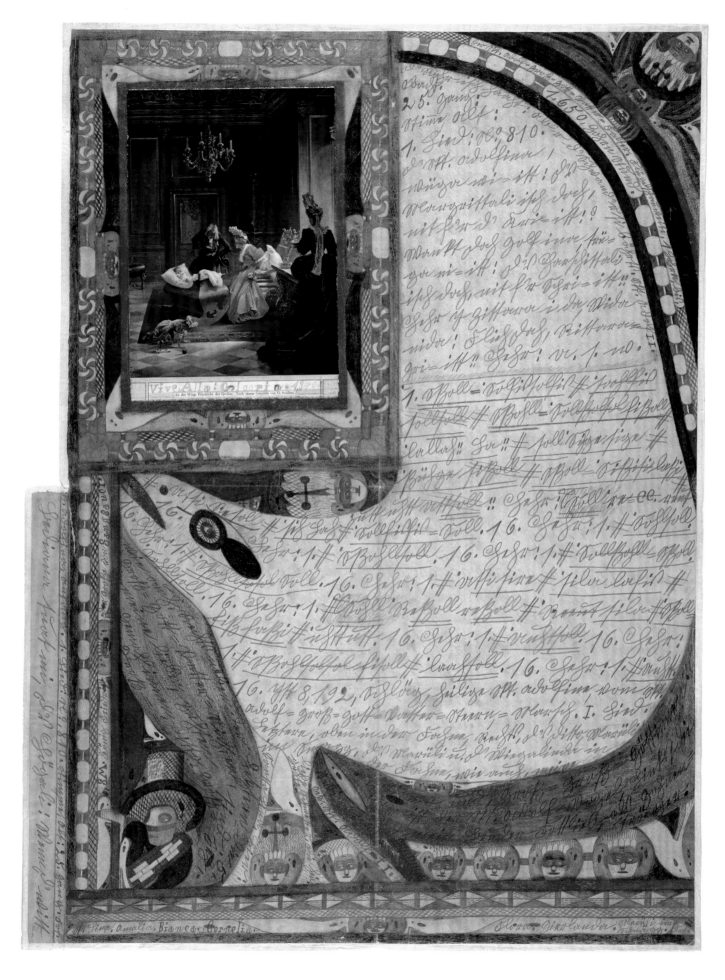

and *Sun-Ring*, horizontal white forms embellished by thin black parallel lines suggest empty musical staves. In subsequent drawings—especially those from his series *Geographic and Algebraic Books*, such as *St. Adolf Brogar-Kitty* and *Skt. Adolf-Diamantt-Ring* (1913; fig. 6)—musical notes appear both on staves and throughout the composition, becoming at times the primary motif and dominant structural device.

The works in the *Geographic and Algebraic Books* series also often contain compulsive columns of numbers, which, like the musical notations, may crowd other drawn or collaged images into subsidiary positions within the composition, as in *End of Profit Calculations in June 1, 1912, The Commercial Bank, Bern* (1912; fig. 7). On a narrative level, the numbers usually signify Wölfli's calculations of the excessively accruing interest he imagined would come from the projected sales and management of lands and industries he described in his written texts. The sum escalated to such a degree that he invented twenty-three exponentially new numerical terms beyond quadrillion, including *Oberon* and ultimately the greatest number, *Zorn*, which, tellingly, means *rage* in German.

Wölfli's texts, handwritten in an old German script, are found throughout the oeuvre, appearing within drawings and, in many of them, totally dominating both sides of the page. In his later works, images, if they occur at all, are integrated into a compositional whole defined by text, which serves as the primary visual statement, whatever its semantic

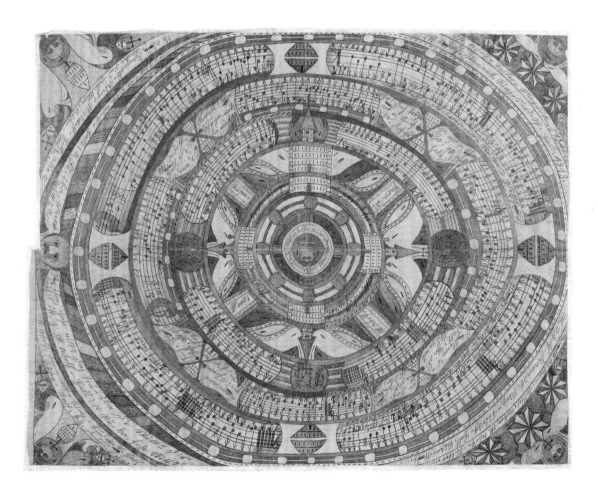

FIG. 6. Adolf Wölfli, *Skt. Adolf-Diamantt-Ring*, 1913. Pencil and color pencil on newsprint, 38⅝ x 29¾ in. (98 x 75.7 cm). Adolf Wölfli Foundation, Museum of Fine Arts, Bern, Switzerland

OPPOSITE: FIG. 5. Adolf Wölfli, *At the Cradle of Frederic the Great*, 1918. Page 761 of Book 15 from *Books with Songs and Dances*. Pencil, color pencil, and collage on newsprint, 28⅝ x 39⅝ in. (72.8 x 100.5 cm). Adolf Wölfli Foundation, Museum of Fine Arts, Bern, Switzerland

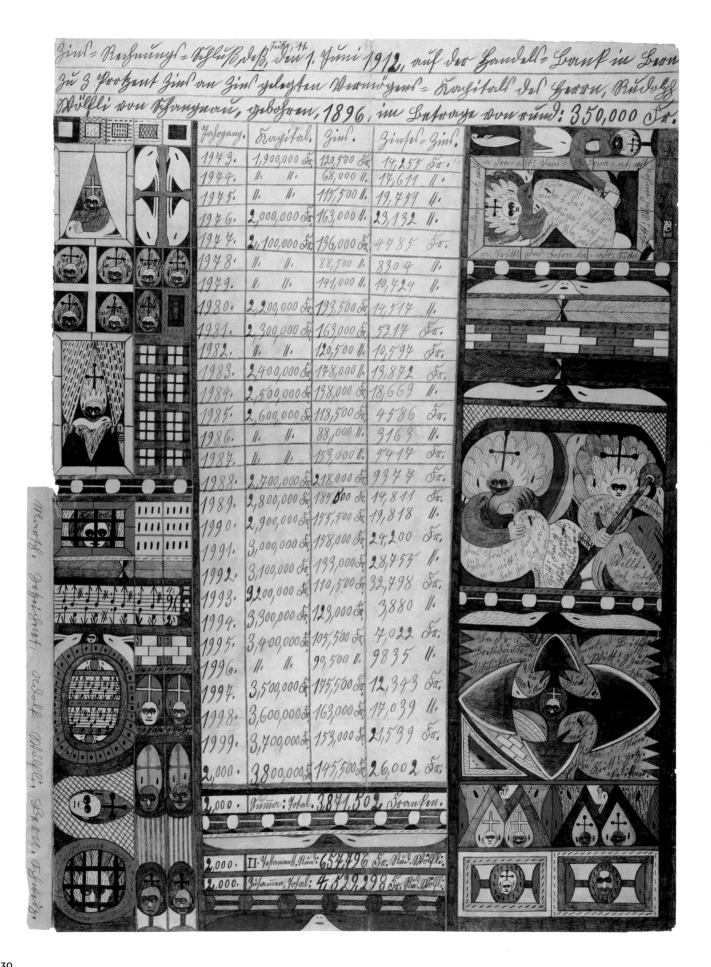

intent. In fact, most of his pages consist of text alone. Thus, although we celebrate Wölfli as a visual artist, he may well be considered primarily a writer.[2] His entire opus is infused with a strong narrative and lyric impulse expressed in rhymes, rhythms, and pure sounds dedicated entirely to the elaboration of his imagined life and vision.

Over the course of his life, Wölfli wrote—and illustrated—some twenty-five thousand pages in forty-five large hand-stitched tomes of newsprint and sixteen school notebooks, which include over 1,620 drawings and more than 1,640 collages. Conceiving them as a coherent whole, Wölfli signed and dated the books, grouping them into five series: *From the Cradle to the Grave* (1908–16); *Geographic and Algebraic Books* (1912–16); *Books with Songs and Dances* (1917–22); *Album Books with Dances and Marches* (1924–28); and the unfinished *Funeral March* (1928–30).

Initiated as an autobiography, *From the Cradle to the Grave* immediately became a fanciful narrative of the great works and adventurous travels across the globe of the two-through-eight-year-old Adolf, known as Doufi, and his extensive and cohesive family, which Wölfli never had in real life. In the succeeding *Geographic and Algebraic Books*, the adult Wölfli becomes a figure of great wealth and power, purchasing and transforming cities and countries, establishing massive public enterprises, traveling across the cosmos, encountering "God-Father," and ultimately forming the "St. Adolf Creation." In 1916 Wölfli renamed himself St. Adolf II, a grandiose and mythic figure of godlike status, inventing and naming objects, buying and controlling the entire world. In *Books of Songs and Marches* through *Funeral March*, the text ceases being a narrative of his life and becomes largely the obsessive calculations of the infinitely expanding value of his creations and the celebration of the objects and life events referenced in the earlier books. Drawn images no longer appear; they are replaced by collaged illustrations from popular magazines surrounded by numbers or, more frequently,

rhythmically phrased texts, words reduced to pure vocables, mere rhymed sounds that Wölfli evidently sang to himself as he wrote (see *Campbell's Tomato Soup*, 1929; fig. 8).[3] By the end of his life, the process of creation appears to have approached a state of ecstatic glorification of Wölfli and the world he invented.

Despite this late achievement, much of Wölfli's work displays signs of tension that belie the stability of the total

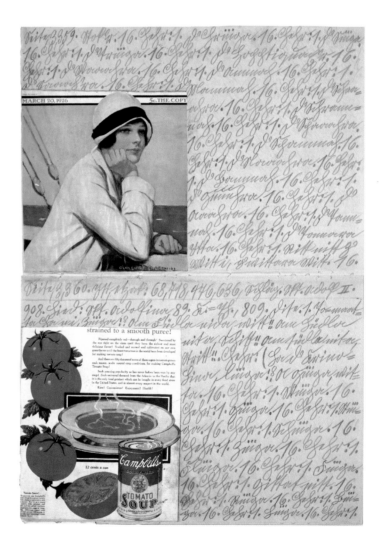

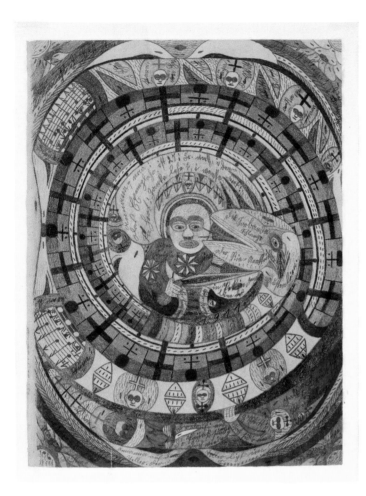

fig. 9). The unsettling depictions introduce an uneasiness that animates the exquisitely composed artworks, even as we might read the intricate and tightly defined compositions as created expressly to contain the disturbing images that insist on popping up everywhere within them.[4] This dialectic built within the autobiographical fantasies of the text and imagery enacts the psychological drama of their creator.

Born in 1864, the youngest of seven children in a rural Swiss family, Adolf Wölfli grew up in dire poverty. His father, an alcoholic stonemason, abandoned the family when Wölfli was about five. Two years later, Wölfli and his ailing mother, who could no longer support herself and her youngest child, were returned to their original village, Schangnau in Emmental, as wards of the community. Separated from his mother, who died the next year, Wölfli worked for seven years as a hireling under harsh and often cruel circumstances. The disruption of his early romance with the daughter of a wealthy farmer who disapproved of Wölfli's inferior status lingered as a painful memory for years. His young manhood was characterized by a string of farming and laboring jobs in and around Bern, military service, and two more failed relationships: one with a young prostitute; the other with a widow some twenty years his senior. When Wölfli was twenty-six, he attempted to molest a fourteen-year-old girl but was prevented by her companions. A week later, he tried to abuse a seventeen year old, was caught, and imprisoned for two years. After his release, he worked a series of odd jobs and his behavior was marked by periods of isolation, piety, and anger. In 1895 Wölfli was arrested for attempting to molest a three-and-a-half-year-old girl and was sent to the Waldau Mental Asylum, where he was diagnosed as schizophrenic and institutionalized for the remaining thirty-five years of his life.[5]

Wölfli's initial asylum years saw the total collapse of his mental stability. Subject to violent outbursts and destructive of hospital property, he was reduced at times to the abject

vision. This is especially evident in the early narratives and images of *From the Cradle to the Grave,* which frequently describe instances of personal collapse and calamity, as when the child Doufi suddenly falls from great heights or swoons at moments of intense emotion. The graphic works' interpolated images include numerous scenes of violence and periodically depict figures who have been hanged for sexual crimes. Large snakes emerge out of the decorative borders and wrap around figures that struggle to defend themselves, as in *The Sorbanda-Snake or Ria-Arattrika, Australia* (1911;

FIG. 9. Adolf Wölfli, *The Sorbanda-Snake or Ria-Arattrika, Australia,* 1911. Page 359 of Book 4 from *From the Cradle to the Grave.* Pencil and color pencil on newsprint, 19⅝ x 14¾ in. (49.9 x 37.5 cm). Adolf Wölfli Foundation, Museum of Fine Arts, Bern, Switzerland

state of being thrown for weeks on end naked in an isolation room containing only a pile of seaweed. Four years after admission, however, he began to draw. Although early doctors' reports called his work "very stupid stuff, a chaotic jumble of notes, words, figures,"[6] they remarked that Wölfli became calm and completely occupied with drawing, so they allowed him to continue. Unfortunately, none of his work was preserved until 1904, by which time he had developed the artistic vision and command of draftsmanship that would define his entire oeuvre.

Once Morgenthaler arrived at Waldau in 1907 and recognized the artistic quality and stabilizing effects of Wölfli's drawing, the patient was encouraged to draw, provided a basic supply of materials, allowed to sell his work, and eventually given a separate room in which to create. Morgenthaler was responsible for preserving Wölfli's works and for bringing him to the attention of the world through his 1921 book-length study *A Mental Patient as Artist.* Morgenthaler departed from traditional clinical writing both by stating Wölfli's name within the text and by treating the patient's creations as more than mere diagnostic data. Like *Artistry of the Mentally Ill*, published just one year later by Hans Prinzhorn of the psychiatric clinic at Heidelberg University in Germany,[7] Morgenthaler's study considered Wölfli's creations as art and investigated what artistic practice meant to the patient and what it could reveal about art in general.

In his analysis of Wölfli's art, Morgenthaler focused especially on the extraordinary achievement of harmonious form and rhythm, locating this accomplishment within the origins and onset of Wölfli's illness, his descent into psychosis, the chaos of his disordered mind, and the partial recovery of a sense of order and control largely through the agency of artistic activity. Wölfli's art was considered the expression of a psychological "counterforce" arising against the domination of his illness. According to Morgenthaler, by taking up writing and then drawing Wölfli began to "work" and thus "to some

degree, freed himself. . . . We don't know how he began to work, how his disordered activity became disciplined, how chaos turned into form,"[8] but the coherence, balance, and harmony of Wölfli's elaborate compositions signal a continuous psychological effort to contain instinctual disorder.

Without fully developing a theory of the psychology of art, Morgenthaler asserted that Wölfli's struggles shared with all artists a heightened effort to create a visual and conceptual order reflective of a desire for psychic coherence in experience. While he held that this desire was fundamental to all humans, Morgenthaler posited that the basic processes of creating imaginative order were felt to greatest effect by the artist: "The task of the artist is two-fold. To crystallize the form given him by nature as purely as possible—this is his true artistic task. But to permeate and fill this form with life is the more general and human task of the artist" (p. 109). Thus, we turn to art precisely because we recognize within it the primary psychic struggles that we experience within ourselves and because we seek the sense of integral and enriched life expressed within achieved aesthetic order.

In Wölfli's body of work, we are stuck by the immediate appearance of masterful, complex, and vivid forms animated by a compellingly lived imaginative life. Morgenthaler recognized, however, that despite their magisterial presence, the works "always result from a struggle between his natural instinct and his counterforce, without diversion, without any secondary aim. That is why his manner of creating and his works have for us such a character of necessity, of urgency" (p. 90). Indeed, the sense of urgency and the absolute importance of the work to the artist lead us to envision life heightened to our very limits of thought and feeling. Within Wölfli's massive, obsessive narratives, his densely packed, expansive compositions, his compulsive numerical lists and bars of musical notation, we recognize "the instinctive character of immoderation, a titanic aspect which attempts to transcend all limits of space and time, which always seeks

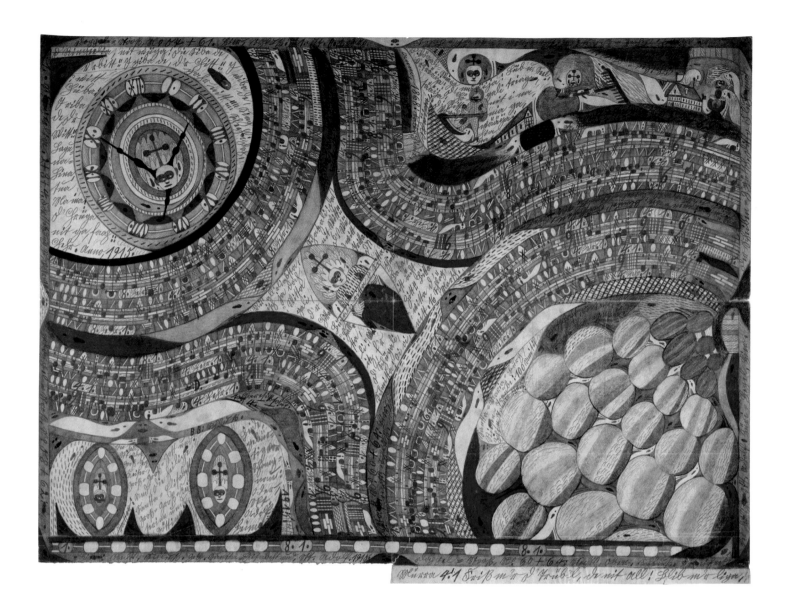

to grasp the totality and sees only the summits, an ever-increasing graduation toward symbolism, a wish for absolute freedom which cripples and mutilates natural forms, a restlessness and a passion which approaches anxiety and which would cram everything into one sheet and say everything in one word, something mystical and demonical" (p. 93) (see *Saint-Mary-Castle-Giant-Grape*, 1915; fig. 10).

Wölfli's work takes us to the limits of artistic and mystical vision, where both the artist and mystic seek "with as little digression as possible, the ultimate end, the absolute" (p. 93). Morgenthaler realized Wölfli's work may have been wondrous and of the highest artistic order, but ultimately the vision within was mad and could only be approached and observed from outside. Like the mystic, Wölfli the artist

FIG. 10. Adolf Wölfli, *Saint-Mary-Castle-Giant-Grape*, 1915. Page 75 of Book 13 from *Geographic and Algebraic Books*. Pencil and color pencil on newsprint, 28⅝ x 39⅝ in. (72.8 x 100.5 cm). Adolf Wölfli Foundation, Museum of Fine Arts, Bern, Switzerland

descended to "beneath the surface delusion of the senses and the intellect into the great irrational substratum" (p. 101), but was not able to return whole with a coherent message for the world. Wölfli was ill, broken by his condition, and he could not integrate his psychic experience with those of others. His oeuvre was not a cure but an essentially autistic terrain of struggle whose associative meanings were intelligible to him alone. We are drawn to the works because of the play of apparent passion and order, but ultimately cannot share in them. Nonetheless, his work provides us with a direct sensation of the desire for the mystical encounter that underlies human experience and art especially, and it offers a particularly vivid insight into the essential struggle of chaos and order that lies within each of us.

Numerous signs of parallel struggles are evident in Prinzhorn's *Artistry of the Mentally Ill*, which also explores the relationship between aesthetic and psychological order and considers the similarities and differences in the behavior of the ill and the healthy. While Morgenthaler studied a single patient, Prinzhorn reviewed over five thousand artworks—created from 1890 to 1920 by some 435 patients treated in institutions in Germany, Austria, and Switzerland, Italy, and Holland—collected for study at the psychiatric clinic at Heidelberg. The works reproduced in the final publication display a wide range of expression served by distinctive aesthetic styles. In many, the viewer is captivated by the complex composition, rigorous patterning, and precise clarity of articulation, only to be brought up short by the evident suffering and loneliness of the artist.

This is especially true in the work of Josef Heinrich Grebing (1879–1940), which presents tightly composed, exactingly ordered charts, maps, calendars, and lists of chronological and mathematical calculations. His art may be interpreted as a desire to control space and time, yet at times it also contains elements that suggest error, imprecision, or indecision that disrupt the perfection of the order. One of his most

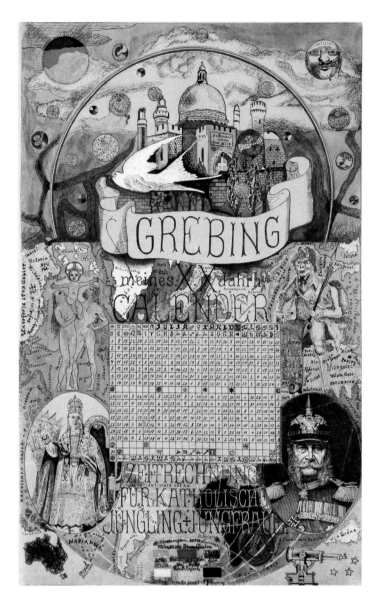

ambitious works, *Calendar of My 20th Century—Chronology for Catholic Youths and Maidens (Hundred-year Calendar)* (1910–20), is an exercise book filled with documentation of significant religious dates. The cover (fig. 11), which combines maps, calendars, astronomical bodies, and images and collages suggestive of mythic and world history, includes the artist's name emblazoned on a decorative scroll. The banner

FIG. 11. Josef Heinrich Grebing, *Calendar of My 20th Century—Catholic Youths and Maidens (Hundred-year Calendar)*, 1910–20. Pen, pencil, on paper, 8¼ x 13 in. (21 x 33.1 cm). Prinzhorn-Sammlung der Psychiatrischen Universitätsklinik Heidelberg (Inv. 613)

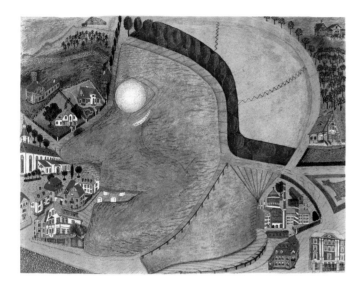

Witch's Head (before 1919; fig. 12), constituted the world itself, embedded in the landscape as both sustaining fields and threatening maw. On the whole, Natterer's art serves narrative and figurative purposes seeking to communicate aspects of his apparition of the last judgment in the sky, a pivotal delusion during which he saw ten thousand images in the course of a half hour. The vision, represented here by *My Eyes at the Moment of the Vision* (1911–13; fig. 13), occurred when he was near forty, and it became the defining moment in his advanced state of schizophrenia, for which he was interred in an asylum near Rottweil for the last two decades of his life.

Like Wölfli, many mentally ill artists call on both word and image to express their psychic experience. Barbara Suckfüll (1857–1934?) used texts to surround and overwrite her spare graphic images, alternately providing commentary on the scene depicted or finding in the image a correlative for the narrative. For Suckfüll, the text might describe incidents of direct or implied threat. It acts as an accusation while the image grounds the context. *Untitled* (1910; fig. 14) depicts her washbasin and narrates an interaction with a nurse that has decidedly antagonistic undertones. Her graceful and evenly presented script is in harmony with the minimal yet lyric line of the washbasin, suggesting placidity and self-control. But the tenuousness of that control is indicated by her investment in the precision of each articulated word: *And. Today. It. Is. Sunday. Too. The. First. Sunday. After. The. Assumption. Too. And. So. It. Will. Be. The. Twenty-first. This. Is. Fine. I. Think. And. That. Is. The. Washbasin. You. See. I. Have. Drawn. That. Too. One. Time. Too. And. Then. Today. The. Redhead. Brought. Cold. Washing. Water. It. Was. Too. Cold. What. She. Brought. Today. And. The. Second. Devil. Was. On. The. Lookout. I. Heard. That. Myself. Too.*

At times, the most powerful and affecting works signify an artist's desperate effort to hold on to the most minimal sense of an extremely vulnerable self, even as that self is given unforgettable presence by the work. Nonetheless, this

serves as the focal point of the composition, linking the wealth of data and references below to the romantically imagined edifice that suggests the attainment of religious and worldly peace.

The beauty of the aesthetic and conceptual order, however, is upset by a folded newsprint image of a man's face, which oddly appears inverted and collaged onto a portrait of a royal figure. The bearded man is probably the popular Prince Heinrich of Prussia (1861–1929), grandson of Emperor Wilhelm I (1797–1988) and brother to Emperor Wilhelm II of Germany (1851–1941). Viewed with the collage element open, the precise symmetry of the overall composition is disrupted and portions of an elaborately calculated grid of dates are obscured. Yet the collage was clearly a late addition to the work, which allows for competing versions of Grebing's chart of universal order. When the upper portion is folded down, a single form—suggestively similar to a reversed letter *G*— reveals a portrait of Wilhelm I, a figure of great power and historic significance, printed on the reverse side.

The artworks of August Natterer (1868–1933) frequently depict the witch that he believed created the world, and, in

FIG. 12. August Natterer, *Witch's Head*, 1915. Pencil, watercolor, and pen on varnished card, 10¼ x 13½ in. (25.9 x 34.2 cm). Prinzhorn-Sammlung der Psychiatrischen Universitätsklinik Heidelberg (Inv. 184)

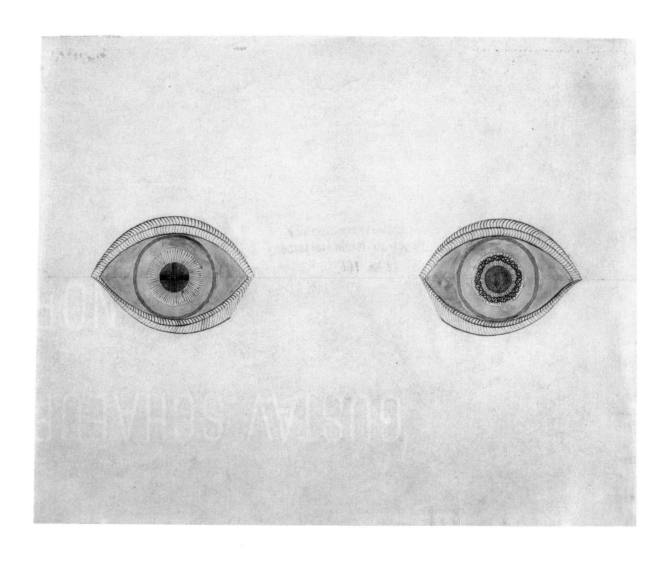

FIG. 13. August Natterer, *My Eyes at the Moment of the Vision*, 1911–13. Pencil and crayon on paper, 5½ x 8¼ in. (16.6 x 21 cm). Prinzhorn-Sammlung der Psychiatrischen Universitätsklinik Heidelberg (Inv. 166)

may not be entirely clear to all viewers, as we recall Prinzhorn's comment that "configurative power is easily underestimated when there is a lack of skill." Prinzhorn unfortunately fell victim to his own statement when he described Emma Hauck's *Letter to Husband* (1909; fig. 15) as an example of "an archetype of decoration" that is "not directed toward any kind of real, formal, or symbolic object."[9] Clearly, he had not deciphered or regarded Hauck's obsessively repeated message imploring her husband to come to her.

Hauck's words are so tightly compacted and overwritten that it is easy to regard the page as an expressive abstraction and take solely aesthetic pleasure in it. Here, however, one should not rely on the "good sense of color and form"

Morgenthaler spoke of, which might prevent a sense of disappointment once the delusional content is noted. Once Hauck's words are deciphered, her private plea becomes hauntingly public and the beauty turns poignant. We can feel her desperate loneliness and helplessness and imagine that perhaps she believed that the repetitive writing itself would effect the result she desired or was the only way for her to focus on what remained of her identity. What is most disturbing is that the letter was never posted; her husband could not read it, and he never arrived to take her away. Written in 1909 during the first months of her confinement, it remains in the Prinzhorn Collection at Heidelberg long after Hauck's death in 1920 at the asylum in Wiesloch.

FIG. 14. Barbara Suckfüll, *Untitled*, 1910. Pencil and pen on office paper, 13 x 16½ in. (33 x 42 cm). Prinzhorn-Sammlung der Psychiatrischen Universitätsklinik Heidelberg (Inv. 1965, verso)

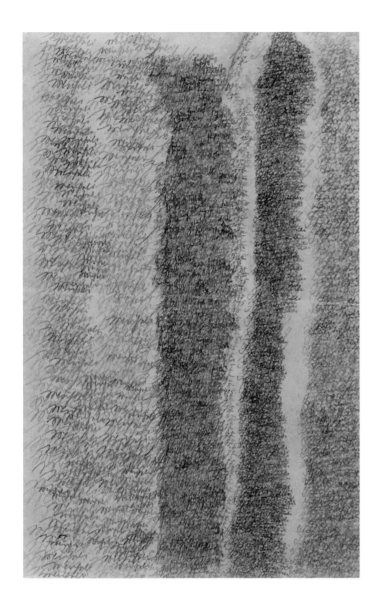

To give Prinzhorn his due, however, in spite of his misreading of Hauck's work, he saw that even in its seemingly meaningless "scribbles" a great power was manifest—the ability of the artist to configure a self and its lifeworld: "Even the simplest scribble . . . is, as a manifestation of expressive gestures, the bearer of psychic components, and the whole sphere of psychic life lies as if in perspective behind the most insignificant form element."[10] This is the power that moves us in our encounters with strong art by outsider and self-taught artists.

Notes

1. Walter Morgenthaler, *Madness and Art: The Life and Works of Adolf Wölfli*, trans. Aaron H. Esman (Lincoln: University of Nebraska Press, 1992), p. 63. This is the first English translation of Morgenthaler's original 1922 study, *A Mental Patient as Artist*.
2. This position was pointed out to me by Daniel Baumann.
3. The Wölfli Foundation's website includes links to recorded readings of several of these texts and to images of the late collaged pages. See http://www.adolfwoelfli.ch/index.php?c=e&level=8&sublevel=0.
4. I am grateful to Daniel Baumann for these insights.
5. Dr. Aaron Esman, translator of Morgenthaler's *Madness and Art*, has speculated that Wölfli's diagnosis might better have been manic-depressive. See Morgenthaler (note 1), p. xiii.
6. Wölfli's medical records, quoted in Elka Spoerri, "Adolf Wölfli, Artist/ Builder: A Consideration of His Life and Work," in Elka Spoerri and Daniel Baumann, *The Art of Adolf Wölfli: St. Adolf-Giant-Creation*, exh. cat. (New York: American Folk Art Museum, 2003), p. 16.
7. Hans Prinzhorn, *Artistry of the Mentally Ill*, trans. Eric von Brockdorff, 2nd ed. (New York: Springer-Verlag, 1995).
8. Morgenthaler (note 1), p. 90. Subsequent page references to this source are given in the following paragraphs.
9. Prinzhorn (note 7), p. 42.
10. Ibid.

FIG. 15. Emma Hauck, *Letter to Husband*, 1909. Pencil on writing paper, 6¼ x 4 in. (16 x 10.3 cm). Prinzhorn-Sammlung der Psychiatrischen Universitätsklinik Heidelberg (Inv. 3621, recto)

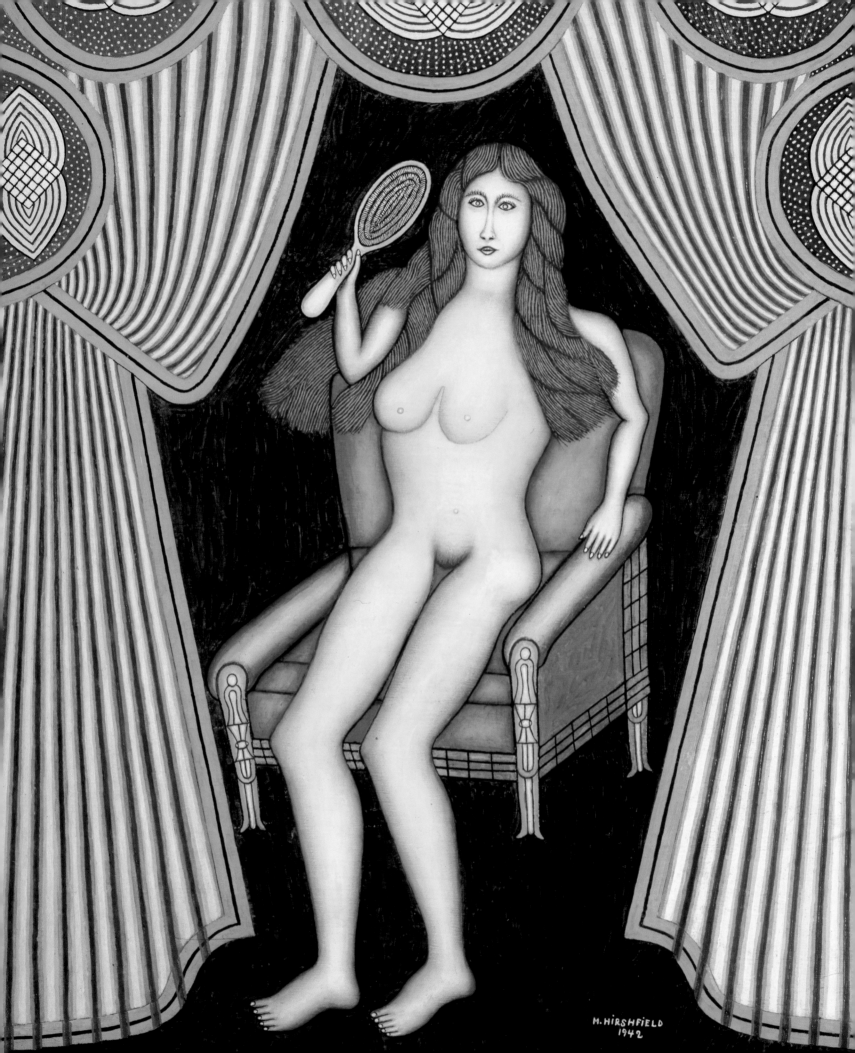

Morris Hirshfield

In the paintings of Morris Hirshfield (1872–1946), we encounter what is found in the work of many self-taught artists: subject matter traditionally associated with "serious" academic painting that nonetheless betrays an intensely personal, if not unconventional, narrative at play. Like many self-taught artists, Hirshfield came to painting after his retirement and was able to recapture a childhood passion by drawing upon skills and techniques he acquired in his profession. We feel this emotional investment in his visually compelling portraits, nudes, landscapes, and still-lifes, which he rendered in a dramatically decorative style that is at once naive, unskilled, and yet studiously composed.

Hirshfield's first painting, *Beach Girl* (1937; fig. 1), establishes the signature style and high regard for his subjects that he would maintain throughout his brief career as an artist (1937–46). A single figure, here (as often) a young woman, is positioned in the center of the canvas, barely anchored on a ground that serves more as a framing device than a credibly defined landscape—yet it is still a landscape. She appears to be standing or lying on a stretch of pale beige veined ground, met on either side by two patterned, dark gray, vertical forms and capped by a frenetically tufted, light blue and white, horizontal swath. The girl floats serenely toward us, buoyed by a narrow black outline that molds her figure and sets her off against the obsessively drawn, elaborately patterned ground. The painting is formally masterful and vivid in detail. Once we realize that Hirshfield intended the top area to depict a brightly clouded sky and the two vertical forms to represent a wave-furled sea lapping against the narrow strip of sandy

OPPOSITE: Detail of Morris Hirshfield's *American Beauty (Nude with Mirror)* (fig. 10)

FIG. 1. Morris Hirshfield, *Beach Girl*, 1937. Oil on canvas, 36¼ x 22¼ in (92.1 x 56.5 cm). The Museum of Modern Art, New York; The Sidney and Harriet Janis Collection (2097.1967)

beach on which the girl stands, do we recognize the conventions of a "bathing beauty" scene, though the insistent verticality of sea, beach, and girl challenges a literal reading. Nevertheless, the picture succeeds as a strong visual statement and communicates the artist's regard for the ideals of feminine beauty and the natural world. Like many of Hirshfield's paintings, it is as precise and luminous as a jewel, and the woman is presented as if an icon.

Paintings of women, whether clothed or unclothed, occupy a special place in Hirshfield's oeuvre. The women are always formally posed, as if on display, against either stark monochromatic or highly variegated decorative grounds. Those who are dressed wear distinctly defined and sometimes elegant ensembles. The nudes are usually framed by patterns and drapes, as if on stage. Indeed, Hirshfield painted a few works of chorus girls on display, accompanied by angels in one work: *Stage Girls with Angels* (1945; see p. 16).

All of Hirshfield's women transmit an exuberant, if quiet, eroticism. Hirshfield, a long-married man, arrived at the erotic in several stages. When, after he had completed his first paintings, it was suggested that he attempt the academic convention of the nude, he seized on the idea; however, his first nude, *Girl in the Mirror* (1940; fig. 2), displays both a distinct reticence (or perhaps prudishness) and possibly an optical naiveté. Hirshfield declared that, contrary to many painters, he found the back of a woman more beautiful than her front.[1] So when he painted a woman regarding herself in a mirror, whether it was from this preference or a blissful denial of the laws of optics, her back appears as the reflection. Hirshfield's subsequent nudes were painted without such modesty, though at least two more paintings exhibit a disregard for optical veracity in favor of idealized poetic beauty.

Nude at the Window (1941; fig. 3) is a particularly direct work. Here, a pale blond woman emerges from a black ground vividly framed by lush, red and yellow drapery. The title informs us we are outside peering in at this naked

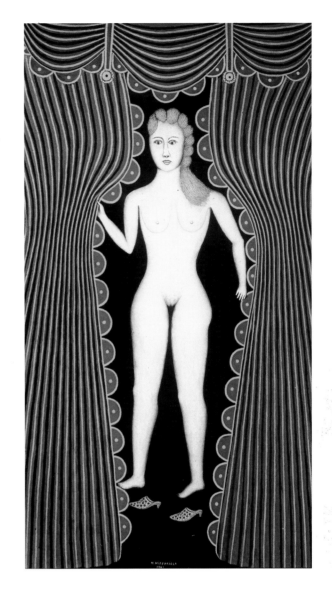

beauty, who is perhaps unaware that she is on display. The darkness around her allows no clear distinction between the floor she stands on or floats above and the room behind her; indeed, the parted curtains suggest the form of an urn on which she may well have been painted. The curvilinear folds of the drapes sweep around her, compressing at her torso, and the scalloped edges obsessively repeat the simple shape and detail of her breasts, which are also suggestively echoed by her plaited hair falling down her neck toward her breasts.

OPPOSITE: **FIG. 2.** Morris Hirshfield, *Girl in the Mirror*, 1940. Oil on canvas, 40⅛ x 22¼ in. (101.9 x 56.5 cm). The Museum of Modern Art, New York (327.1941)

FIG. 3. Morris Hirshfield, *Nude at the Window*, 1941. Oil on canvas, 54 x 30 in. (137.2 x 76.2 cm). Collection Carroll Janis

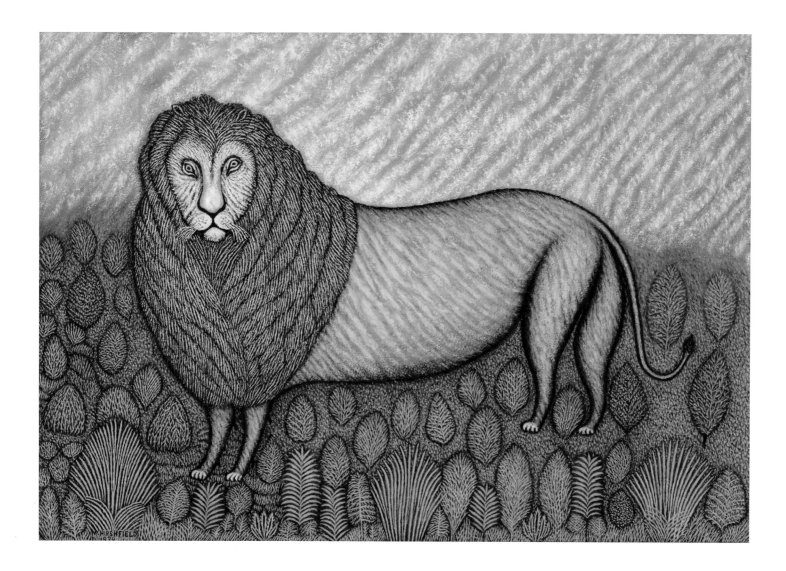

All these elements conspire to accentuate her openness to the erotic gaze. Even her slippers, above which she floats, complete her nudity in their disuse.

Hirshfield lent a similarly charged emotion to his depictions of animals, which, like his images of women, are usually centered on the canvas, staring directly if enigmatically at us. *Lion* (1939; fig. 4), like *Beach Girl*, features a subject in a richly patterned environment. The sky is filled with diagonal cloudlike forms that move across the composition, energizing the top third of the picture and setting off the majestic head

of the beast, whose mane appears wrapped around his head like a formidable stole of many stitched pelts, one edge overlapping the other as if buttoned. From this mane emerges a calm, self-possessed face, which bears some resemblance to the painter. The animal's lithe, long body is composed of gentle curves; its tiny, delicate feet tread on none of the plants that fill and animate the scene with Hirshfield's signature decorative repetitiveness.

Although Hirshfield painted other wild or circus animals—a tiger, zebras, elephants—he turned most frequently to the

FIG. 4. Morris Hirshfield, *Lion*, 1939. Oil on canvas, 28¼ x 40¼ in. (71.5 x 102 cm). The Museum of Modern Art, New York; The Sidney and Harriet Janis Collection (608.1967)

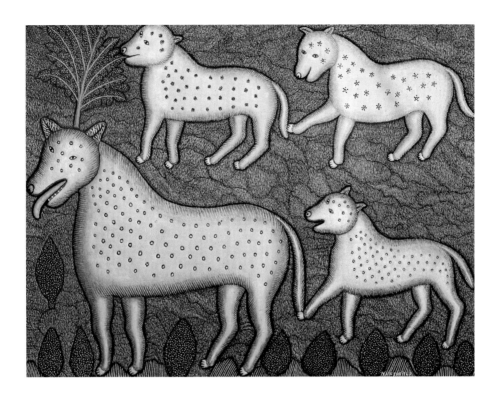

domestic realm of dogs and cats. These creatures are sometimes positioned alone or with women, but they most often appear in cute familial groupings, as in *Dog and Pups* (1944; fig. 5), which features an adult dog and three of its litter profiled in a landscape. The grass, a mottled ground more carpetlike than herbaceous, is augmented by the leaflike bushes on which the dogs do not stand (even if one of the plants has to lean away to avoid the hind leg of the largest dog). The tree at the upper left, however, is not as considerate or fortunate—a frisky puppy is chewing on it. The dogs are uniformly spotted, or rather patterned, and edged with feathery fringelike strokes that suggest their hairy pelts. Charmingly, although he presented the heads in profile, Hirshfield felt it necessary to include both eyes to capture the playful personality of the dogs—even if it meant positioning two eyes on one side of the head. This technique, normally associated with proto-cubism, appears in the work of many untrained artists who preferred the profile to the challenges

of creating depth in the full-frontal view. Hirshfield actually favored depicting his women and animals face forward and succeeded in using minimal touches to suggest the roundness and depth of his figures. Here, however, sentimentality trumped realism.

Sentimentality met a different challenge when Hirshfield paired dogs with his other favorite subject, women. In *Woman with Dog* (1943; fig. 6), a leashed dog stands between the viewer and the girl who, footless, seems to be floating. The dog's bared teeth belie the peaceful tone of the scene. The statuesque woman wears an elegant, low-cut dress, which Hirshfield highlighted by tucking her full blond mane neatly under the meticulously scalloped neckline. Both iconic figures are set off against an obsessively decorative ground comprising over a thousand starlike forms, which generate an optical vibrancy behind the formally posed couple. Roger Cardinal has remarked that the work exemplifies the archetypal theme of beauty and the beast.[2] If so, Hirshfield

FIG. 5. Morris Hirshfield, *Dog and Pups*, 1944. Oil on canvas, 32 x 42 in. (81.3 x 106.7 cm). Collection Caroll Janis

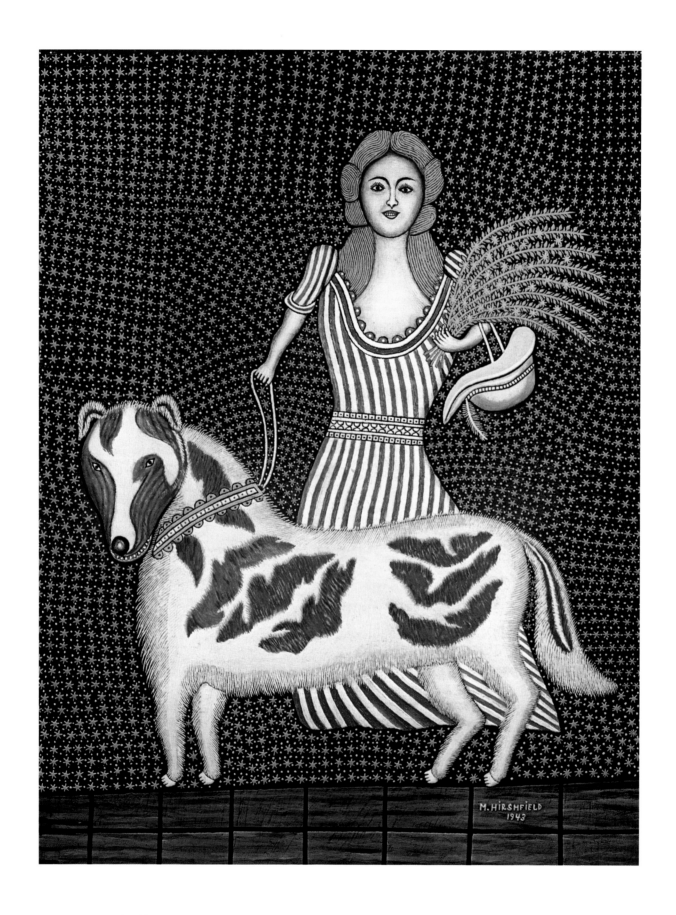

FIG. 6. Morris Hirshfield, *Woman with Dog (Girl with Dog)*, 1943.
Oil on canvas, 46 x 36 in. (116.8 x 91.4 cm)

advanced that theme more provocatively in *Girl and Dog* (1944; fig. 7), in which a girl, now naked (one cubist breast coyly sliding to her back to make sure we appreciate her nudity), playfully waves a sprig of flowers before a dog, now much larger than she. The animal responds by biting at the plant, though perhaps not as innocently as does the puppy in *Dog and Pups.*

Clearly, no matter how innocently Hirshfield turned to the conventions of popular and academic painting, he was susceptible to the power of the image as a vehicle of expansive imaginative projection that allowed him to conjoin the sacred and the profane (*Stage Girls with Angels*) and to oscillate between domesticated and transgressive sexuality (*Girl and Dog*) as often as it left him on the borderline of the kitsch and the academy.

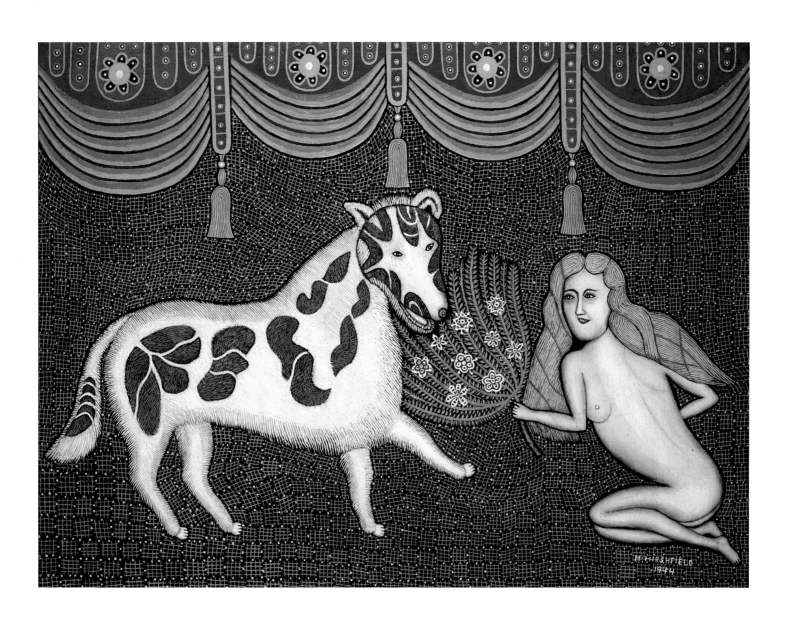

FIG. 7. Morris Hirshfield, *Girl and Dog (Dog and Nude)*, 1944.
Oil on canvas, 32⅛ x 42 in. (81.5 x 106.6 cm)

Morris Hirshfield was born in 1872 in a small Lithuanian Jewish community in Poland. Immigrating at age eighteen to New York, he worked in a women's coat factory before founding, with his brother, a firm manufacturing women's coats and suits. Later, he became a very successful manufacturer of women's boudoir slippers. In 1937, at age sixty-five and after a long illness, he retired and started making art. Although he claimed to have "exhibited artistic tendencies" as a sculptor in his youth, he now chose to paint. An autodidact impassioned by the creative process, he set up work in his bedroom, leaning a canvas against his dresser's mirror and painting all day.

Hirshfield executed *Beach Girl* over an old painting that initially hung in his living room. The only detail that remains from the original work is the girl's face, which he touched up with green and gold-brown paint to complement the sections he had overpainted. In subsequent works, he used his skills as a tailor, often preparing full-scale drawings of his primary images to use as patterns he would trace on the canvases. He would occasionally repeat a specific form, such as a bird, several times in a piece, or, as in some of his mirrored nudes, he would reverse the pattern of the body in the image. After struggling to achieve his desired effects, Hirshfield would confidently have the works framed, photographed, and shown to friends, including John I. H. Baur, a curator at the Brooklyn Museum.

Within two years, Hirshfield was discovered by the curator and collector Sidney Janis, who was seeking works for the 1939 exhibition *Contemporary Unknown American Painters*, at the Museum of Modern Art (MoMA). Janis showed Hirshfield's first two paintings at MoMA and three years later included him as one of the primary artists in his groundbreaking publication *They Taught Themselves: American Primitive Painters of the Twentieth Century*. This recognition encouraged the artist to continue painting. By his death in 1946, he had created seventy-four works, several of which

had been sold, often to Janis and his family. Hirshfield's greatest personal triumph was a 1943 solo exhibition at MoMA awarded by its director, Alfred H. Barr, Jr., and curated by Janis. The exhibition was roundly criticized by the reigning art world as frivolous and not befitting the institution, for few figures other than Barr and Janis could envision self-taught artists playing a significant role in modern art history. Rather, Hirshfield was seen at best as a quaint American version of the French "primitive" painter of a previous generation, Henri Rousseau (1844–1910).

The comparison was not entirely inappropriate. Like many self-taught artists, Rousseau had found through art an imaginative dimension sorely lacking in his daily life. An undistinguished toll collector, Rousseau admired the masterpieces of traditional art at the Musée du Louvre, Paris, and contemporary academic painters such as William-Adolphe Bouguereau. Initially copying the themes of those masters, he sought to capture in paint the intensity of a reality he perceived—and dreamed. Following the rules of representative art that he could master, he applied himself assiduously to perfecting his pictures and confidently entered the official Salon of 1885, only to see his paintings slashed by an irate viewer. He received a better response at the progressive Salon des Indépendants and the Salon d'Automne, where his work hung with that of the rising avant-garde. Rousseau found a receptive audience among the likes of Constantin Brancusi, Georges Braque, Robert Delaunay, and Pablo Picasso, even if their acclaim was tinged with mild ridicule of his perceived naiveté and confidence that he was a fully modern painter and master of portraiture and landscape (see *Myself, Portrait-Landscape*, 1890; fig. 8). One of Rousseau's most avid supporters, Guillaume Apollinaire, believed that the artist's naiveté was the very source of his distinction: "[Rousseau] went to the very end in his work. . . . His paintings were made without method, systems, or mannerisms. . . . He did not distrust his imagination any more than he did his hand."[3]

romanticized the art of the non-Western "primitive," of children, and of the insane as similar direct expressions of an inner reality free from academic convention, the Blaue Reiter identified naive artists as natural allies in the creation of a new spiritual reality in art. Kandinsky discerned two significant tendencies in modern art: one destructive, which tore away the conventions of the academy; the other constructive, which sought to establish new modes of expression. Although vanguard artists self-consciously participated in both, their actions often seemed primarily deconstructive in their efforts to break through to an inner spiritual and creative essence. The primitives, already acting outside the academy, were seen as essentially constructive, creating their own visual languages without knowledge of or submissive regard for the existing aesthetic conventions. Kandinsky praised in particular the simplicity and completeness of Rousseau's vision, but did not consider his idolization of Bouguereau.

Later vanguard and modernist artists who demanded that art assume an attitude critical of cultural values were not so sanguine about the naive artist's imaginative freedom. Rather, they criticized the primitive artist's frequent efforts to emulate academic conventions as a failure to fully engage the sources of imaginative experience. For Jean Dubuffet, especially, the naive artist had too much respect for the conventions of "cultural" art for the work to be considered "art brut."[5] Similarly, Michel Thévoz cited the naive artist's "deferential attitude towards culture and its institutions" as the reason "we react with emotion rather than uneasiness to the pictures of children and naïves . . . Because . . . the transgressions . . . never exceed certain limits and are never in danger of involving the viewer."[6] One scholar of outsider art has simply stated: "naïve art . . . though interesting in itself, belongs to a different history."[7]

Part of that history was being written in America, where, during the 1930s when Hirshfield began painting, the work of untrained artists was recognized as an affirmation of the

To modernists like Apollinaire, Rousseau's passion to create, no matter what convention he followed, signaled his profound state of imaginative freedom. Similarly, Vasily Kandinsky and the artists associated with the Blaue Reiter believed that Rousseau exemplified the originality of vision they found in folk art and in the work of untrained naives— one unhampered by the academic rules they felt deadened a painter's spirit.[4] Consequently, Rousseau's work was included in the 1912 *Blaue Reiter Almanac* amid examples of peasant folk art and vernacular religious images, along with works of the avant-garde. Just as the Expressionists

FIG. 8. Henri Rousseau, *Myself, Portrait Landscape (Moi-meme, portrait paysage)*, 1890. Oil on canvas, 57½ x 44½ in. (146 x 113 cm). National Gallery, Prague (O 3221)

art of the "common man," whose roots extended deeply into American cultural traditions. Folk and popular artists and "naive-primitives" (Janis's initial term to describe the self-taught artists he exhibited at MoMA) were seen to draw their inspiration and visual models from a wealth of sources, none of which was considered anticultural. Even the vanguard American modernists looked to folk and popular arts to spur their aesthetic innovations. What was most appreciated about their work was the sense of authenticity based not in the irrational substrate but in the integrity of the pure, unbridled imagination.

Unlike Rousseau, Hirshfield did not claim to be a member of the avant-garde, nor did he stake an anticultural position. But like Rousseau, Hirshfield trusted his imagination and went to the "very end in his work." He also shared with Rousseau, as well as with many other American and European self-taught artists, an awareness of and positive response to academic conventions (especially those rooted in nineteenth-century stylistic verisimilitude), and he was just as prone to respond to the imagery of popular culture as to the art of academic tradition.

Indeed, for the untrained artist, exposure to the academic likely occurs through popular media and its appropriation of high cultural conventions. Being self-taught, naive artists have to draw upon their own resources, vision, and materials. They have to invent and discover the terms, methods, or strategies that professional artists have been taught or have learned through extensive study. Usually, the self-taught artist advances only so far into academic conventions to achieve the desired effect of expressing his or her personal vision. If, in the process the naive artist ignores or inadvertently transgresses against other conventions, their works may be visually stronger for it.

Most commonly, like Hirshfield, the naive or primitive artist fails to master the laws of perspective, the techniques of establishing a vanishing point, or the ability to suggest

contours, shading, or diffusion of light. But in the painter's efforts to compensate for or solve these issues, distinct personal and sometimes highly effective strategies of expression are discovered, strategies noticed and appreciated by the trained eye. For example, writing on the work of the French naive painter Louis Vivin (1861–1936), Jane Kallir astutely remarked on his dramatic use of the diagonal as a compositional element: "Vivin knew that diagonal lines could be used to define receding objects, and he had also noticed that these lines tended to converge in the distance. What he lacked was the awareness of a single vanishing point that would give dimensional unity to an entire composition. Therefore, his diagonals refused to recede. They functioned as two-dimensional design elements while simultaneously alluding to space"[8] (see *La Porte Saint Martin*; fig. 9). If the work fails by the criteria of the academy, it succeeds on the terms that the artist has unexpectedly set.

While the visual inventiveness of the untrained artist may challenge the formal sophistication of mainstream creators,

FIG. 9. Louis Vivin, *La Porte Saint Martin, Paris*, n.d. Oil on canvas, 21 1/4 x 25 5/8 in. (54 x 65 cm). Museum Charlotte Zander, Schloss Bönnigheim, Bönnigheim, Germany

the self-taught artist's strongest work also communicates the distinctive vision of its maker. In the best works of the naive or primitive painter, we sense the passion of a life both seen and dreamed. The most frequent expression of this lived and imagined intensity in naive art is the extreme investment the artist places in every element of each painting. The oft-noted difficulties in establishing ocular perspective or subtlety of light and shading in self-taught art find their roots in the fact that every object, every brushstroke, carries exceptional meaning for the artist. Viewers have often commented on the surrealist quality of these artworks. Perhaps we might rather speak of a super-realism, for the artists convey such a heightened visual response to their subjects that they infuse them with an aura of unnatural clarity and more, perhaps, than just a suggestion of their unconscious desires.

Certainly, in Hirshfield's oeuvre, we observe his passionate effort to shape a world of vivid personal meaning from the common visual vocabulary of his time. His images, however clichéd at times, have an aura of dream and myth about them. They embody the relationship between the fantasy found within self-taught painting and the power of popular imagery presented through ubiquitous modern media. Meyer Schapiro reflected on the motivations of the self-taught artist in an unpublished note: "modern naive, home-made ptg [painting] presupposes the general change in ptg to express art of personal experience and perceptions. The domestic pter [painter] discovers this not thru contact with artists but thru the pictures themselves; the fact that he sees so many landscapes and intimate scenes and beautiful girls permits him to identify ptg with his own desires and images. The relation between ptg and fantasy or perception is . . . direct. . . . The pter who represents a beautiful landscape or woman recreates the stimulus or the object of desire, its dreamed of colors and shapes."⁹

We feel the force of the dream in Hirshfield's *American Beauty (Nude with Mirror)* (1942; fig. 10), a painting that

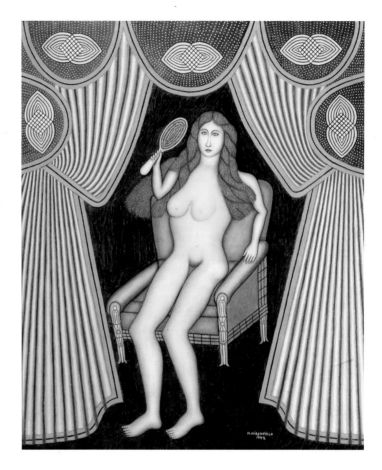

André Breton reproduced in his seminal book *Surrealism and Painting* and to which he was surely referring when he remarked: "the naked girl suddenly becomes an idol. . . . No other source allows us to grasp so fully the breadth of this constantly evolving [public] mythology, or to appreciate the organic and vivacious nature of these series of psychic events which, in the words of Novalis, 'run parallel to the real events.'" Is the "American Beauty" solely Hirshfield's private vision, or is she a collective dream? Breton evidently thought the latter, for he commented on how American primitive painters are able to make manifest through their work the psychic sources of myth that still lie within the popular imagination.¹⁰

FIG. 10. Morris Hirshfield, *American Beauty (Nude with Mirror)*, 1942. Oil on canvas, 48 x 40 in. (121.9 x 101.6 cm). The Gael Mendelsohn Collection

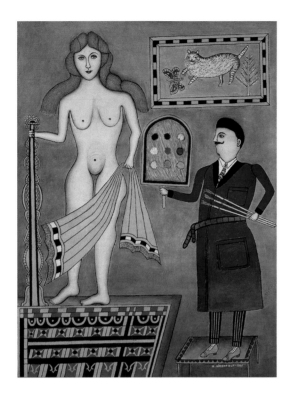

The emotional power of Hirshfield's work lies in his personal animation of popular imagery, rendering the specific image vividly present to both himself and the viewer. As with many works of self-taught and outsider art, we sense we are looking both at and into a private realm of desire and drama. But because Hirshfield tapped into the sources of myth both found within his personal psyche and manifest throughout the conventions of popular and elite culture, the works do not evoke the frisson of transgression Michel Thévoz demanded of outsider art. Rather, they threaten to involve the viewer in a shared recognition of the power of "psychic events" running below and throughout our lives.

Hirshfield's 1945 work *The Artist and His Model* (fig. 11) animates personal and cultural imagery on a further self-referential level, presenting a somewhat wistful idealized portrait of a successful artist and his imagined model and muse. As in Rousseau's self-portrait, the artist is presented in professional guise, well-dressed, with palette and brushes in hand. But if Rousseau's towering image announces his mastery of the portrait and landscape genres, Hirshfield's artist stands subservient to his muse.

We observe a similar impassioned, personal yet familiar artistic statement in the paintings of Drossos P. Skyllas (1912–1973). In *Three Sisters* (1950–53; fig. 12), an over-the-top but earnest evocation of (I assume) the three graces, the pinup model figures occupy a beautifully manicured rose garden, the refulgent blooms coyly positioned to both invite and prevent sexual peering. The seemingly superfluous—but is anything here superfluous?—bulldog and kitten either domesticate the scene or layer another suggestive narrative within it.

Skyllas, a Greek immigrant who had wanted from childhood to be an artist only to have to work in his father's tobacco business, began painting when he came to the United States after World War II. Supported largely by his wife, he devoted himself to art, failing, however, to find customers for his work, which he priced at a rate competitive with the most successful contemporary artists. Striving to create works of clarity and exactitude that merited his description as "pure, realistic paintings, one hundred percent like photographs," he completed only thirty-five canvases during his lifetime.

In *Young Girl with Cat* (c. 1955; fig. 13), Skyllas's attempt at photorealistic precision takes the work far beyond realism into a kitsch-driven private fantasy. Perhaps tapping into the same sources that led Hirshfield to repeatedly portray women and domestic animals, Skyllas depicted an idealized young girl surrounded by a dreamlike landscape including a country manor, swans, and a blooming cherry tree. But the girl's intense stare adds to the oddly unsettling quality of the work, as if Skyllas was seemingly torn between offering his desired customers a beautiful image they would surely find familiar or a glimpse into a disturbed realm known only to himself.

FIG. 11. Morris Hirshfield, *The Artist and His Model*, 1945. Oil on canvas, 44 x 34 in. (111.8 x 86.4 cm). American Folk Art Museum, New York; Gift of David L. Davies

Notes

1. Hirshfield's comment is recounted by Sidney Janis in *They Taught Themselves: American Primitive Painters of the 20th Century* (New York: Dial, 1942), p. 33.

2. Roger Cardinal, *Primitive Painters* (New York: St. Martin's, 1979), n.p.

3. Guillaume Apollinaire, *Apollinaire on Art: Essays and Reviews 1902–1918*, ed. Leroy C. Breunig, trans. Susan Suleiman (New York: Viking, 1972), p. 350.

4. Vasily Kandinsky and Franz Marc, *The Blaue Reiter Almanac*, ed. Klaus Lankheit (New York: Viking, 1974), p. 178.

5. Jean Dubuffet,"Honneur aux valeurs sauvages," in *Prospectus et tous écrits suivants*, vol. 1 (Paris: Gallimard, 1967), pp. 216–17. See also Mark Rothko, "Primitivism," in *The Artist's Reality: Philosophies of Art*, ed. Christopher Rothko (New Haven: Yale University Press, 2004), pp. 113–16.

6. Michel Thévoz, *Art Brut* (Geneva: Skira, 1995), pp. 90–91.

7. Colin Rhodes, *Outsider Art: Spontaneous Alternatives* (London: Thames and Hudson, 2000), p. 140.

8. Jane Kallir, *The Folk Art Tradition: Naïve Painting in Europe and the United States* (New York: Viking, 1981), p. 42.

9. Meyer Schapiro, "Significance of modern naive painting," unpublished note, n.d., Meyer Schapiro Collection, Columbia University Rare Book and Manuscript Library.

10. André Breton, "Autodidacts Called 'Naïves,'" in *Surrealism and Painting*, trans. Simon Watson Taylor (New York: Harper and Row, 1972), p. 293.

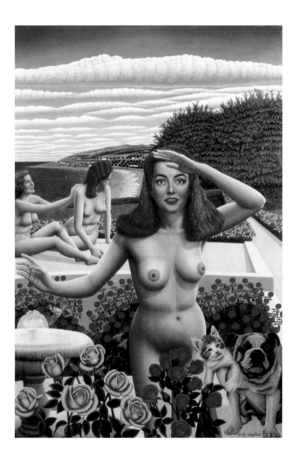

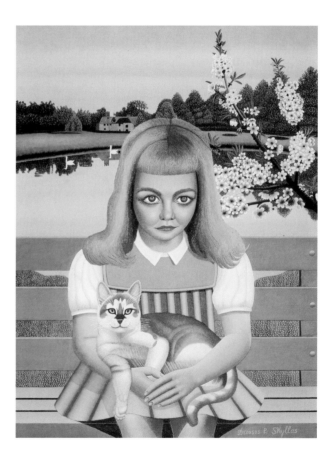

FIG. 12. Drossos P. Skyllas, *Three Sisters*, 1950–53. Oil on canvas, 58 x 39 in. (147.3 x 99 cm). Robert M. Greenberg Collection

FIG. 13. Drossos P. Skyllas, *Young Girl with Cat*, c. 1955. Oil on canvas, 33 x 26 in. (83.8 x 66 cm). Milwaukee Art Museum; The Michael and Julie Hall Collection of American Folk Art (M1989.211)

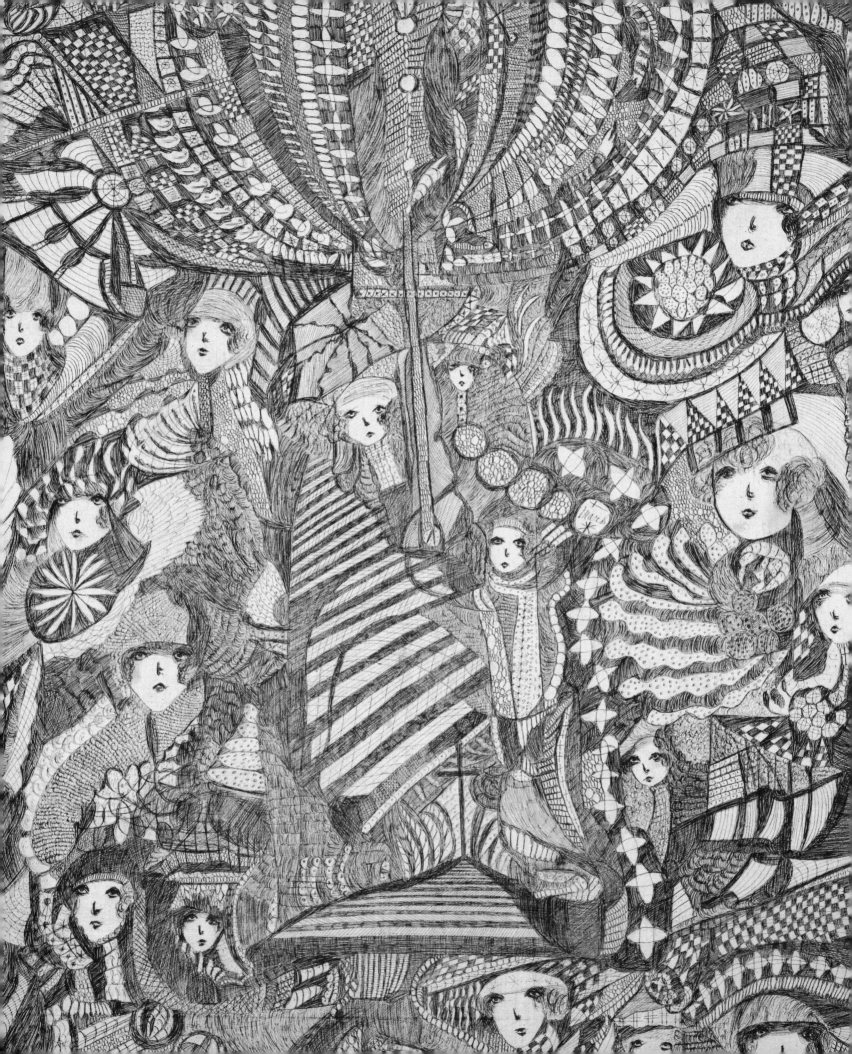

Madge Gill

The artwork of Madge Gill (1882–1961) is intimately bound with her involvement in spiritualism and her identity as a medium, providing her with an explanation of the powerful "unseen force" of creativity that suddenly emerged during a period of personal grief and illness. This involvement also justified her singular behavior within her family and established a role for her in the local community. But that force took her deep within herself and opened her to psychic realms unknown. She came to inhabit opposing worlds of private and of public demands, living much of her affective and creative life within a private realm of the night and bearing a public persona as a figure of special and mysterious powers. The drawings she produced make manifest these opposing lives and blur the lines between private and public existence. Expressing an intensely felt inner experience and dimensions of being that took her far beyond herself, Gill's oeuvre challenges us to imagine the realms into which she was drawn and to measure their distance or propinquity to us.

Standing before Gill's largest work can be a captivating but disorienting experience. We are pulled into an extremely dense, abstract composition dominated by multiple competing patterned segments often drawn on conflicting tilted planes. Our eyes find few points of stability, save for the numerous pale, delicate, female faces and figures floating amid the turbulent ground. The features of these women are barely articulated: two minimally drawn oval eyes usually glancing aside into a space different than that of the viewer; a single curved or hooked line providing the barest sugges-

tion of a nose; and an oval-shape mouth whose lips read as if slightly and guilelessly open. Many of the faces are framed by elaborate hairdos or fashionable hats of an era past, their rich patterning merging into the dense, abstract designs that threaten to swallow up the figures. Indeed, at times we perceive the slightest indication of the women's bodies; their flowing gowns become part of the swirl of conflicting patterns that compose the unstable ground from which the faces emerge. Here and there, small hands appear from the folds of the design, but for the most part the faces alone suggest a human presence in this crazy-quilt abstraction.

Although the white, unworked faces may provide spots of calm on which our eyes may momentarily rest, we cannot avoid the surrounding confusion of the overall composition— nor do we wish to, generally. In one particular work, we are drawn into the active realm of oddly angled, receding, and advancing shapes whose varied planes are each distinguished by different finely rendered patterns (see fig. 2). The drawing's ground is, at alternate times, obsessively checkered, defined by vertical, horizontal, and curvilinear lines, or energized by crosshatchings of diagonals, zigzags, spirals, or herringbone configurations. Each pattern briefly invites us to consider it as the face of a three-dimensional geometric form, for they frequently abut other patterns at ninety-degree angles, thus leading us to identify various rhomboid or skewed and curved parallelograms within the labyrinth. But inevitably, the interplay between patterns pulls our eye toward alternate shapes or planes within the composition, leading us into mazes of entirely different orientations.

OPPOSITE: Detail of an untitled work by Madge Gill (fig. 1)

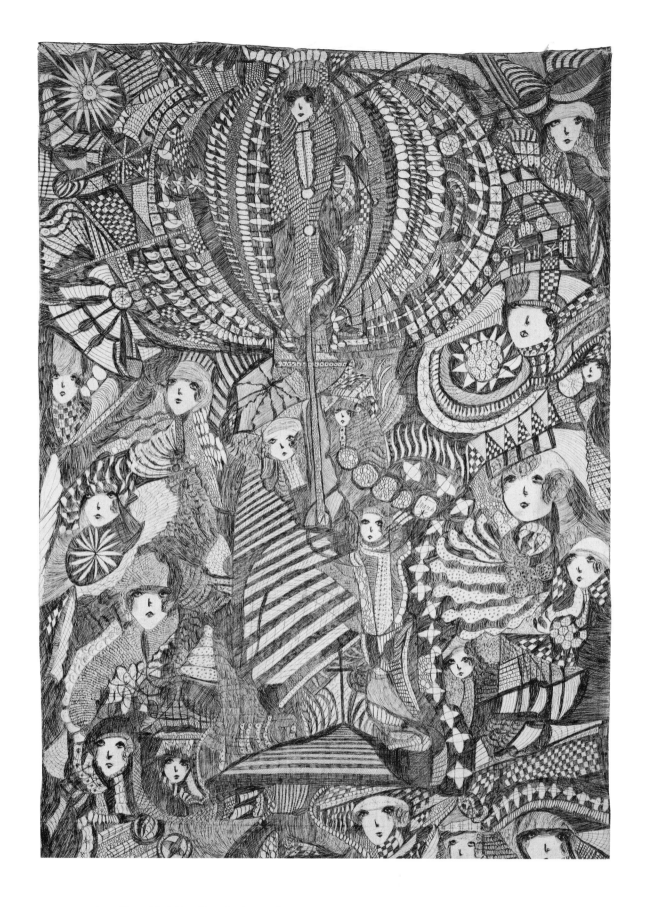

FIG. 1. Madge Gill, *Untitled* (detail), n.d. Ink on calico, 83⅞ x 34 in.
(213 x 86.5 cm). Collection de l'Art Brut, Lausanne

Because many of the geometric shapes and planes seem to suggest steps, floors, or arcades through which one could move, we find ourselves reading the complex ground as architectural elements that might define a graspable figural space. And indeed, at times Gill included in the center of a composition what seems to be a receding and rising set of steps leading toward a woman's face. Gill, however, also countermanded such perspectives by intervening dislocations of plane and perspective that block the implied direct connection between the viewer and the hovering face.

While we are entranced by the rigorous and varied complexity of the overall composition, we also recognize that its vitality and density are the result of finely drawn lines, endlessly repeated in tightly defined compact areas within it (as in fig. 3). The straight or curved parallel lines, the intense crosshatchings, and the dots and dashes are precisely, if obsessively, laid down. Gill worked most frequently in black India ink, rarely losing control of her media. In numerous works, however, she also used blue, red, and yellow ink, at times mixing them to create secondary and tertiary colors (see *Untitled [Two Women]*, 1954; fig. 4).

Gill created art in all sizes, apparently with little respite, for at her death she left behind hundreds of works. Of the many postcard-size compositions, some feature one or more women's faces, others are pure abstractions, and still others suggest vegetal or vaguely familiar yet still mysterious symbolic forms. Other works are substantially larger and correspondingly more complex. Her major pieces were created on rolls of calico fabric some six feet wide stretching up to thirty feet long. Gill's son built a type of easel that allowed sections of the fabric to be scrolled out, folded over so that one half was positioned for her to draw on at a time while standing for long sessions. Gill worked in this fashion usually well into the night in near darkness. Consequently, she never saw her large compositions until they were completed. Nonetheless, these pieces display a remarkable coherence and visual consistency.

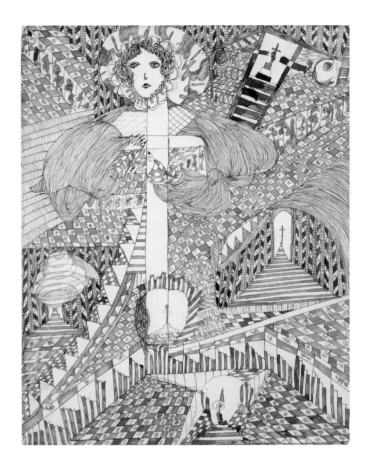

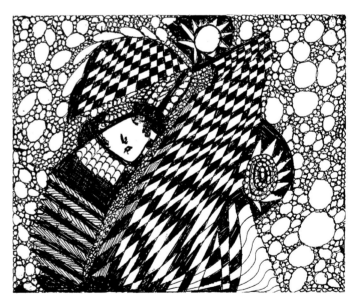

TOP: FIG. 2. Madge Gill, *Untitled*, 1954. Colored ink on cardboard, 25 x 20½ in. (63.5 x 52.07 cm). Milwaukee Art Museum; Gift of Anthony Petullo (M1994.268)

BOTTOM: FIG. 3. Madge Gill, *Untitled*, 1920s. Indian ink on paper, 7 x 8⅞ in. (17.6 x 22.5 cm). Collection Roger Cardinal

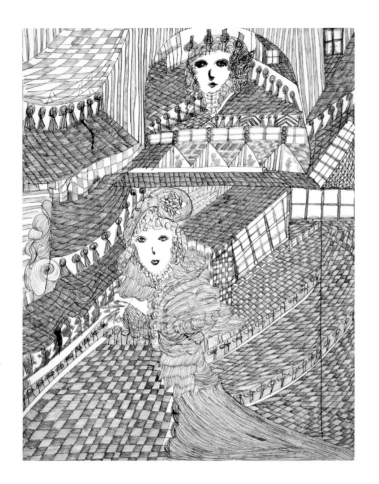

In one of these extensive scrolled works—on display at the Collection de l'Art Brut in Lausanne, Switzerland (see fig. 5)—we can gather a sense of both how it was composed and the absolute control of her vision. Fully unfolded, the work is clearly a single composition, even though it is horizontally divided into two halves, each bearing its own dominant architectural patterning. The bottom half, which seems more clearly laid out, is structured around a line of faces that extends across the entire length of the drawing. Other faces appear intermittently at various levels below this dominant line, pulling our eye toward them and back up, creating a varied rhythm amid the animated planes of abstract forms that surround the faces. The entire top half of the work is less regular in its overall structure, though it repeats the motifs and patterns that shape the lower half. Most remarkable, although the two halves were probably created during discrete stretches of time, they are connected visually throughout by geometrically abstract patterned shapes that move diagonally from lower left to upper right. These sporadically placed diagonals direct our eye to read the work from left to right, creating a regular dynamic within the contradictory skewed planes of the composition at any one section. Against this general movement, however, Gill has inserted small

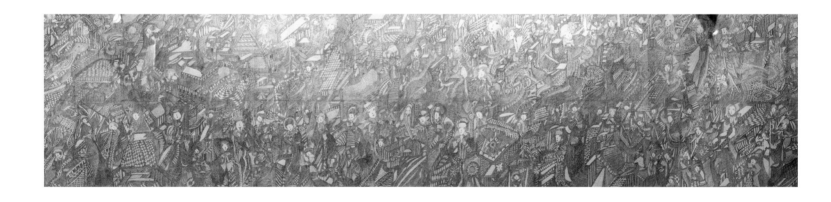

FIG. 4. Madge Gill, *Untitled (Two Women)*, 1954. Indian ink on paper, 25 x 20⅛ in. (63.5 x 51 cm). Collection de l'Art Brut, Lausanne

FIG. 5. Madge Gill, *Untitled*, n.d. Ink on linen, 66⅛ x 308⅝ in. (168 x 784 cm). Collection de l'Art Brut, Lausanne

triangular shapes that point in the opposite direction of the diagonals, creating a quiet syncopation and slowing our movement through the work.

The entire surface is densely worked with Gill's characteristic strategies of tightly woven lines, patterns, and multiple conflicting and disorienting planes. Yet the regularity of the minimally inflected, white faces suspended throughout the composition asserts an unworked plane and intimates a different dimension from which the female figures seem to emerge. Furthermore, Gill regularly interspersed barely inked, white ground, geometric grids on skewed angles, which suggest still other receding planes and complicate the integrity of the white ground of the faces.

Overall, Gill's drawings display an essentially coherent and repetitive aesthetic that harbors a deeply unsettled and disorienting tension. As a purely ocular experience, the works can be vertiginous,[1] as if we are standing before a piece of op art several decades before its time. The complex relationships between the feminine figures and the unstable labyrinthine ground provide the viewer no certitude of perspective, leading us to wonder if this was the calculated intent of the artist and, if so, what that might indicate about her or her imagined relationship to her viewers (see fig. 6). However, we also sense a hermeticism in these works that turns them inward upon themselves and their creator. In the placidity and untouchable mien of the women within the busily worked and obsessively defined space, we observe the characteristic "sense of focus," "intensity," and "lack of guile" that are implicit in the private dramas of outsider artists, but explicit in the life of Madge Gill.[2]

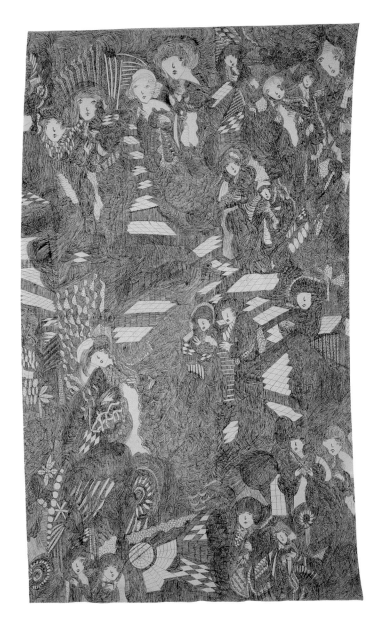

FIG. 6. Madge Gill, *Untitled*, 1930. Ink on calico, 69½ x 41 in. (176.5 x 104 cm). Milwaukee Art Museum; Promised gift of Anthony Petullo

Born Maude Ethel Eades in London in 1882, Madge Gill was an illegitimate child whose mother, with the help of a sister, apparently kept her hidden from the public for some time. Although accepted for awhile into her mother's large Victorian family, Madge was nonetheless sent to an orphanage at the age of seven, later to be shipped off to Canada with other orphans when she was twelve. Returning to England at nineteen, she found employment as a nurse and lived with a widowed aunt who introduced her to spiritualism, astrology, and seances. In 1907 Madge married her aunt's son, Tom Gill, a clerk on the stock exchange. Together they had three sons, one of whom died at age eight in the influenza pandemic of 1918. The next year, Gill, who had longed for a daughter, gave birth to a stillborn girl, herself almost dying of complications. Ill for several months, she eventually lost her left eye, which was replaced with a glass one.

After she recovered, Gill began her prodigious creative production, initially manifest as an outpouring of drawing, knitting, and "inspirational writing, mostly Biblical." Twenty years later, she recounted, "I felt that I had an artistic faculty seeking expression. . . . I was in quite a normal state of mind and there was no suggestion of a 'spirit' standing beside me. I simply felt inspired. . . . But I felt I was definitely guided by an unseen force, though I could not say what its actual nature was."[3] Although this 1937 statement describes the force within as an upswelling of an innate expressive impulse, in the mid-1920s she identified it not as artistic inspiration but as an otherworldly spirit guide named *Myrninerest*. Her son Laurie, who remained devoted to her and her spiritualist art throughout his life, cited March 3, 1920, as the date Gill first fell into a trance and became the medium for *Myrninerest*. Within a few years, the name appeared on many of Gill's works as if signed by the real creator.

Throughout the 1920s, Gill progressively withdrew into this trancelike state of creativity, producing numerous works on paper, cards, and large bolts of inexpensive cloth. She worked deep into the night, often with minimal illumination, and always alone. In the early 1930s, her husband (from whom she had become emotionally estranged) died, and, while living with her two devoted sons, Gill expanded her spiritualist activities, emerged publicly as a medium, and held weekly seances in her home, in addition to preparing horoscopes and offering spontaneous predictions about her neighbors' lives. She also began to display her artwork annually in amateur exhibitions, but she either refused to sell these works or priced them impossibly high so that no one would purchase them. She declared that they were not hers to sell since they were not her creations but those of her spirit guide.

The implicit paradox of Gill's periodic exhibition of her works versus her insistence that they were the property of *Myrninerest* suggests an inner conflict she must have endured as a medium and an artist. Each identity brought on a heightened sense of self and at the same time a relinquishment of self unto some force or dimension she could not command. However much Gill accepted the public role of being a medium, the main drama of her life was intensely private. The enormous scrolled drawings and hundreds of postcard-size works testify to her nightly compulsive submission to a powerful spirit that was both herself and not herself. Her obsessively dense and complex compositions required a concentrated process of mark making to fill in small-scale grids across expanses of paper and cloth (see fig. 7). Although she was reported to have resented the oppressiveness of these activities, she returned night after night to the privacy of her darkened room to draw.

The works read both as representations of another dimension and as expressions of Gill's enraptured psychic state. The constantly shifting planes and fragmented, disorienting compositions may communicate both her tremulous state of mind during possession and her depiction of a realm in which the familiar three-dimensional coordinates

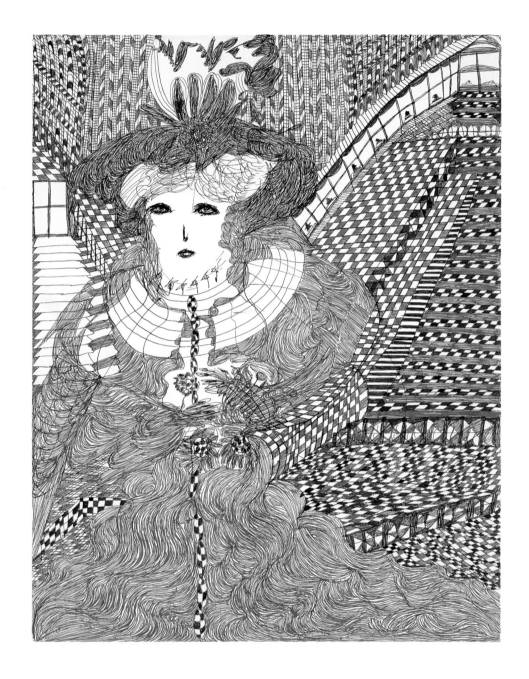

FIG. 7. Madge Gill, *Untitled*, n.d. Ink on cardboard, 25 x 20 in. (63.5 x 50.8 cm). Milwaukee Art Museum; Promised gift of Anthony Petullo

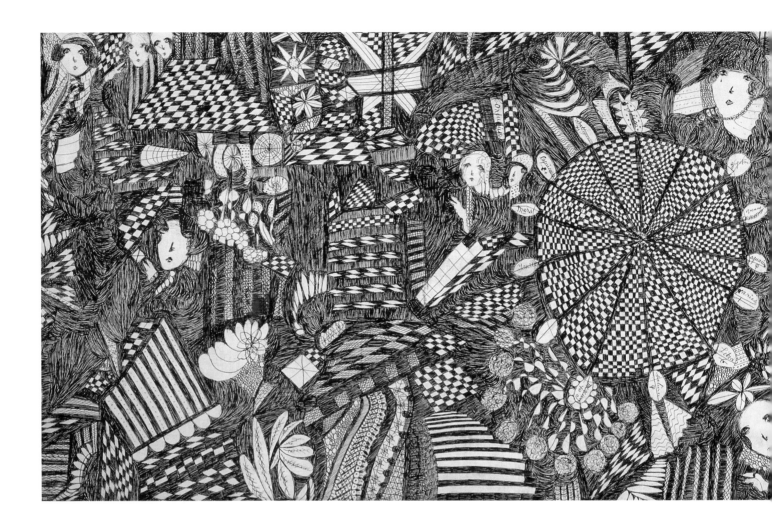

of physical space are deemed irrelevant. And although the female faces hovering within that realm may suggest a deeper, more stable ground of being, their diminutive and partial presence amid the dense swirl of forceful abstract lines may also communicate the fragility of Gill's contact with them (see fig. 8). While she was willing to show some of her creations in public, they had little direct role in her mediumistic practices. She would produce notecard-size works with cryptic messages or prophesies, often voiced in stereotypical spiritualist or astrological terminology, but the large artworks played a deeply personal role she did not share with others.

This divided state of being took its toll on her. In a 1952 message to a friend, Gill hauntingly stated: "Man directs his efforts in the trend of thoughts which scoop through the brain. The crust of the earth, beneath lies untold wealth, so it is with the mastermind true genius will out. Dear Louise, I

FIG. 8. Madge Gill, *Untitled*, n.d. Ink on textile, 33⅛ x 107⅞ in. (84 x 274 cm). abcd art brut collection, Paris

wish I could be normal."[4] The statement begins in a magisterial voice, as if she were fulfilling her role of transmitting truths from beyond, but collapses into a cry of despair to a friend. Evidence of Gill's despair became increasingly public. Although she remained a prolific artist of visually compelling works until 1958, by the mid-1940s, Gill had become a heavy drinker and appeared to her neighbors as a progressively disturbed person. One of her sons confided that he feared

for her sanity. Falling seriously ill in 1960, she died early in 1961 at the age of seventy-nine. Her sole remaining son, Laurie, donated many of her works to the local borough council in Newham, which still conserves some two hundred of the them.

The spiritualism Gill was introduced to by her aunt was a widespread phenomenon among the poor and industrialized working classes throughout England, Europe, and the United

through the services of a medium, whose special receptivity to the spirits beyond the grave allowed them to communicate with the living (see fig. 9).[5]

The medium inhabits a doubly problematic space within society. She—or occasionally, he—is both central and marginal to a community, which is itself socially marginalized by class and as participants in a subcultural religious practice. The medium, or "sensitive," seemingly provides a liminal point of access to a mysterious dimension and to beings of ancestral or archetypal significance. Standing between realms of the spirits and the humans who are her clients, she is an actor in a drama inaccessible to others except through her powers. Seeming to help people contact spirits of the departed, her actions provide a form of psychic or spiritual consoling and healing or serve to warn or inform the supplicant how to live. In this, the medium functions in the local and semiclandestine community of spiritualist believers much as a tribal shaman, entering a state of altered consciousness to allow strong nonrational forces to find voice and magical powers to be released.[6] But however valuable to the community, the medium, like the shaman, finds herself alone on the margins of its everyday life.

In her solitude, possessed by these powers denied others, the medium must endure the paradoxical state of extreme passivity and activity. During a seance, she loses her selfhood to allow that of the spirit to communicate through her body or her voice, or to inhabit the space around her and make its presence known through knocking, table turning, and "spectral emanations." Yet it is her initiative that opens the door to the other dimension and to the spirits that inhabit it, and it is through her mind and body that their reality is communicated.

Gill's artwork served her private psychological needs as well as a community larger than the London neighborhoods where it was periodically displayed. Her art emerged from the local confines of her life to enter broader discussions of

States. First appearing in the mid-nineteenth century, spiritualist activities offered a way for people to sustain a primal connection to their ancestors and served as an alternate form of religious practice that provided a more intimate and fervent connection with the spiritual realm than did most established religions. Spiritualist practices surged in popularity in the early twentieth century, especially during and just after World War I, when many grieving individuals yearned for contact with those lost in conflict or in the influenza pandemic. At its heart lay an essentially sacred belief in the existence of a transcendent dimension just beyond the realm of ordinary life. That dimension could be made immediately accessible

FIG. 9. Madge Gill, *Untitled*, c. 1953. Ink on card, 24 x 19½ in. (61 x 49.5 cm). Raw Vision Collection

cultural significance. Her mediumistic orientation finds distant echo in the early twentieth-century spiritualist aspiration of vanguard art, while her persona as a possessed transmitter of otherworldly images spoke directly to the struggles of the contemporary artists of her day to unleash the psychic roots of the creative process from the strictures of artistic convention.

While Gill's social and artistic worlds were shaped by working- and lower-middle-class life, the phenomenon of mediumistic art flourished within the greater historical context of late-nineteenth- and early-twentieth-century explorations of various occult and mystical beliefs, a number of which attracted artists and members of the mainstream art world and contributed to the development of modernist and avant-garde art movements. For instance, the philosophical doctrines of Helena Blavatsky and the Theosophical movement and Rudolf Steiner's Anthroposophical Society were manifestations of a popular belief in the spiritual evolution of humanity in contact with other dimensions of being. They were expressions of a romantic-idealist transcendental vision that rejected the materialist bases of modern science and the rigidity of established religious orthodoxy. Common to such movements was a desire for contact with some dimension beyond the quotidian level of experience, more intense and more meaningful than that offered by conventional sacred or secular institutions. The vision could be transmitted through the actions of the spiritualist, medium, or artist and experienced as a personal and cultural revivification.

Modern artists such as Vasily Kandinsky, František Kupka, and Piet Mondrian were receptive to certain forms of spiritualist thinking, especially Theosophy. They responded to two especially resonant ideas that affected art discourse for several generations: the belief that an artwork could evoke a transcendental dimension of spirit and value absent from material life; and the artist's necessary journey deep within the self to tap the primal connection to existence from which a vision of the transcendent could emerge. Although these early modernists were not concerned with mediumistic spiritualism that pursued direct contact with spirits of the dead, they sought new forms of abstract or nonrepresentational art to communicate the mystical principles of the cosmos. Kandinsky for one, found in spiritualism a manifestation of an awakening of interest in abstraction attuned to his own sense of "the higher realities, the cosmic orders."[7]

The surrealists were the first to consider the medium an apt model for artistic creativity. They were less concerned with the resulting aesthetic object than with the medium's demonstration of the unconscious creative process. By giving the self over to a nonrational state in search of a different dimension of being within, the medium exemplified the surrealist strategy of psychic automatism. Especially during their early "intuitive" epoch of the 1920s, the surrealists attempted programmatically to disengage conscious, critical judgment during the creative process in order to allow direct experience of a preconscious flow of images, or their "inner voice." In the earliest surrealist literary works—Philippe Soupault and André Breton's collaborative automatic writing and the later trance recitations of René Crevel, Robert Desnos, and Benjamin Péret—the artists sought to enter a passive, semi-somnambulistic state that would allow an inner monologue to be "spoken as rapidly as possible without any intervention on the part of the critical faculties, a monologue consequently unencumbered by the slightest inhibition."[8] Breton described the surrealists' efforts to subvert traditional artistic processes as having "made ourselves into simple receptacles of so many echoes, modest *recording instruments* who are not mesmerized by the drawings we are making."[9]

Although at times the surrealists publicly modeled their actions on the mediums' entry into this state of "magical dictation," they never believed that the mediums were actually in contact with the spirits of the dead. Breton declared: "I absolutely refuse to admit that any communication whatsoever can exist between the living and the dead."[10] Rather, for

the surrealists, the mediums' descent within was to the primary processes that are the repressed sources of creativity. Their liberated inner monologue was seen as the record of an unconscious self, which had an unperceived emotional continuity and provided access to truths that the conscious self, always subject to the demands of quotidian reality, could never claim. That which spoke was not the spirit of the dead, but of true life. Nor were the surrealists especially interested in the mediums' works as art. Rather, the mediums' visual and written works and their process of emergence served solely as models of unconscious creativity that the surrealists sought to emulate. The created text or object was primarily a trace of a past mental state, not an aesthetic experience bearing value in itself.[11]

In contrast, Breton's friend Jean Dubuffet recognized the mediums as true artists, and he valued their art's unconventional visual languages and formal achievement. He held their work as prototypically "art brut," for it emerged independently of high cultural aesthetics and challenged artistic conventions by privileging a psychological state of unfettered creativity. Dubuffet focused not on the validity of the mediums' beliefs, but rather on the force and originality of their personal visions. He prized the mediums' state of high creative passion as the upswelling of authentic creation. For Dubuffet—who collected the work of Gill and other mediums, such as Joseph Crépin, Augustin Lesage, Raphaël Lonné, and Laure Pigeon—the mediums' marginal status in society and their creation of works independent of artistic convention ensured their visionary freedom and their works' dramatic effect on the viewer. The art allowed a contact, if not communion, between the creator and the audience on levels rarely experienced in what Dubuffet disparagingly called "cultural art."

Michel Thévoz, former director of the Collection de l'Art Brut, extended Dubuffet's position by arguing that the power of the medium and the art brut artist lies less in their specific imagery or message than in their willingness to give themselves over fully to the irrational forces within, forces that are shared, if only weakly sensed, by us all. The medium and outsider artist follow the descent into self that Walter Morgenthaler invoked when comparing artists to mystics: "beneath the surface delusion of the senses and the intellect into the great irrational substratum."[12] The artwork, a creation of the perilous experience whose threat is irrevocable disintegration of self, is a living testament of the origins of being from which we rise. As viewers, we are affected so strongly by outsider art precisely because although it appears so distant from our conscious, social experience, it provokes what is close and deep within us. For Thévoz, it is "a kind of *communication between unconscious minds.*"[13]

Because each medium's submission to irrational forces from within and beyond is always a solitary experience, the visual works that result follow no predictable style. Mediumistic artists employ a range of communicative and visual strategies, creating metaphors for different aspects of each medium's experience. For instance, when he was thirty-five, the French coal miner Augustin Lesage (1876–1954) heard a voice deep in the mine predicting he would be a painter. Startled by this encounter, he became familiar with spiritualism and began a series of automatic drawings that he believed were inspired by the spirit of his deceased three-year-old sister. A subsequent pronouncement in the mines led him to begin painting. His first canvas was a ten-by-ten-foot square, purchased by error. Nonetheless, instructed by the voices to continue, he took up his small brushes and oil paint and began with no plan for the composition in mind. Lesage stated that he had no control over his creation: "A picture comes into existence detail by detail and nothing about it enters my mind beforehand. My guides have told me: 'Do not try and find out what you are doing.' I surrender to their prompting. . . . I follow my guides like a child."[14]

This intuitive process seems particularly evident in the resulting work, *First Canvas* (1912–13; fig. 10), which took Lesage more than a year to complete. Starting in the upper-right quadrant, he painted loosely composed forms as if organic waves pour forth onto the canvas. These vegetal motifs are soon met by gridlike structures, and, on the whole, the composition divides vertically into roughly equal halves, the other three quadrants dominated by internally symmetrical block-like structures. Lesage's subsequent works are generally as large in scale and almost all strongly symmetrical if more architectural than organic in motif. He worked extremely rapidly, moving from top to bottom, line by line, shifting from edge to edge and maintaining a rigid symmetry. Highly decorative, the works increasingly contain representational imagery that calls on exotic iconography associated with the

spiritualist movement, in which Lesage had become a famous and eventually self-sufficient painter.

If Lesage emerged from the mines to create art and subsequently found public renown, Laure Pigeon (1882–1965) retreated into her room to commune with the spirits in private. In 1933, at age fifty-one and recently separated from her unfaithful husband, she began a largely solitary life. Initiated into spiritualism, she started creating mediumistic drawings, at first composed of free-flowing, nonrepresentational, meandering lines (rendered as if the pen had never left the page), from which emerge forms vaguely suggesting knitting or embroidery. These later developed into more densely woven markings resembling leaf- or featherlike masses, from which feminine profiles appear against the open ground of the paper.

FIG. 10. Augustin Lesage, *First Canvas*, 1912–13. Oil on canvas, 118⅛ x 118⅛ in. (300 x 300 cm). Collection de l'Art Brut, Lausanne

A relatively early untitled work dated August 2, 1935 (see fig. 11), indicates a transition from closely drawn lacelike filigree on the left into more open plantlike structures across the rest of the paper. The work suggests the continuous movement of the pen curling back in and around the emerging composition, as if Pigeon was open to the vagaries of thought or dream, or to the spirits she contacted. Later in life, Pigeon incorporated messages from the spirit world, recorded in loose calligraphic text, amid her abstracted forms. In some works, she would embellish names of her former family and also of her husband from an imagined previous life, the apostle Peter. None of this work was shared with others. When she died, some five hundred drawings and several notebooks were discovered in her room.

In contrast, Parisian-born Jeanne Tripier (1869–1944) was exuberantly public about her spiritualist and mediumistic gifts. She threw herself into drawing, writing, and embroidery as a means of allowing numerous spirits to communicate through her. Her involvement in the spirit world came when she was fifty-eight years old, late in life, as it did for Pigeon. Once Tripier became convinced of her revelatory powers, she devoted herself completely to exploring them, driving herself into poverty and apparent madness. She was committed in 1934 to a Paris hospital, where she remained until her death ten years later.

Tripier was immensely prolific while interned; her preserved works from 1935 to 1939 include some fifty cloth pieces, three to four hundred drawings, and two thousand written pages. Her writing transmits messages from the many spirits she channeled. Her drawings combine text with free-form imagery and blots of ink that were interpreted as figures and signs, which then spun off further texts. Among her most

FIG. 11. Laure Pigeon, *Untitled*, August 2, 1935. Ink on paper, 9⅝ x 12½ in. (24.5 x 31.5 cm). Collection de l'Art Brut, Lausanne

expressive and inventive works, however, are her embroideries, in which she abandoned all sense of traditional orderly craft and design in the interests of vigorously expressing the "great irrational substratum" that commanded her (see fig. 12). Through the abstract unbridled expressionism of her embroidery, we observe both revelation and delusion, a woman's savage pride in liberation from the constraints of traditional roles and domestic craft and the collapse of self into the "unconscious mind" that communicates on some immediate level to us.

Notes

1. Roger Cardinal, "L'art et la transe," in *Art spirite, médiumnique, et visionnaire: messages d'outre-monde*, exh. cat., ed. Roger Cardinal and Martine Lusardy (Paris: Hoëbeke, 1999), p. 28; see also, Roger Cardinal, "The Art of Entrancement," *Raw Vision* 2 (Winter 1989–90), repr. in *Raw Vision 1-2-3* (2005), p. 93.
2. Gregory Amenoff, quoted in Carol S. Eliel, "Moral Influences and Expressive Intent: A Model of the Relationship between Insider and Outsider," in *Parallel Visions: Modern Artists and Outsider Art*, exh. cat., ed. Maurice Tuchman and Carol S. Eliel (Los Angeles: Los Angeles County Museum of Art, 1992), p. 17.
3. Roger Cardinal, *Outsider Art* (New York: Praeger, 1972), p. 135.
4. Ibid., p. 138.
5. Lucienne Peiry, *Art Brut: The Origins of Outsider Art*, trans. James Frank (Paris: Flammarion, 2001), pp. 16–20; Cardinal, "Art of Entrancement" (note 1), p. 84.
6. Cardinal, "L'art et la transe" (note 1), p. 15. Michel Thévoz compared the medium to an "African witch doctor." Michel Thévoz, *Art Brut* (Geneva: Skira, 1995), p. 189.
7. Vasily Kandinsky, quoted in Rose-Carol Washton Long, "Expressionism, Abstraction, and the Search for Utopia in Germany," in *The Spiritual in Art: Abstract Painting 1890–1985*, exh. cat., ed. Maurice Tuchman and Judi Freeman (Los Angeles: Los Angeles County Museum of Art, 1986), p. 202.
8. André Breton, "Manifesto of Surrealism," in *Manifestoes of Surrealism* (Ann Arbor: University of Michigan Press, 1972), p. 23; see, however, Roger Cardinal's insightful reading of the changes within Breton's public assessments of the nature and value of mediumistic work, "Du modèle intérieur au nid d'oiseau: Breton, Crépin et l'art des médiums," in *Art spirite, médiumnique* (note 1), pp. 67–77.
9. Breton (note 8), pp. 127–28.
10. André Breton, *The Lost Steps*, trans. Mark Polizzotti (Lincoln: University of Nebraska Press, 1996), p. 92; "Entrée des médiums," in *Les pas perdus*, new ed. (Paris: Éditions Gallimard, 1969), p. 121.
11. Peiry (note 5), pp. 20, 94–97. See also, Martine Lusardy, preface to *Art spirite, médiumnique* (note 1), pp. 7–9.
12. Walter Morgenthaler, *Madness and Art: The Life and Works of Adolf Wölfli*, trans. Aaron H. Esman (Lincoln: University of Nebraska Press, 1992), p. 101.
13. Thévoz (note 6), p. 190.
14. Augustin Lesage, quoted in John Maizels, *Raw Creation: Outsider Art and Beyond* (London: Phaidon, 1996), p. 56.

FIG. 12. Jeanne Tripier, *Rectangular Embroidery*, c. 1935–39. Embroidery, 9⅞ x 35½ in. (25 x 90 cm). Collection de l'Art Brut, Lausanne

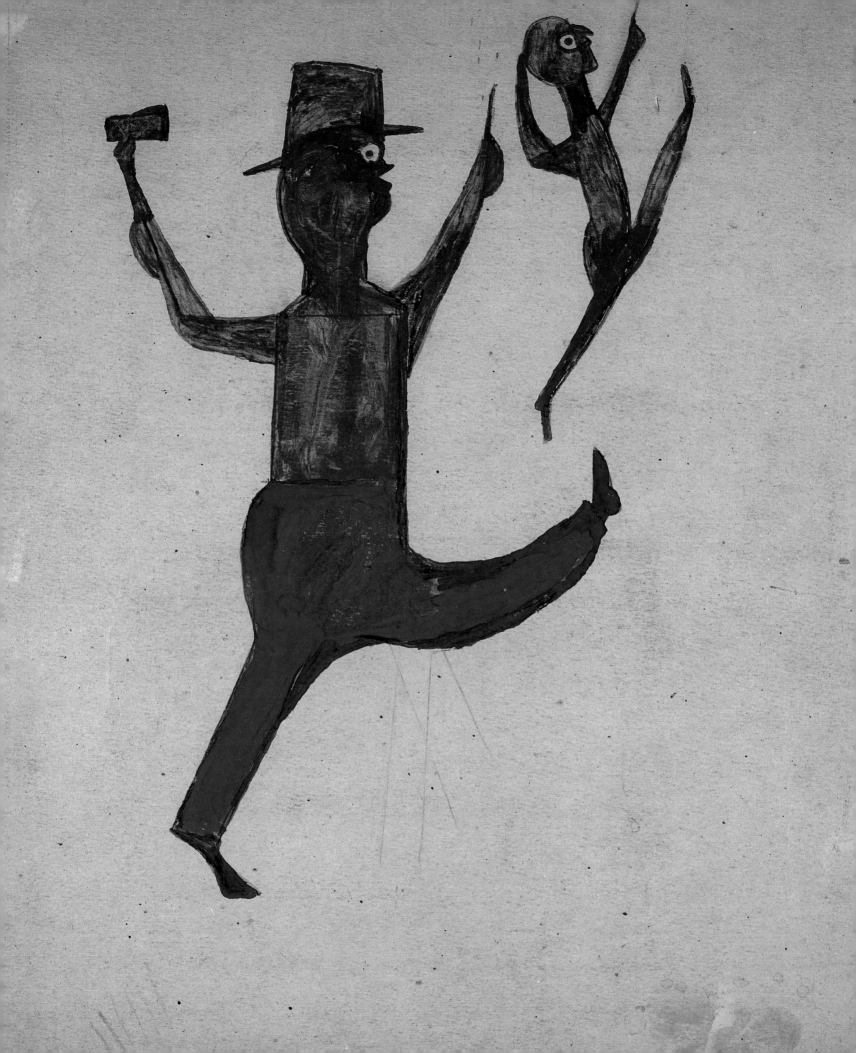

Bill Traylor

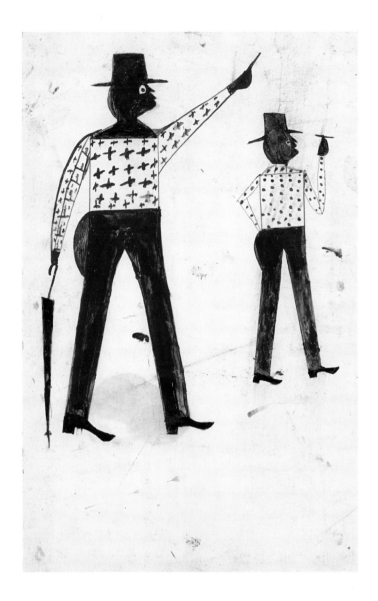

dred drawings and paintings he created mostly from age eighty-five to eighty-eight, Traylor established a distinctive iconographic vocabulary and an economic grammar that defined his social and aesthetic vision.

Traylor, a self-taught artist who was born a slave and lived much of his long life as a sharecropper, may have begun drawing only near the end of his life. Discovered by chance by Shannon, Traylor's works speak to both the art of his time and that of the present. He has been described alternately as a folk artist, a proto-modernist, an unmediated expression of African aesthetics, and a vernacular voice of southern African American culture. Each interpretation illuminates and contests conventional readings of mid- to late-twentieth-century art.

However abstract, Traylor's work is rooted in a representational impulse. The majority of his drawings are either portraits of individuals or animals or eventful scenes often involving numerous figures. We are constantly struck by the visual economy of the works, which communicate the character of the subjects and capture the complexities of the events with formal precision. Many of Traylor's drawings make evident his reliance on and love of geometric forms, which underlie the figure or shape the event. Shannon watched Traylor use a straight-edge ruler to establish the rectangles or squares that define the figures' bodies, as well as the triangles or wedges that he subsequently added to create legs, arms, and necks. After blocking out the figure, Traylor would modulate it by drawing freehand curved lines, adding arcs and semicircles to depict hips (see fig. 1). He was also adept at drawing assured curvilinear lines to depict remark-

S peaking of the drawings of Bill Traylor (1853–1949), Charles Shannon, the young white artist who in 1939 noticed Traylor drawing at streets' edge in a black section of Montgomery, Alabama, asserted, "You have to be responsive to the abstract play as well as the realism to enjoy his work fully."[1] Indeed, the power of Traylor's art is manifest in the balance of his sharply focused figurative imagery and his masterful command of the abstract, formal aesthetic that governs the works. Throughout the more than twelve hun-

ABOVE: FIG. 1. Bill Traylor, *Two Men Walking*, c. 1939–43. Tempera and pencil on paper, 22 x 14 in. (55.9 x 35.6 cm). The Metropolitan Museum of Art, New York

OPPOSITE: Detail of Bill Traylor's *Man with Hatchet Chasing Pointing Man* (fig. 8)

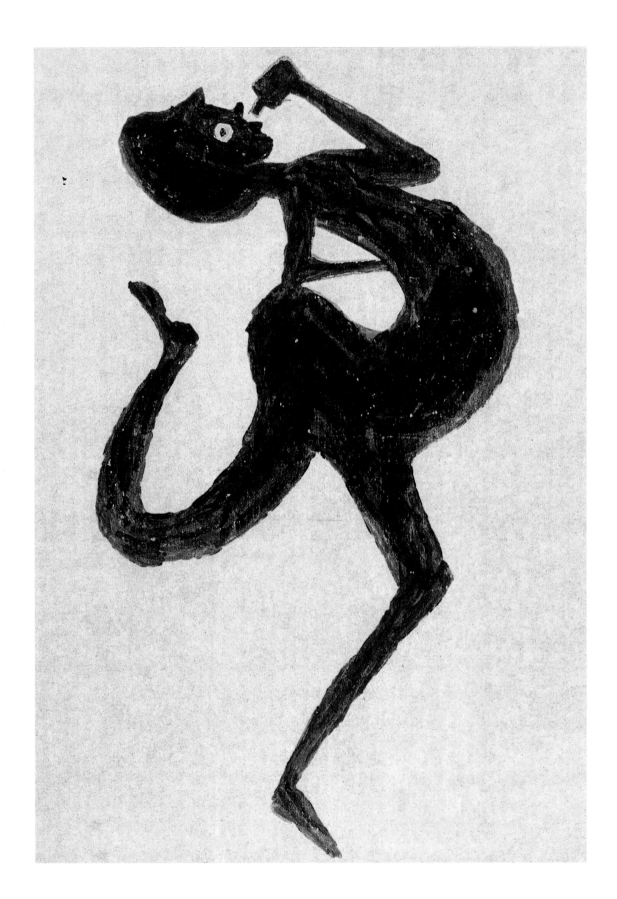

FIG. 2. Bill Traylor, *Female Drinker*, c. 1939–42. Gouache and pencil on cardboard, 11½ x 8½ in. (29.2 x 21.6 cm). The Metropolitan Museum of Art; Promised gift of Charles E. and Eugenia C. Shannon

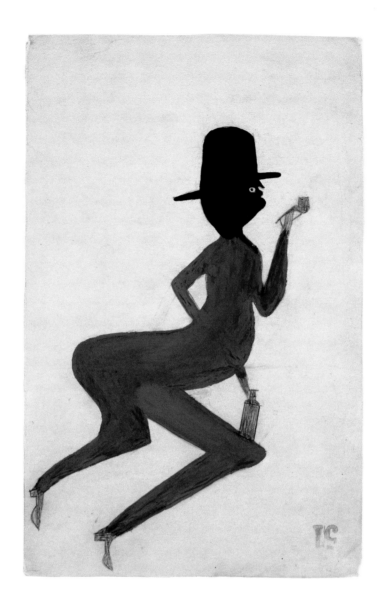

ably supple figures. The female drinker in figure 2 is simultaneously sharply focused and balanced and loose and lithe, her concentration on the bottle and its desired effect already evident in the kick the alcohol gives. The sweeping curves of her left leg, buttocks, torso, and back of head provide a lyricism to her private dance accented by the sharp angles of the leg that holds her up, the bent arms that deliver the drink, and the lips that await it. However inward directed her imbib-

ing, the similarly contrasting curves and sharp angles of the red man in figure 3 affirm an individual whose confident self-presence is entirely outward directed. Armed with pipe and bottle, the man appears to tiptoe forward, even as his upright torso and black head and hat announce his steady presence.

Traylor clearly enjoyed exploring the geometric and abstract forms within his figures. Shannon related that for a period Traylor drew mostly baskets and abstracted objects

FIG. 3. Bill Traylor, *Red Man*, c. 1939–41. Poster paint and pencil on cardboard, 12 x 7¾ in. (30.5 x 19.7 cm). Private collection

FIG. 4. Bill Traylor, *Little Blue Basket*, 1939–42. Pencil and poster paint on cardboard, 12¾ x 7½ in. (32.4 x 19.1 cm). Private collection

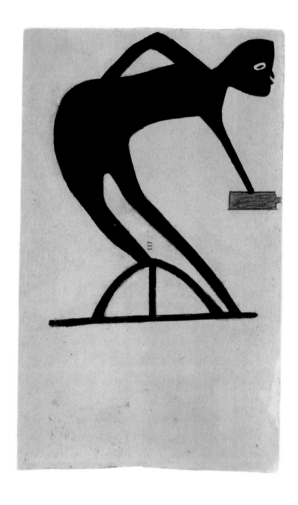

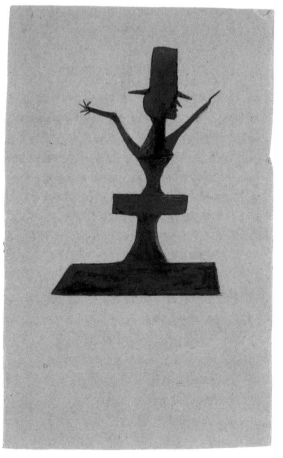

(see fig. 4). His appreciation of the regularity of gridlike patterning is also evident in his occasional indications of fabric designs on clothes (see fig. 1). Traylor's formal orientation assumes primary importance in drawings that are largely pure abstractions or that combine figurative and abstract elements in fanciful, if not surreal, mutations of animate figures and inanimate forms. In one such work (fig. 5), a man, bottle in hand, is bent over as if he has had too much to drink. One of his legs morphs into a wide, semicircular form, which provides a much-needed source of balance and echoes the shape of his upper torso and arm. In figure 6, an abstract form serves as a dais for the gesturing, self-important figure, who is rendered comic by appearing to emerge from a vase as a potted plant.

In both cases, we observe how the identities of the subjects and the authority of the abstraction are established by Traylor's dynamic figure-ground relationships. He frequently placed figures off-center, creating a tension between their bodies and the edges of the drawing while simultaneously giving great power to the negative space. The curve of the man's back in figure 5, for instance, appears to be pressed down by the top edge of the paper, while the large open ground below him gives the impression that he is floating upward. In figure 6, the man and pedestal similarly appear to move up and off-center, the broad base of the plinth hovering over the empty bottom third of the ground as the entire figure heads in the direction he is pointing.

Traylor displayed an assured, intuitive sense of abstract relations among figurative elements and their placement in response to the shape and condition of the surface. He made creative use of the odd shapes and uneven surfaces of the found paper and cardboard on which he worked, often incorporating blemishes or imperfections and rough or non-linear edges into his compositions to great effect. In figure 7, the unconventional shape of the cardboard allows for slight variations in the work's orientation, which can alter our

TOP: FIG. 5. Bill Traylor, *Man Bent at Waist with a Bottle*, 1939–42. Poster paint on cardboard, 11¾ x 7½ in. (29.8 x 19.1 cm). William Louis-Dreyfus Collection

BOTTOM: FIG. 6. Bill Traylor, *Blue Man with Hat atop Construction*, 1939–42. Poster paint on cardboard, 15 x 9½ in. (38.1 x 24.1 cm). Private collection

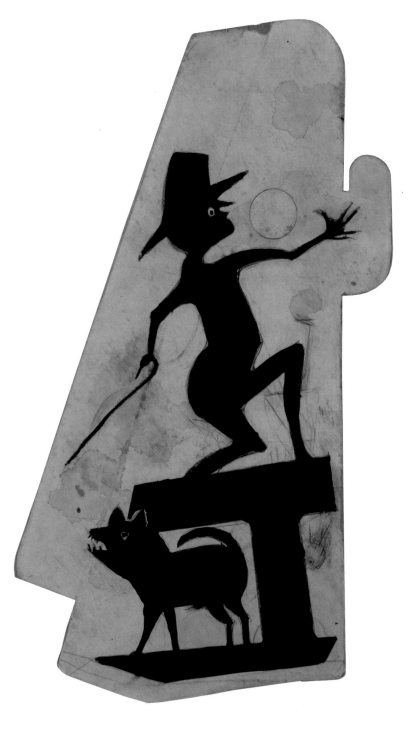

interpretation of the image. As presented here, the man's loss of balance is accentuated, his torso leaning backward toward the threatening dog below, despite his effort to step forward and grasp something in the empty space of the cardboard's hinge edge. No matter how vicious the awaiting dog, the scene is comic yet graceful, given the delicacy of the man's pose, however imminent his fall.

Traylor preferred responding to stressed surfaces, either rejecting Shannon's offers of clean art boards or weathering them in the elements until they were appropriately "seasoned." In one particular work (fig. 1), Traylor's subtle incorporation of preexisting lines is one of the few suggestions of receding perspective in his oeuvre, though the effect is also implied by the difference in scale of the two men. A similar, though nonperspectival, disparity occurs in figure 8, in which the large, hatchet-wielding man tries to kick the small figure who flees upward. Traylor often drew figures of different scale within his works, especially in the busy scenes that Shannon called "Exciting Events." These drawings are energetic, chaotic, mysterious depictions in which tiny creatures bedevil larger figures, probing their private parts with sticks and toppling or striking them from behind. While the diminutive size of the figures has led some to see them alternately as children or as malevolent spirits, many adult-size figures in Traylor's scenes contribute equally to a world that seems chaotic and violent (recall fig. 8). In this malicious realm, figures are climbing and falling, chasing and threatening others, fingers pointed, hatchets and guns raised; dogs are sicced on people by their enemies, while snakes and dogs loom as constant threats (see fig. 9). The prevalence of violent and threatening acts has recently led several scholars to speculate about traumatic events or psychological motives in the artist's life.[2] Other authors interpret the scenes as either representations based in southern African American storytelling traditions, expressions of Africanist spiritual and mythological retentions, or playful exaggerations on Traylor's part.[3]

FIG. 7. Bill Traylor, *Kneeling Man with Cane on Construction*, c. 1939–42. Poster paint on cardboard, 14 x 7 in. (35.6 x 17.8 cm)

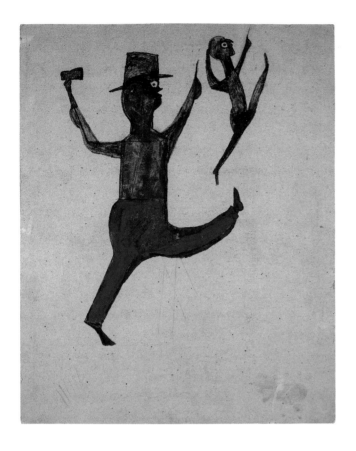

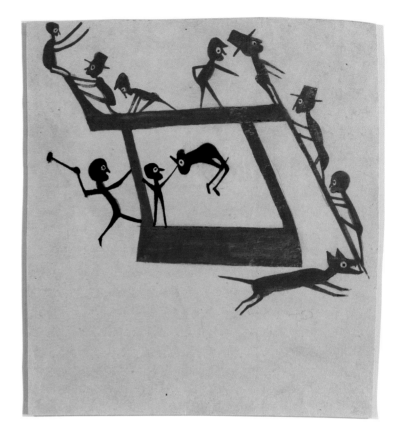

Indeed, despite the threatened violence and agitated animation, the "Exciting Events" rarely depict the aftermath of violence. Rather, the constant yet inconclusive pursuit, the climbing and falling, and the disproportionate scale between figures chasing or being chased can also be seen as whimsical, even comic. Furthermore, Traylor's frenetic world is curiously static. There is much action, but a sense of order and stability, however fragile, prevails. Will the man in figure 8 ever strike his prey? Will the chase around the parallelogram in figure 9 find conclusion? Will the various assailants ever satisfy their aggression? Alison Weld noted that Traylor's scenes are frequently composed around a centered structure—a house, a tree, or an often-unidentifiable geometric

construction—which provides a core of stability in the frenzied world, a point around which chaos occurs but one that also tames the disruption and violence.[4] Susan Crawley similarly observed that "motion in Traylor is often motion suspended." Nevertheless, we are present at a moment of "fleeting equipoise; . . . the stillness of these compositions is illusory, the momentary pause before uncontrollable motion begins, encapsulating that motion."[5]

Traylor's is an aesthetic of tension and balance, disorder and order manifest on both formal and figurative levels. The precision of his art arrests dramatic motion in a "complex and harmonious" scene,[6] and it captures the particular essence and universality of a figure in an abstracted portrait (see fig. 10).

FIG. 8. Bill Traylor, *Man with Hatchet Chasing Pointing Man*, c. 1939–42. Pencil and poster paint, 21½ x 16⅞ in. (54.6 x 42.9 cm). Private collection

FIG. 9. Bill Traylor, *Figures, Construction*, 1940–42. Watercolor and pencil on cardboard, 12¾ x 11⅝ in. (32.4 x 29.5 cm)

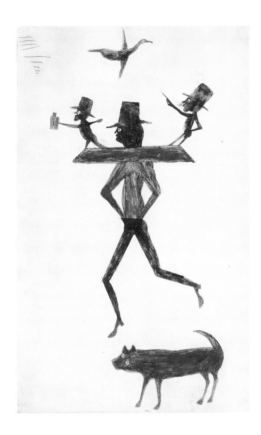

After the Civil War, the emancipated Traylor worked as a sharecropper and laborer for the Traylor family well into the first decade of the twentieth century. Little is known of his life, save what is recorded in census reports, which document that in 1891 at the age of thirty-seven he married his first wife, a young woman named Louisa, with whom he had eight children, the first born in 1884, when she was twelve and he was thirty. In 1909 Traylor married his second wife, Larcey (Laura), with whom he had five children. Both families apparently raised additional offspring born of Traylor's relationships with other women. Although he claimed to have fathered more than twenty children, by 1930, at the age of seventy-seven, Traylor lived alone in a rented shack in Montgomery, his family scattered around the country or deceased. He had come to Montgomery, most likely in 1928, working in a factory as a shoemaker until arthritis made it impossible for the seventy-five-year-old man to continue.

The Traylor known to us as an artist was discovered in 1939 by the young, white, southern artist Charles E. Shannon, who noticed Traylor sitting along Monroe Street drawing images on pieces of cardboard and found paper. At the time, Traylor was around eighty-five, unemployed, living on public assistance, and sleeping at night on a pallet in the showroom of a funeral parlor. Traylor might have been drawing for several years, but Shannon believed the elder artist had just begun to work. Shannon befriended Traylor and provided him with art supplies—colored pencils, poster paints, and brushes, as well as poster cards and boards.

Although Shannon saw Traylor frequently, they rarely conversed. Indeed, Shannon recorded or remembered few statements by Traylor, and almost none about his art. Traylor occasionally spoke of a depicted figure as if remembering it or giving it an identity. One painted mule was described as "sullen;" another was "let out to die." On one occasion Traylor stated, "I wanted to be plowing so badly today I made me a man plowing."[8] Or he would make a comic reference to one

Bill Traylor was born most likely in 1853,[7] a slave on the small cotton plantation in Benton, Alabama, founded by John Traylor and at that time managed by his brother George. Traylor's father, Bill Calloway (named after *his* original owner), had been born in coastal Georgia, a region into which large numbers of slaves from the Kongo culture of west central Africa had been imported. Traylor's mother, Sally, had been born in Virginia, a region where the preponderance of slaves were of the Igbo culture of Nigeria. The Traylor plantation held some fifteen slaves, all from the Calloway/Traylor clan, who remained together until emancipation. Their slave quarters were a mile from the owners' house, and they evidently had a good amount of unsupervised life. Recent scholarship on the slave experience has theorized that traditional African cultural beliefs and social practices could well have been sustained in such conditions, and thus Traylor might have been exposed to them in his youth.

FIG. 10. Bill Traylor, *Man with Yoke*, n.d. Pencil and gouache on cardboard, 22 x 14 in. (55.9 x 35.6 cm). Collection Judy and John M. Angelo

of his chaotic scenes. While we can imagine the reluctance a black man might have speaking to an inquiring white man during the Jim Crow era, Shannon did not press him. He did not mention that he himself was an artist nor did he engage Traylor in any substantive discussion about the art he watched him produce. To Shannon, Traylor represented a direct link to the African spirit. Not wanting to spoil the "primitive" authenticity of this artist, he limited their interaction to the point that Traylor came to regard himself as "working for" Shannon, which was not an unreasonable assumption since Shannon ultimately acquired between twelve and fifteen hundred of Traylor's works.

Shannon presented the first solo exhibition of Traylor's art in 1940 at New South, the cooperative culture center in Montgomery that Shannon had founded with other young artists. One year later, through an acquaintance at the Museum of Modern Art, Shannon arranged for Traylor to have a solo show in New York. Traylor's works were shown to MoMA's director, Alfred H. Barr, Jr., who attempted to purchase some of them for his personal collection and that of the museum. Shannon refused the transaction, offended by Barr's presumption that they were for sale and by the meager sum Barr sent him without asking. We can only speculate what might have happened to Traylor had his works been acquired by and shown at MoMA while he was still alive. Nonetheless, Shannon preserved the works in his possession, even after losing touch with Traylor, whose health problems withdrew him from view. Traylor died in October 1949, a resident of a wretched rat and roach infested nursing home for Negroes.

Shannon was fascinated by Traylor and his oeuvre from the day he first saw him. He was responsible for preserving what we have of Traylor's drawings and for bringing them to the attention of the art world, both in the early 1940s and again in the 1970s. Yet despite these efforts, in many ways Traylor and his body of work remain mysteries. Like many self-taught and outsider artists, he was discovered unexpect-edly and little information about his life and his artistic past or intent is known. Although he was not a figure isolated within himself by mental illness—as were Wölfli, Aloïse, Walla, and Ramírez—or socially withdrawn from the world, as was Darger, Traylor was separated by race, culture, class, and age from Shannon and the world into which his art was introduced. As is common to the field of self-taught and outsider art, interpretation of the art is left to viewers, collectors, critics, and art-world members, who project their interests and orientations onto the work and the little-known artist.

Traylor was "discovered" in the late 1930s and then "rediscovered" in the 1980s. The first moment was characterized by a confluence of discussions of the nature of American modern, folk, regional, and popular art, within which scant attention was given to the work of African Americans. The second brought him into postmodern discussions of multiculturalism, African American diasporic art, and revisionist modernism, as well as self-taught, vernacular, and outsider art.

Shannon's initial response to Traylor reflects a 1930s appreciation of the "art of the common man" and of folk art, as articulated by Holger Cahill's efforts at the Works Progress Administration. By entitling Traylor's New South show *Bill Traylor—People's Artist*, Shannon emphasized the artist as an authentic representative of ordinary folk. More personally, perhaps, Shannon saw him as a figure of regional American art. Shannon was funded by the Julius Rosenwald Foundation to study the indigenous art of the South, among both black and white cultures. A leftist by political and cultural bent, Shannon was uncharacteristically receptive to the art of a poor, black, homeless man. Exhibiting Traylor in the context of the "new" South, Shannon declared, "Bill Traylor is perhaps one of the most significant graphic artists the Negro race has yet produced in this country," signaling his respect for Traylor's artistic achievement. But he also suggested that this unexpected distinction arose from Traylor's direct links to a primitive, cultural tradition long abiding within the South:

"Bill Traylor's works are completely uninfluenced by our Western culture. . . . his roots lie deeply within the great African tradition, and not within that of the white man."[9] Shannon did not explain what constituted the African sources of the art, but his comments placed Traylor both within American culture, as a man of the people, and outside of it, as a representative of African tradition—a duality that is echoed across later commentary on his work.

Having preserved Traylor's works for three decades, Shannon in the late 1970s sought again to have them shown, this time with much more successful results. He arranged for Traylor's presentation in a 1979 solo exhibition in New York, as well as several subsequent group shows, and for Traylor's inclusion in the seminal exhibition *Black Folk Art in America: 1930–1980*, organized by Jane Livingston and John Beardsley for the Corcoran Gallery of Art in Washington, D.C. Through these shows, Traylor initially found great renown in the revitalized field of American folk art, which in the 1960s had advanced beyond traditionalist views that it was primarily an expression of pre-twentieth-century Americana. Embracing works produced throughout the twentieth century, *Black Folk Art in America: 1930–1980* greatly expanded the field by tapping the vast range of southern African American vernacular creativity. This receptivity to black folk art reflected a national awakening to African American history and culture spurred by the recent drama of the civil rights movement and the destruction of the decades-old Jim Crow laws throughout the South. All but one of the twenty artists in the exhibition had been born under the systemic racism that ruled the South and constrained the opportunities for blacks to speak or be heard through their art. Their works were seen as glimpses of a suppressed culture previously unknown to the nation at large.

Although Traylor's works thus became extremely popular in the folk art world, to many the concept of folk proved suspect in its evocation of a docile rural populace and was found inappropriate to describe the sustaining material and behav-

ioral creativity of African Americans during four centuries of oppression. Consequently, two competing interpretations of African American self-taught art emerged in the late 1970s and 1980s: one of the radical outsider artist whose works contested cultural values and practices of the dominant, white society; the other of the artist deeply embedded in African American traditions with roots in African cultural retentions that helped sustain blacks under centuries of oppression.

The outsider model—made especially popular by Roger Cardinal's 1972 publication on European art brut, *Outsider Art*—appeared to denote both African American works steeped in a religious spirit that transmitted personal visions and evangelical enthusiasms, and the singular creations of seemingly isolate artists who embellished their immediate home or yard with objects of personal symbolic meaning. In addition, the outsider paradigm was especially attractive because it sustained both the familiar romantic trope of the genius of the alienated artist and the enduring myth of the authenticity of the primitive artist. Hence it was applied to artists like Traylor, whose lives and cultural roots were ill known and whose creations followed no familiar aesthetic conventions, even though they unexpectedly manifested what seemed to be an intuitive mastery of valued visual practice. Finally, African American culture, whether arising (as Shannon imagined) independently of white society or an expression of oppression and protest, represented to some the ultimate outsider culture, the archetypal Other to the dominant white society.

These notions marked how little African American culture has been known by the dominant society, and by the art world in particular. In distinct opposition, scholars such as Robert Farris Thompson, Maude Wahlman, and Grey Gundaker have insisted the culture in which Traylor and countless other self-taught African Americans have lived could scarcely be called outsider. Rather, it is to be recognized as sustaining

vital, creative, and historically defined traditions with their own aesthetic, religious, and social formations. Central to their argument is the identification of manifest traces of African behavior and beliefs within African American material and visual culture. Because of the creolization of numerous African cultures that had been disrupted by the slave trade and their interaction with Europeans and Native Americans in the Americas, specific cultural retentions and their individual uses are often difficult to identify, even though general patterns of behavior and imagery appear across many collective contexts and individual lives.

Nonetheless, scholars seeking to apply such methods to individual artists and works, such as those of Traylor, frequently arrive at disparate interpretations, both because so few examples of African American visual culture have been preserved to provide models of retained and hybrid forms and because so little is known about Traylor's beliefs and life influences. For instance, because Traylor's immediate family could have drawn from both Igbo and Yoruban cultural practices, conflicting interpretations arise about the identity and meaning of figures in his art. One such example is the oft-appearing top-hatted man. Even though black men can be seen wearing similar hats in photographs of Montgomery of the time, scholars have insisted that the recurring figure might depict either Baron Samedi, the Vodou loa of the dead, or the Yoruban trickster deity, Eshu.[10] But because Samedi is depicted smoking a pipe and holding a container of rum, and Eshu is frequently associated with the colors red and black, Traylor's red man (fig. 3) could be either, or neither. Similarly, a man wearing a broad-rimmed hat and clutching a cane (see fig. 7) could denote the Vodou figure Papa Legba, for whom dogs are sacred. If so, the interpretation of the man's fear of falling toward the dog would be completely invalid. Because Traylor's life is so poorly documented, the identity of the figures and their meaning for the artist will probably remain subjects of intriguing, but speculative, analysis.

Nonetheless, the desire is strong both to explain specific and recurring images in Traylor's works and to develop a more complete biographical picture of the artist. Recent books by Betty M. Kuyk and Mechal Sobel have drawn extensively upon the theories of Africanist retention and Vodou imagery, in particular, to explain the works. In addition, both rely greatly on a recent recounting of a half-century-old comment by a purported friend of Traylor stating he had murdered a man and was deeply troubled by his act. Upon these bases they have developed elaborate, if circular, analyses that interpret Traylor's imagery as either a means of reliving the violent event and of seeking expiation for the death or proving that the event actually occurred. While such interpretations are not especially convincing, they do make it difficult to read the violent scenes as mere whimsy and they remind us how little certainty we enjoy with the art of outsider or self-taught artists. And although Shannon opined that "[Traylor's work] seems to have already transcended the labels of 'black' and 'folk,' but the label doesn't matter; the work has carved out a place for itself,"[11] it seems we are only beginning to unpack its personal and cultural resonances.

Similar issues may haunt our experience of other early- to mid-twentieth-century southern African American self-taught artists, such as William Edmondson, Horace Pippin, and Clementine Hunter, even though they achieved much greater renown and had more extensive interaction with the wider world than had Traylor. The sculptures of William Edmondson (c. 1870–1951), which began as carved limestone tombstones for his fellow members of the United Primitive Baptist Church in Nashville, Tennessee, achieved national recognition shortly before Traylor was first seen by Shannon. Their minimal and precise forms—primarily of human figures drawn from biblical tales or contemporary public life—display a mastery of abstraction and balance (see fig. 11). The weight and roughness of the stone are modulated by the delicacy of the minimally inflected details of face, hands, and hair. Although

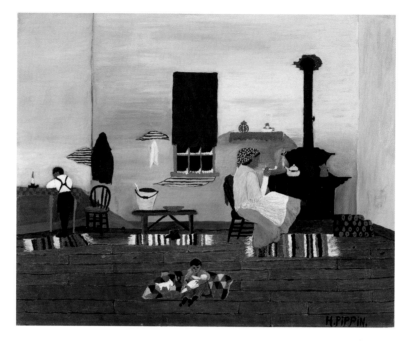

the sculptures' aesthetic strength arises from Edmondson's functional, craftlike approach to the material, he sought to reveal an inner truth in the subject rather than attending to surface stylization: "I ain't got much style; God don't want much style, but he gives wisdom and speeds you along."[12]

Edmondson, a son of freed slaves, lived most of his life in and around Nashville. After many years doing menial labor and then working as a hospital janitor, he had a vision in which God directed him to become a stone carver. Using limestone gathered from streets and fields, some scrap stones given to him by black workers, Edmondson carved tombstones, garden ornaments, and freestanding figures, which he placed in his yard to sell. His work was noticed by Sidney Hirsch, a white scholar associated with the Fugitive poets movement, who brought Edmondson to the attention of fellow Nashville intellectuals and writers. Within a short time, his work was photographed by Louise Dahl-Wolfe, who showed it to Alfred H. Barr, Jr., at the Museum of Modern Art. Barr responded to the minimalist aesthetic of Edmondson's sculptures, much as he did to Traylor's drawings, for they seemed to validate a belief in the consanguinity of modernist

spirit, art of the common man, and primitivist vision. In 1937, some five years after he started carving, Edmondson became the first African American to receive a solo exhibition at MoMA.

The paintings of Horace Pippin (1888–1946) depict a range of subject matter much more broad and varied than the work of either Traylor or Edmondson, in large part because of Pippin's more extensive travels and scope of experience as a northern-born black man. His painted subjects include battle scenes of World War I, in which he had fought and been wounded; the daily life of impoverished African American families he knew (see fig. 12); decorative interiors and floral arrangements from the homes of poor blacks and his monied collectors; as well as political and racial matters, including a series on John Brown and a bold anti-Klan painting, *Mr. Prejudice* (1943).

Pippin had drawn or painted privately since childhood, kept a notebook of war images during service, and later briefly took classes at the Barnes Foundation before he was "discovered" at a local county art show in West Chester, Pennsylvania, and brought to the attention of artists and dealers in the area. Within a year, he was included in MoMA's exhibition *Masters*

FIG. 11. William Edmondson, *Crucifixion*, 1932–37. Carved limestone, 18⅛ x 11 x 6⅛ in. (46.1 x 30.5 x 15.5 cm). Smithsonian American Art Museum, Washington, D.C.; Gift of Elizabeth Gibbons-Hanson (1981.141)

FIG. 12. Horace Pippin, *Interior*, 1944. Oil on canvas, 24⅛ x 30⅛ x ¾ in. (61.2 x 76.6 x 0.2 cm). National Gallery of Art, Washington, D.C.; Gift of Mr. and Mrs. Meyer P. Potamkin (1991.42.1)

of Popular Painting (1938), and he was later featured in Sidney Janis's publication *They Taught Themselves: American Primitive Painters of the Twentieth Century* (1942). These successes brought him gallery representation, entry into numerous private and public collections, and commissions.

The paintings of Clementine Hunter (1886?–1988) are largely restricted to scenes of her life on a plantation in northern Louisiana. Like Traylor, Hunter rarely used perspective in her well-populated images of rural life, but her figures are usually anchored within representational grounds delineating clear spatial and narrative relationships among the individuals (see fig. 13). Most of her human figures are stiffly posed, with minimal delineation of their facial features, their individuality communicated through their work and activities or through their relationships with others in the shared environment.

Hunter's works suggest the folk art genre of memory paintings, offering somewhat nostalgic, if not idyllic, portrayals of plantation life of a disappearing past. A descendent of slaves, she was born on a plantation and moved in her teenage years to Melrose Plantation in Natchitoches, Louisiana, where she spent the remainder of her long life. By the 1940s,

Melrose had become a center for visiting artists, and Hunter's talent had been noticed and encouraged by its owners and visitors. As she aged, her works were frequently exhibited, bringing her great regional and then national renown.

Notes

1. Charles E. Shannon, "Remembering Bill Traylor: An Interview with Charles Shannon," in Frank Maresca and Roger Ricco, *Bill Traylor: His Art, His Life* (New York: Knopf, 1991), p. 31.
2. See Betty M. Kuyk, *African Voices in the African American Heritage* (Bloomington: Indiana University Press, 2003) and Mechal Sobel, *Painting a Hidden Life: The Art of Bill Traylor* (Baton Rouge: Louisiana State University Press, 2009).
3. For insightful critiques of Traylor scholarship, see Susan M. Crawley, "Words and Music: Seeing Traylor in Context," in Carol Crown and Charles Russell, *Sacred and Profane: Voice and Vision in Southern Self-Taught Art* (Jackson: University Press of Mississippi, 2007), pp. 214–37 and Jenifer P. Borum, "Bill Traylor and the Construction of Outsider Subjectivity," in Crown and Russell, pp. 238–59.
4. Alison G. Weld, "Dream Singers Story Tellers: An African-American Presence," in Alison G. Weld and Sadao Serikawa, *Dream Singers, Story Tellers: An African-American Presence*, exh. cat. (Trenton, NJ: New Jersey State Museum/Fukui, Japan: Fukui Fine Arts Museum, 1992), p. 41.
5. Crawley (note 3), p. 226.
6. William Louis-Dreyfus, "Bill Traylor: An American Prodigy," in *Bill Traylor: Observing Life* (New York: Ricco Maresca Gallery, 1997), p. 1.
7. Various years have been given for Traylor's birthdate, several by Traylor himself. Mechal Sobel's analysis of the Traylor plantation "slave schedule" (the inventory of human property) gives greatest credence to 1853. See Sobel (note 2), p. 5ff.
8. Charles E. Shannon, "Bill Traylor's Triumph," *Art and Antiques* (Feb. 1988), p. 62, quoted in Crawley (note 3), p. 232.
9. Charles E. Shannon, *Bill Traylor: People's Artist*, exh. cat. (Montgomery, AL: New South Center, 1940), quoted in Borum (note 3), p. 242.
10. See Jenifer P. Borum's discussion of these interpretative possibilities in Borum (note 3), pp. 254–57.
11. Maresca and Ricco (note 1), p. 31.
12. Bobby L. Lovett, "From Plantation to the City: William Edmondson and the African-American Community," in *The Art of William Edmondson*, exh. cat. (Nashville: Cheekwood Museum of Art, 1999), p. 23.

FIG. 13. Clementine Hunter, *The Wedding*, 1960. Oil on canvas, 21³/₈ x 27¹/₂ in. (54.3 x 69.9 cm). High Museum of Art, Atlanta; T. Marshall Hahn Collection (1996.176)

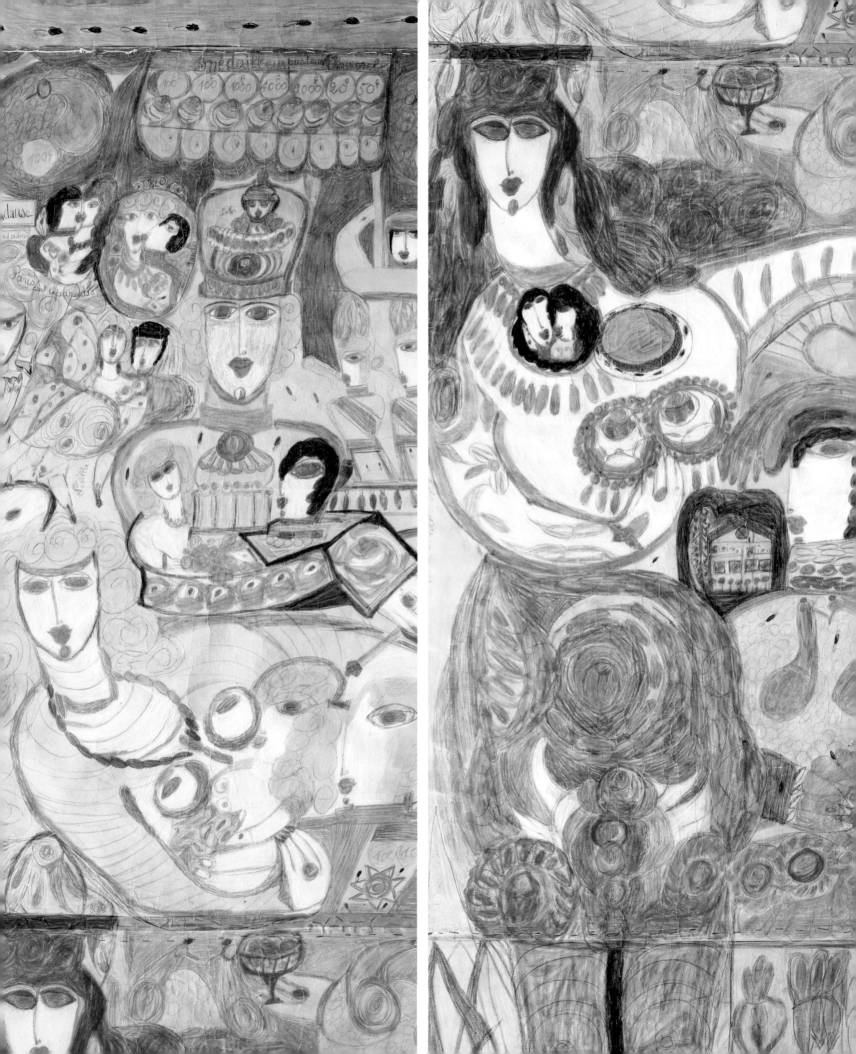

Aloïse Corbaz

The visual world of Aloïse Corbaz (1886–1964) is an expansive realm of feminine power coursing through history and the Western cultural imagination. Her artworks are infused with the captivating presence of women—imperious, luxurious, sensuous, sexual, stately, and self-composed. They appear to dominate the men around them, commanding the visual field of the drawing and the attention of the viewer.

These images of splendor are drawn from opera, art, romance, and history, which Aloïse knew as a young woman in Switzerland and as a governess at the imperial court in Germany before her commitment to La Rosière asylum near Lausanne for forty-four years. Yet no matter how isolated in Rosière or withdrawn into the visual realm of her creations, Aloïse remained connected to her society through her transformations of the era's romantic imagery. In her oeuvre, we observe an alienated creature ceaselessly projecting an imagined life through the repertoire of women idealized and scorned in our culture; we encounter a drama greater than that we might find in the theater she adored.

Women are the center of Aloïse's visual universe. Opulently dressed, or in dramatic deshabille, and always extravagantly coiffed, the women are portrayed suffused with bright, warm hues and enfolded in swirling floral bouquets and sweeping ermine cloaks. They are attended by elegant, often diminutive, male figures—either students, nobles, popes, or emperors—who stand behind or kneel beneath them, extending their hands or pursing their lips to kiss the women's vermilion mouths or opulent breasts (see *La Caporale*

Dieu Bien Fou, 1951–60; fig. 1). Aloïse constantly drew her women in gowns exposing their shoulders and necks, or allowing unconstrained breasts with refulgent nipples to emerge. Their sensuous being is further acclaimed by red, blond, or chestnut tresses and wigs that may sweep out and around them, taking over the composition or becoming the ground on which the women are drawn. In other works, heads and torsos culminate in garlands of flowers and fruits or gowns and cloaks festooned with lush vegetal imagery, further ornamented by images of birds—peacocks, doves, lovebirds, and nests full of eggs. However imposing and outrageously proportioned the women may be, they are curiously delicate; their feet, when visible, are tiny and gracefully curved, rarely touching the ground.

Aloïse's women are the center of resplendent scenes of romance and eroticism and are posed as if on display for others. In this, they are figures of desire—largely male, or male-identified, desire—passively open to the erotic gaze. Yet, the women are also figures of power, even terror. They stand imperious in their nudity or deshabille. Many bear attributes of the sphinx: claws, wings, and a beastlike body. Others are sirens and mermaids, their curvaceous bodies culminating in scales and a fishtail that might sweep up and around the attending males. Still others carry a painter's palette, signaling their ability to create a universe and a self-portrait of empowerment. In *The Imperial Crown of the Royal Earth* (1943; fig. 2), a large, commanding woman, palette in hand, stands before an easel painting the bust of a woman, above whose head floats a celestial globe.

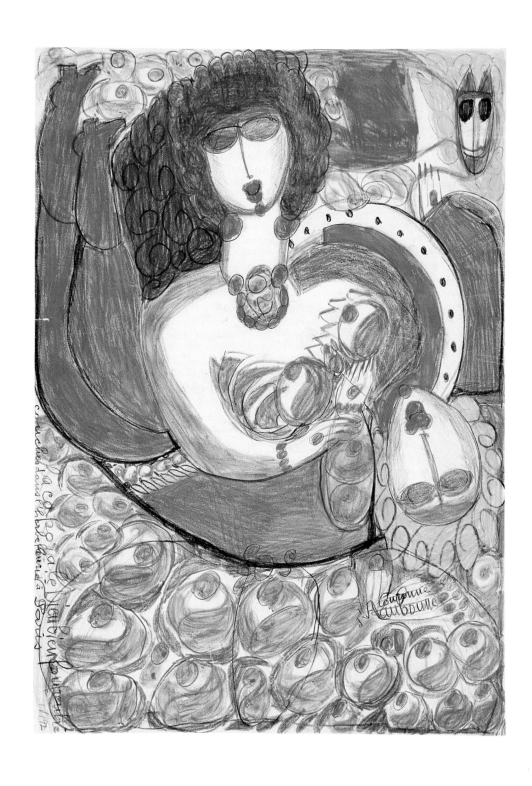

FIG. 1. Aloïse Corbaz, *La Caporale Dieu Bien Fou*, 1951–60. Colored pencil on paper, 23½ x 16¾ in. (60 x 43 cm). Collection Steck, Switzerland

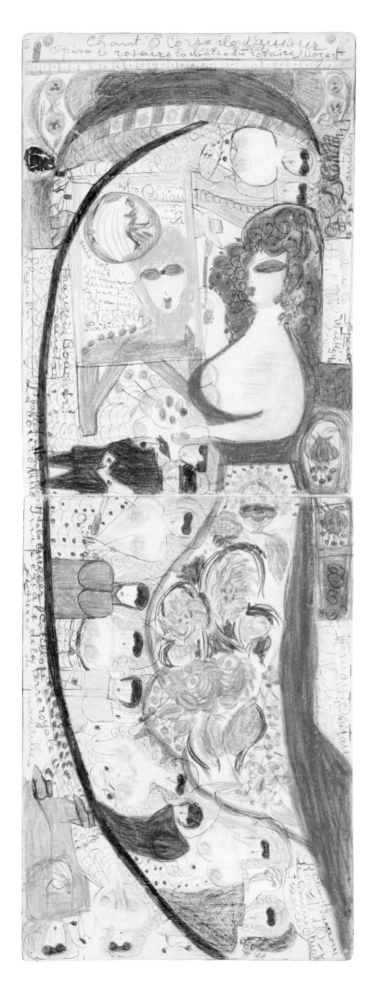

Appropriate to Aloïse's work, the phrase *"François Boucher peintre"* (François Boucher painter) is written adjacent to the easel. Like the work of this rococo painter of *scènes galantes*, Aloïse's erotic depictions of women and their admirers or hopeful lovers seem to proliferate endlessly. They appear throughout single compositions, which are frequently juxtaposed with other drawings or extend across several linked panels. These conjunctions, at times stretching into works several feet wide or high, create the sense of an amorous realm at once unceasing and hyperbolic. *The Star of the Paris Opera (Napoleon III at Cherbourg)* (between 1952 and 1954; fig. 3), for instance, offers two parallel depictions of a couple, each scene extending over four vertical panels. The bodies of both men stretch across the four sections, while the women, who only extend through the top three, appear as if held off their feet by their lovers. Yet the men play only supporting roles. The primary focus is on the women: one clothed in a dress embellished with floral and avian figures; the other nearly nude save for decorative bands of strategically placed jewels and flowers. In both images, the women face forward, embraced by the men standing behind them. The men's heads are in profile as if they are looking at the women, even though their single visible eyes seem to be peering out at the viewer.

Although the feminine body is a constant focus of display, the eyes of the women and their lovers are perhaps the most captivating element of Aloïse's works. Almost invariably, Aloïse drew the eyes as bright blue ovals, unmarked by pupils and rarely with any indication of white. Simultaneously suggesting an excessively romanticized ideal of Teutonic beauty, blindness, tinted glasses, theatricality, and impenetrable masks, the swaths of blue seem to peer out at the viewer but prevent any insight into the figure's individuality. The women and men seem inaccessible, hidden, perhaps without interior life. They exist in their own world, magisterial and on display perhaps, but removed from our realm. The only time we see more definition of the eye is when the lovers' faces are in

FIG. 2. Aloïse Corbaz, *The Imperial Crown of the Royal Earth (La Couronne impériale de la terre royale)*, 1943. Colored and black pencils on paper (pages 6 & 7 of the book of drawings "Pâques 1943"), 26 x 9½ in. (66 x 24.5 cm). Private collection

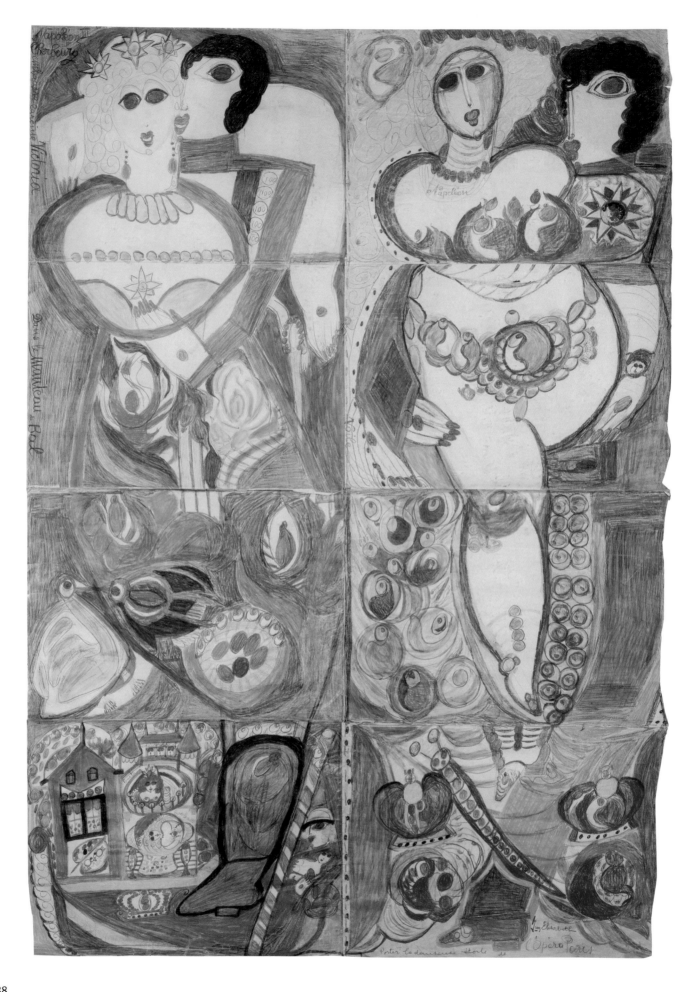

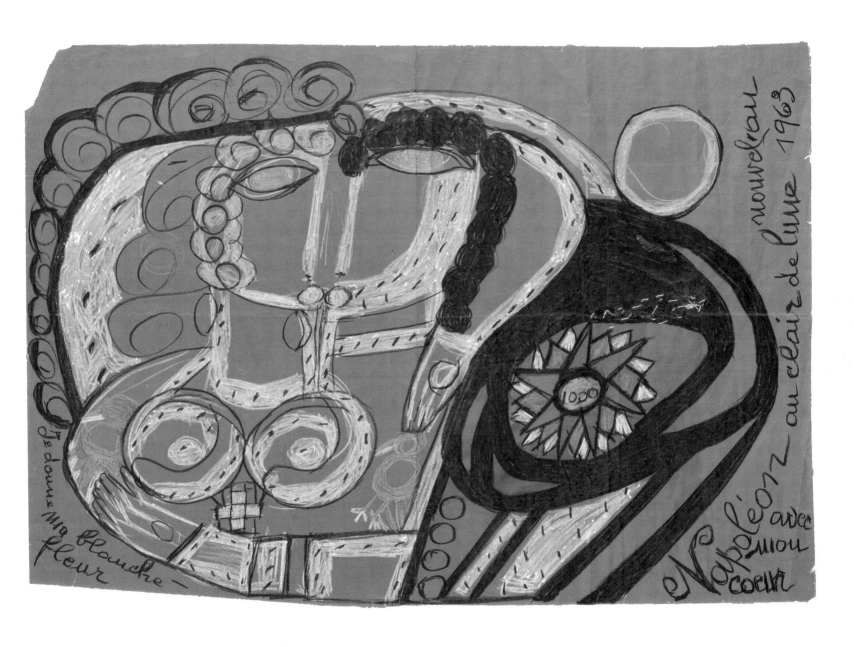

FIG. 3. Aloïse Corbaz, *The Star of the Paris Opera (Napoleon III at Cherbourg) (L'étoile de l'Opéra Paris [Napoléon III à Cherbourg]),* 1952–54. Colored pencil on paper, 64½ x 46 in. (164 x 117 cm). Collection de l'Art Brut, Lausanne

FIG. 4. Aloïse Corbaz, *Napoleon by Moonlight (Napoléon au clair de lune),* 1962. Crayon on paper, 19 x 27 in. (48 x 69.5 cm)

profile, but even then, the white is barely visible on both sides of the giant blue iris, as in *The Star of the Paris Opera*. When two lovers kiss, their lips and noses appear to merge, forming a single face, and their now-joined eyes seem to stare directly at us with a penetrating intensity and haunting presence (see *Napoleon by Moonlight*, 1963; fig. 4).

If the masklike eyes deny the figures psychological depth, they also do little to animate the relationship between the figures. Aloïse's women almost invariably look out toward the viewer, oblivious to their attending lovers, who themselves are occasionally positioned so that their eyes stare toward the space of the viewers. The blankness of their gazes and the formality of their poses make the lovers appear static and further removed, as if they are on stage, stopping for a moment in their roles, perhaps deigning to acknowledge the viewer's presence across the fourth wall. However much the work's tone suggests eroticism, the lovers display a passion that seems less an action than an emblem.[1]

Throughout her works, Aloïse placed brief, scrawled texts, which serve as captions to the images, commenting on the scene or identifying the figures. The texts encourage us to read the compositions as if they are theater pieces. They invoke famous figures drawn from history, politics, opera, and theater: Cleopatra, Charles de Gaulle, Napoleon and Josephine, Pius XII, Mary Stuart, Wilhelm II, Woodrow Wilson. All find roles in Aloïse's fervent imagination, especially in the grand love relationships of her amorous universe. Intimate scenes between couples are thus magnified by the epic scope of history and cultural mythology: moments of grand opera where private lives are projected onto the public sphere of cultural celebrity.

The work *1st Act of Mary Stuart in Prison* (1941; fig. 5), from the book of drawings that Aloïse significantly entitled *Peinture et musique au théâtre*, is emblematic of Aloïse's self-projection into her theatrical universe. The queen—attended by a pope standing behind her and a supplicant lover with curiously

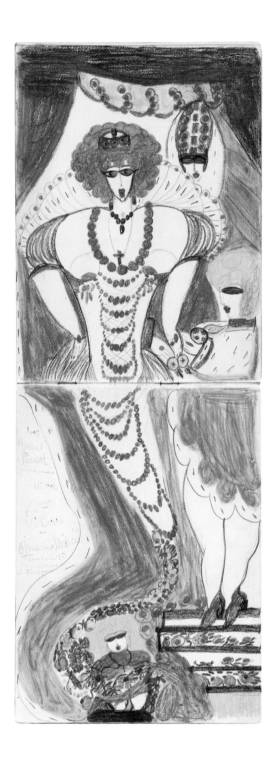

FIG. 5. Aloïse Corbaz, *1st Act of Mary Stuart in Prison (1er acte Marie Stuart prisonnière)*, 1941. Colored and black pencil on paper (pages 34 & 35 of the book of drawings *Peinture et musique au théâtre*), 26 x 9½ in. (66 x 24.5 cm). Private collection

feminine, diminutive feet rising on steps toward her—is a figure of eminence and tragic romance, breasts bared, long strings of chainlike necklaces sweeping down her torso. She is imprisoned and presented to us, yet she stands assertively, inviolate behind her masklike blue eyes.

As if the artist's romantic vision cannot be contained within a single image or narrative, Aloïse gave multiple, if incompatible, identities to the figures within individual works and inserted small supplemental figures and events into the composition, intensifying and extending the amorous theme. Scenes from theater and opera meld with historical and religious moments: sacred and profane love are conjoined; Holy Mother and Child, eroticized and enflowered, are visited by the magi. In her most impassioned works, text comments on image; image spurs new textual associations; and both image and text call up further images that are interpolated in the convoluted ground of the drawings.

Even with such overdetermined compositions, for Aloïse, single works could not contain her intimate passion and epic vision. As a result, she sewed pages together to create multiple panel works in which scenes succeed scenes to suggest extended personal and operatic narratives. *Le Cloisonné de théâtre* (1951; fig. 6), regarded as her masterpiece, stretches forty-four feet high. It has been interpreted as a five-act drama of love and separation, redemption and rejection.[2] The drama of love and loss, feminine power and vulnerability, that plays out in *Le Cloisonné de théâtre* is encapsulated in panel after panel of lovers separated and united (see fig. 7). The work is an immediate but distanced world, presented as theater larger and more dramatic than life, yet patently artificial. To that performative artifice, that ecstatic imaginary domain, we are invited and yet excluded. It is a visual realm both entranced and entrancing. We observe a drama of ravishment that is its creator's, but we are positioned as passive spectators, no matter how much we sense the creative passion stirring within it or ourselves.

FIGS. 6 AND 7. Aloïse Corbaz, *Le Cloisonné de théâtre*, 1951 (full view and detail). Colored and black pencil on paper, 552¾ x 39 in. (1404 x 99 cm). Collection Eternod Mermod, housed at Lille Métropole

Born in 1886 into a family of six children whose father was a postal official, Aloïse Corbaz lost her mother when she was eleven and came under the domineering care of her older sister. She received a solid middle-class education, which included drawing classes and private voice lessons that spurred in her a fervent desire to become an opera singer and acquainted her with the extensive opera repertoire.

After working for some years as an overseer of various pensions in Lausanne, in 1911 she shocked her family by having a passionate relationship with a defrocked priest. Sent away to Germany, she found employment in Potsdam as a governess in the home of the chaplain to Emperor Wilhelm II. Although enamored of the splendors of court life and of the emperor, for whom she developed an intense—and imaginary—attachment, she was forced to return to Switzerland by the start of the war in 1914. Shortly thereafter, she began exhibiting signs of a mental collapse, expressing strong pacifist, religious beliefs and inappropriate erotic behavior, which caused her to be committed by her family in 1918 to the psychiatric hospital in Cery. Deemed an incurable, but not dangerous, schizophrenic, she was transferred two years later to La Rosière for the remainder of her life. There, as was customary, she effectively lost her surname, referred to familiarly only as Aloïse, the name by which she would later achieve fame as an artist.

In the first throes of her mental collapse, Aloïse described herself in a state of dissolution—a "wreck of the universal conflagration" (the war)—and pictured herself as dead, having lost her animate body, descending into mud. She also compared herself to an extinguished Christmas tree. She suffered periods of complete withdrawal into herself, interrupted by moments of intense eroticism, jealousy, and violence. Nevertheless, Aloïse found a means of emerging from this desolation, re-creating a sense of self by projecting a cosmogonic vision in which she became a central element creating and illuminating the world. Jacqueline Porret-Forel, a doctor who

established a several-decades-long relationship with Aloïse, has described Aloïse's emergence from this deathlike state as a process of identification, first with vegetal matter growing out of the dark earth she believed she had become.[3] Feeling vivified by the light of the divine sun, Aloïse then considered herself a reflective agent by which that light ricocheted from her onto the world. Ultimately, she identified with everything that received the light from her; she projected herself onto her imagined world through the images she created, and she found incarnation of herself in everything she depicted.

Aloïse's self-stabilization and self-creation as an artist recall Adolf Wölfli's subconscious efforts to free himself from his illness, a process Walter Morgenthaler described as "disordered activity became disciplined . . . chaos turned into form."[4] Both artists found the means to define a self by constructing a private cosmology in which they were the central force. Both turned within themselves, away from their past—unrecoverable, but still ever-threatening—world. Living within the protective, if generally indifferent, environment of the asylum, they managed to define themselves, at first by writing their thoughts on paper and later by giving those thoughts visual form.

And as with Wölfli, after years of drawing and imaginative self-projection, Aloïse was recognized for and encouraged in her artistic pursuits by a new director of the asylum. In 1936 Dr. Hans Steck, director of the psychiatric hospital in Cery, which oversaw La Rosière, took notice of Aloïse, whom he had met as a young doctor when she was first committed to Cery eighteen years earlier. He began collecting her drawings, of which very few had previously been preserved. In 1941 Steck called Aloïse to the attention of Porret-Forel, and he eventually suggested that she write her doctoral dissertation on Aloïse. While Porret-Forel did not treat the patient, she befriended her, supplied her with paper and drawing materials, and assiduously collected, preserved, and ultimately promoted her work. In 1946 Porret-Forel introduced Aloïse to

Jean Dubuffet, who soon championed her and acquired many of her works for what would become the Collection de l'Art Brut.

The support and supplies Aloïse received propelled her into an enormously productive state. The years 1941 to 1946 were especially ecstatic and prolific; during this period, her works developed a full-blown sensuality, visual complexity, aesthetic dynamism, and repertoire replete with historical, operatic, and theatrical references. Later in the decade, the drawings, while less visually complex, became increasingly theatrical pieces, in that Aloïse physically merged many individual compositions to form monumental scrolls with implied narratives, culminating in *Le Cloisonné de théâtre*. Having achieved this artistic apogee, Aloïse continued to create a series of works elaborating on her universe of intense theatricality — beautiful, resonant, and always luxurious — ceasing only at her death.

The appeal of this visual universe of endless, unfolding, and interweaving theatricality — for both Aloïse and the viewer — is of an imaginative field of amorous and mutable affirmation, ceaselessly present, supremely revealed. It is quite simply the realm of art, the embraced illusion to which we, too, can turn from the world of daily life to experience our projected desires and fancies, if not our fears. For Aloïse, moreover, it is the sole dimension in which she reigns. It is a projected universe comprised entirely of herself, in which Aloïse is everyone and everything. Thus it is appropriate that her ideal realm is that of the theater, which is explicitly unreal yet mimics life.

Aloïse was fully aware that the reality she fled (what she called the *ancien monde*) remained ever present in the people around her and in the world just outside the asylum walls she never wanted to pass. She preferred the world of her delusions. For the schizophrenic, the aesthetic realm of the unreal holds a special allure, for it protects the self from the terrors of the external and uncontrollable world. The experi-

ence of Aloïse is analogous to that of Adolf Wölfli, about whom Louis Sass remarked: "delusional worlds, like aesthetic ones, may be chosen not in spite of but *because* of their imaginariness or unreality, since it is these qualities that afford escape from the perpetual uneasiness inherent in a world capable of resistance and surprise."[5] Aloïse accommodated herself to the realm of delusion, retreating from the entreaties of others, content to be the creator and impresario of her visual opera.

Yet however hermetic Aloïse's artifice, it is suffused with traces of the world she left behind. Her cherished subject — the sensually powerful, often tragic, woman — lies at the heart of the Western imaginary. Although formidable projections of an impassioned female creator, her works are embedded within particular culturally determined conceptions of womanhood, class, and education, through which a woman's self is found, or lost, but always contested. The images are expressions of a male-dominated cultural order in which women are objects of desire and romance, powerful in their sexuality but constrained in how their selfhood may be expressed (see *Students' Female Pope*, 1924–41; fig. 8*)*. The threat to such image-based art like Aloïse's is that the personal must be described through the stereotypical; selfhood known through cliché. The distinctiveness of her work arises from its uniquely distanced perspective on the culture, which both shaped her and rejected her. The power of the work resides in the richness of its interpretive resonance. Through her personal struggle and artistic vision, Aloïse animated the culture's representations, allowing them to be observed anew in all their beauty and horror. As a consequence, the art has provoked multiple, conflicting responses.

Aloïse's works have been read variously as resplendent assertions of feminine power and desire, as destructive fantasies of a broken and submissive woman, as slyly ironic commentaries on infantilized men, as luxurious paeans to romantic eroticism, and as displays of imperial command

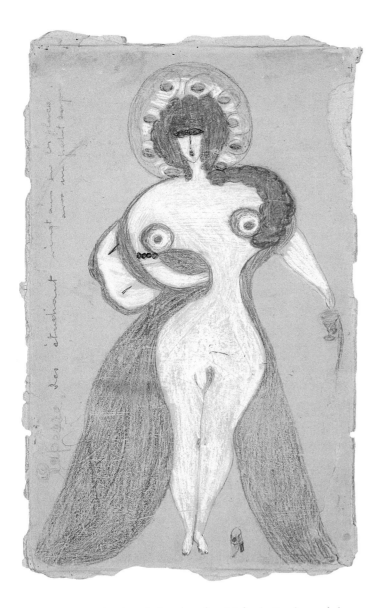

has observed how frequently Aloïse's women appear to disdain the men around them. They are superior in position and presentation to the men, who are often drawn as hermaphrodites or appear quite feminine.[7] In stark contrast, Germaine Greer described the "appalled viewer" who confronts "the repetitive image of the loved sex object, the mere depiction of which relieves some of the anguish of Aloïse's own emotional and sexual frustration. The inauthenticity of the recognizable images . . . is not the result of self-censorship or any calculated manipulation of the perennial public taste; it is rather Aloïse's helpless fealty to the insidious archetype which invaded her mind and laid it waste."[8] Roger Cardinal, on the other hand, responded to "the awakening feeling of erotic plenitude" conveyed by the works,[9] while Jean Dubuffet insisted that the theatrical realm of Aloïse's imaginary was purely conceptual, the lush images serving as mere rhetorical devices that allowed her to establish a mental realm under her own control (see *Cleopatra's Bed of Flowers*, 1941–51; fig. 9).[10]

Dubuffet's interpretation emphasized Aloïse's freedom from cultural conventions. Even though she mobilized the imagery of popular and high culture, Dubuffet argued, her attitude was essentially acultural. Within her mental illness she found a space of independent selfhood and creativity. Dubuffet believed she was exemplary of other radically alienated and culturally isolated artists whose unconventional creations were, in his opinion, superior to all mainstream art. In fact, we know of Aloïse's work largely through the writings and efforts of Dubuffet. Although Aloïse initially displayed complete indifference to Dubuffet's presence (as she had to Porret-Forel), he believed her work was an ideal example art brut.

Acting fully within the tradition of avant-garde artists who have sought the primordial roots of art, Dubuffet proclaimed Aloïse and other art brut artists to be the sole authentic artists, those who work directly from the sources of the creative

over a conceptual and visual realm. Melanie Farrimond, for instance, perceived Aloïse's work as suggestive of a feminist utopian imaginary extending beyond social reality into a dimension where women transcend the submissive role men have assigned them.[6] Jacqueline Porret-Forel found feminine power and sexual restraint, even prudery, in the works and

FIG. 8. Aloïse Corbaz, *Students' Female Pope (Papesse des étudiants)*, 1924–41. Colored and black pencil on cardboard, 15½ x 9½ in. (39 x 24.5 cm). Collection Steck, Switzerland

impulse. Scorning the mainstream art world of which he nevertheless remained a member, Dubuffet contrasted art brut with the tamed and clichéd "cultural" art whose primary role was merely to affirm the bourgeois values of a culture he disdained.

As he formulated the concept of art brut, Dubuffet turned largely, but not exclusively, to the work of untrained individuals institutionalized with mental problems. Visiting the psychiatric hospitals of Switzerland, he discovered the work of several art brut artists, including that of Wölfli, and he met Walter Morgenthaler, whose *A Mental Patient as Artist* was translated into French and published by Dubuffet's fascicule series, *Art Brut*, in 1964. Yet unlike Morgenthaler and Hans Prinzhorn, Dubuffet was less interested in the patients' creativity as a manifestation of an expressive urge or an attempt to communicate with the external world, than in its fundamental affirmation of the artist's existential being. For Dubuffet, true creativity was a profound psychological experience that led potentially to self-discovery and, even more significantly, to self-creation. In typical avant-garde fashion, he passionately railed against academic conventions while affirming widely shared romantic notions of the sensitive and alienated artist. Dubuffet found his model of primitivist imaginative freedom in the supposed radical alienation of the most culturally marginal, untaught, asocial, and isolated creators.

Dubuffet, a powerful polemicist, cast this vision in starkly dramatic terms, invoking the attraction and fear we sense in the intense personal struggle and discovery within art that transgresses the given order:

> In my view, art consists essentially in the externalization of the most intimate internal events occurring within the depths of the artist. And since we all experience such internal passions, it is astonishing to encounter them projected before us. In effect, cohering before our eyes are those psychological states we feel within ourselves

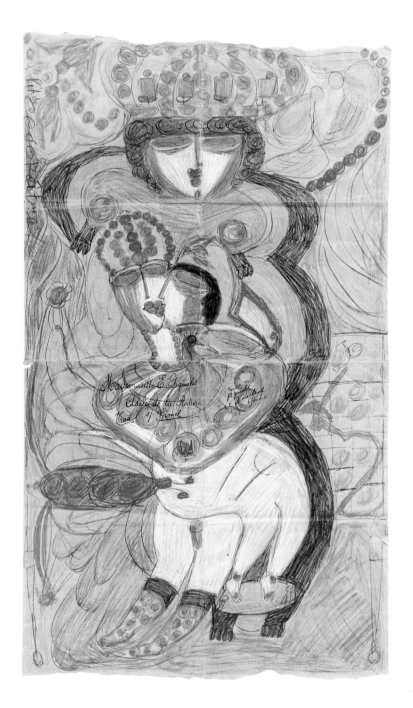

FIG. 9. Aloïse Corbaz, *Cleopatra's Bed of Flowers* (*Lit de Cléopâtre fleurs*), 1941–51. Colored and black pencil on paper, 39½ x 23½ in. (100 x 59.5 cm). Collection Steck, Switzerland

existing in the artist exactly as in ourselves—subterranean, obscure, profoundly buried under successive layers of crust. And this sudden confrontation with our most intimate selves appears like a thrilling revelation which illuminates our true being and the world around us, so that we are able to see the world through different eyes than those we have known.[11]

This is a powerful, seductive image, still compelling despite— or because of—its long and familiar history. The tropes of the alienated artist, the suffering, sensitive, visionary artist, the impassioned, even mad, artist are well established. In Dubuffet's writings they may be presented in extremis, but even he recognized that "everyone" shared these beliefs on some level. His effort, then, was to awaken their spirit:

> Art creation is something that one expects, that everyone expects, to be strongly marked by the influx of an unusual personal secretion. Such a characteristic obviously implies in the maker a mental standpoint different from that of other people; it presupposes the questioning of norms and usages, that spirit of non-alignment, that withdrawal into oneself which . . . are on the way to *alienation*.[12]

Just as Prinzhorn's and Morgenthaler's responses to the artistry of the mentally ill reflected in part a post–World War I cultural recoil, Dubuffet's interest in isolate, anticultural artists developed in the months immediately following the end of World War II. In the prewar era, he had shared a belief common in both Europe and the United States that authentic creation would best emerge from the "common man." Dubuffet soon rejected this hope, having recognized that the cultural values of the proletariat and peasants were deeply shaped by the dominant society. In the aftermath of the war, like other leading intellectuals throughout Europe, Dubuffet found the source of individual freedom and creative responsibility in an

acknowledgment of humanity's existential condition. Indeed, at the heart of his belief in the essential alienation of the true artist is an existential humanism that demands that artist and viewer alike confront their primary existence and the necessity of creating the world of meaning themselves.

To Dubuffet, the art brut artists created such realms of intensely private and authentic meaning without regard for the conventions of the world around them. Asserting that the "work of art is of no interest, to me, unless it is an absolutely immediate and direct projection of what is occurring in the depths of an individual,"[13] Dubuffet avidly collected works that have become for many the model of outsider art. Devoting over thirty years to the identification, acquisition, promotion, and presentation of art brut, Dubuffet brought together the most extensive and masterful collection of works by artists well outside the mainstream tradition, including examples by almost all the artists in this book. Since his death, the successive directors of the Collection de l'Art Brut—formerly Michel Thévoz and now Lucienne Peiry—have continued to develop the collection, expanding it beyond its primarily European focus to exhibit and collect North American self-taught and outsider artists, as well as works by artists from South America, Asia, and Africa.

The core of the Collection de l'Art Brut nonetheless lies in the works Dubuffet amassed by early- and mid-twentieth-century European artists such as Madge Gill, Vojislav Jakic, Augustin Lesage, Raphaël Lonné, Edmund Monsiel, Heinrich Anton Müller, Adolf Wölfli, Carlo Zinelli, and the anonymous "French Voyager." The collection is wide-ranging. Although a significant number of the artists were patients in psychiatric hospitals, Dubuffet insisted that there was no such thing as an art of the mentally ill, just as there was not an art of dyspeptics or people with bad knees, as he once stated.[14] Rather, the work was the result of intense subjectivity, the ventures of untrained and unacculturated artists unto themselves to create profoundly original, distinctive works. Biographical

information might identify something about the nature of their socially marginal, hence artistically sui generis, situation, but does not in itself explain or account for the work.

Heinrich Anton Müller (1865–1930), originally a wine grower in the Swiss canton of Vaud, developed mental problems that led him, at age forty-one, to be institutionalized in a psychiatric hospital near Bern. Having suffered from what his doctors identified as delusions of grandeur and persecution, he settled into a private realm of creativity. Presumably fascinated with the concept of perpetual motion, he sketched a series of inventions and constructed on the hospital grounds a number of large and intricate "machines" with movable parts. He also drew images of figures and animals on sheets of wrapping paper that he stitched together to form large surfaces. Some of these figurative works feature large, strangely distorted, sometimes-double heads that display a strong, flowing, even lyrical quality of line. Other, later works, such as *Untitled (The Man with the Flies and the Snake)* (1925–27; fig. 10), are drawn with a jagged, frenetic line that bespeaks of a psychological tension and symbolic narrative.

FIG. 10. Heinrich Anton Müller, *Untitled (The Man with the Flies and the Snake [L'homme aux mouches et le serpent])*, 1925–27. Colored pencil on paper, 26⅝ x 16¾ in. (57.5 x 42.5 cm). Collection de l'Art Brut, Lausanne

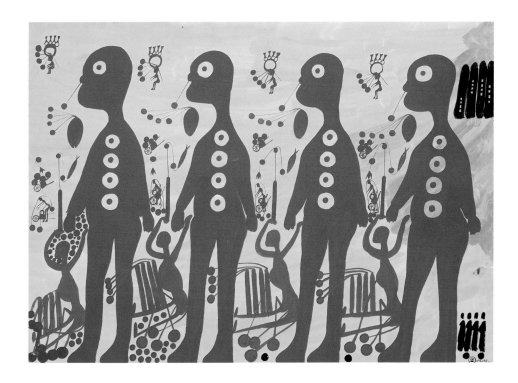

The experience of World War II had a traumatic effect on Carlo Zinelli (1916–1974), who suffered a breakdown while in the Italian army and was institutionalized in 1947 by his family. After his doctors noticed he had begun using a broken brick to scratch graffiti forms onto the hospital walls, he was given a studio in which to paint. For some fourteen years, he painted silhouette images—mostly men, though also women, birds, and boats—that are evenly distributed in sometimes-packed compositions (see fig. 11). The pictograph-like figures and abstract motifs frequently appear in groups of four, emphasizing the compulsively ordered nature of Carlo's vision, while the static nature of the rounded bodies and the anonymity of the figures' single-eyed profiled faces connote a regimented and oppressive world.

Vojislav Jakic (born 1932) was born the son of an Ortho-dox priest in Montenegro, but has lived most of his life in Serbia. An artist since 1954, he has created both scrap-wood sculptures incorporating skulls and bones, and large-scale ballpoint pen drawings depicting disturbing, overlapping and interpenetrating images of heads, insects, and animals (see fig. 12). Ill-defined organic forms, monstrous fetuslike beings, and swarming insects compete in tightly packed composi-tions that leave little room to determine stable ground or depth. The works are sometimes immense, up to forty-five feet wide, yet they are filled with precisely drawn minute images suggesting a horrific, symbolic commentary on per-sonal and contemporary life. One of the works bears the inscription: "This is neither a drawing nor a painting but the sedimentary deposit of suffering." Such "deposits" exemplify the creative delirium that Dubuffet relished in art brut.

FIG. 11. Carlo Zinelli, *Untitled (Four Figures on a Yellow Background)*, 1961. Gouache on paper, 19¾ x 27½ in. (50 x 70 cm). Collection de l'Art Brut, Lausanne

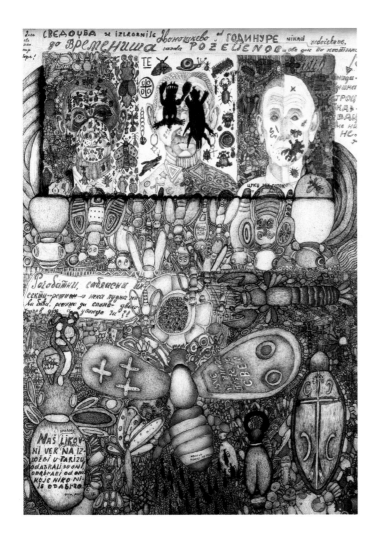

Notes

1. Jean Dubuffet, "Haut art d'Aloïse," in *Prospectus et tous écrits suivants*, vol. 1 (Paris: Gallimard, 1967), pp. 307–08.

2. Jacqueline Porret-Forel, "*Le Cloisonné de théâtre*: Aloïse Corbaz," *Raw Vision* 57 (Winter 2006), pp. 46–53.

3. Jacqueline Porret-Forel, *La voleuse de mappemonde: Les écrits d'Aloïse* (Geneva: Éditions Zoé, 2004).

4. Walter Morgenthaler, *Madness and Art: The Life and Works of Adolf Wölfli*, trans. Aaron H. Esman (Lincoln: University of Nebraska Press, 1992), p. 90.

5. Louis A. Sass, "Adolf Wölfli, Spatiality, and the Sublime," in *Adolf Wölfli: Draftsman, Writer, Poet, Composer*, ed. Elka Spoerri (Ithaca: Cornell University Press, 1997), p. 140.

6. Melanie Farrimond, "Alternative Worlds: Utopia and Madness in the Work of Cixous, Aloïse, and Vivien," in *The Impossible Space: Explorations of Utopia in French Writing*, Strathclyde Modern Language Studies, n.s., 6, ed. Angela Kershaw, Pamela M. Moores, and Hélène Stafford (Glasgow: University of Strathclyde, 2004), pp. 45–47 passim.

7. Jacqueline Porret-Forel, "Aloïse et son théâtre," in *Aloïse*, Publications de la Compagnie de L'Art Brut, Fascicule 7 (Paris: Compagnie de L'Art Brut, 1966); 2nd ed. (Lausanne, 1989), pp. 72–73.

8. Germaine Greer, *The Obstacle Race: The Fortunes of Women Painters and Their Work* (New York: Farrar, Straus and Giroux, 1979), p. 117.

9. Roger Cardinal, *Outsider Art* (New York: Praeger, 1972), p 164.

10. Dubuffet (note 1), pp. 307–08.

11. Jean Dubuffet, "Honneur aux valeurs sauvages," in *Prospectus* (note 1), p. 206. Partial translation by John M. MacGregor, *The Discovery of the Art of the Insane* (Princeton: Princeton University Press, 1989), p. 298; partial translation mine..

12. Jean Dubuffet, *L'art brut*, fascicule 5 (1966), quoted in Michel Thévoz, *Art Brut* (Geneva: Skira, 1995), p. 175.

13. Dubuffet (note 11), p. 298.

14. Jean Dubuffet, "L'art brut préféré aux arts culturels," in *Prospectus* (note 1), p. 202.

FIG. 12. Vojislav Jakic, *The Frightening Horned Insects*, c. 1970.
Ballpoint pen and colored pencil on paper, 55¾ x 40 in. (141.5 x 101.5 cm).
Collection de l'Art Brut, Lausanne

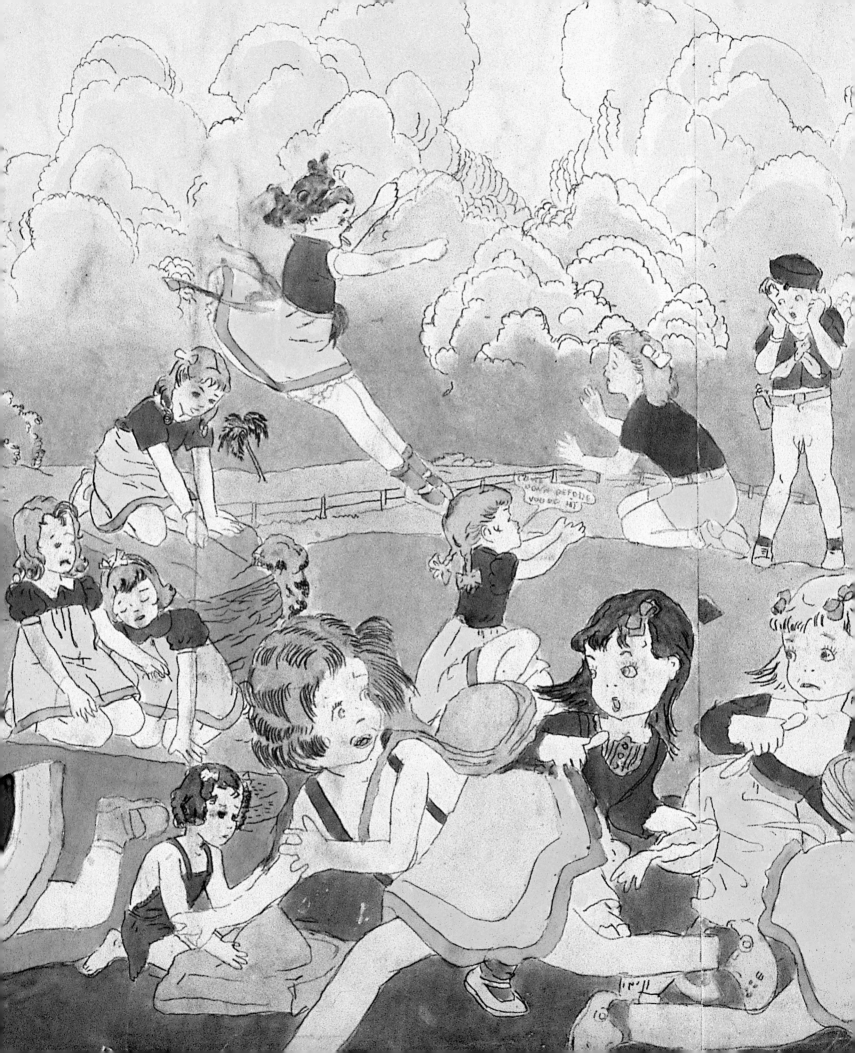

Henry Darger

The art and writing of Henry Darger (1892–1973) present a vision of rampant sentimentality and vividly pictured horror, awestruck religiosity and prurient brutality, sanctimonious moral condemnation and perverse delight. Entering his world, we are swept immediately into the turbulent imagination of a solitary artist whose most private fantasies give voice and vision to the subconscious drama of our popular culture.

This world is intensely visualized in Darger's expansive watercolors, which stretch as much as ten feet wide and present panoramic landscapes—some dense with extraordinarily lush vegetation, others opening onto a broad veldt or dark forest—almost all animated by billowing clouds of impending storms. Often the landscapes are populated by scores of comic-strip children running and leaping in all directions (see fig. 1), while at other times, groups of young girls stand placidly in peaceful environments filled with huge, extravagantly colored flowers.

There is something mysterious about the scenes, even though the images may appear at first innocent and playful.

They seem to depict particular moments in time, the characters caught in some momentous event or briefly pausing within a larger narrative flow. Occasionally, we find within the complex compositions penciled speech balloons stating what some figures are saying, or a scrawled caption situating the scene. But the caption may only increase the sense of mystery. In figure 1, for instance, we discover that these apparently happily cavorting girls are actually in the middle of a violent action of dark import: *Part two. Break out of concentration camp killing and wounding enemy guards.* The caption compels us to look more closely at the children and realize that many of their expressions are of concern or fear, even though some of them seem contentedly playing with their dolls or relaxing as if they are participants in an entirely different story.

In other works, Darger is even more explicit, providing not only descriptive captions, but also laying out his compositions in discrete sequential panels that suggest an immensely enlarged adventure comic strip. The triptych in figure 2, for example, announces: Left: *At Sunbeam Creek. Are with little*

FIG. 1. Henry Darger, *Part two. Break out of concentration camp killing and wounding enemy guards*, n.d. Watercolor, pencil, and carbon tracing on pieced paper, 24 x 120 in. (61 x 304.8 cm). Private collection

OPPOSITE: Detail

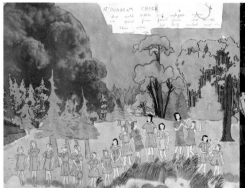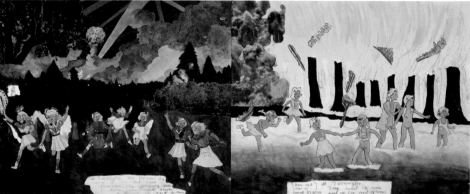

girl refugees again in peril from forest fires. But escape this also, but half naked and in burned rags; Middle: *At Torrington. Are persued* [sic] *by a storm of fire but save themselves by jumping into a stream and swim across as seen in next picture*; Right: *At Torrington. They reach the river just in the nick of time. Their red color is caused by the glare of the flames.* The dramatic storyline begins with a moment of respite for a group of young girls (seven of whom are blond) who are unaware of the plumes of smoke (created by a collaged photograph) entering the scene behind them. The pale greens and blues of this image are contrasted dramatically by the deep black ground of the center panel, accented by the vibrant oranges of the advancing inferno and the bright red and yellow clothes of the seven blond girls fleeing toward us. Panel three depicts the seven girls amid the conflagration, sharply reversing the color sense so that the yellow flaming background—broken by black stumps of burned trees and another collage of smoke—sets off the now "half naked and in burned rags" reddened little girls, who find refuge in the mauve-colored river.

Exploring Darger's visual art further, we learn that all the images are inspired by his unpublished 15,145-page epic, *The Story of the Vivian Girls, in What is Known as the Realms of the Unreal, of the Glandeco-Angelinean War Storm, Caused by the Child Slave Rebellion*. Both text and images depict a war raging on an imaginary planet "a thousand times as large as our own world" of which the earth serves as its moon.

Four great Catholic countries, led by the largest, Abbieannia, are battling the nation of Glandelinia, formerly subservient to Abbieannia but now fallen away and worshiping Satan. The Glandelinians, "as wicked as wickedness can be," practice child slavery, rip children from their parents, work them to death in brutal factories, throw them in slave prisons, and torture, strangle, and disembowel them en masse. The Christian nations fight for four and a half years before subduing Glandelinia and ending the abuse of children.

In the Realms of the Unreal, as the work has come to be known, graphically and extensively describes the many battles during which millions of people are killed, maimed, and terrorized, as well as the cataclysmic storms and floods seemingly unleashed by the war between good and evil. The Catholic forces are aided by dragonlike creatures, Blengiglomenean Serpents, "protectors of children and mortal foes of any who would harm them" (see *Crimmecian Gazoonian Venemous Calvernia* . . . ; fig. 3). Most notable, however, are seven Abbieannian princesses, the Vivian Girls, noble daredevils who face constant danger helping the Christian forces, fight battles, spy behind enemy lines, and liberate enslaved children. "Pure as pure can be," these seven sisters endure harrowing trials. Always vulnerable, constantly exposed, and often naked, they are frequently captured by the Glandelinians and threatened with torture, strangling, hanging, and other hideous forms of death, yet they always manage to escape to provide moral and courageous leadership to other children

FIG. 2. Henry Darger, Left: *At Sunbeam Creek. Are with little girl refugees again in peril from forest fires.* Middle: *At Torrington. Are persued by a storm of fire but save themselves by jumping into a stream and swim across as seen in next picture.* Right: *At Torrington. They reach the river just in the nick of time,* n.d. Watercolor, pencil, and carbon tracing on pieced paper, 19 x 70½ in. (48.3 x 179.1 cm). American Folk Art Museum, New York; Anonymous gift in recognition of Sam Farber

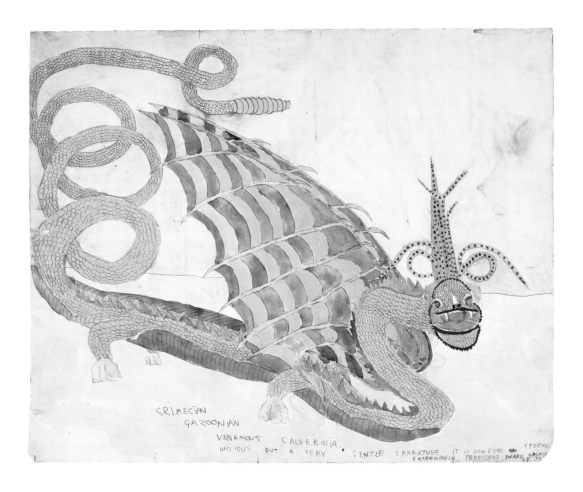

FIG. 3. Henry Darger, *Crimmecian Gazoonian Venemous Calverria*, n.d. Watercolor and pencil on paper, 19 x 24 in. (48.3 x 61 cm)

and adult soldiers. That they and other young girls appear naked so frequently in Darger's compositions—and that they are usually shown to have penises—introduces an aberrant element in this fantasy struggle supposedly for the protection of childhood innocence.

After having spent some twenty years writing his epic, Darger then painted more than three hundred large watercolors illustrating it. He had previously painted portraits of particular characters and mythological creatures, drawn detailed maps of military campaigns, created some collages of battle scenes, and designed flags for the warring nations (see *National Flag of Angelina*; fig. 4). At first, the illustrations refer to specific incidents in the text, but they soon become freestanding elaborations on the themes of his imaginary

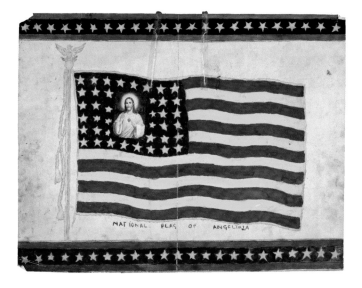

FIG. 4. Henry Darger, *National Flag of Angelina*, n.d. Watercolor, pencil, collage, and carbon tracing on pieced paper, 18½ x 24 in. (47 x 61 cm). Private collection

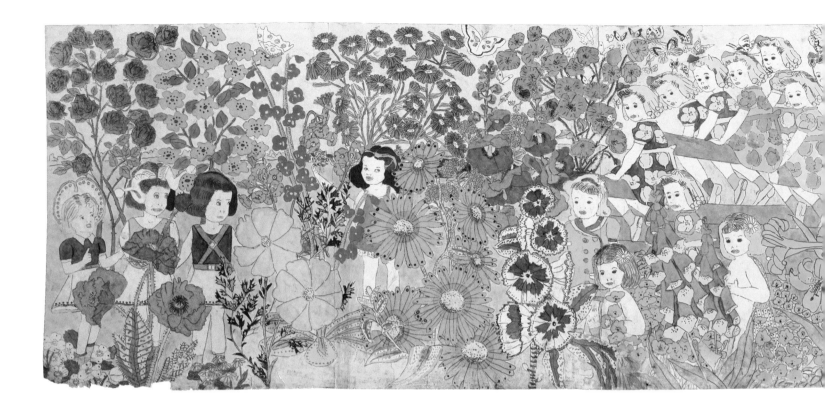

world. For most viewers, the watercolors represent Darger's visionary realm. Few people have read more than selected excerpts from the unpublished novel. Almost no one (including this writer) has read it in its entirety.[1] Yet the artworks succeed as autonomous scenes because of Darger's strengths in composition, color, and inventive figuration and because his narrative impulse is so intense that an epic vision is communicated within the often densely animated image.

Many of the most beautiful scenes are of peaceful moments when young children nestle within lush landscapes untouched by war, although few such occasions exist in the novel (see *Untitled [overall flowers]*; fig. 5). More consonant with the breathless, hyperbolic, action-driven narrative, however, are the fervid images of battles, raging storms, abductions of children, and horrors of child torture and slaughter. These violent scenes play out in tempestuous landscapes seemingly stirred up by the human-generated chaos. In *18 At*

Norma Catherine. But wild thunder-storm with cyclone like wind saves them (fig. 6), for instance, the seven Vivian Girls and the enemy soldiers that have captured them are buffeted by the tumult of a suddenly risen storm; only the caption indicates the happy ending in store.

If Darger's immense novel reveals an unrestrained spirit of excess, his potentially endless story having been written over decades, we note in the watercolors a similar tendency toward an ever-expanding visual field and profusion of detail. Dissatisfied with the meager space of a single sheet of paper, Darger joined several pages together to create large horizontal panels for his landscapes and interior scenes. Many works are nineteen inches high by seventy inches wide; some extend to two feet high by ten feet wide. Even though Darger was entirely self-taught, he developed mimetic and compositional strategies that give the works dynamic coherence even as they overflow with images. In fact, he proved a greater

FIG. 5. Henry Darger, *Untitled (overall flowers)*, n.d. Watercolor, pencil, and carbon tracing on pieced paper, 24 x 108 in. (61 x 274.3 cm). Collection Kiyoko Lerner

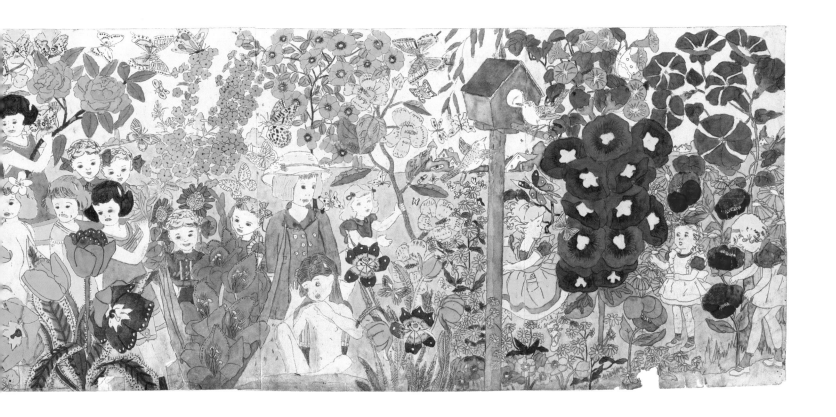

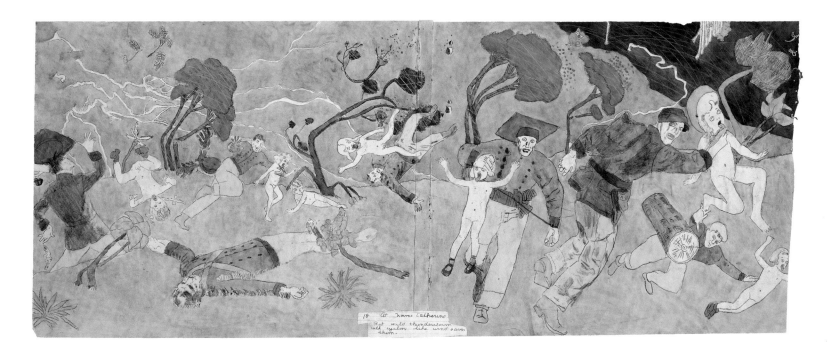

FIG. 6. Henry Darger, *18 At Norma Catherine. But wild thunder-storm with cyclone like wind saves them*, n.d. Watercolor, pencil, and carbon tracing on pieced paper, 19 x 47¼ in. (48.3 x 120 cm). American Folk Art Museum, New York; Museum purchase

self-taught visual artist than an outsider writer, due in large part to the nature of his media. The written epic presents action extended through time, and for Darger the pleasures of returning night after night to the writing of *In the Realms of the Unreal* were more important than constructing a coherent narrative or completing the story.[2] The watercolors, on the other hand, essentially demanded the effective ordering of space. Even if Darger felt the compulsion to paste multiple panels together to encompass more detail, at some point he reached the paper's edges and his exuberant imagination had to stop, select, and order what could be pictured. (It has been suggested, however, that perhaps the narrow confines of his 13½-by-16½-foot room must also have been a contributing factor.)[3]

Convinced he could not draw adequately, Darger developed inventive methods to illustrate *In the Realms of the Unreal*. Early in his writing of the text, he began cutting out news photos of figures and battle scenes over which he would draw or paint and then collage into portraits of leading characters or events in the narrative.[4] There is no evidence he was aware of the contemporaneous development of collage by European vanguard artists. Rather, Darger independently established a masterful sense of composition, guided in large part by a keen awareness of the necessity of maintaining perspectival space and defining relationships of scale among figures in his receding landscapes. Having been especially sensitive to weather conditions and cloudscapes throughout his life, Darger paid particular attention to the depiction of the sky as a background element, frequently employing it to introduce threats of imminent narrative change, hence creating a forward-moving visual dynamic in many of the works. The paintings also benefit from Darger's well-honed color sense, which supports both the lateral unity of the composition and contributes to the work's depth. From his diaries, we learn that Darger often devoted several months to the drawing and composition of his large works, and then spent

several more coloring them, much as if he were filling in an enormous coloring book.

As Darger developed his artistry and increasingly made young girls the primary subject of his works, he relied less on photographic collages and more on tracing images of figures and landscape details found in magazine illustrations, comic strips, and coloring books, which he then inserted into his compositions. He amassed thousands of depictions of young girls from popular media, repeatedly using favorite images, modifying their smallest details to fit each picture's theme. Striving for proportional scale, Darger devised the technique of having particular images photographed and then printed in several sizes from which he could select and trace those appropriately scaled for discrete compositions.

Viewing many of his works, we come to learn Darger's favorites figures and observe the dramatically different scenarios into which he placed them. Considering how he consistently adopted popular, saccharine images of little girls to illustrate an epic of slavery, warfare, and child abuse on an imaginary planet, we are unsettled by the mix of innocence and horror and the religious zealotry and violent fantasies that define *In the Realms of the Unreal* and, we imagine, that characterize Darger's private life.

Darger was born in Chicago in 1892 and lost his mother, who died giving birth to a girl, when he was four. His sister, whom he never saw, was given up for adoption immediately, and he was raised for several years by his widowed father before being placed in an orphanage at age eight when his father proved too infirm and poor to care for him. A few years later, because of his odd behavior, Darger, who had earned the nickname "Crazy," was committed to the Asylum for Feeble-Minded Children in Lincoln, Illinois, a place marked by scandals of neglect and physical abuse of the children. Beginning at age fifteen, when he learned of his father's death, Darger made several efforts to escape, finally succeeding two years

later by fleeing to Chicago. After his traumatic upbringing, Darger settled into an uneventful life, working such menial jobs as dishwasher, bandage roller, and janitor at several Catholic hospitals and attending mass up to five times per day.

We get a brief glimpse of the quality of this life in the beginning section of a text Darger called *The History of My Life*. Here, he chronicled an uneventful, emotionally sterile existence. Once he moved beyond recounting his broken childhood, the text is mostly a dry account of workplace tedium, conflicts with fellow workers and superiors—most of whom are women—and mundane observations about the weather. Apparently he had but one close friend, with whom he formed *Gemini*, a two-member club for the protection of young children. But Darger offered no insights into the club or the friendship except to mention his loneliness when the friend moved away and died shortly thereafter. The only other hint of emotion comes when Darger admitted he was quickly stirred to anger, resentment, and desire for revenge, usually over petty grievances. Significantly, he referred to himself as an artist only once and never commented on the tremendous time and energy he committed to his creativity.

Darger had a long if dreary life, was regularly employed, and attended church habitually. Probably having had little opportunity for normal maturation in the asylum and living a marginal life as a social underling, Darger found little in his daily life that offered much to connect with emotionally. We believe he began *In the Realms of the Unreal* at nineteen years old, shortly after escaping from the Asylum for Feeble-Minded Children. He wrote the entire work first by hand and then produced a typed version of it. Although he probably began to illustrate *In the Realms of the Unreal* early during the writing process, the large watercolor collages most likely date to the 1930s, when he had completed the text, and were continued into the 1960s. After Darger finished writing *In the Realms of the Unreal,* he also threw himself into other texts,

sustaining his imaginative life for four decades almost until the moment of his death.

Darger lived alone all his adult life—from 1931 until his death in 1973 in a one-and-a-half-room apartment where the writings and paintings that were his life's true work were discovered by his landlord after Darger entered a nursing home. The room contained the massive manuscript *In the Realms of the Unreal* and its over three hundred illustrations, along with an eight-thousand-page sequel, *Further Adventures in Chicago: Crazy House*; a six-volume, decades-long daily journal detailing the weather, *Book of Weather Reports*; and his more than five-thousand-page autobiography, *The History of My Life*, which primarily featured an extended imaginary tale of a cataclysmic tornado named "Sweetie Pie" he claimed to have witnessed in his youth.

The prodigious amount of writing and the visual power of the watercolors testify to Darger's intensely impassioned hidden life in which he was caught up in the elaboration of an imaginary realm dramatically different from his social existence. We have gained entry to this realm only by the landlord's chance discovery and preservation of Darger's abandoned work. While it is rare to have such voluminous access to the creations of any artist, outsider or mainstream, Darger's words and images are so unrestrained and unguarded that our experience of them feels somewhat transgressive. Even though as an "author" Darger adopted the conventions of popular and sentimental writing, addressing the "dear reader" of his text, his audience was clearly himself—or perhaps his God by whom he wanted to be overheard. We feel like voyeurs. As Michel Thévoz asserted, "we have rummaged around in the bedroom of a dead man. . . . We are not responding to an artist's overture to us; we are committing an indiscretion."[5] Nevertheless, we return again and again, drawn by the openness of what is usually hidden, the sense of closeness of what seems to be so distant, and the familiarity of what should be so alien. The works are fascinating in

their singularity, compelling in their passion and artistic achievement, and troubling in their vivid content and what it suggests about the artist and the culture to which he responded and in which we live.

In many respects, Darger is an exemplary outsider artist, an extremely reclusive individual whose tenuous psychological stability placed him at the margins of acceptable social behavior. His horrific imagery has led some to suggest that he "crossed over" at some point into the realms of the pathological. Art historian and psychiatrically trained scholar John MacGregor has described his works as "the ongoing fantasies of a serial killer,"[6] though he argued that Darger managed to constrain his most violent urges by establishing the art and text as an "alternate world" that enabled him to indulge his inadequately repressed desires, fears, and anger.

In the Realms of the Unreal clearly provided Darger a dimension of self-exaltation, allowing, in a manner not unlike the works of Adolf Wölfli, an unceasing expansive projection of his emotional turmoil into text and image. Darger created a cataclysmic realm of rage, desire, and adventure characterized by emotional hyperbole and artistic excess—sustained throughout the length of the narrative and size of the images, the density of the graphic and narrative events, the numbers of characters and dimensions of the warring nations, the ferocity of the epic battles and natural disasters—and above all by the artist's shrill moral and perverse voice and vision.

Darger declared the text "perhaps the greatest ever written by an author, on the line of any fabulous war that can ever be entitled with such a name."[7] Although admitting that the events take place "among the nations of an unknown or imaginary world," Darger announced: "Readers will find here many stirring scenes that are not recorded in any true history, great disasters that are awful in magnitude: enormous battles, big fires, awful tragedies, adventures of heroes and heroines, many of them fatal, great wars and disasters, and the readers will be taken through accounts which they will never, never, never forget."[8]

Through such breathless prose, we recognize that the author and artist was totally entranced by *In the Realms of the Unreal*. Yet while Darger appeared to glory in imaginative powers, we detect his desperate struggle to control his psychological stability within his imaginary realm. Apparently caught within the swirl of conflicting impulses, he presented himself variously as creator, as reader and viewer, and as numerous participants named Darger within the tale, all of whom seem subject to shifting allegiances to the opposing sides of the war of child slavery.

Although we are assured by Darger that the Glandeco-Angelinean War ends in victory for the Christian forces, the narrator often rages against the God who allows such suffering to occur or who is unresponsive to his contributions to the war effort, to the point that Darger often threatens in the text to allow the Glandelinians to triumph. Indeed, it seems that every victory or defeat by either side and even the effects of raging storms have the potential to swing the conflict in favor of good or evil, regardless of the author's stated intent. Similarly, in the watercolors, Darger revealed an extraordinary ability to invest equal emotional force in his pacific scenes of young girls amid luxurious flora (see fig. 5) and in the horrific landscapes of carnage (see fig. 8).

Despite the absolute dualism of good and evil in the work, *In the Realms of the Unreal* communicates a profound ambivalence. Darger presented himself as both a protector and a destroyer of innocence; a servant of God and an agent of Satan; a vulnerable child and a murderous adult; a victim of horrific torture and a slayer of demons; a little girl and a little boy. Every element of Darger's Manichean world claims equal validity, all being the projected psychological and moral struggle for which Darger had no convincing resolution. "Which side are you on, Henry?" we find ourselves asking, only to imagine the anguished response, "both, alternately! simultaneously!"

Such ambivalence is most evident in Darger's representation of the young girl as both an ideal moral being and as vulnerable victim. Darger clearly embraced the cult of purity and innocent beauty of girls and adopted their images from the most popular and saccharine media—comic strips, coloring books, children's and family magazines. He idolized girls and their traditional social roles and may well have identified with them as a fellow victim and beleaguered innocent. He also asserted that little girls, so often the utter victim, could be as heroic as, perhaps more than, little boys. He enjoyed placing girls in the middle of battle, brandishing guns and saving other endangered children (see *6 Episode 3 Place not mentioned. Escape during violent storm, still fighting though persued for long distance*; fig. 7). Whether or not he consciously imagined himself as a girl, Darger was clearly intrigued by gender-switching characters, evident, for example, in the late narrative revelation that the hero "Rattlesnake Boy" Radcliffe was actually a girl in disguise, even though she had originally been introduced as the most violent and revenge-prone boy who, incidentally, had to be socialized by the Christian model boy, Penrod, a "long-lost brother" of the Vivian Girls.

Darger was also compelled to depict girls naked, with penises. It is possible that he was not aware of the anatomical differences between boys and girls, and had not fully learned of sexual relations. Presumably however, he had some awareness of sexual stirring, so his focus on the sexual organs of the girls cannot be entirely benign, especially since he so frequently rendered them naked, even burning off their clothes and reddening their bodies (see fig. 2). Much more extreme, of course, are the graphic depictions of young girls being strangled, disemboweled, crucified, hanged, flayed, and dismembered. The images, which are tame when compared to Darger's many lurid descriptions of torture in his texts, clearly express a fully imagined sadistic bloodlust visited upon these pure and vulnerable figures. (see Left: *They are almost murdered themselves though they fight for their lives. Typhoon saves them*; Middle: *At Norma Catherine via Jennie Richee. Vivian girls witness childrens bowels and other entrails torn out by infuriated Glandelinians. The result after the massacre. Only a few of the murdered children are shown here*; Right: *Vivian girl princesses are forced to witness frightful massacre of children—Vivian girls not shown in this composition. At Jennie Richee-via Norma Catherine. The*

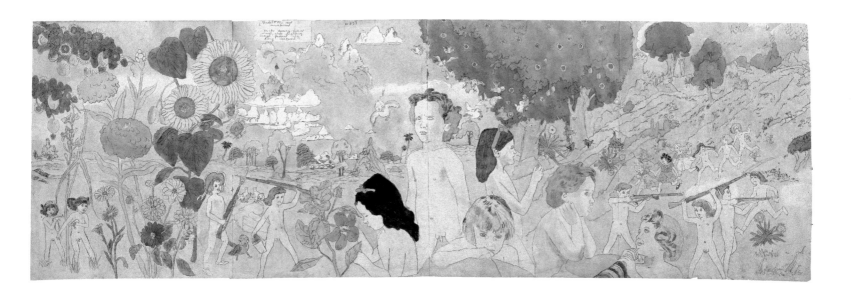

FIG. 7. Henry Darger, *6 Episode 3 Place not mentioned. Escape during violent storm, still fighting though persued for long distance*, n.d. Watercolor, pencil, and carbon tracing on pieced paper, 24 x 74¾ in. (61 x 190 cm). American Folk Art Museum, New York; Gift of Nathan and Kiyoko Lerner

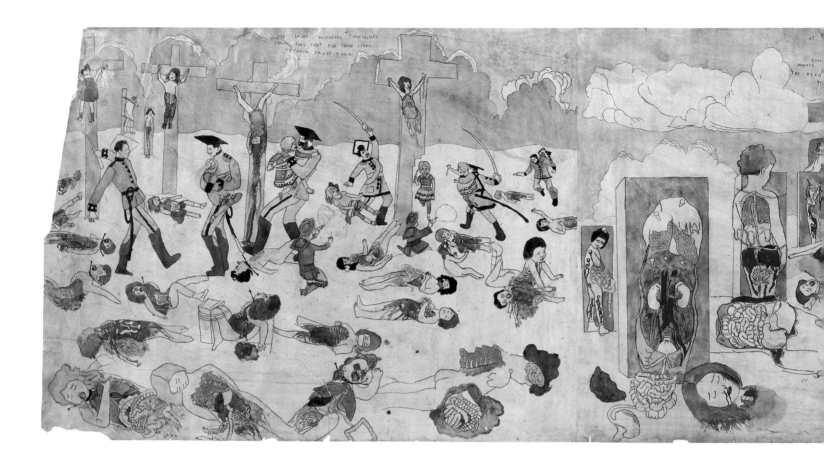

children who are naked are made to suffer from the worst torture under fierce tropical heat imaginable; fig. 8). Reacting to these radically opposing depictions of young girls, Ellen Handler Spitz wondered whether they were assaulted *despite* or *because* of their innocence.

We can sense throughout Darger's works a rampant self-righteousness mixed with self-loathing, an unrestrained anger at the powerful, always-threatening Other, yet a deep rage at oneself for being so vulnerable. Darger seemed to express horror and anger in his depictions of innocence being assaulted, yet one senses as well his spiteful punishment of the vulnerability of innocence. Nevertheless, despite the proliferation of landscapes strewn with disemboweled corpses of young naked girls or the cosmic projections of girls being strangled in the billowing clouds (see *Untitled [image of*

strangled child in sky]; fig. 9), the seven Vivian Girls always escape and lead the vulnerable to safety and the forces of good to victory. However far Darger's imagination might have gone into the realms of the blasphemous and demented, and no matter how many times or for how long he lingered on the killing fields, he always stepped back, if only temporarily, to regain himself and his ties to the common culture of righteousness and sentimentality.

Darger's constant return to the dominant moral and religious codes reminds us that however much he might be considered an "outsider," his passions and his art are strongly linked to the values of his society. Even if his construction of an alternate world signaled a psychological rejection of the day-to-day grind, he managed to function within the given work world and found a deep and sustaining connection to

FIG. 8. Henry Darger, Left: *They are almost murdered themselves though they fight for their lives. Typhoon saves them.* Middle: *At Norma Catherine via Jennie Richee. Vivian girls witness childrens bowels and other entrails torn out by infuriated Glandelinians.* Right: *Vivian girl princesses are forced to witness frightful massacre of children–Vivian girls not shown in this composition*, n.d. Watercolor, pencil, and carbon tracing on pieced paper, 22 x 89 in. (55.9 x 226.1). Collection Kiyoko Lerner

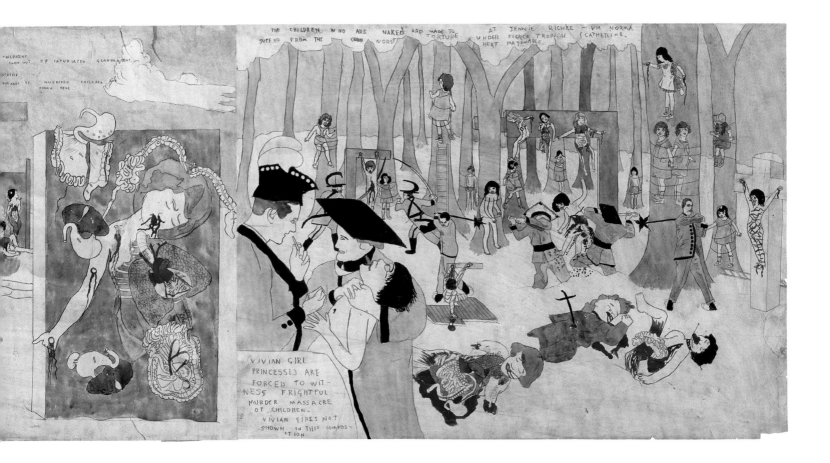

the broad culture through his ready, even obsessive, adoption of popular visual and narrative forms. Darger has appropriately been called a "naive" artist who emulates the forms and aesthetics of the established culture.[9] But unlike other naive artists, such as Morris Hirshfield, Darger found his aesthetic models in the popular media, not high culture. And like many self-taught artists, he made the forms and formulas of these media his own through a highly individualistic visual and literary sense.

Strongly influenced by fiction written for adolescent males—particularly tales of moral, brave, Christian boys—as well as by the widely popular *Wizard of Oz* books, Darger also freely incorporated characters, incidents, and themes of nineteenth-century popular literature, such as the works of Charles Dickens and Harriet Beecher Stowe. Stowe's novel

Uncle Tom's Cabin (1852) provided an especially rich trove of sentimental and horrific imagery, including the lingering death of angelic Little Eva, the horrors of slavery, Simon Legree's prolonged brutality toward Tom, and the exaltations of sanctimonious Christianity. All these sources share popular cultural conventions of explicit or latent threats to innocence that are ultimately rebuffed, and of moral conflicts engaged and overcome. Necessary to all these narratives—from the adventure story to the sentimental tale—is a prolonged, emotionally charged tension during which the threat of evil dominates before the much-delayed moment when the moral order triumphs.

Darger's sources of violent and inherently perverse imagery included not only popular fiction, but also historical writing and daily newspapers. He was fascinated by tales of the

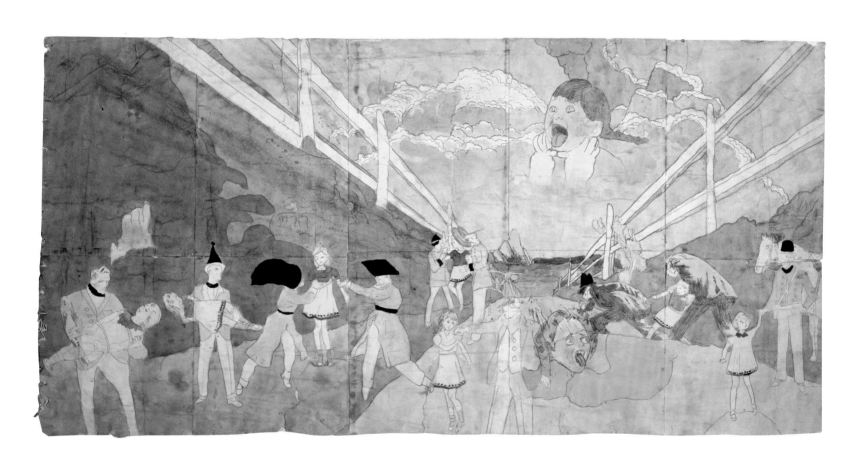

FIG. 9. Henry Darger, *Untitled (Image of strangled child in sky)*, n.d.
Watercolor, pencil, and carbon tracing on pieced paper, 24 x 45 in.
(61 x 114.3 cm). Collection Kiyoko Lerner

Civil War, which were still present in the cultural discourse of his youth, and he used them as a base for many of his battle scenes and drawn maps. He must also have been aware of the demonizing images of the enemy in both world wars, during which he created much of his work. Especially revealing, however, is that Darger avidly read and collected newspaper stories and pictures of abducted or murdered children. A staple of the so-called "news" even today, stories of domestic threat and tragedy feed a seemingly insatiable collective thirst for the lurid sensations of anger, fear, and perhaps desire stimulated by sporadic outbreaks of the culturally repressed into "public" view.

In Darger's tortured and fervid mind, these themes and conventions are made more intense and extreme. In the art and text of *In the Realms of the Unreal*, we encounter the familiar fantasies of our culture, fantasies of innocence protected, moral triumph, and religious fidelity, as well as those of pervasive sexual aggression, gender antagonism, and sanctimonious brutal violence. The artist thrust forward the uncomfortably widespread, long-enduring cultural obsessions with vengeance, war, rape, pedophilia, and resentment against God that coexist so easily with desperate religious longing and utopian, if infantile, sentimentality.

Like the work of all great artists, Darger's art responds to, animates, and makes personal the collective desires, fears, and imagery of the common culture. He made explicit, whether consciously or not, the collective unconscious in which we too are immersed. Instead of being viewed as an outsider or naive artist, Darger might best be seen as working from within, a self-taught vernacular artist, extremely responsive not only to the aesthetic forms of the popular arts but also to the prevailing form of hysteria in American culture. Who knows how many other unrecognized artists exist in his fashion—living on the margins of a society that finds itself strangely mirrored in works that have yet to be discovered.

Working at the same time as Darger, Morton Bartlett (1909–1992), another orphaned boy who never married and lived alone, constructed a "family" of thirteen plaster-carved, anatomically correct, prepubescent children. He photographed them in varied poses or vignettes, either in the clothes he made for them or nude. Three of his "children" were boys; ten were young girls. Having himself been adopted and given good educational opportunities, Bartlett lived a successful life, including work as a commercial photographer. He referred to his private "hobby" as an outlet for "urges that do not find expression in other channels;"[10] but it was only after his death, when the dolls and photographs were found, that the nature of that hobby was revealed. We gather a sense of Bartlett's expressed urges in the intimate portraits, which range from sweetly sentimental to erotically tinged portraits (see fig. 10). Although the well-composed and studiously lit images challenge no aesthetic convention,

FIG. 10. Morton Bartlett, *Girl Waving (nude)*, 1950–60. Carved and painted plaster with fiber hair, 32¼ x 6 x 4 in. (82 x 15.2 x 10.2 cm)

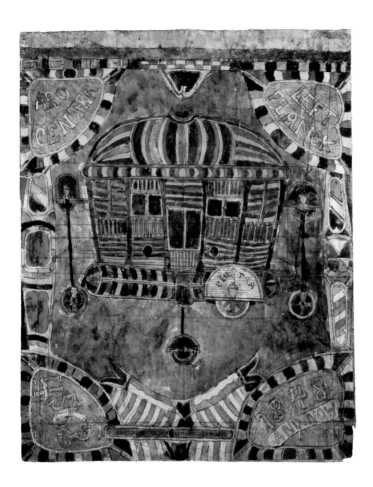

plement the geometrically patterned, balloonlike inventions, Dellschau created several thousand works, many of which include collaged newspaper articles about early experiences in flight (see fig. 11). He also wrote of a secret society dedicated to building the first navigable airships, in which he claimed a mid-nineteenth-century membership. However private Dellschau's passion for flight, his work is one man's contribution to the populace's enthusiasm for the birth of aviation. A personal and collective celebratory spirit is reflected in the circus-tent aesthetic of his flying machines. Unfortunately, apparently no one in Dellschau's family knew or shared that ebullience. Some forty years after his death, his books were discovered at street edge awaiting a trip to the landfill after his descendants' house was cleaned out.

Born near Neuwied, Germany, Josef Wittlich (1903–1982) had an impoverished youth and vagabond life before settling as an agricultural worker in 1934. Almost immediately thereafter, he developed an enthusiasm for painting brightly colored images of soldiers and war. He may have produced thousands of works, giving many away, though few were appreciated by their recipients. The remaining pieces were destroyed during World War II, which diminished Wittlich's obsession neither with war nor with the art of war. Once he found steady employment in a ceramics factory, he threw himself again into the prolific production of paintings, which shared the primary-colored, pop art–like aesthetic and subjects he had developed in the 1930s. The spirited and accessible, vibrantly painted subjects appear in dynamic, often off-kilter compositions of competing planes and perspectives, all framed within boldly colored painted edges (see fig. 12). Although Wittlich found the local response muted at best, some of his works were noticed in 1967 by an artist visiting the factory, who brought them to the attention of the art world. In short order, his paintings were shown throughout Germany and Europe and for his last fifteen years Wittlich saw his life work achieve renown.

the poignant depictions reveal a terribly naked longing that is unsettling to the viewer who has gained uninvited access into a lonely realm of desire and possession.

Charles A. A. Dellschau (1830–1923), a German who immigrated to Texas, where he worked as a butcher and raised a family, evidently spent much of the last three decades of his life withdrawn from his family constructing books of drawings, watercolors, and collages that portray fanciful flying machines he called *areos*. Presenting each machine on a separate page within colorfully decorative frames that com-

FIG. 11. Charles A. A. Dellschau, *4563 AERO CENTRA – LEFT FLANK*, 1920.
Pencil, pen, watercolor, and collage on paper, 18½ x 15 in. (47 x 38.1 cm)

Notes

1. Selections from Darger's texts are printed in Michael Bonesteel, *Henry Darger: Art and Selected Writings* (New York: Rizzoli, 2000) and John M. MacGregor, *Henry J. Darger: Dans les royaumes de l'irréel* (Lausanne: Collection de l'Art Brut, 1996). MacGregor's *Henry Darger: In the Realms of the Unreal* (New York: Delano Greenidge Editions, 2002) contains numerous excerpted passages cited within the context of MacGregor's analysis of Darger. A selection from Darger's "The History of My Life" is printed in Klaus Biesenbach, ed., *Henry Darger* (New York: Prestel, 2009).

2. John MacGregor offered a diagnosis of Darger's clinging to the imaginary as preferable to the defeats of daily life to which most normal adults have resigned themselves. MacGregor claimed that we all know the power of the imagination and have sought relief there to compensate from the constraints and frustrations imposed by reality. However, Darger did not grow up and resign himself; rather, the dream world took over his existence entirely, providing a "life infinitely more rich, more intense, and superior to that which he was permitted to experience in 'reality.'" John M. MacGregor, "La création d'un monde alternatif," in Lucienne Peiry, ed., *Ecriture en délire*, exh. cat. (Lausanne: Collection de l'Art Brut, 2004), p. 29.

3. I thank Christopher Lyon for this observation.

4. For MacGregor's thorough and astute analysis of the development of Darger's art techniques, see *In the Realms of the Unreal* (note 1), pp. 118–80.

5. Michel Thévoz, "The Strange Hell of Beauty . . . ," in *Darger: The Henry Darger Collection at the American Folk Art Museum*, exh. cat., ed. Brooke Davis Anderson (New York: American Folk Art Museum/Harry N. Abrams, 2001), pp. 15–16.

6. MacGregor, *In the Realms of the Unreal* (note 1), p. 596.

7. Henry Darger, introduction to vol. 1 of *In the Realms of the Unreal*, p. 1, repr. in Bonesteel (note 1), p. 39.

8. Ibid.

9. Jack Burnham, "The Henry Darger Collection: Another Art Treasure Lost to Chicago?," *New Art Examiner* (Oct. 1979), p. 1, quoted in Michael Bonesteel, "Henry Darger: Author, Artist, Sorry Saint, Protector of Children," in *Henry Darger: Art and Selected Writings* (note 1), p. 16.

10. Morton Bartlett, quoted in John Turner and Deborah Klochko, *Create and Be Recognized: Photography on the Edge* (San Francisco: Chronicle Books, 2004), p. 129.

FIG. 12. Josef Wittlich, *Blue Soldiers in Combat (Kampf mit blauen Soldaten)*, n.d. Tempera on paper, 40⅛ x 28¾ in. (102 x 73 cm). Collection de l'Art Brut, Lausanne

Martín Ramírez

The art of Martín Ramírez (1895–1963) is distinguished by its equal investment in formal abstraction and representation as bearers of expressive significance. His is a precisely defined and rigorously ordered visual world in which every element contributes to meaning that is at once intensely personal and cross-cultural. Ramírez—a Mexican farmer who traveled to the United States for work only to spend the last three decades of his life in California mental hospitals—found within his art a precision of vision and method that belies whatever psychological disorder he may have endured and a realm subject to his personal command that defied the conditions of his physical environment.

Ramírez's art embraces the fundamental genres of figuration and landscape. He framed figures and objects of personal iconic value within abstracted exterior or interior spaces depicted in stylized, often highly decorative and ornamental forms. Ramírez restricted himself to a few key images to which he returned repeatedly with only slight variations, as if ceaselessly elaborating upon psychological, conceptual, and aesthetic realms of deep personal value. Yet however private their meaning, and however little is known about Ramírez himself, the works succeed in communicating a world we might well understand, if not share.

Viewing Ramírez's artworks, we are struck most immediately by the precisely ordered and elaborately designed world he depicts. Our dominant impression is of a highly focused visual and psychological intensity, expressed through an aesthetic that greatly prizes order and balance. This sense of balance is achieved through a remarkable harmony of formal structure, figurative subjects, and decorative patterning. Each visual element suggests that the artist was highly conscious of its placement and recognized its importance to the overall composition. Throughout, the virtuosity of Ramírez's draftsmanship is apparent. The works are characterized by extremely precise, well-drawn, ordered, and repetitive lines, modulated by sensitive touches of shading that establish an effective tension between flatness and depth. In Ramírez's art, we sense the exuberance and self-assurance of the inventive and masterful craftsman, such that the visual order carries as much aesthetic and psychological significance as the work's subject.

One subject of evident importance is a "cowboy" figure, which appears in more than eighty known works and most likely represents a *charro*, a traditional horseman originating in the Jalisco region of Mexico, where Ramírez was born. The rider wears a bandolier of bullets and is often shown shooting a gun off to the left (see *Untitled [Horse and Rider]*, c. 1953; fig. 1). While the *charro* was renowned primarily for horsemanship, the bandolier and weapon suggest the turbulence of early-twentieth-century Mexico, familiar through the popular images of the rebel Emiliano Zapata, who adopted the *charro* style of dress. However, Ramírez also created a series of works in which the mounted figure is either a modest man on a mule or an elaborately dressed horseman blowing a monstrous bugle while seated on a *charreada* parade horse.

Ramírez's horsemen are most often presented within a constricted rectangular space that suggests a proscenium

OPPOSITE: Detail of Martín Ramírez's *Untitled No. 79 (Arches)* (fig. 4)

rate staging threatens to dominate the players. Although Ramírez occasionally foregrounded the figures, he was more prone to place the horse and rider on the last of a series of receding stages so that the distanced figure commands a small portion of the picture's surface. Yet there is something poignant about the isolated figure, a feeling heightened by the visibly fragile nature of the paper, which Ramírez pieced together from several found scraps.

Ramírez repeatedly used the stage format, probably to feature figures from his early life, especially animals: dogs, deer, stags, and rabbits. He also enshrined on the stage the image of the Virgin Mary, particularly in her form as *La Purisima*, or the *Inmaculata*, a devotional figure found in the church where he had been married and common in Mexican retablos. In *Untitled (Madonna)* (1953; fig. 2), Mary of the Immaculate Conception is regarded as the second Eve, who stands over and is ready to trample the serpent of seduction and evil while positioned on the globe of crescent moon. As is traditional, she is bedecked with a heavenly crown and adorned with a blue sash, her hands raised in benediction.

Ramírez's landscapes—especially his depictions of trains traveling through mountainous scenes full of dark tunnels—are often as formally and abstractly configured as his stages. In some drawings, such as *Untitled (Trains and Tunnels)* (1950s; fig. 3), the hills and mountains are composed of billowing, whorl-like forms articulated in precise, schematic, repetitive curved lines of great beauty and assurance. Although we recognize the patterned shapes as abstracted geological figures, they also suggest biomorphic, geometric, and architectural forms, which lend a sense of mystery to the imagery. Similarly, Ramírez's numerous images of trains momentarily caught within such decoratively delineated geometric landscapes as they enter and emerge from tunnels create a simultaneous feeling of motion and stasis, freedom and constraint. Like the scenes of proscenium stages, the tunnels and mountainous landscapes suggest receding

stage. In figure 1, the horse and rider have been displaced from their natural environment and instead appear on a rising and receding platform of wood planking; the space into which the *charro* shoots is a nearby wall of vertical boards or curtains. Overhead, the progressively darkening horizontal banding denotes a curtain or the roof of the stage, and above it, a line of decorative oval friezelike forms further establishes the theatrical, if not ceremonial, effect of the drawing. The ground behind the horse and rider seems to recede infinitely into a blank space, which further emphasizes the busy, constrictive, yet formal display of the figures. At times, the elabo-

FIG. 1. Martín Ramírez, *Untitled (Horse and Rider)*, c. 1953. Crayon and pencil on pieced paper, 33¾ x 23½ in. (85.7 x 59.7 cm). Collection Jan Petry

FIG. 2. Martín Ramírez, *Untitled (Madonna)*, 1953. Crayon and colored pencil on pieced paper, 26¼ x 25½ in. (66.7 x 64.8 cm). Private collection

FIG. 3. Martín Ramírez, *Untitled (Trains and Tunnels)*, 1950s. Crayon and pencil on pieced paper, 32½ x 96 in. (82.6 x 243.8 cm). Collection Nina Nielsen and John Baker

FIG. 4. Martín Ramírez, *Untitled No. 79 (Arches)*, c. 1960–63. Gouache, colored pencil, and graphite on pieced paper, 24 x 72 in. (61 x 183 cm)

depths into another dimension of personal significance. In *Untitled (Trains and Tunnels)* (c. 1950/p. 12), one train makes a brief appearance, moving horizontally between two oval-shape tunnel openings, while a much longer train vertically steams toward the viewer out of a tunnel through an especially narrow valley. The work suggests at once the immensity of the landscape and its strangely intimate, if not sexual, nature.

Ramírez's later drawings grow progressively more geometrically structured, and the figurative images, such as trains, are increasingly repeated within the compositions. These works evoke in the viewer a kinesthetic reaction in which one is attuned to the suggestions of frenetic, cumulative movement yet constrained by the rigorous patterning of the landscape. Unlike Madge Gill's disorienting compositions, which provoke a near-vertiginous experience within disordered and frenetic visual planes, Ramírez's works are more

likely to have a hypnotic effect of animate stasis.[1] This mesmerizing effect is especially apparent in his "last" works, a collection of more than 130 drawings made public only in 2007. In these works, Ramírez approached near-total abstraction. His landscapes and edifices—whether hills, mountains, fields, tunnels, or arches—became largely abstract, decorative, and entirely graphic. Arcades or tunnels that had previously served as framing devices become repeated abstractions, even though a hint of the original reference remains. In these overall geometric compositions, the pure pleasure of the perception of order and the virtuosity of the craftsmanship are overwhelming—hypnotic, even. One such work, *Untitled No. 79 (Arches)* (c. 1960–63; fig. 4), stretches 19½ feet wide by 16½ inches high. Its enormous size is especially remarkable since it was constructed from dozens of scraps that Ramirez patched together, rolled, and saved within the mental institutions where he was confined for the last three decades of his life.

Although Martín Ramírez was a ward of the state of California from 1931 until his death in 1963, little was known about him until early in this century when the first serious efforts were made to recover the details of his life before his involuntary commitment in California state hospitals. Even today, much remains to be discovered about the life, work, and travels of his youth and young manhood.

We do know that he was born Martín Ramírez González in January 1895 in Rincón de Velázquez in the state of Jalisco in west-central Mexico, a region with a strong Spanish heritage and Catholic religious traditions. Ramírez was raised in a devout religious family. His father was a sharecropper who also served as a teacher to the local youth. Ramírez also worked as a sharecropper and laborer before purchasing a small rancho and orchard. He was renowned as an accomplished horse rider and took great pleasure in hunting rabbits and deer for his family. He married in 1918, and by 1925 he was father to three daughters. That year, however, he traveled to California looking for work, unaware that his wife was pregnant with their son, whom he would never meet. Hoping to pay off the loan on his fifty-acre rancho, Ramírez followed streams of Mexicans into the United States to work on the railroads and in the mines of Northern California. For some five years he sent money back to support his family and pay for the ranch. Evidently, the letters he wrote also contained drawings of his travels.

Ramírez's situation was disrupted dramatically by subsequent events in Mexico and the United States. During the violent Cristero rebellion of Catholic forces against the militantly secular central government (1926–29), Jalisco was the scene of great destruction. Amid widespread battles and pillaging, the Ramírez farm and animals were devastated. Furthermore, by 1930 life in the United States was made barely tenable by the onslaught of the Great Depression. In 1931 Ramírez, apparently without work or place of residence, was picked up by police for being disoriented and unable to care for himself and was committed to the psychiatric hospital in Stockton.

Having only spotty police and hospital records and inconsistent commentary by institutional personnel and relatives, we cannot fully trust the accuracy of Ramírez's original diagnosis and condition during the following thirty-two years he spent in California mental institutions. Although initially described as "violent, dangerous, destructive, excited, and depressed,"[2] he settled into the hospital calmly, though he made several attempts to escape, a few times voluntarily recommitting himself after days without food or a place to stay. By 1933 Ramírez was diagnosed as a type of schizophrenic, and in 1948 he was transferred to DeWitt State Hospital near Sacramento, where he remained until his death.

Throughout his institutionalization, Ramírez remained unto himself, speaking little. It was long assumed that he was mute, incapable of interacting with the external world except through his art. Recent comments by a relative who conversed with Ramírez in the 1950s confirm his psychological disorientation and his fixation on the world of his youth long past, though they also prove he was not mute.

Apparently during the mid-1930s while at Stockton, Ramírez began to draw, avidly scavenging scraps of paper bags, envelopes, greeting cards, and menus, which he pasted together with glues improvised from potato starch, flour, and saliva. He rolled out his handmade sheets of paper between beds in the crowded facility and, using pencils and crayons, drew his decisive and intense straight lines with a tongue depressor as a guide. He then rolled and stored the works in a corner or under his clothes to protect them from other inmates or the cleaning staff. Some staff members apparently recognized the works' importance and sent a number of them to his family in Mexico when Ramírez was transferred to DeWitt.

As an elderly, supposedly incurable but nonviolent patient, Ramírez was allowed much free time and was able

to hang some of his works in the ward. In 1948, these were noticed by Tarmo Pasto, a Sacramento State College professor of art and psychology who visited the hospital with his classes. Pasto was especially interested in the underlying nature of creativity and aesthetics. He supported Ramírez's creativity by supplying him with paper and pencils, collecting the works, and instructing the hospital staff to date and record the drawings. Pasto also helped arrange exhibitions of Ramírez's art and even sent pieces to the Solomon R. Guggenheim Museum in New York hoping to stimulate an exhibition there. Uninterested in such a venture, the museum nevertheless kept the works, which languished in storage until the late 1980s and have yet to be exhibited there.

With Pasto's support and the hospital's consent, Ramírez became intensely productive throughout the 1950s and into the early 1960s, even after Pasto's professional interests led him away from further involvement with Ramírez. He spent all his time making art, working intensely, repeating images and compositions, and creating drawings of great size. Yet many of these late works disappeared for four decades, and after Ramírez's death in 1963, knowledge of him was almost completely lost.

It required a second "discovery" by the artist Jim Nutt to bring Ramírez's work to the attention of the outsider and self-taught art world. In 1968 Nutt, a Chicago Imagist teaching at Sacramento State, was introduced to Ramírez's work by Pasto. Nutt and the gallerist Phyllis Kind subsequently purchased some three hundred drawings, mostly from Pasto, and with Kind's Chicago gallery energetically promoting the work, Ramírez ultimately gained recognition as an artist. Although Ramírez was initially viewed as an outsider artist about whom little was known and much assumed, recent assiduous research has both expanded our understanding of Ramírez and his art and shifted discussion from the realm of the "outsider" to a more complex vision of a culturally embedded creator.³ In the process, we have benefited from

what Robert Storr has described as a "widening and changing of our perspective . . . to transfer discussion from matters of categorical otherness to that of locatable difference."⁴ Ramírez is now seen as a bicultural figure who spans two distinct cultures and historical moments. His art conjoins imagery of Mexico and the United States; early-twentieth-century traditional and folk cultures and modern media-driven commercial visual vocabularies; a rural agricultural environment and the landscapes of northern railroads and suburban communities; a devoutly Catholic vision and a compelling secular world.

Ramírez's art responds to these competing cultural contexts either by selecting specific images of personal significance from opposing worlds or by juxtaposing contrasting elements from each (e.g., Mexican villages and modern highways; horses and automobiles; beasts of the natural world and sleek trains). Out of a dynamic of remembrance and observation, familiarity and difference, he created artistic and psychological order. Through his work the seemingly distant world of the "other" becomes immediate, while our world is re-visioned through his eyes. In the process, he and his work become more "locatable," and we, perhaps, become a bit more "other."

Ramírez's repeated return to a small set of iconic images suggests that they had personal import grounded in biographical, religious, and historic experiences, as well as in his reactions to the land and condition in which he found himself. Many images seem especially imbued with a sense of memory and appear charged with emotions arising from a sense of unbridgeable separation in time and space. Although Ramírez bore little in common biographically or stylistically with traditional American memory painters, who late in life paint naive and generally idyllic visions of their past, he mastered the "paradox inherent in the successful painting of memories" identified by Roger Cardinal: the need to "[adopt] a distance from the strict facts and [achieve] a more striking 'essential' form, endorsed by a schematic style which

depletes superfluities."[5] Ramírez's clarity of line, precision of formal design, and emblematic depiction of a limited repertoire of significant figures concentrate his and our gaze on the essential themes of his life.

This is especially apparent in the images of *La Purisima* and of the *charro* rider, which suggest the life Ramírez left behind in Jalisco but carried with him in his memory. The Virgin of the Immaculate Conception, a figure of grace and power, appears in about a dozen surviving works in a range of compositional formats, including those in which she is highlighted within a proscenium stage or floats in the center of an open ground. Several times she is flanked by landscape forms, intimating her presence in Ramírez's past and travels north. In one work, *Untitled (Madonna)*, c. 1950–57, a horse and rider are set within their own diminutive stage, perched above a much larger, proscenium-framed Virgin; both figures wear halolike crowns. The humble bearing of the rider imparts a pacific and religious sensibility, while his placement near the Virgin is perhaps a prayer for divine accompaniment and protection.

The stage-framed rider on horseback also appears in several configurations and seems to imply self-referential memory and nostalgia. Numerous drawings appear to celebrate young Ramírez as a joyful hunter astride a rearing horse, gun pointed, and at times holding slain a rabbit. (In its own series, the rabbit receives the honor of being the sole figure on the stage.) Other versions of the rider suggest nostalgic or idealized self-projections, from farmer on a mule, circus or *charreada* rider, macho hunter, to armed revolutionary.

In Ramírez's works, spatial relations and formal framing of figures are always weighted with aesthetic and psychological significance. The many tunnel entrances that feature so prominently in his opus seem like foreboding and dark gateways to another dimension through which trains, cars, boats, and men on horses—travelers all alike—incessantly move. A few times, Ramírez opened up the landscapes to depict the

FIG. 5. Martín Ramírez, *Untitled (Madonna)*, c. 1950–57. Crayon and colored pencil on pieced paper, 60 x 25 in. (152.4 x 63.5 cm). Collection Joan Humphrey

worlds on either side of the tunnel, which suggest his remembered or imagined expanses on either side of the Mexico–United States border. In *Untitled (Landscape)* (c. 1950–57; fig. 6) both lands are referenced to enact the artist's memories and his will to compose a coherent life narrative. The sprawling (40-by-105-inch) collage and drawing is one of Ramírez's least rigorously structured works, but it contains the most dense and varied imagery. It literally pieces together images of the Mexico Ramírez left behind and scenes of modern-day America known to him largely through the magazines and movies offered to hospital inmates. Northern America is represented at the top of the composition by two rows of drawn and collaged automobiles lined up end-to-end as if in a traffic jam. Separated from the scene below by a horizontal band that indicates plateaus or mountainous cliffs, the automobiles pass through a tunnel and plunge down into a Mexican landscape replete with a *charro* rider, other human and animal figures, and numerous churches whose architecture resembles those in Ramírez's hometown. Drawn village buildings are situated among

fields, hills, and mountains and are accessed by the requisite tunnels and emerging or departing trains. Ramírez also collaged magazine photos of an Amish farm to accentuate the rural landscape, and above it, amid exotic drawn flowers, he signed the piece with great flourish in an elaborately decorative letter *R*, which frames a smiling self-portrait.

In other works the artist's presence is less declaratory. *Untitled (Tunnel with Man, Woman, and Dog)* (1954; fig. 7) suggests a subdued narrative of separation and longing. On the upper right, a small man is perched at the top of four steps recessed into a proscenium-like enclosure; below, an equally tiny woman is walled off in the foreground as if in an entirely different dimension framed by a deep and imposing tunnel. Accentuating their remove from each other, a beast—which appears more of a bear than a dog—is placed between them.

A more self-assertive series of works features a man writing, or perhaps drawing, at a desk. In the most haunting images, the man sits as if on stage; the floor behind him recedes into darkness, while above, as if depicting his thoughts, a similarly framed train has curved into view (see *Untitled*

FIG. 6. Martín Ramírez, *Untitled (Landscape)*, c. 1950–57. Crayon, pencil, watercolor, and collage on pieced paper, 40 x 105 in. (101.6 x 266.7 cm)

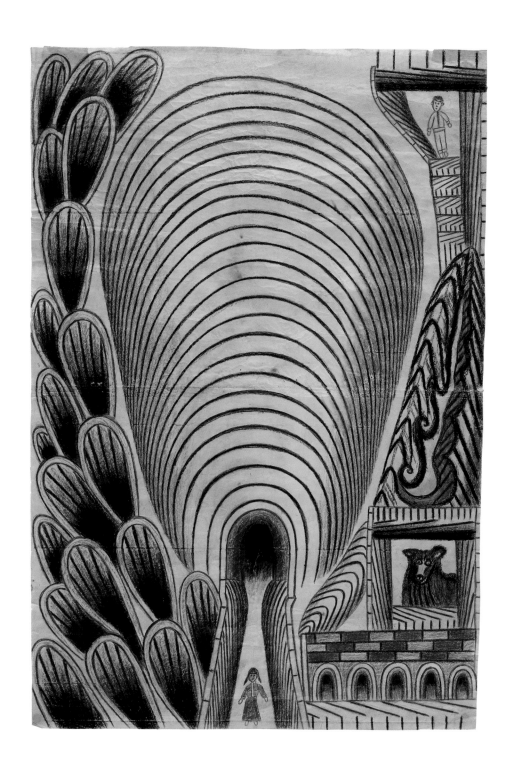

FIG. 7. Martín Ramírez, *Untitled (Tunnel with Man, Woman, and Dog)*, 1954. Crayon and pencil on pieced paper, 33½ x 23 in. (85.1 x 58.4 cm)

FIG. 8. Martín Ramírez, *Untitled (Man at Desk)*, c. 1950–57. Crayon and pencil on pieced paper, 34¾ x 23½ in. (87.6 x 59.7 cm). Collection Stephanie Smither

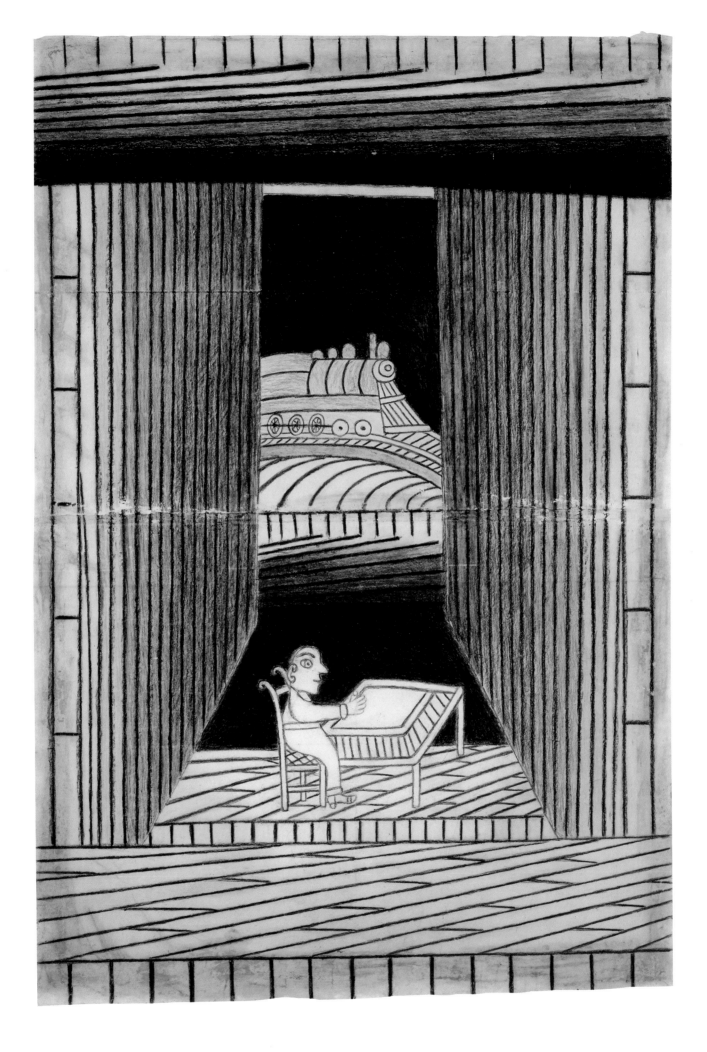

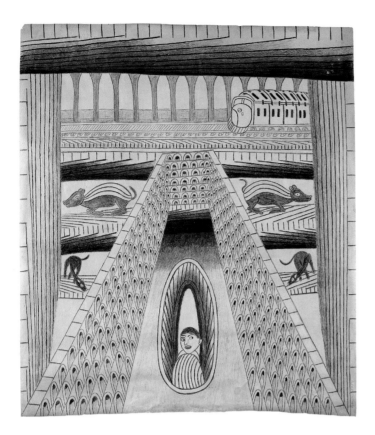

[Man at Desk], c. 1950–57, fig. 8). The dark areas behind both the man and the train evoke the depth of traveled and imagined space, psychological isolation, and the power of memory to animate the constricted space the man finds himself in. Considered as a self-portrait, the drawing presents the artist creating the world in which he resides.

Untitled (Courtyard) (c. 1953; fig. 9) can also be read as a depiction of the artist and the world of his memory and creation. Exquisitely drawn and highly structured, it unites several of Ramírez's favorite themes (trains, animals, courtyard architecture) and formal strategies—dramatically receding depths, multiple vertical and horizontal frames, strongly articulated horizontal and diagonal structures, and oval and rectilinear shapes. At the center of this intricate composition is a framed portrait of a self-assured man, his glance slightly askew, looking out at a world that, in turn, looks back at the realm of his creation. This drawing exemplifies Ramírez's

achievement of integrated personal, cultural, and aesthetic signification. Its meaning is as manifest in form as in subject, and it balances abstraction and representation or, rather, abstraction *in* representation. The portrait is framed by both the oval and the courtyard, the latter drawing upon traditional Spanish-Mexican architecture, while reiterating a sense of the abstract arches found in Ramírez's depictions of prosceniums and tunnel entrances.

In a number of the recently discovered works from late in Ramírez's life, the formal ordering appears to have become self-sufficient; subject matter is reduced to a bare minimum. In *Untitled (Arches)* (fig. 4), the obsessive repetitive structure dominates the visual field. Although the emptiness of the 242 arches resonates with a sense of inevitable passage to another dimension of uncertain emotional import, the stark geometric forms assert their own unchallenged presence. Yet paradoxically, even if no subject is framed within those arches and certainly no self-portrait is figured, Ramírez is fully manifest in the traces of his extended bravura execution of the work, however crepuscular in tone that performance. The extended rows of arches seem a culmination of a persistent tendency toward schematic abstraction throughout Ramírez's work. Every drawing relies on extensive geometric patterning composed of finely drawn parallel lines, which define the shape and surface of figures, landscape forms, or formal compositional structures and perspectives.

Ramírez's formal patterning can assume such visual prominence that the works appear to exemplify what E. H. Gombrich has distinguished as the perception of order over the perception of meaning. Although the two forms of perception are never completely divorced within the artwork, an explicit emphasis on the creation and manipulation of formal relationships testifies to an inherent need to exercise a sense of order attained largely by abstracting from or reducing the complexity of visual elements of the depicted world to create a distinct "conceptual" image. Gombrich noted the pleasures

FIG. 9. Martín Ramírez, *Courtyard*, c. 1953. Pencil and colored pencil on pieced paper, 40½ x 36 in. (102.9 x 91.4 cm). Milwaukee Art Museum; Promised gift of Anthony Petullo

of "making and contemplating simple configurations regardless of their reference to the natural world."[6] At one pole of art, the elaboration and orchestration of forms freed from representational fidelity allows a realm of conceptual and visual performance evident in the decorative impulse, a drive often felt in Ramírez's work. His studied attention to precisely repeated lines and shapes results in a strongly ornamental effect, seen, for instance, in the rigorous patterning of the two trains in *Untitled (Trains and Tunnels)*; the clustering of ovular, upended, tunnel-mouth forms that fill the left third of *Untitled (Tunnel with Man, Woman, and Dog)* (fig. 7); and the seven-tiered courtyard enclosing the framed figure in *Untitled (Courtyard)* (fig. 9).

In such decorative art, the precision of line and orderly patterning of the composition are often declarations of the artist's virtuosity, the display of which delights both maker and viewer. Ironically however, too great a submission to the formal demands of an elaborate design results in the diminishment of artistic vitality. Alternately, too great a commitment to a private visual language may signal the artist's reflexive retreat from a threatening world into the illusion of a self-enclosed artifice. Fortunately, Ramírez's highly elaborated frames and grounds are saved from the deadening mechanistic artifice of "mere" decoration by the constant and slight but sophisticated variations of images, the perspectival tensions of inconsistent receding planes, and the personal inflection of subtle hues and shading.

However much Ramírez was drawn to the ornamental, we find in his work a greater commitment to a type of abstraction in which he established, in the words of Rudolf Arnheim, "an elaborate play of shapes . . . described variously as geometric, ornamental, formalistic, stylized, schematic, or symbolic."[7] These are distinct, though not necessarily separate, attributes. Geometric forms can serve ornamental purposes, but both the forms and the ornament can also be expressions of a highly self-conscious and self-referential

stylization celebrating the virtuosity of the artist. Furthermore, geometric or decorative forms in themselves can underlie patently symbolic systems of personal or collective value. The task we face in confronting Ramírez's work is to discern the weighted uses and possible meanings within any particular abstracted figure or formalist strategy.

This is, of course, the challenge of understanding art in the modern era, whether that of the self-taught and outsider or of mainstream artists. All share to some degree what Arnheim described as a lessened "allegiance to the complexities of nature,"[8] and affirm the power of the individual to shape a personal realm of expressive meaning through the manipulation of selected fragments of form and image.

This is evident in many other outsider and self-taught artists who create extremely ordered, often lushly decorative works that combine abstraction and figuration. In their art a range of configurative impulses—symbolic, expressive, ornamental, and mimetic, for instance—may be found in separate or in conjoined motifs, as seen in the work of Minnie Evans, Anna Zemánková, and Frank Jones.

The drawings and paintings of Minnie Evans (1892–1987) depict mysterious, heavenly—and occasionally satanic— beings surrounded by lush floral and vegetal forms. Faces

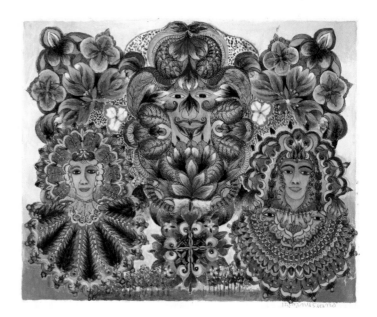

FIG. 10. Minnie Evans, *Design Made at Airlie Gardens*, 1967. Oil and mixed mediums on canvas mounted on paperboard, 19⁷⁄₈ x 23⁷⁄₈ in. (50.5 x 60.6 cm). Smithsonian American Art Museum, Washington, D.C. (1972.44)

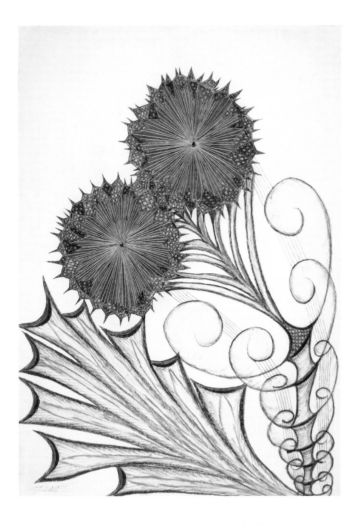

emerge from the blooms, or at times only the eyes stare out at the viewer. The works are usually structured with an exuberant symmetry underlying a complex design. The regularity of the forms establishes the primal coherence from which luxuriant life flourishes. Naturalistic figuration flows easily into abstract forms, suggesting both a divine and an earthly order at the heart of this mystical, floral realm (see fig. 10).

Evans's imagery derives from her long employment as gatekeeper at Airlie Gardens in Wilmington, North Carolina. The works' spiritual dimension reflects her deep religiosity and fascination with mythological subjects. In 1935, about ten years before she started painting seriously, Evans had a calling in a dream instructing her to paint. She did two drawings in response, but put them aside until she began her job at the gardens. Responding to the gardens, she took up her paintbrush and pen and for the next thirty years created over a thousand works, some of which she sold to the tourists who visited the gardens, and nearly half of which were bought by the collector Nina Howell Starr, who counseled her and sought avidly to place her works in collections and arrange exhibitions of Evans's art.

Although Anna Zemánková (1908–1986) had wanted to create art from a young age, she acquiesced to her Moravian parents' advice that she pursue a more practical route in life. After becoming a dental technician, marrying an army officer, settling in Prague, and raising three children, she suddenly began to draw following a period of depression at age fifty-two. Her work was accomplished in an exalted state of trancelike passion generally during the early hours of the day, from four until seven in the morning, before she resumed her domestic routine. She spoke of her "creator spirits" and recounted that the works drew themselves, leading a number of critics to compare her drawings to the rich spiritualist tradition of Moravian mediumistic art.

Like the work of Evans, Zemánková's pastel and ink drawings transform biological and organic forms into delicate and fanciful abstractions suggestive of imaginary or spiritual realms made present through the artist's exotic sensibility. Unlike Evans's mysterious beings, however, Zemánková's evocative mutant forms float on an open ground, their filigree qualities seemingly illuminated from behind (see fig. 11). As her work developed, Zemánková manipulated her surfaces, crimping or perforating them and incorporating needlework, crochet, and collage, at times drawing directly on silk. Many of the works evoke the ornamental patterning of Moravian folk textile design and embroidery at which she was proficient. Her evident skills at decorative design and her inventive use of her media underlie an imaginative freedom evoked in her abstracted naturalistic forms.

FIG. 11. Anna Zemánková, *Untitled*, c. 1970s. Pastel, ballpoint, and embroidery on paper, 24 x 17¾ in. (62.5 x 45 cm)

Frank Jones (1900–1969) found imaginative freedom within highly patterned, geometrically structured, yet frenetically animated drawings of multichambered buildings filled with dancing spirits (see fig. 12). Jones called these constructions "devil houses" and claimed that, having been born with a caul over one eye, he was gifted with second sight that enabled him to the see the "haints" and devils all around him. That this African American artist spent the last twenty years of his life incarcerated in a Texas prison provides ample explanation of the presence of those haunting devils. Yet like Ramírez, who also endured involuntary commitment, Jones used his art to establish a semantic terrain over which he had full control and through which he had the freedom to depict the world he knew.

The imaginative houses Jones inhabited are orderly but not rigid, filled with "devils" who smile and cavort, often on the roofs and outside walls. The entire edifice from exterior walls to interior partitions is decorated with flamelike forms in primary colors, energizing the space and animating the resident spirits—devils, perhaps, though more likely spirits of Jones's spiritual release.

Notes

1. See, for example, Roberta Smith, "Radiant Space: The Art of Martín Ramírez, in Lynne Cooke, *Martín Ramírez: Reframing Confinement*, exh. cat. (Madrid: Museo Reina Sofía/Munich: Prestel, 2010), p. 145.
2. Víctor M. Espinosa and Kristin E. Espinosa, "The Life of Martín Ramírez," in *Martín Ramírez*, exh. cat., ed. Brooke Davis Anderson (Seattle: Marquand Books/New York: American Folk Art Museum, 2007), p. 24.
3. The need for research into Ramírez's cultural background was long argued by Randall Morris. Significant work has been done by Víctor M. and Kristin E. Espinosa.
4. Robert Storr, "Introduction: Mindscapes, Landscapes, and Labyrinths," in *Martín Ramírez* (note 1), p. 16.
5. Roger Cardinal, "Memory Painting," in *Self-Taught Art: The Culture and Aesthetics of American Vernacular Art*, ed. Charles Russell (Jackson: University Press of Mississippi, 2001), p. 95. Brooke Davis Anderson introduced the comparison of Ramírez to memory painters in "Martín Ramirez, 'The Last Works,'" in *Martín Ramírez, The Last Works*, ed. Brooke Davis Anderson (Petaluma, CA: Pomegranate, 2008), p. 42.
6. Ernst H. Gombrich, *The Sense of Order: A Study in the Psychology of Decorative Art*, 2nd ed. (London: Phaidon, 1984), pp. 2, 5.
7. Rudolf Arnheim, *Art and Visual Perception: A Psychology of the Creative Eye*, "The New Version," rev. ed. (Berkeley: University of California Press, 1974), p. 145.
8. Ibid.

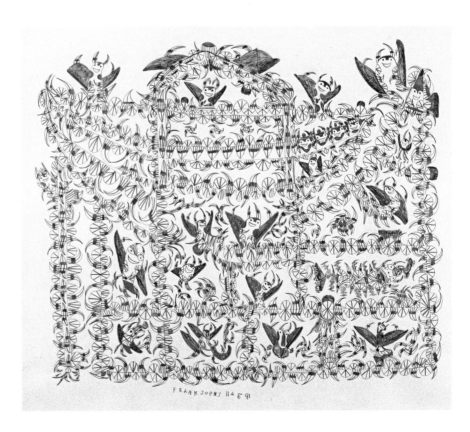

FIG. 12. Frank Jones, *Untitled No. 5*, c. 1968. Colored pencil on paper, 25½ x 30½ in. (64.8 x 77.5 cm). Private collection

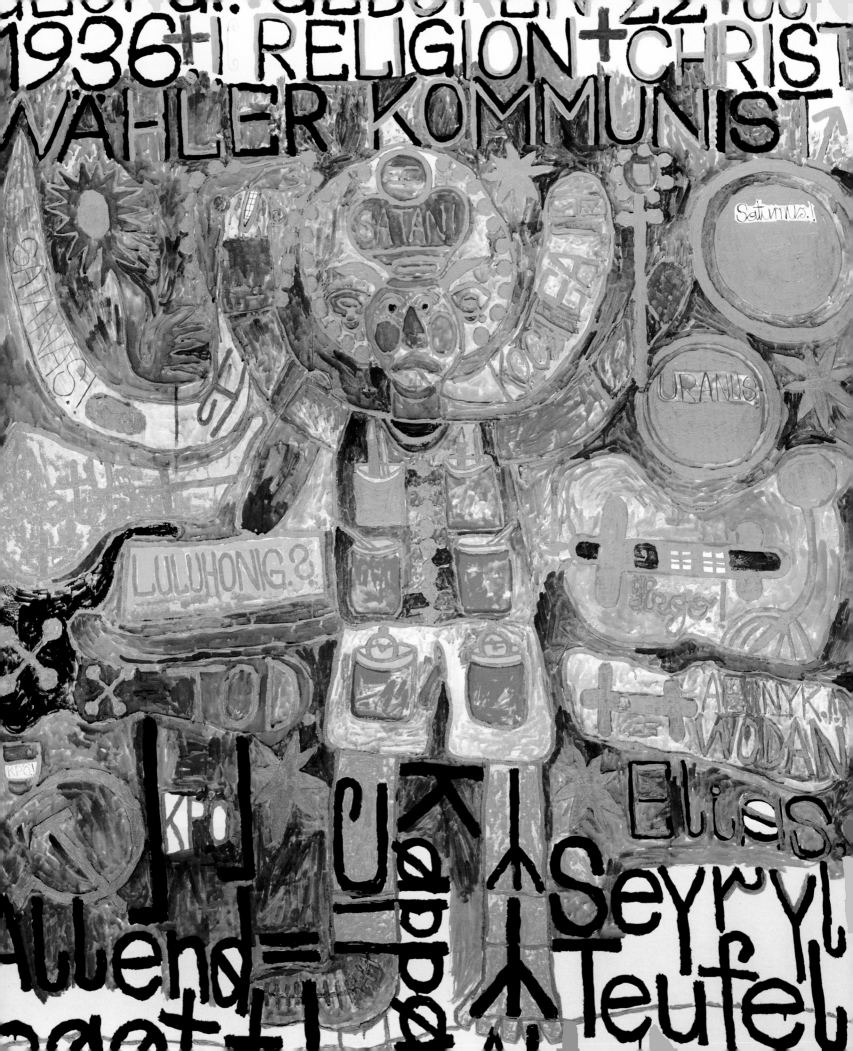

August Walla

hile viewing August Walla's emphatic expressions of himself and his world, we find ourselves, once again, in the "realm of the unreal," recalling John MacGregor's admonition that only an exceptional tolerance of the irrational can make such work accessible.[1] Once again, we find an artist who is, indeed, strangely accessible, no matter how personal and idiosyncratic his self-depiction or confusedly structured the world he pictures. If Walla's world, being so completely focused on his own sense of the mystery and passion of personal existence, at first appears to exclude us, we begin to decipher clues of a common condition within his private symbols. Through the eyes of the outsider, we see the enveloping presence of religious and political forces in the cultural surround, and we observe the personal drama of one man's confrontation with the existential enigmas of sexuality and death. We cannot but be aware as well that Walla boldly proclaimed to all—as had Adolf Wölfli, Aloïse Corbaz, and Henry Darger before him—that he was the absolute center of a world at once ecstatic and threatening.

The paintings of August Walla (1936–2001) confront us straight on. Assertive in their palette, they are boldly drawn, text-ridden works. Their enthusiasm for the immediacy and power of both word and image is inescapable. They present large blocklike caricature figures, all drawn in flat frontal perspective, gesturing amid cluttered fields of large-script words and a profusion of private and public symbols. The works have the energy and directness of carnival signs and the intensity of commercial banners communicating earnest messages to—and perhaps *for*—us.

Unreserved in their tone, the abundance of images, words, signs, and symbols overwhelms any coherence to which the works might aspire. They are filled with normally incompatible, even contradictory, signs and symbols and thrust forth a medley of unrecognizable words, oddly misspelled texts, and rarely a clearly articulated statement. *Untitled (Teufelgott [Devilgod])* (1984; fig. 1), for instance, boldly announces Walla's name and birthdate, though his name is misspelled and reordered (he was born August Alois Georg Walla). Extending this declaration of self is the avowal: "Religion + Christ, Voter Communist." Expecting the figure below to represent a self-portrait, we find a creature whose head bears two horns, a halo, and a crown emblazoned with the word "SATAN.!." In his left hand, he bears a scepter; in his right, he holds a snake, also labeled "SATANAS.!." A penis emerges from his opened pants. He is surrounded by symbols such as the Christian cross, the hammer and sickle, the abbreviation KPÖ for the Communist Party of Austria, and private signs and amorphous forms bearing words such as "GOD"; "LULUHONEY"; "DEATH"; "WODAN" (Wotan); "URANUS"; SATANAS; as well as a jumble of words at his feet, some unrecognizable, others provocative, including "Allah"; "Devil"; "Elias"; and "End-of-All-God."

This proliferation of familiar and idiosyncratic words and images reveals Walla's utter fascination with vessels of meaning and his syncretic enthusiasm to marshal all elements of his emotional life. Similarly, Walla appealed to the gods of all religions—and invented a good number of them himself—to manifest themselves within his existential and spiritual

OPPOSITE: Detail of August Walla, *Untitled (Teufelgott [Devilgod])* (fig. 1)

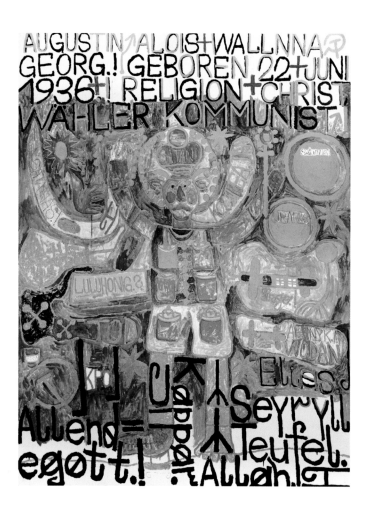

universe. In the ecstatic *Alle heiligen Götter (All Holy Gods)* (1984; fig. 2), for instance, a pantheon of gods appears, among them Zeus, Allah, Buddha, Neptune, Wotan, Sabaoth (the Lord of Hosts), the "Jewish god" Elias, and the Half-Devil God, as well as Death and Satan. At the far right, Walla included an image of himself, horned and winged, holding both a hammer and sickle and a cross (toward which Satan below him reaches). Divinity—and death—is ever present in Walla's art, as are political symbols and blatantly exhibitionist sexuality, all promiscuously gathered at the call of the painter. The works ever transmit Walla's childlike awe of himself, his immediate family, his surroundings, and the mysteries of life, death, and eternity, all of which merge in a confusion of realms at once exalted and frightening.

The works seem grounded in the Catholic catechism, within which the blessed figures of the women in his life— his mother and deceased grandmother—hold an angelic place. Walla, however, pictured himself excluded, deemed without religion (*religionslos*). He often labeled himself "half-hellish," allied with the devil, yet still bound to the religion in which he was raised but from which he felt expelled, most likely for his robust carnality. Walla often painted himself nude or partially clothed with phallus exposed, often discharging urine or semen. Many of his self-representations (as well as the devil and Satan images) bear a double-pronged penis signifying that member's dual secretions (see fig. 3).

If Walla felt himself a sinner, he was nonetheless flamboyantly self-assertive, alternately as a boy (*doppel-bube*), a man, a hunter, an angel—or even a God. However vital Catholicism might have been in his life, ultimately it proved inadequate to define him or constrain the threat of death. Thus, his works admit images of the death god, while appealing to all gods of the world—including Satan, even in his form as the painter Walla—for protection from death (see *Weltallenedeteufelgott Walla.? [End-of-universe-devil-god Walla.?]*; fig. 4).

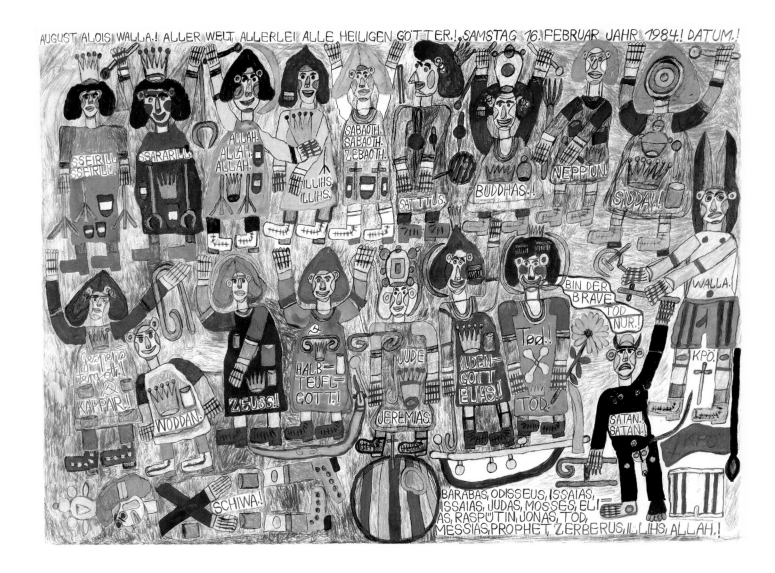

AUGUST ALOIS WALLA.! ALLER WELT. ALLERLEI ALLE HEILIGEN GÖTTER.! SAMSTAG 16. FEBRUAR JAHR 1984! DATUM.!

Walla's body was shameless, his spirituality expansive, his alliance with earthly powers unbound. He often declared himself a communist angel, holding in balance the symbols of antagonistic systems of belief. Indeed, he identified extensively with parties of the left—especially the Communist Party of Austria (KPÖ); the Socialist Party of Austria (SPÖ), with which he associated his mother; and the power of Russia, particularly in connection with his experience of puberty. In addition, Walla depicted swastikas throughout his works and

linked himself with Adolf Hitler, calling himself the diminutive Adolli, for almost all references to Nazi power are associated with his childhood. Indeed, like many artists, Walla constructed his imagery from an intensely lived and imagined life. His works depict a domain where the joys, fears, mysteries, and fervent desires stirred up by a life over which he had little control could be engaged, explored, and made subject to his manipulation.

FIG. 2. August Walla, *Alle heiligen Götter (Pandemonium) (All Holy Gods [Pandemonium])*, 1984. Gouache and colored pencil on paper. Collection de l'Art Brut, Lausanne

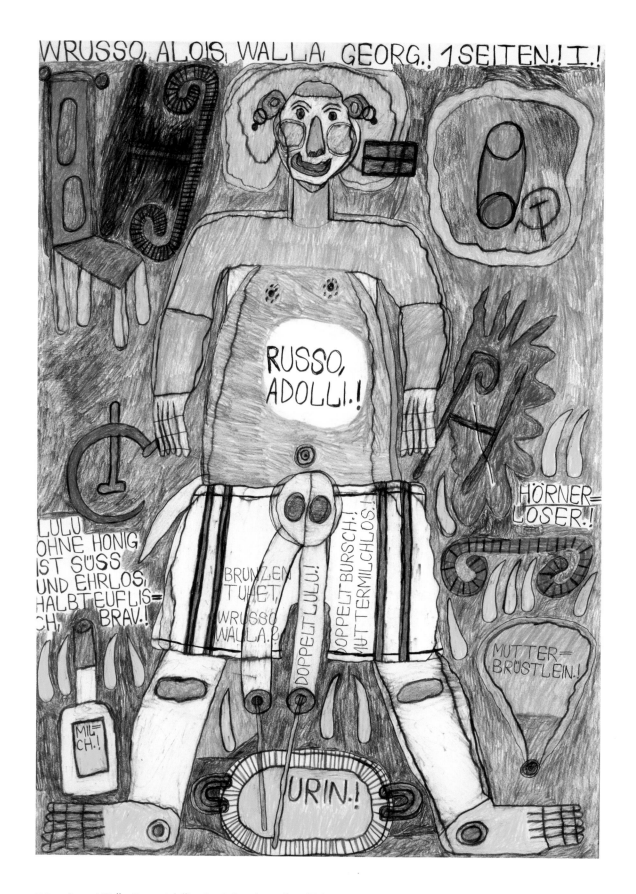

FIG. 3. August Walla, *Russo Adolli*, 1984. Colored pencil and ink on papier collé on Pavatex, 27½ x 19⅝ in. (70 x 50 cm). Collection de l'Art Brut, Lausanne

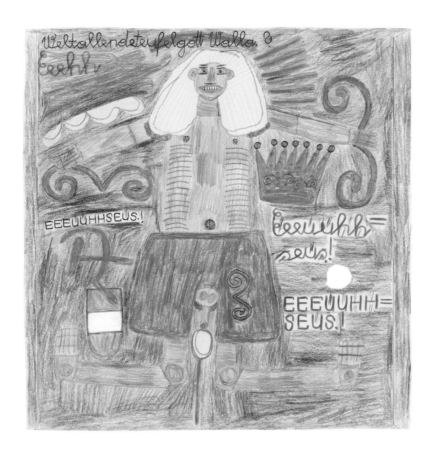

August Walla led an extremely marginal existence, both socially and mentally. Having been observed from early childhood to suffer from mental problems, he was deemed a mental incompetent by the state, which excluded him from public schools and prohibited him from voting. He also never held employment. Branded an idiot by childhood classmates and adults alike, Walla felt acutely vulnerable and sought in his art and his daily life means to protect and assert himself.

Born an illegitimate child to a forty-year-old mother and a sixty-year-old father who refused marriage and had but slight involvement with his family, Walla was protected and cared for by his mother throughout her long life and, early on, by his grandmother, who lived with them when he was a child. He was especially close to his grandmother, apparently shared a bed with her and was greatly affected by her death when he was six, possibly witnessing the event firsthand. She

appears in his paintings and drawings both as a figure communicating from beyond the grave and as a fixture in imagined family portraits. In one work—*Wir als die ganze Famiele Walla, als Engeln in Himmel (We as the Entire Walla Family, as Angels in Heaven)* (fig. 5)—his absent father joins them.

Beginning at age four and a half, Walla was taken to Viennese clinics for childhood health and mental disorders, staying at times for extended periods of diagnosis and treatment before being returned to his mother's care. He received various inconclusive or questionable diagnoses. During World War II, he was seen by Dr. Ernst Illing, who was later executed for his role in sending mentally defective children to their deaths under the Nazi euthanasia program. Fortunately, Illing believed young Walla could benefit from attending a special school for "backward" children, in which he was enrolled until he was fifteen. At sixteen he was sent to the mental

FIG. 4. August Walla, *Weltallenedeteufelgott Walla? (End-of-universe-devil-god Walla?)*, n.d. Pen, pencil, and colored pencil on cardboard, 12¼ x 12 in. (31 x 30.5 cm)

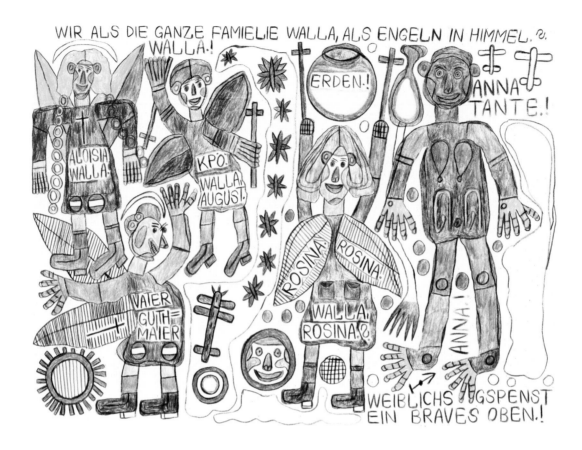

hospital in nearby Gugging for having threatened to burn his home and to commit suicide. He was treated there for several years both as a resident and as an outpatient living with his mother.

During these years, Walla and his mother shared a life of extreme marginality in the small town of Klosterneuberg, north of Vienna. Theirs was an intensely close bond; he was completely dependent on her. Inordinately shy, he followed her closely when in public and remained silent, letting her engage with others. She, who had barely adequate financial means, was totally devoted to him. She submersed herself in his mental world, allowing his fantasies and desires full expression. The two were known by their unkempt appearance and

odd ways, for which they were at times excluded entry to stores and restaurants. They lived in public housing for the indigent but were at times evicted because of their poorly managed housekeeping. At one point, they lived much of the year in a garden shack near the Danube River, sleeping outside exposed to the elements, until they were one again forced out by their neighbors, who bulldozed the disorderly habitat.

Nevertheless, this period and place represented paradise for Walla throughout his life. It was a world apart where he imagined creating a protective realm, shared with his mother, to which he sought continual return. He filled the garden and shack with found and made objects, painting significant words and symbols on household items or on signs hung

FIG. 5. August Walla, *Wir als die ganze Famiele Walla, als Engel in Himmel (We as the Entire Walla Family, as Angels in Heaven)*, 1984. Crayon, 17 1/4 x 23 5/8 in. (44 x 60 cm)

throughout the environment. These were avidly photographed by Walla as testament to his successful intervention in a world of his making. It was a domain of deeply personal symbolic meaning, one sanctioned and shared by his mother.

Walla was returned to Gugging in 1972 for care while his mother entered the hospital for an operation. There he met Dr. Leo Navratil, who, while administering a diagnostic test in which the patient drew a human figure, was struck by Walla's strongly articulated work. He subsequently visited Walla and his mother at their garden encampment, where he discovered the extent of Walla's creations. Although Walla was not a resident patient, Navratil continued to visit and treat him. He believed that Walla exhibited signs of schizophrenic behavior, possibly influenced by early childhood encephalitis. Navratil had been studying the creativity of schizophrenics and he supported the artistic activities of a group of patients with diverse mental disorders at the Gugging facility. He encouraged Walla's creativity and included his art in the exhibitions of works by Gugging patients, which he introduced to the mainstream art world. In 1983 Navratil noted the seriously deteriorated living conditions of Walla and his mother and realized the eighty-eight-year-old woman could no longer care for herself or her son. He arranged for them to be put under state care and found a place for them in the newly established Haus der Künstler (House of Artists) at Gugging.

The Haus der Künstler is a residence facility where small groups of mental patients who exhibit significant artistic ability are allowed to live and encouraged to work freely at their art. For Walla, it was a space of protection and support where his artistic activity flourished. Given his need to shape his immediate environment through words, signs, and symbols, he was permitted to paint the walls and ceiling of his room, which he did exuberantly (see fig. 6). He then continued outward, painting the building's exterior walls and sidewalks, as well as placing signs in trees throughout the wooded environment.

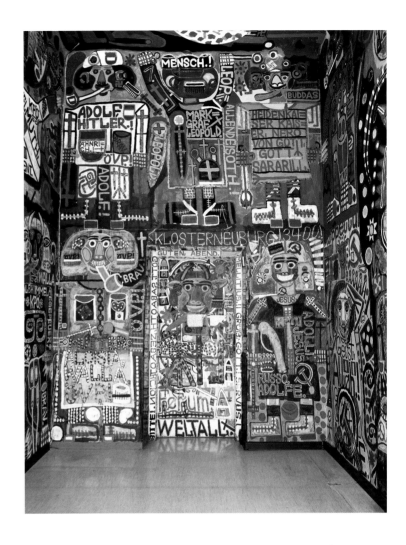

Despite this freedom and support, Walla often chafed at his institutional confinement. Usually shy and silent in public, he relied on the written word to communicate. Instead of speaking with his doctors, he sent messages through the post or, more dramatically, wrote on the pavement around the building phrases such as *IRRENHAUS* (crazy house) and *IDIOTENANSTALT* (idiot asylum). When his mother was removed to the hospital's geriatric facility, Walla greatly resented the separation, even though he visited her every day; he marked

FIG. 6. August Walla's room at the Haus der Künstler in Gugging

the pavement: *PFLEGER SIND KEINE MUTTER!* (Caretakers are no mother!). Walla often threatened to kill himself should his mother die; when she did, he ceased creating for several years, but then resumed until his death at age sixty-four in 2001.

Encountering Walla's art we are again challenged, as with many outsider works, by the appeal of its visual immediacy and the insular, almost alien qualities of his personal vision. Amid the profusion of figures, words, and symbols in his densely packed compositions, Walla transmitted a vision of a world of profound meaning and inherent order. Michel Thévoz has noted Walla established a "personal mythology" that is "at once both delirious and rigorous."[2] However delirious Walla's private cosmogony may be, we recognize his adoption of symbols of religious and political power presented in a "rigorous" visual and thematic order through which our world is seen anew.

Our entry into Walla's art is aided by the decades-long observation and support of Walla by Navratil, described in his book *August Walla: His Life and Art* (1988). As a psychiatrist, Navratil viewed the works primarily to diagnose his patient's psychological condition and thus read them principally for their latent and manifest content, deciphering much of the complex and often overdetermined realm of words and images in Walla's visual field.[3] Navratil's studies illuminate Walla as a subject of turbulent emotion and conceptual disorder caused in part by the distorting effects of his mental illness, as well as by his limited education, his social isolation, and his mother's active intent to keep him ignorant about sexuality. Yet all Walla's creations—built and altered environments, writings, drawings, and paintings—can be seen to reflect a ceaseless and passionate effort to understand, explain, and control his experience of his body and mind, and of the spiritual and earthly powers around him. Walla's symbolic realm is constructed around imagery derived from the Nazi and communist presence in his youth, the discovery

of death, the associations of the afterlife and the existence of the gods, the child's fascination with bodily functions and the onset of sexuality, and the concomitant if confused notions of sin, vitality, the devil, heaven, and eternity.

For example, Walla was two when the Anschluss occurred and Austria was annexed by Nazi Germany. He lived through the war for nine years under the fascists and was eleven when the Russian army began its ten-year-long occupation of the Niederösterreich region of Austria, where Walla and his mother lived. The symbols, acronyms, and names associated with both fascism and communism assumed such great power for Walla that he appropriated them as ubiquitous markers of personal understanding and annunciation. Similarly, the catechism and symbols of Catholicism had deep resonance for him, and he pictured himself, his mother, and his grandmother in an imperfect and addled interpretation of their meaning. The death of his grandmother when he was six introduced a lifelong terror of death and fear of ghosts and opened his mind to the cosmic mysteries of gods, eternity, and life beyond the known world, as well as the possibility of the end of everything and the fervent hope for the reappearance of all.

Walla conjoined all these signs, symbols, fragmentary concepts, and imaginative associations through an assertion of self, especially his physical being. He never lost the child's and early pubescent's enthrallment with the body and its compelling pleasures—especially, it seems, masturbation and urination—or the fascination with the physical changes that mysteriously occurred. Hence, we encounter images of sinful *"religionslos"* Walla, as frequently as we do the flamboyant two-pronged spurting penis *"doppeltlulu"* Walla. He is half-sinful, half-devil, yet double enriched. From his penis urine, sweet honey, and condensed milk flow (see fig. 3). The milk also links him to his beloved mother, and images of "mother's breasts" and mother's milk often accompany his self-portraits. Walla had learned there were differences between sexes, and

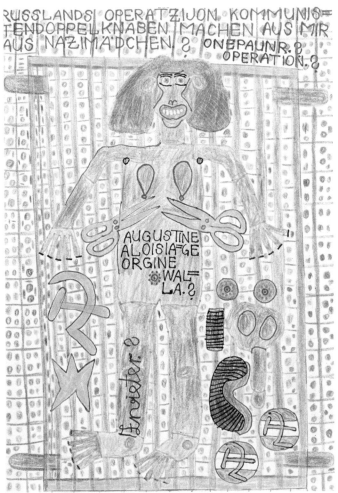

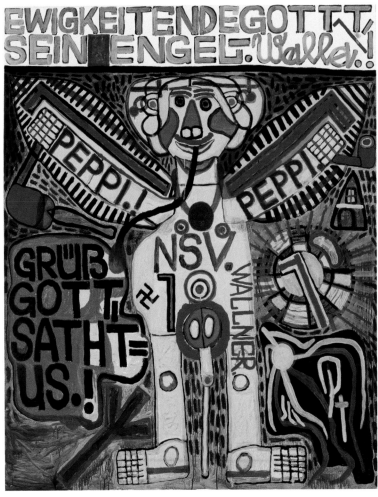

he believed that the onset of puberty changed him from a little girl to a young man. Because this occurred during the era of the shift from Nazi to Soviet occupation, he often portrayed a "Russian operation" in which his breasts were removed and new penises attached, changing him from a "*Nazimädchen*" to a "*communistbube*" (see *RUSSLANDS OPERATZIJON KOMMUNISTENDOPPELKNABEN MADCHEN ALS MIR AUS NAZIMÄDCHEN.?*; fig. 7). When Walla did not picture himself as a half-devil, he declared himself a

"*communistangel*" linking the ideals of earthly and religious power with the bravado of young manhood (see *Ewigkeitendegott, sein Engel. Walla.! [End-of-eternity-god, His Angel. Walla.!]*, 1987; fig. 8).

Walla often employed punctuation—specifically, a period followed by an exclamation point, *Walla.!* —to characterize emphatic declarations throughout his art and writings. Each word and image is laid down in dramatic assertion of Walla the creator. Although silent in public, Walla found voice in

FIG. 7. August Walla, *RUSSLANDS OPERATZIJON KOMMUNISTENDOPPELKNABEN MADCHEN ALS MIR AUS NAZIMÄCHEN?*, n.d. Pen, crayon, and marker, 11⅝ x 8¼ in. (29.5 x 21 cm)

FIG. 8. August Walla, *Ewigkeitendegott, sein Engel. Walla.! (End-of-eternity-god, His Angel. Walla.!)*, 1987. Acrylic on canvas, 78¾ x 63 in. (200 x 160 cm)

constant writing. Words lie at the core of his world and his works. They appear on the signs and objects that he placed everywhere in his home and in the garden environment of his youth. When he designed his room at the Haus der Künstler in Gugging, he drew the words first, giving structure to the wall, and then painted the images. Subsequently, he continued to paint over the words or images to add new ones. A number of his paintings depict single words or symbols that compete with other text for space within the frame. Many are palimpsests that accrue in power even as their origins are obscured (see figs. 9–11).[4]

Evident in all these works are the potency Walla found in words and symbols and his joy manipulating them. He was an avid collector of foreign dictionaries, plumbing them for words that would accentuate the messages he transcribed, and then altering the words according to his own system of spelling and associative meanings. Assuming total

liberty with many languages allowed him both a global extension of self and a private coded realm of freedom. Significantly, Walla showed no knowledge of or interest in the geographical sources of the languages he appropriated. He stands at the center of his world; the words encompass the cosmos and join in a glossolalia that speaks a private, all-encompassing language.

Walla's eccentric language is most evident in his many works that are composed primarily of text. *Vater unser der du bist in dem Himmel (Our Father Who Art in Heaven)* (c. 1980; fig. 12) begins as the familiar Lord's Prayer, slips into prayers of the rosary, then morphs into a list of Walla's gods and foreign words, fragmentary prayers to the holy mother and Mary Magdalene, and, finally, references to Nazi and Russian prayers from a "religion-less Russian student." Clearly, Walla took delight in the plastic aspect of words, changing the color and style of the scripts and placing symbols among the neatly

FIG. 9. August Walla, *MYXYNHA*, n.d. Varnish on metal plate, 20⁷/₈ x 22 in. (53 x 56 cm)

FIG. 10. August Walla, *Palimpsest with Crown*, n.d. Varnish on metal plate, 20⁷/₈ x 22 in. (53 x 56 cm)

hand-drawn characters. For Walla, far more than for many outsider artists who incorporate text in their art, words have weight equal to images. The word is image. The intensity of this immersion in language led Navratil to suggest that Walla was primarily a writer, even though his enthusiasm for the graphic elements of language and imagery produced powerful visual works.

But Navratil also asked whether Walla's creations should be called works of art. They are certainly expressions of human meaning borne within powerful and often beautiful visual terms. Navratil argued, however, that by viewing them purely aesthetically we are either applying the wrong criteria or focusing on a narrow aspect of their creation from a position outside their intended use. Walla's creations have purposes other than the aesthetic: *Vater unser der du bist in dem Himmel* (fig. 12) is a prayer; *Weltallenedeteufelgott Walla.?* (fig. 4) is an existential declaration of identity. For Navratil, Walla's work is, at its essence, an effort to control a threatening world through the power of language and image.[5] His creations allowed him to manipulate the space before his eyes and the environment around him as a reflection of his imagined potency and freedom.

Navratil readily admitted that his understanding of aesthetics was limited. Unlike Hans Prinzhorn and Walter Morgenthaler, Navratil at first did not know much about modern art. He initially viewed the forms and themes of patients' visual creations as diagnostic tools and only later developed an interest in the relationship between art and mental disorders. All of his writing on art and the artists he treated as patients focuses on understanding their psychological and psychiatric condition; the artworks are referred to as "spectacular symptomology."[6]

Navratil's perspective was enriched only after he encountered Arnulf Rainer and other Viennese artists who responded strongly to those at Gugging. These artists taught Navratil how to "go further . . . from the purely diagnostic aspect, to the aspect of art itself,"[7] and helped him learn "to select what was artistically relevant."[8] Despite this tutelage, Navratil's avid support of the Gugging artists had less to do with the aesthetic value of their work than with the salutary effects the patients might receive from recognition by the art world. For the Gugging patients, the creation of art became a stabilizing form of behavior, which also gave them the possibility to connect with the external world or at least achieve a valued social identity. To Navratil, the connection between patient-artist and viewer was probably more important than the appreciation of the specific works. Believing that even the most serious schizophrenic desired connection to the external world, he offered those patients who were creative a means for that contact: "They give us and—I am certain also the schizophrenic patients—a feeling of mutual relatedness, a common bond."[9]

By establishing the Haus der Künstler, Navratil initiated a new model for treatment of the mentally ill: a form of art therapy that shifted the goal from the rehabilitation of patients into society to the endorsement of their creativity within the conditions of their illness. Moving beyond the earlier model of mere committal of the insane as well as more recent practices that encouraged reliance on neuroleptic medications to allow some patients to re-enter society,

FIG. 11. August Walla, *LULUHONIG*, n.d. Paint on commercial sheeting, plastic clothes line, 10⅝ x 19⅛ in. (27 x 48.5 cm)

FIG. 12. August Walla, *Vater unser der du bist in dem Himmel (Our Father Who Art in Heaven)*, c. 1980. Graphite and colored pencil on paper, 15¾ x 11¾ in. (40 x 30 cm). Collection de l'Art Brut, Lausanne

Navratil recognized that some patients who needed institutional care could be creative and therapeutically helped within their illness.

Navratil's work at Gugging has influenced other institutions that emphasize the therapeutic values of artistic activity, some of which—La Tinaia in Italy, Atelier Incurve in Japan, and Creative Growth Art Center in California—have enabled high artistic achievement to be attained by individuals with great disabilities. All of these facilities emphasize the essential freedom to create without invasive artistic guidance by staff.

Since Navratil's retirement in 1986, Gugging has evolved from an institution focused largely on therapy into a "grounds for art" ("ein ort der kunst"), an environment for artists who need social support. Under Navratil's successor, Johann Feilacher, a doctor and accomplished professional artist, Gugging has been renamed the Art/Brut Center Gugging. The center, now separate from the hospital, serves both as a residence and workspace for artists with mental disabilities and as a locale for the exhibition and sale of their works. The creations of Gugging and other art brut artists presented at the center are declared the professional and creative equivalents of mainstream artists. Their work is presented solely as art.

Many of the original Gugging artists brought together by Navratil have died, and new artists have been admitted and nurtured by Feilacher. Yet the Haus der Künstler is perhaps best represented by two of Gugging's earliest artists: Oswald Tschirtner and Johann Hauser. The spare, minimalist drawings of Oswald Tschirtner (1920–2007) exhibit an assured line and absolute command of space. His abstracted figures appear on mostly blank grounds, though he occasionally graced the paper or canvas with a succinct, sometimes poetic, title. Through the barest of figurative means, Tschirtner managed to capture the essence of his subjects—whether inanimate objects, animals, or the individuals or groups of people he most frequently depicted. Three simple marks indicate an

eye, a mouth, and an ear. Heads are perched on elongated bodies identified solely by thin parallel lines. In *4 Tanzpaare (4 Pairs of Dancers)* (1972; fig. 13), the bodies might well be greatly extended necks. In other works, these cephalic creatures seem to have no torsos, but eight parallel lines indicate pairs of equal-length arms and legs so that they seem to be some form of four-legged creatures with human heads. Yet there is nothing monstrous about Tschirtner's figures; rather,

FIG. 13. Oswald Tschirtner, *4 Tanzpaare (4 Pairs of Dancers)*, 1972. Indian ink on paper, 9⅝ x 12⅜ in. (24.5 x 31.5 cm). Collection de l'Art Brut, Lausanne

they have a calm grace and a comic air about them in their simple facticity.

Tschirtner was committed to the sanatorium at Gugging following his service in World War II. A retiring but gracious person, he would only create at the urging of either Navratil or Feilacher. Navratil would often suggest subjects to which he would respond in his unique style. Tschirtner showed little interest in the reception of his art or its exhibition in solo or group shows. He preferred reading the Bible and doing puzzles.

Johann Hauser (1926–1996) was recognized by Navratil in the 1950s and became one of the first and most acclaimed artists at Gugging. His work is noted for his mastery of using colored pencils in two distinct drawing styles. In the first, he rendered images of single objects in simple precise forms, one of which—a blue, four-pointed star—became the institution's emblem. Alternately, Hauser created intensely worked, heavily layered, richly hued drawings, often depicting provocative images of women. In these works, Hauser grossly exaggerated the women's features, usually focusing on the genitals and torpedo-like breasts above which grimacing,

toothy faces are surrounded by elaborate explosions of hair (see fig. 14). Hauser established dramatic contrasts of color and dark tonality built through forceful and repeated passages of pencil work, sometimes denting or tearing the paper.

Navratil attributed Hauser's two styles to his medical condition, which shifted from manic to passive stages. Hauser had been transferred to Gugging at age twenty-three after some six years at another institution, which had declared him feeble-minded, never advancing beyond the mentality of an eight year old. Working with Navratil, he began drawing, taking inspiration from magazine photographs, pinups, photo-news items, and images of weapons. Despite his mundane sources and social remove, he developed a rigorous control of an aesthetic image of great communicative power.

Judith Scott (1943–2005) could not communicate except through her sculptural works and the emotive power of personal presence. Born deaf with acute Down's syndrome, she spent much of her first forty-three years in institutions for people with severe disabilities, until she was located by her healthy twin sister, whom she had not seen for thirty-six

FIG. 14. Johann Hauser, *Untitled No. 89-016*, 1986. Pencil and colored pencil, 28¾ x 40⅛ in. (73 x 102 cm)

years. Having been brought into her sister's home, she was enrolled in the arts workshop program at Creative Growth Art Center in Oakland, California, where she began to create the yarn-wrapped biomorphic forms that are her singular gifts (see fig. 15).

Scott amassed skeins of yarn, string, jute, and plastic filaments to wrap, tie, and bind found objects under progressive layers of material. Whether the hidden objects had personal significance or emotional resonance or whether they served primarily as armatures cannot be known. Similarly, whether the shapes that developed through the wrapping process signify figurative or symbolic presences will remain mysteries. Their construction was an intensely physical process, engaging Scott in close bodily manipulation of materials and the work, which she would embrace and then take leave. They now enter our space and consciousness, their meanings to be drawn out of our own silences.

Notes

1. John M. MacGregor, "La création d'un monde alternatif," in Lucienne Peiry, ed., *Ecriture en délire*, exh. cat. (Lausanne: Collection de l'Art Brut, 2004), p. 23. MacGregor, of course, was speaking of the work of Henry Darger.
2. Michel Thévoz, *The Art Brut Collection, Lausanne* (Zurich: Swiss Institute for Art Research, 2001), p. 117.
3. Leo Navratil, *August Walla: Sein Leben und Seine Kunst (August Walla: His Life and Art)* (Nördlingen: Greno, 1988). Although some viewers of Walla's works resist Navratil's emphasis on medical etiology, he was an assiduous and perceptive viewer of Walla's art.
4. In *LULUHONIG* (LULU-HONEY), *Naraka* is Indonesian for hell; *batu* is Walla for *honey*.
5. Leo Navratil, "La calligraphie de August Walla," in Peiry (note 1), p. 38.
6. Leo Navratil, "Art Brut and Psychiatry." *Raw Vision* 15 (Summer 1996), p. 46.
7. John Maizels, "Interview: Dr. Leo Navratil," *Raw Vision* 34 (Spring 2001), p. 48.
8. Leo Navratil, "The History and Prehistory of the Artists' House in Gugging," in *The Artist Outsider: Creativity and the Boundaries of Culture*, ed. Michael D. Hall and Eugene W. Metcalf, Jr. (Washington, D.C.: Smithsonian Institution, 1994), p. 202.
9. Navratil (note 6), p. 46.

FIG. 15. Judith Scott, *Untitled (Blue Form)*, 1995. Synthetic and natural yarns with found objects, 23 x 7 x 8 in. (58.4 x 17.8 x 20.3 cm)

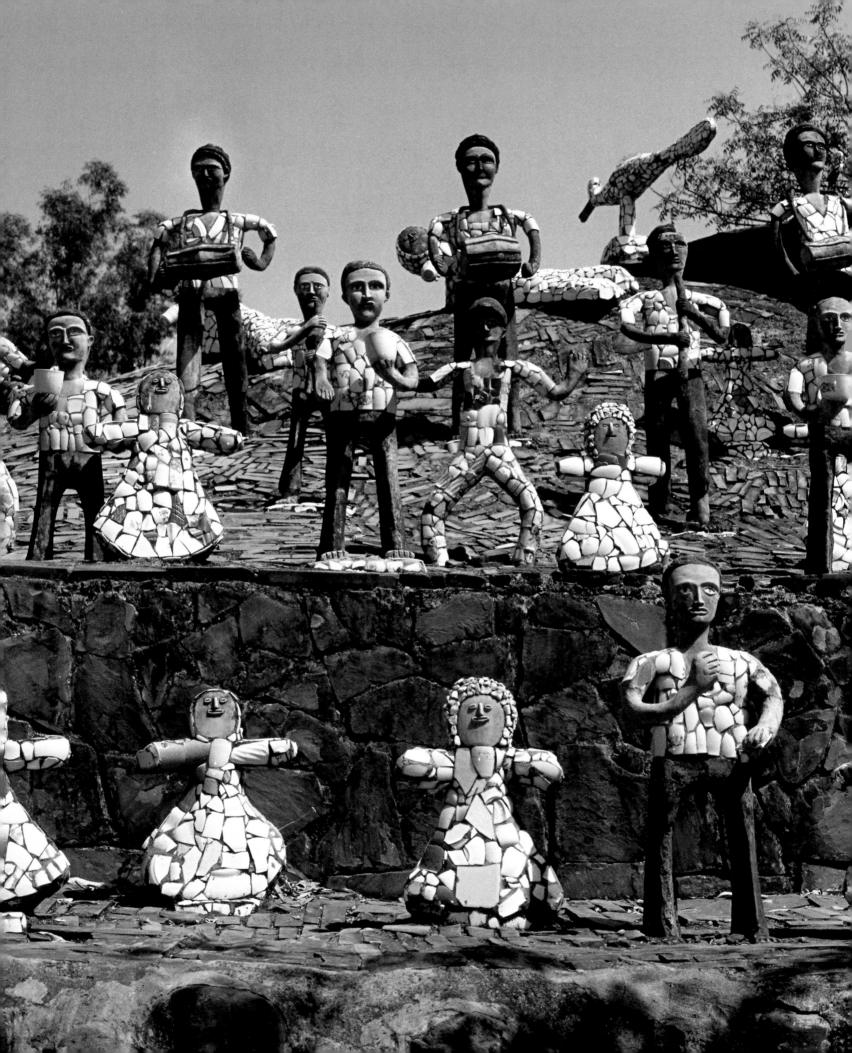

Nek Chand

ek Chand (born 1924) demonstrates the imaginative vision and fervency of creation that characterizes the greatest of outsider artists—attributes that are shared by all great artists, trained and untrained alike. He took up his life's artistic mission in secret, in an act of illegal appropriation of public land in defiance of the government of Chandigarh, India, for which he worked. Like the most impassioned outsider artists, he felt compelled to create a physical expression of an ideal dream world regardless of social convention and law. Yet that creation proved to be so deeply in tune with the spirit of his culture that it has become the embodiment of the aesthetic and spiritual commonweal. His deepest dreams have established a physical environment—The Rock Garden—that embraces, and is embraced by, India's masses. The outsider speaks for the core of society.

One does not experience Chand's Rock Garden alone. This once private, clandestine environment built on the edges of Chandigarh now attracts some two thousand visitors daily. What had previously been the hidden realm of a visionary individual who illegally appropriated publicly owned wasteland is now nationalized property, the second most popular tourist destination in all of India, surpassed only by the Taj Mahal.

The Rock Garden is an eighteen-acre artwork.[1] It is a visually rich site containing over three thousand sculptures and naturally formed rocks dramatically placed throughout a multichambered, constructed environment through which viewers are led via an intricate web of winding walkways. The Rock Garden is an ambulatory experience, one in which

OPPOSITE: Human and animal figures from Nek Chand's Rock Garden, Chandigarh, India (fig. 7)

FIG. 1A. Passageway leading to the first waterfall from Phase 1 (1972–78) of Nek Chand's Rock Garden

space is encountered sequentially and visitors are ever attuned to the rhythm of their movements within the constantly shifting landscape of closed and open, light-strewn or shadowed areas. The sensation is at once kinesthetic and optical. It stirs the emotions and provokes reflection on elemental existence in space—our physical world, our spiritual cosmos.

Walking through the garden, viewers often find the terrain closing in on them in narrow passages whose stone walls rise thirty feet. In those walls, a myriad of oddly shaped weathered stones are embedded. They suggest faces or biomorphic shapes, which texture and animate the mineral realm though which the viewers pass (see fig. 2). Then, suddenly, plazas come into view where hundreds of statues of

FIG. 1B. Amphitheater and waterfall from Phase 1 (1972–78) of Nek Chand's Rock Garden

humans and animals are arranged on sloping fields of stone or mosaic or placed on raised rock walls (see fig. 3).

Even though this is called a *Rock* Garden and stones are indeed everywhere, the mineral terrain is richly animated by lush vegetation, flowing streams, and dramatic waterfalls cascading down rock embankments (see fig. 4). Furthermore, inserted high into the landscape are architectural creations of varying size, ranging from a diminutive archaic peasant village built from rudimentary stones to the mosaic-encrusted domes of Mughal-style palaces.

Following the paths through the constantly shifting terrain, viewers can frequently lose their orientation. At moments one can peer across the walls to lower areas where other visitors walk—perhaps in advance or perhaps following. The

FIG. 2. Rock walls from Phase 1 (1972–78) of Nek Chand's Rock Garden

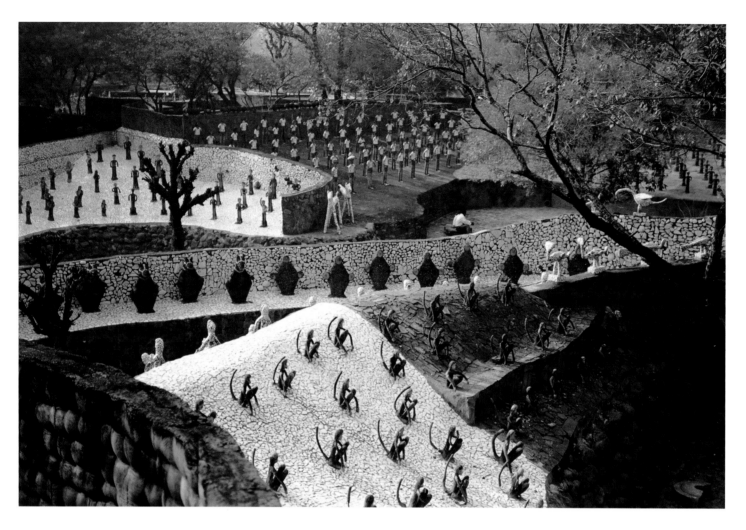

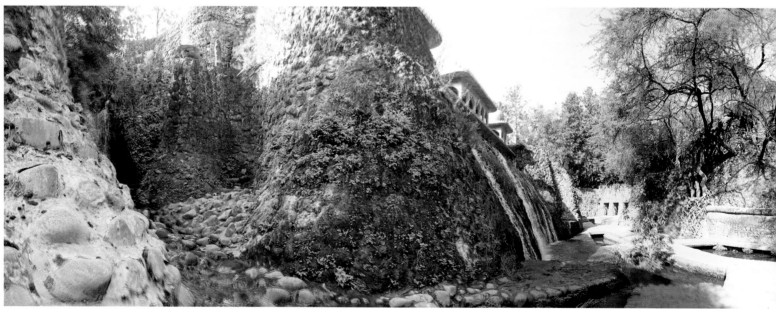

ABOVE: FIG. 3. Animal and human figures from Phase 2 (1976–78) of Nek Chand's Rock Garden

BELOW: FIG. 4. Panoramic view of Phase 1 (1972–78) of Nek Chand's Rock Garden

garden is never glimpsed in its entirety. Rather, viewers are rooted in successive moments of perception, each one constantly renewed by the next turn in the path or passage across a plaza. A heightened sense of structured time has intentionally been built into the garden experience and reflects the environment's development as a public site. The garden was built in phases, and although one's movement through those discrete phases may be unmarked, upon reflection one recognizes the choreography of sequential movement and perception.

Phase I (constructed from 1972–76) bears closest connection to Chand's original vision. Comprising several chambers linked by narrow passageways of stone walls, this section seems the most naturalistic, to the extent that the builder's imprint lies primarily in the arrangement of elements of the natural world—rocks, water, and vegetation. However, the environment is somewhat illusory: constructed walls are made to look like naturally occurring canyons; built waterfalls spill down hills on which miniature stone huts are perched. No matter how naturalistic, the landscape features numerous signs of the human realm, such as the small buildings, the shrinelike structures built into walls, and the archways

and arcades through which viewers walk. Stagelike stone embankments—some encrusted with mosaics built from porcelain shards of plumbing and electric fixtures—present suggestively shaped eroded or extruded rocks for contemplation (see fig. 5).

In Phase 2 (1976–78)—into which one may have passed without notice—the displayed rocks are replaced by figurative sculptures. Some assume amorphous, often biomorphic, somewhat human shapes. Several have oddly geometric torsos with multiple protruding faces that smile at the viewer (see fig. 6). Most, however, are recognizably representational humans or animals, ranging in size from less than a foot to five feet high; in Phase III some stand fourteen feet high. Queens, water carriers, partying celebrants, lepers, soldiers, boys, monkeys, tigers, and birds, to name but a few of the sculpted inhabitants, are lined up in massive, separate but conjoining installations.

The sculptures are frequently built from gray or flesh-tinted cement on metal armatures and are variously covered with recycled domestic and industrial materials: porcelain shards, colorful broken wrist bangles, or ground industrial slag. Created in many styles, the figures may display minimally

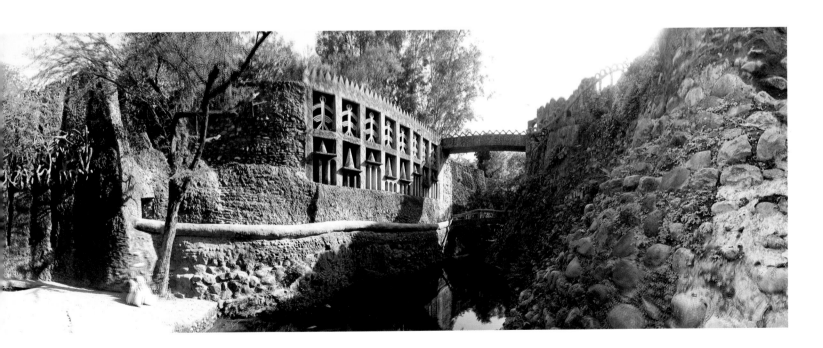

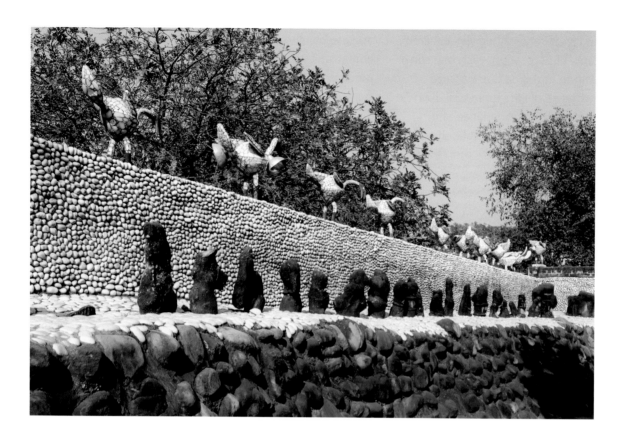

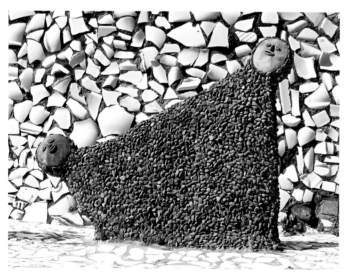

inflected expressions etched in flat cement faces; others are embellished by broken shells used as eyes; while still others are adorned with shocks of real human hair. These unusual and unexpected mixed materials establish an aesthetic of contrasting color and texture. In some groups of men or boys, the figures' upright, rigid postures are emphasized by a stark contrast of white tunics, formed of smooth ceramic shards embedded in concrete, and dark brown pants, composed of rough fragments of foundry slag. Other figures in the group wear a reverse palette of white pants and brown tunics.

Because they are formed from concrete applied over metal armatures, many of which are made of recycled bicycle frames, most of the sculptures assume stiff poses, empha- sized by the multiple replications of similar figures. Yet each

ABOVE: FIG. 5. Weathered stones on raised platforms from Phase 1 (1972–78) of Nek Chand's Rock Garden

BELOW: FIG. 6. Two-headed figure modeled on a bicycle frame from Phase 2 (1976–78) of Nek Chand's Rock Garden

piece is slightly different, having been given some expression of individuality, and in spite of their rigidity, many possess a delicate lyricism. One group of women water bearers is especially captivating. They bend to their right to grasp their buckets, while their torsos twist left; their eyes, mostly made of bright white cowrie shells, look up at the viewer, communicating a constrained yet intense presence.

Seen en masse arranged in regularly spaced rows on raised beds, the human and animal figures appear as if lined up in full-frontal display for our pleasure. But given the care and individuality that have gone into the articulation of each face — especially the wide-open, observant eyes — it seems as if they might well be staring back, watching the mortals that pass on display for them (see fig. 7).[2]

In Phase III, begun in 1983 and still under construction, the masses of sculptures increase dramatically in number and size, the plazas expand, and the architectural elements grow to monumental scale. Though massive, the space is much less exotic and mysterious. This section of the garden is built for crowd pleasure; it depicts simulated romantic ruins and royal palaces and displays imposing engineered

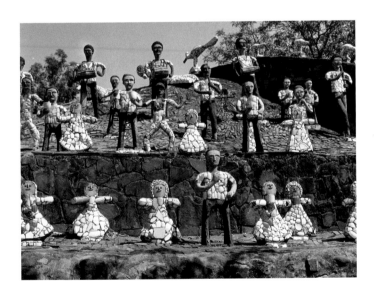

archways. Spectacular waterfalls are meant to awe and please the eye, and stone amphitheaters await crowds of many hundreds for musical and dramatic performances. Open plazas often host weddings, and families are usually seen playing on large swings suspended from the massive arches over which large white horse sculptures stand. Here, the garden is given over to the crowds who stroll through it every day and to the sculptures and rocks that permanently inhabit the site, patiently accepting the passage before them of the humans seeking pleasure, respite, or soulful awakening. And observing them almost daily is Chand, the former peasant farmer who once conceived of constructing a strictly private realm for himself.

Nek Chand Saini (he dropped the last name decades ago) was born in December 1924 in a small agricultural village in Punjab. Unlike most village children, he received a high school education by living for several years with an uncle in a larger town before returning home to become a farmer, as was traditional in his community. However, his life and that of his entire family and village was radically disrupted by the 1947 partition of Pakistan and India following India's independence from British rule. Chand's family found their village abruptly located within the new borders of Islamic Pakistan and, being Hindus, they were forced to flee into India, joining the massive and violent cross-border migration of many millions of Hindus and Muslims. Unlike the hundreds of thousands who died during the tumult, Chand's family successfully reached the Indian section of Punjab, but only after leaving all they possessed behind. Shortly thereafter, Chand struck off on his own, secured work in the Public Works bureaucracy, and, having married in 1954, moved to Chandigarh in 1955 as a road inspector for the Public Works Department.

Following the partition, Chandigarh was conceived as the new capital of Indian Punjab (the former capital, Lahore, was now in Pakistan). Proposed by India's first prime minister,

FIG. 7. Human and animal figures from Phase 2 (1976–78) of Nek Chand's Rock Garden

Jawaharlal Nehru, Chandigarh was meant to be a triumphant assertion of the new and rising India. In characteristic post-colonial fashion, however, the Indian government elected to adopt a Western high modernist architectural style to signal its legitimacy as a world power. Planning the city became the project of Swiss architect Le Corbusier, his largest urban venture. Located on a broad plain with a distant view of the sacred Himalayas, Chandigarh was designed as a rigidly ordered space, divided on a grid of thirty-seven sectors in which five hundred thousand people would live.

As a symbol of the modern state, the new city was to embody a vision of collective perfection, made manifest in the minimalist purity of concrete and concept. In declaration of this vision, a city edict was issued "to enlighten the present and future citizens of Chandigarh about the basic concepts of planning the city so that they become its guardians and save it from the whims of individuals."[3] Not mentioned in the edict were the interests of an estimated nine thousand residents of twenty-four previously existing villages that had been leveled by the government to make space for the new city.

In the course of Chand's job as road inspector, he encountered remnants of these villages strewn in the rubble on which Chandigarh was being built and in mounds of debris at the garbage dumps. He also had the opportunity to observe the erection of Le Corbusier's vision and its innovative construction techniques for building free-form cement structures.

As much as Chand's eye was caught by the scattered debris of past village life, he was even more drawn to the weathered and water-tossed shapes of stones and rocks he observed in dry river beds. The rocks, which had been washed down from the mountains during monsoon floods, spoke to him of a spiritual, animist presence: "All the stones have a soul. . . . They are alive. . . . The stones are like gods and goddesses: there is life in them. Whenever I look at them or pass them, they touch my heart. When we look at them, they look at us too."[4]

In 1958 he began collecting these stones, transporting them on his bicycle as many as twenty-five miles from the rivers where they lay to a special hidden site he had cleared on the outskirts of Chandigarh. The site was a rough patch of dense vegetation, located in the wild, untouched boundary of the city used initially as a barrier against unplanned encroachments upon the architecturally designed center of Chandigarh's governmental zone. Chand had the idea of creating a magical place that recalled a childhood tale of a mythological "immortal king" of a kingdom where "all the denizens . . . whether they are human beings, birds or animals, have been endowed with immortality as a fruit of good deeds they had done in their mortal life."[5]

The locale Chand chose was public land. His appropriation of it for his private purposes was analogous to the growing squatter communities of displaced people in the "informal sectors" of Chandigarh.[6] Yet although Chand's action was illegal, it was made possible largely by his status as an official of the Public Works Department. The site was situated behind Public Works buildings. It was easy for him both to build a wall of barrels to disguise its presence and, apparently, to appropriate materials for his project from the government stores. At times, he also had his employees help with the heavy work.

However, Chand's creation of his private space within the thicket was primarily a private venture, an arduous act of personal passion. Working weekends, holidays, and at least four hours after work often deep into the night, he cleared the site, collected building materials, and began planning his private realm. For seven years (1958–65), he transported large numbers of found rocks and cleared a half-acre space in the dense brush to store and sort them. He also transported tons of detritus of the destroyed villages and abandoned materials gathered from public and private rubbish heaps at local factories, hospitals, and businesses. From crockery shards, broken electrical fittings, and discarded

bicycle parts, he would later create figurative sculptures to inhabit the space. He also rolled and carted barrels and pots of water to cisterns he had built in the dry scrubland. The water was to be used for his cement constructions and early sculptures and to nourish the hundreds of flowering plants and tree seedlings he brought into his developing garden. Having amassed the rocks, salvaged materials, and plants, in 1965 he began to organize the cleared space and build his structures, sculptures, and display sites.

As Lucienne Peiry has remarked, Chand led a dual life: functionary by day; visionary by night.[7] As a functionary, he well knew the power of bureaucracy and the danger to his site and job of his illegal appropriation of city land. As a visionary, he was convinced of the site's sacred value and strove to keep it hidden. Nonetheless, early in 1972, a city work crew came across the site and word quickly spread throughout Chandigarh of a remarkable realm of rocks and sculptures hidden on the edge of the city. Hundreds turned out to see it and the city's government was thrown into a quandary about how to respond to the unsanctioned place.

Despite calls to punish the interloper, city officials recognized the popular response to the site and its potential touristic appeal and economic value to the city. Thus, the chief commissioner of Chandigarh recommended that the garden be "preserved in its present form, free from the interference of architects and town planners."[8] In effect, the visionary artist who had contravened the original city edict preserving Chandigarh's architectural vision from the "whims of individuals," was now to be protected from the urban designers themselves.

Chand's dream space enchanted many in the city, and he soon received materials and support from individuals and businesses. Spurred by this response and government sanction, he was not content merely to preserve the site in its "present form," but rather redesigned, significantly expanded, and greatly transformed it. From an inwardly directed private

space, it was turned outward to become a public realm. Chand and his assistants landscaped the space, built walls and walkways between discrete chambers for viewing the formally displayed rocks and early sculptures, and created a miniature Punjab village that might have reminded him of his childhood home as well as the villages that once existed within the city's footprint.

In 1976 the garden was officially opened as a nationalized site. Chand was named creator-director with an annual construction budget, work crew, and heavy moving equipment at his command. The site was also given an official name—The Rock Garden—though Chand privately demurred, stating that "it's a child's dream and not a garden of cold rocks . . . it is my poetry with rocks."[9]

Over the next three decades, Chand made the Rock Garden a vast space of considerable poetry, a magical realm that found favor with millions of visitors. Nonetheless, he encountered much resistance and was subject to the subterfuge of various city officials angered at the growing acclaim of and demands placed on them by a lowly former peasant who had defied legal authority. Chand fought successful court battles to prevent demolition of the Phase 3 area, and when efforts were made to build a road through the garden, more than a thousand citizens formed human shields around it, preventing bulldozers from leveling the garden and convincing the State Assembly to cancel the road.

The citizenry's protection of the garden was a dramatic display of the great popularity of the site, which, though begun as a purely personal realm, had been transformed into a public possession. Chand's private vision engaged India's collective spirit. Here, what has been called "outsider" art proves more culturally affirmative than the aesthetic of high modernism officially endorsed and imposed as the architectural vision for the region.

As private vision turned public terrain, the Rock Garden is a remarkable example of a worldwide phenomenon of

constructed environments shaped by outsider and vernacular artists who transform parts of the given world into aesthetic and spiritual creations. These artists take common social behavior—the decoration of one's home, yard, or immediate surrounding—to qualitatively distinctive levels of visionary creativity.

Constructed environments are manifestations of the formidable sense of self evident in many outsider artists; they are expressions of a primal interaction between the individual and the natural world; and they reveal an individual's relationship with the immediate social community. As such, they articulate the psychological, spiritual, and communal or political dimensions of experience, expressed through the aesthetic.

The process begins as an existential statement. Constructing the environment is an act of primal meaning making. It is a self-enactment locating the artist within a chosen and self-defined portion of the physical world. In effect, the world as found is rejected as insufficient to the artist's greatest needs, and the artist's creation is an expression of his or her underlying belief in the possibility of affecting, if not determining, the terms of our existence. Roger Cardinal has noted the "distinctive density" or self-presence of outsider artists. Unfettered by or in implicit rebellion against social convention, the outsider transmits onto the personally constructed environment an "aura of intensity and urgency" through which "an

acute discharge of psychic energy" finds physical form, testifying to both the artist's self-assurance and his or her passionate struggle with intensely personal subjects.[10] Thus, while the environments are frequently beautiful, they may also inspire awe and mystery, for they clearly bear more than solely aesthetic significance.

"All the stones have a soul. . . . They are alive"—the Rock Garden proclaims the animating spiritual presence of the natural world. Chand's initial vision was an expression of associative recognition. The abstract shapes of the rocks fascinated him with their figurative suggestions. The contortions within the masses seemed at once human, bestial, and divine and were charged with "the mythic, the erotic and the primitive."[11] Especially the erotic and bestial: many of the early rocks have a brute presence suggestive of a turbulent energy finding corporeal vitality (see figs. 8–10). Chand placed these rocks on pedestals and raised embankments so that they would be encountered in the first moments of passage through the garden (see fig. 5). They invite the viewers to engage their own imaginative and associative responses to something present, yet mysterious. As in a dream, perception hovers between recognition and creation. The world steps forward announcing its presence, inviting a response. Something seems recognizable, yet in its deformation suggests a realm of otherness, of possibility that extends beyond the known.

FIGS. 8–10. Weathered stones from Phase 2 (1976–78) of Nek Chand's Rock Garden

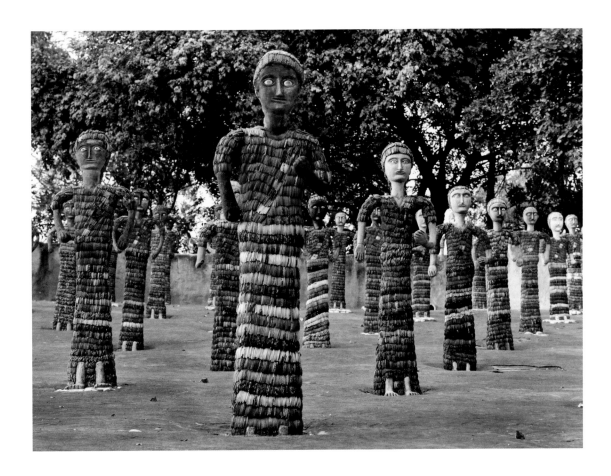

Chand responded further to felt presences in the natural world by creating more figural works. In part in mimetic response and perhaps because he was not academically trained, his early constructions are often strangely shaped, only partially humanoid figures. Faces are perched on oddly shaped partial torsos or vaguely biomorphic shapes. Increasingly, once the garden became a public site, the works assumed much more clearly representational forms of humans or gods who have taken human and animal shape. Significantly, none of these sculptures bears any of the erotic, bestial, or brute associations of the found rock. Rather, they are ceremonial, chaste, and precise in their social identities.

The representational figures are identifiable as types—boys, soldiers, queens, and partygoers—often placed in groups suggestive of narrative situations, as when the queens emerge from their bath or are observed on high by the king (see fig. 11). Their stately presentation suggests they belong to another dimension of time and space. Chand placed the garden's origins in a "child's dream," a place built for gods and goddesses whom he would attend. Evidently, many who come to the Rock Garden experience something of that child's sense of possibility. To the extent that the entire garden is "seeded" in a mythological tale known from childhood by Chand and his visitors,[12] the sculptural groupings can be seen as symbolic embodiments of an eternal present. For the viewers who constantly move before and through these static figures, the garden may evoke a sense of time present and eternally recurring.

Time also manifests itself on the plane of human history. Chand's decision to build his sculptures and embellish the

FIG. 11. Queen figures from Phase 2 (1976–78) of Nek Chand's Rock Garden

walks, platforms, and architectural structures almost entirely with recycled material found in the remnants of destroyed villages and in the detritus of the new city signals his memorial, organic, and spiritual disposition. The garden affirms the natural process of recycling. Nature recycles everything; what was once alive is drawn upon to sustain succeeding life.

Recycling and bricolage are common in outsider and vernacular art, both because the artists have little access to resources or professional art materials and because of personal reasons, such as an artist's desire to preserve and honor cultural tradition. For Chand, the discarded materials gathered from the destructive intrusion of Chandigarh into rural village life carried a human history. He returned the human trace into a natural, cosmic rhythm and embedded it in an environment of minerals, water, and vegetation that celebrates humans and gods—a garden linking human and spiritual realms. Similarly, his frequent use of industrial construction materials—especially cement, which is the defining element of Chandigarh's sterile modernity—repositions modern culture within the natural realm (see fig. 12).

Walking through Chand's Rock Garden is meant to be a spiritual experience. The many archways through which one passes from chamber to chamber are purposively built low so that one must bow one's head and acknowledge one's humility before creation and the gods when entering their presence. Each passage into a new courtyard enacts a renewal of self within a new moment. Because these passages are choreographed by Chand, he has been called a shaman leading others through a ritual of initiation and redemption.[13] The journey that this "shaman" takes the visitors through is not into the frightening depths of the dark mysteries; rather, it is a recalling of the self to the recognition of the gods and goddesses always already present. The soul is liberated from the limits of the quotidian world and one finds oneself receptive to the spiritual life communicated through the physical world. Fittingly, the garden is a park, a place apart, a playground, a public entertainment, and a delight. The laughter and cries of surprise that one hears throughout the garden signal the achievement of heightened spiritual and human awareness brought forth through an aesthetic experience.

The garden is, at base, a work of art. It is an aesthetic experience in the richest, most expansive sense. It begins with personal recognition and manifests itself within the life of the imagination. The garden is intended to stimulate a spiritual awakening and a contemplative experience that affirms one's sense of being. The world that we have long known is seen anew; things never seen but sensed are brought into view.

The remarkable phenomenon of an individual's personal vision made manifest in singular objects or environments that capture the imaginative spirit of many thousands of people recurs throughout centuries and across the globe. Whether the artist was moved by sacred, secular, or aesthetic passions, the urge to transform the given world finds deep resonance in the desires of many who travel to see the constructions as tourists, pilgrims, or seekers of heightened artistic and imaginative life.[14]

Le Palais Idéal (see fig. 13), perhaps the most famous visionary environment, was constructed between 1879 and 1912 by the rural French postman Ferdinand Cheval (1836–1924) in the small town of Hauterives. Much like Chand, he became fascinated by the oddly shaped rocks he stumbled across on his daily rounds. Struck by the suggestive biomorphic forms he perceived in them, he decided to amass them and bring them home in a wheelbarrow after work. As he walked his postal route, Cheval had dreamed of building "a fairy-like palace beyond imagination . . . with grottoes, towers, gardens, castles, museums and sculptures . . . trying to bring back to life all the ancient architectures and primaeval times."[15] The found stones provoked him to build it. Working entirely on his own and teaching himself rudimentary

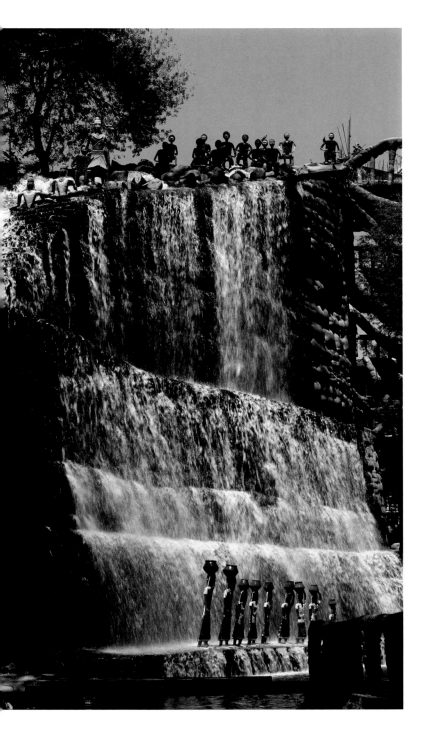

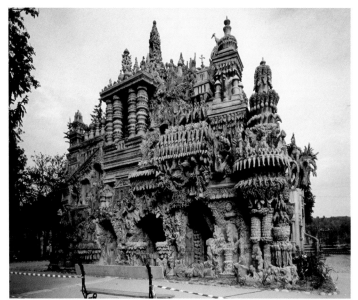

masonry skills, Cheval spent the next thirty-four years constructing a building—thirty-three feet high, eighty-six feet long, forty-six feet wide—encrusted with concrete sculptural figures, animals, and plant forms, as well as ornamental reliefs, shell mosaics, and elaborate stone work. Within the structure is a long gallery containing miniature replications of other architectural delights: an "Arabian Mosque;" a Swiss chalet; the Maison Carrée of Algiers; and a medieval chateau, among others.

Cheval has been considered the exemplar of the self-taught artist who dedicates his or her life entirely to personal vision. He was aware that his creation provoked amusement in his neighbors, yet he dismissed their criticisms, realizing that most people ridicule what they do not understand. He preferred to realize his dream and later enjoyed the acclaim he received from his former detractors and the wider world when *Le Palais Idéal* was recognized as the marvel it is. Cheval wished to be buried within his dream, but when denied by the public authorities, he instead constructed an elaborate tomb for himself in the local cemetery.

FIG. 12. The Great Waterfall from Phase 2 (1976–78) of Nek Chand's Rock Garden

FIG. 13. Ferdinand Cheval's *Le Palais Idéal* (1836–1924), Hauterives, France

The Italian immigrant to America Simon (born Sabato) Rodia (1879–1965) also built his dream, but walked away from it. From 1921 to 1955, Rodia built what are now known as the Watts Towers in the front yard of his home on a small one tenth of an acre triangular lot in Los Angeles (see fig. 14). Working alone—his third wife left him shortly after he began his time-consuming project—and without tools, Rodia constructed three tall towers and six smaller ones made of structural steel bars, rods, and pipes covered by mortar embedded with glass, shells, and pottery shards. The tallest tower rises nearly one hundred feet. Rodia surrounded his lot with a concrete wall, also encrusted with mosaics and reliefs, tall enough to shut out the distractions of the external world. Without architectural plans, engineering or welding experience, or access to building machinery and scaffolding, he built the environment entirely by hand, developing inventive methods to bend steel bars, wrap them with wire mesh, cover them with concrete, and link them together without rivets or bolts. While a great self-taught engineering feat, the towers also possess a remarkable beauty created by the proportion and balance of their architectural structure and the visual dynamism of the contrasting dense materials and delicate streams of light that flow through the towers' interstices.

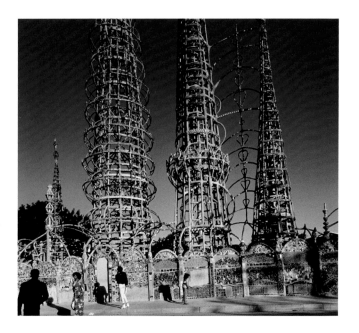

Billowing circular structural forms moderate the angular skyward thrust of the narrow conical towers. The cement that covers the towers is contrasted with the vibrant colors of the shells and shards embedded in it.

Although he was said to have called the environment *Nuestro Pueblo* (Our Town), Rodia offered no explanation for its creation, giving vague, incomplete, contradictory comments when asked. Most apt, perhaps, is his statement: "I had it in mind to do something big, and I did." Looking for possible models for the towers' form, if not their meaning, scholars have pointed to the regional Italian religious festivals of Rodia's native province, where towerlike structures called *gigli* are borne on the shoulders of believers in ceremonial parades. Rodia, however, voiced strong anti-Catholic sentiments and gave no indication of nostalgic feelings for his youth. Perhaps he did not look back in general. In 1955, at the age of seventy-six, he gave the deed to the land to a neighbor and moved away.

The Heidelberg Project, the extended environment built by Tyree Guyton (born 1955), is neither monumental nor beautiful. Like Chand's Rock Garden, it is built on land Guyton does not own, yet he constructed it in full view of his neighbors and public authorities, not always to the latter's pleasure. Guyton grew up in the city of Detroit and witnessed the devastation occasioned by the riots of 1967, when many neighborhoods saw destruction and abandonment of homes. Heidelberg Street, where he was raised, had numerous vacant lots and abandoned homes, some of which were used for drug trade. In 1986 Guyton—with the help of his then wife; his grandfather, Sam Macky; and the neighborhood youth—began cleaning up the area, collecting its refuse and using it to create an art environment much like an extended yard show (see fig. 15). Transformed into "gigantic art sculptures," derelict buildings were painted, a number with what became the project's trademark, bright polka dots. Found domestic objects, clothing, furniture, and toys were spread

FIG. 14. Simon Rodia's Watts Towers (1921–55), Los Angeles

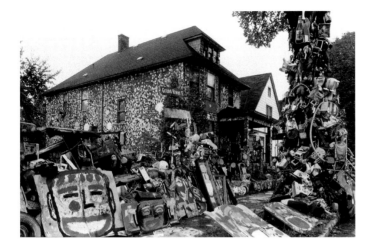

across empty lots and piled against and on top of buildings. Objects were hung in trees and the sidewalks and streets painted. Not incidentally, these visual markers created an unwonted visibility for the drug sites, and the trade moved out of the area.

To the eyes of city officials, it looked like a junk-strewn neighborhood. Despite considerable local support for the Heidelberg Project, city council resolutions were twice passed, in 1991 and 1999, to demolish some of the offending buildings. At the same time, Guyton and the project were winning national and international recognition and support, and the site had become a major tourist attraction. (Today some 275,000 visitors pass through every year.) The government was conflicted. One year after the city passed the first demolition resolution, Guyton received the Michigan State Governor's Artist of the Year Award. In 1997, two years before the second city assault, the city's Cultural Affairs Department gave Guyton a grant to construct a welcome center at the site. Currently, the Heidelberg Project is accepted as a community development project of economic and artistic significance. It is also considered a model for other cities to embrace a form of public environmental art, a far cry from the self-generated actions of an individual and his family.

Notes

1. Although estimates have reached forty acres, the total expanse is closer to thirty acres, eighteen of which are accessible by the public.
2. Lucienne Peiry made a slightly different observation, commenting on the massed statues: "They appear in tens, their intent gazes turned towards the viewer. As they saunter around, visitors necessarily partake of a movement that runs counter to the hieratic immobility of the statuary." Lucienne Peiry, "Nek Chand's Kingdom in Chandigarh," in *Nek Chand's Outsider Art: The Rock Garden of Chandigarh*, ed. Lucienne Peiry (Paris: Flammarion, 2005), p. 21.
3. The Edict of Chandigarh, quoted in Leslie Umberger, "Nek Chand: A Tale of Two Cities," in *Sublime Spaces and Visionary Worlds: Built Environments of Vernacular Artists*, exh. cat. (Princeton: Princeton Architectural Press/Sheboygan, WI: John Michael Kohler Arts Center, 2007), p. 320. See also Soumyen Bandyopadhyay and Iain Jackson, *The Collection, the Ruin, and the Theatre: Architecture, Sculpture and Landscape in Nek Chand's Rock Garden, Chandigarh* (Liverpool: Liverpool University Press, 2007), p. 35 n. 15.
4. Umberger (note 3), p. 321.
5. S. S. Bhatti, "The Rock Garden of Chandigarh," *Raw Vision* 1 (Spring 1989), repr. in *Raw Vision 1-2-3* (2005), p. 28.
6. Ibid., p. 31.
7. Peiry (note 2), p. 13.
8. Bandyopadhyay and Jackson (note 3), pp. 13–14.
9. Ibid., p. 14.
10. Roger Cardinal, "Figures and Faces in Outsider Art," in Simon Carr, Sam Farber, Allen S. Weiss, et al., *Portraits from the Outside: Figurative Expression in Outsider Art*, exh. cat. (New York: Parsons School of Design Gallery/Groegfeax Publishing, 1990), p. 22.
11. Bandyopadhyay and Jackson (note 3), p. 26. Iain Jackson discussed the various configurations of the found rocks and provided many more images on pp. 25–29, 57–63.
12. Bhatti (note 5), p. 28.
13. Peiry (note 2), p. 31.
14. Information about the international phenomenon of built environments can be found in the following sources, among others: *Raw Vision 1-2-3* (2005), esp. 1, 2; John Maizels and Deidi von Schaewen, *Fantasy Worlds*, ed. Angelika Taschen (Cologne: Taschen, 2007); Roger Manley and Mark Sloan, *Self-Made Worlds: Visionary Folk Art Environments* (New York: Aperture, 1997); and Umberger (note 3).
15. Ferdinand Cheval, "The Story of the Palais Idéal, Hauterives," *Raw Vision* 38 (Spring 2002), pp. 24–25.

FIG. 15. Tyree Guyton's Heidelberg Project (begun 1986), Detroit

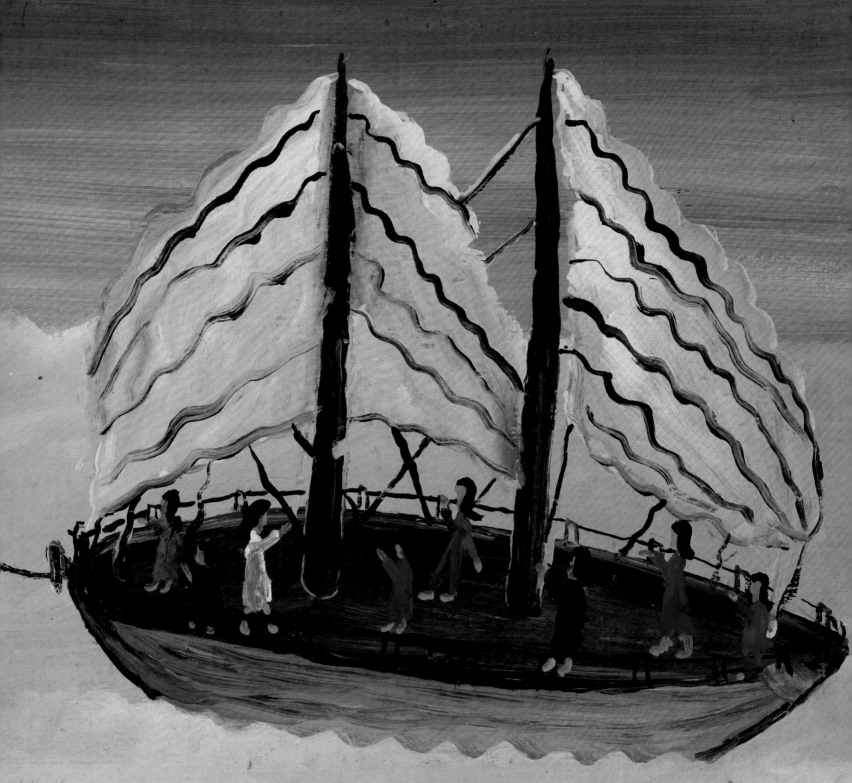

R FOR A MAN TO HAVE A MILL S
NECK AND CAST INTO THE MIDS
THAN TO OFFEND ONE OF G
BE CAREFUL PLEASE

Howard Finster

Howard Finster (1916–2001) was a singularly creative artist, an environment builder, and a preacher who exemplified the rural religious culture of the American South. His art is an expression of a uniquely vivid imagination deeply rooted in a shared collective sensibility. His complex vision encompassed the personal and the canonical, the religious and the secular, the biblical and the kitsch. He was at once a humble instrument of God and an eccentric, egocentric showman; his message was fundamentally conservative, yet delivered through imagery based as much in modern pop culture as in the Bible. Finster assumed his audience to be both those already familiar with the Lord's message and infidels unknowingly ready to be saved by the sudden revelation of his painting and sculpture.

Finster's uniqueness derives from his conjoining of seemingly disparate, even contradictory, religious and secular concepts, metaphors, and attitudes. Although his body of work oscillates between the sacred and the profane, it is constantly grounded in his visions of God's plans for earth, which Finster presented through a mixture of personal, biblical, folk, and pop-culture imagery.

Three of the first paintings by this southern evangelical minister and artist were originally nailed to the cement walls of his four-acre constructed environment, Paradise Garden, in Pennville, Georgia. Because they were hung adjacent to one another, they are often viewed as a triptych, though they are in fact separate works. Yet they share an aesthetic, a spiritual vision, and a didactic intent. Each painting is a landscape inspired by biblical themes of sin and salvation. Passages from holy scripture and the artist's commentary appear throughout the works, usually in small lettering that becomes integral elements of the whole. Finster's frequently misspelled words assert significant presence by visually contrasting with the ground, identifying the biblical scenes, and offering appropriate holy textual readings.

The Lord Will Deliver His People across Jordan (1976; fig. 1) contrasts a landscape representing this earth of troubles and woe with God's heavenly kingdom across the River Jordan. Standing on the river, Jesus holds out his hands so that his believers "want haf to cross Jordan alone," as the text superimposed on the blue water announces. The lower third of the painting lists the sins, sorrows, and inequities of earthly life in texts so densely overwritten that the green grass appears darkened and despoiled. Tiny figures labeled "false prophets," "fornicators," "Long Tongue Liars," and "Rich" are depicted within Finster's field of condemnations. A sole, white-robed figure reaches out to Christ, appealing "DELIVER ME OH LORD." Across the water, the kingdom of "ETURNAL LIFE," in contrast, is marked by open expanses on which magnificent castles rise toward the blue sky where angels float. Other saved souls walk the green, unmarked ground, "the Green Pastors." Words describing the pleasures of heaven— "KINDNESS"; "LOVE"; "PEACE"; "CONTENTMENT"— are written on white walkways leading to the mansions.

In contrast to the pacific greens, blues, whites, and reds of this work, the broad swaths of deep red and dirty green and blue in *And the Moon Became as Blood* (1976; fig. 2) limn a scene of apocalyptic horror. Texts from the Book of

Revelations caption images of God's angels pouring forth blood on the land. Broad bands of red—"The River of Blood" and "Sea of Blood"—compose over half of the landscape, while a blood-red moon, a "Winepress of Blood," and "The Fountain of Blood" hover over or flood the land and rivers with blood. Save for the artist's signature, the sole texts are either passages of biblical prophecy or identifying captions. The third painting, *Ther Shall Be Earthquakes* (1976; fig. 3), adopts a similar strategy, depicting Christ standing atop a mountainous landscape of tumult filled with tiny figures falling or clinging to steeply pitched slopes. Amid the chaos, Finster has included Old and New Testament passages proclaiming earth's sinful and temporal status versus God's unchanging being.

Finster united word and image in almost all his works to deliver admonitory messages. Drawing on biblical texts, the artist exhorted his audience to envision with him their lives and future. Illustration is balanced by textual passage; biblical authority by Finster's personal voice. His paintings are charac-terized by flat coloration, minimal perspective, and naively drawn figures and scenes; his texts by simple, declarative didacticism. The pieces vary greatly, however, in their mix of a personal and a traditional message, and Finster's perspective often dominates, especially in works that depict his "visions" of other worlds that meld religion and science fiction. *This Board Shows a Speck of God's Endlass Space* (1978; fig. 4) presents a cosmic landscape of the many planets that Finster believed God created. Indeed, Finster's indignant tone seems to ask: Who dare presume that this "earth's planet" is the only one in the universe?

IF MAN OF EARTHS PLANET WAS MADE IN GODS OWN IMAGE AND IN GODS LIKENESS AND MAN DON'T STOP ON 500 THOUSAND CARS. DON'T STOP ON 200 THOU-SAND SHIPS OR 40 THOUSAND PLANES OR 29 MILLION HOUSES THEN WHY DO YOU THANK GOD WOULD STOP ON ONE LITTLE 6-DAY JOB ON EARTH PLANET CANT YOU SEE GOD,S. PLANET WORK IS BEYOND NUMBER

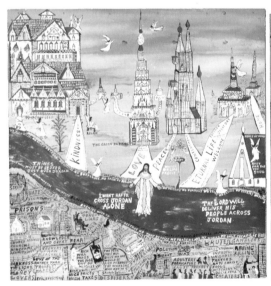
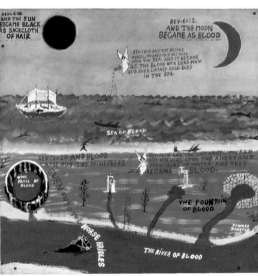
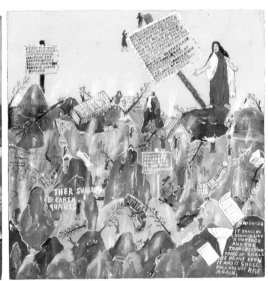

FIG. 1. Howard Finster, *The Lord Will Deliver His People across Jordan*, 1976. Enamel on fiberboard, 30⅛ x 29⅝ in. (76.4 x 75.1 cm.) Smithsonian American Art Museum, Washington, D.C.; Gift of Herbert Waide Hemphill, Jr. (1988.74.6)

FIG. 2. Howard Finster, *And the Moon Became as Blood*, 1976. Enamel on fiberboard, 29½ x 30⅛ in. (75.0 x 76.4 cm). Smithsonian American Art Museum, Washington, D.C.; Gift of Herbert Waide Hemphill, Jr. (1988.74.7)

FIG. 3. Howard Finster, *Ther Shall Be Earthquakes*, 1976. Enamel on fiberboard, 30 x 29⅝ in. (76.2 x 75.2 cm). Smithsonian American Art Museum, Washington, D.C. Gift of Herbert Waide Hemphill, Jr. (1988.74.8)

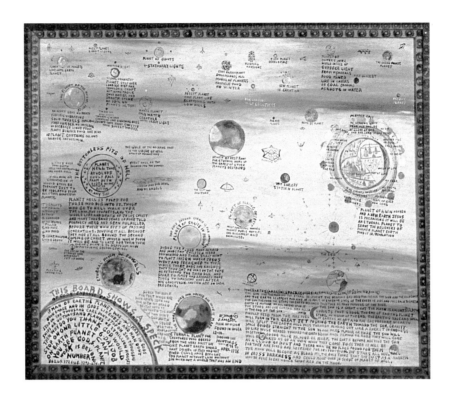

The planets that Finster envisioned—and that God surely must have created—include: "The Planet of the Mussel People"; "Energy Station Planet"; "Eden Garden Planet small islands all manner of flowers tropicle food no winter"; "PLANET HELL"; "Planet of Flying Objects"; "Water Planet"; as well as "The ones who herd and obeyed and have it made Eturnal Planet," which is what the earth would have been like if humanity had not sinned. At the lower right, Finster also described and portrayed the apocalyptic end of earth.

Among Finster's vast opus—he created nearly fifty thousand works in twenty-five years—are numerous portraits and images much less divinely inspired, including an entire series of Elvis Presley at varying stages of his life; cultural and political figures such as George Washington, Abraham Lincoln, Henry Ford, "Shake Spear," and Mona Lisa; Finster's collec-

tors; and, incessantly, Finster himself. In these works, famous figures of the secular world serve as populist, often nationalistic glorification of human spirit, energy, and creative potential. Finster frequently placed them in a divine setting or used the familiar icons of popular and national culture to direct the viewer's attention to another dimension of being, as in *George Washington #6* (1987; fig. 5). Finster's portraiture typically displays a flat face in a frontal or slightly angled profile, minimal facial features, and only a general resemblance. Nonetheless, his emphasis on the eyes (often accented by many-lined eyelashes), the broad and narrow lips, minimally drawn noses, and hairstyles usually succeed in rendering a recognizable caricature. Here, Finster offered a "Vision of the Youth of George Washington in Another World," presumably referring to heaven, where there is "No Death or War." Having

FIG. 4. Howard Finster, *This Board Shows a Speck of God's Endlass Space*, 1978. Enamel on wood, 34¼ x 41 in. (87 x 104.1 cm). Collection Amr Shaker, Geneva

Elvis, Jesus, and George Washington were affixed to walls and buildings, as were many placards bearing prophetic and admonitory messages.

The garden remains intensely sculptural, constructed out of found and used objects (old bicycle and machine parts, metal bedposts, and hubcaps). Finster covered old boxes, plastic cups, and tin cans with cement, embedding shards of glass and mirrors and pieces of metal, and then placing the sculptural objects throughout the garden as posts, decorations, light catchers, and objects of amazement. Finster was adept at redeeming what was held to be worthless. That redemption suggested a greater meaning. On a sign at the entrance to the garden, Finster proudly asserted that he took what others discarded and gave the fragments and their viewers new life: "I built this park of broken pieces to try to mend a broken world of people who are traveling their last road. I took the pieces you threw away and put them together by night and day."[1] At the heart of the garden stands the World's Folk Art Church (see fig. 6), a dilapidated building Finster transformed into a three-story, sixteen-sided, spire-peaked church and art gallery embellished with metal and glass pendants that make it appear like a giant wedding cake. The resplendently ostentatious structure embodies the populist, enthusiastic, and self-consciously promotional aesthetic and evangelical spirit of Finster.

Howard Finster was born in 1916 into a rural family with thirteen children in northeastern Alabama and lived his entire life in the region, moving to nearby Georgia as a young man. Although his father owned a small lumber mill and the family had a forty-acre farm, they led a hardscrabble life, as was typical of early-twentieth-century rural folk in the South. They grew almost all the food they consumed and made most of the objects they used. From an early age, Finster was accustomed to building his own home, making what he needed, and supporting himself throughout most of his life by the

linked the "Man of Truth," general, and president to heaven, Finster further inscribed the painting with pithy religious messages: "Jesus is Coming Back Be Ready"; "Heaven is worth it all"; "Time Waits for No One Be Ready"; and informed us "I WAS CALLED FROM ANOTHER WORLD I AM AS A SECOND NOAH TO POINT THIS WORLD TO A REAL LIVING GOD."

Finster's greatest and certainly most extensive work is his now-deteriorated, four-acre site Paradise Garden, which he built over the course of twenty-five years. Originally the plot on which his house stood, it became a visually rich and densely constructed environment filled with artworks, signs, and lush vegetation. Paths snaked through the plot, crossing three streams Finster channeled from the natural springs that flowed through what had once been swampland. Walkways and walls were embellished with shards of ceramics, old watches, tools, or discarded jewelry. Paintings of

FIG. 5. Howard Finster, *George Washington #6*, 1987. Paint on board, 48 x 48⅛ in. (121.9 x 122.2 cm). High Museum of Art, Atlanta; T. Marshall Hahn Collection

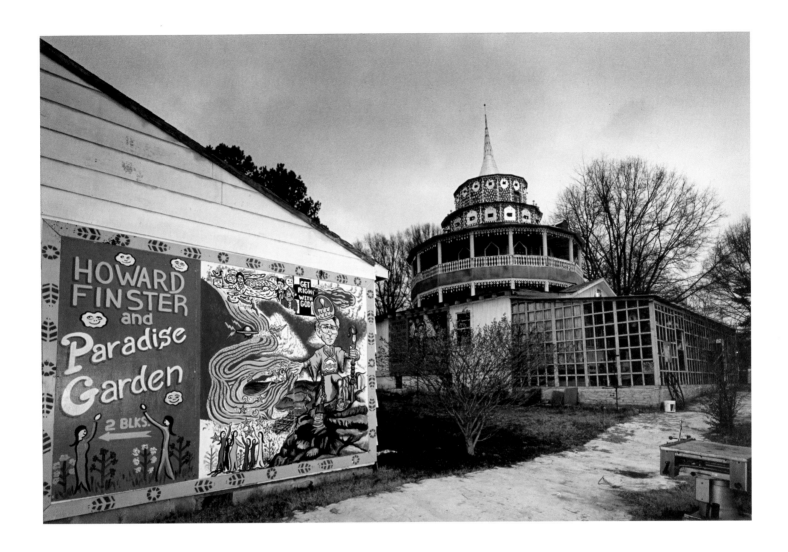

products of his own hands, working variously as a mechanic, factory worker, plumber, carpenter, and bicycle repairman.

Although neither of his parents was particularly religious, Finster proved especially sensitive to otherworldly experiences. He often told of having a vision at age three, seeing his recently deceased sister descending a staircase in the sky and then rising back into the heavens. Although it was years before he could interpret this sight, Finster referred to it as his awakening as a "Man of Visions." Throughout his life, he spoke of his visions: being visited by a spectral figure delivering him a message; feeling the presence of someone departed; "conversing" with a figure from world history— Hitler, Shakespeare, George Washington; or having out-of-body experiences featuring interstellar travel. His greatest visions were inspired by the Holy Spirit and prophesied God's plan for earth and humanity.

FIG. 6. Howard Finster's World's Folk Art Church (right) at Paradise Garden, Summerville, Ga.

Finster's evangelical life began at age thirteen, when he felt called to Christ during a revival meeting. Three years later he began his life mission as a preacher. Married at age eighteen and eventually fathering five children, Finster supported his family through many jobs, but he considered himself primarily a preacher, teaching Sunday School, traveling extensively as a revivalist minister, and preaching to Baptist and Methodist churches across the South. At age twenty-five, he became pastor to the first of a dozen congregations he served during his life.

Finster's sense of personal calling was far from unique. He was one of thousands of Protestant preachers called to their lives' work. Finster was not schooled beyond the sixth grade and received no formal theological training. Rather, he imbibed a southern religious tradition that stressed direct access to the Holy Spirit. As an evangelical Baptist, Finster believed each individual could know God's grace and experience a "saving moment of religious revelation."[2] Just as the supernatural could cause his personal transformation, Finster and his fellow evangelicals believed that divine will was active throughout human history as revealed in the Bible. The Bible's fundamental authority is central to evangelical Christianity for it provides both a model for personal life and a vision of God's plans for humanity. In both, the polar opposition of sin and salvation is writ large and time is of the utmost importance. Personal salvation must be achieved before the ever-impending but unknown moment of death and judgment. Souls must be saved before the prophesied end-time of the apocalypse arrives.

The struggle to overcome sin and to be saved is the compelling imperative of the born-again Christian. Once saved, the sinner is charged to share the "good news" of Christ's mercy, use one's own experience as model of transformation and proof of divine grace, and call others to recognize God's presence in their personal lives and history.[3] Finster took up this personal mission fervently, and, like preachers before

him and since, he placed his testifying self at the center of all his sermons. Calling himself the "second Noah" and "God's last red light," he warned of doom and damnation faced by every person who could hear his words or see his work, promising the possibility of being saved through his message.

Although Finster's ministry often took him away from his family, he saw home life as a direct extension of his spiritual calling. He decorated the furniture and walls of his home, planted extensive gardens, and built his children playhouse "mansions" in the yard, which quickly became as much a public environment as a family realm. At one home, he converted a backyard building into a "museum" filled with antique and found objects for his neighbors and parishioners "to see the hand of God in ordinary, everyday things."[4] And in 1961, having moved to Pennville in northwestern Georgia, he began to construct Paradise Garden.

Finster originally conceived the garden as a religious environment where every verse of the Bible would be written on objects, buildings, and even plants, teaching the people walking amid them. He often recounted, however, that in 1976 while painting a repaired bicycle, he noticed what looked like a miniature face on the tip of his paint-covered finger. Simultaneously, he felt a divine instruction to "paint sacred art." Considering himself untrained as an artist, he copied the image of George Washington off a dollar bill—his first "sacred" painting. During the next several weeks, he confined himself at home to paint continuously, primarily illustrations of biblical verses and scenes.

Although this "divine inspiration" scene echoes those of numerous self-taught artists who heard God's command to create, at this moment Finster was neither unknown nor unaware of the potential to reach an audience through his "sermons in paint."[5] The previous month, *Esquire* magazine had published an article on Paradise Garden that brought him national attention. Finding the means to preach to many more than just the garden's visitors, Finster took up painting

full-time. In short order he entered the folk art world, he began to amass the first of thousands of collectors, and he received commissions from the American Folklife Center at the Library of Congress. Within a decade he had sold thousands of works, received a National Endowment for the Arts Fellowship, appeared on *The Tonight Show Starring Johnny Carson*, was commissioned to create record cover art, and had a solo exhibition at the New Museum of Contemporary Art in New York.

Ever the evangelical preacher seeking to expand his congregation, Finster embraced all opportunities to create, promote, and distribute his body of work. Early in his career, he felt compelled to produce five thousand sermons in paint, a number he reached by 1987. He decided to go "over his limit,"[6] painting well over forty-six thousand works by his death in 2001. To accomplish this, he worked tirelessly, often throughout the night. He readily copied works he had done before, used an overhead projector to repeat designs, made templates for multiple exemplars, and arranged an assembly line production with his family preparing basic patterns and painting the ground for scenes he superimposed. By the 1980s and 1990s, he was a nationally famous "folk" artist and a commercial enterprise (see fig. 7).

Finster's work was adopted most enthusiastically by the recently revived folk art field. To Herbert Waide Hemphill, Jr., one of Finster's first major collectors, Finster exemplified the contemporary folk artist. Although folk art had traditionally been regarded as an expression of early American culture, Hemphill — an avid collector, board member, and then curator for the Museum of American Folk Art (now the American Folk Art Museum) in New York — was instrumental in expanding that concept to include work of living untrained artists. Sharing Holger Cahill's romantic evocation of the artistry of the "common man," Hemphill defined folk art broadly as the creations of "everyday people out of ordinary life [who] are unaffected by the mainstream of professional art."[7] In the 1960s

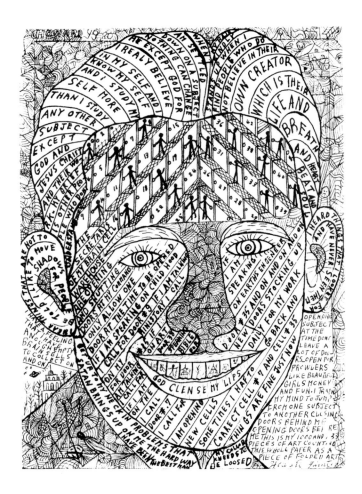

and 1970s, artists, dealers, and collectors embraced this vision of populist creativity, and by 1974 more than two hundred folk artists had been "discovered" in America, many of them, like Finster, products of the South.

Strictly speaking, little of what is celebrated as folk art represents traditional folk culture. Academic folklorists, such as Henry Glassie and John Michael Vlach, argue that few such cultures survive intact in the United States and insist on properly differentiating the residual forms of folk material culture from the objects of visual delight appreciated under the guise of "folk" art.[8] Such rigorous thinking, however, does not

FIG. 7. Howard Finster, *Self-Portrait (My Brain is Like a Wirehouse)*, n.d. Pen and ink on paper. Collection Marion Stroud-Swingle

characterize the folk art field, particularly with regard to Southern visual culture, which appears sufficiently different from mainstream art to be deemed "folk" enough. The South seems simultaneously to represent the most traditionalist, even patriotic, of American values and to be proudly antagonistic to much of the prevailing national culture. Inherently antimodernist, antisecular, and deeply racist, the South of the first half of the twentieth century proved especially fertile ground for singular works of untrained creativity, whether expressed in traditional crafts (such as whittling and pottery), the visual culture of rural and urban African American artists, or the paintings, sculptural objects, and shaped environments of individuals testifying to the deeply ingrained religious spirit of the region.

While Finster proclaimed his self-appointed title of World's Minister of Folk Art Church, he most frequently referred to himself as a Man of Visions. As a visionary artist, he saw himself as part of a long line of biblical prophets and messengers of God, and he found sanction for his idiosyncratic, if homiletic, visions.

The term *visionary* is also often applied to outsider artists, however, and Finster's popularity in the art brut field, especially in Europe, is in part a reflection of this. The visionary artist—whether outsider or religious ecstatic—challenges the emotional and conceptual confines of quotidian existence to infuse life with greater resonance and extend spirit into other dimensions, whether they be frightening or appealing, mystical or visceral, mysterious or provocatively familiar. The visionary self may seem autistically self-referential, even megalomanical, as do Adolf Wölfli or August Walla, whose visions assert intimate connections among the artist, god (or gods), and entire cosmos. She may serve as a transmitter between spirits of another dimension and this earthly existence, as does Madge Gill. Or he may be charged by the Holy Spirit to communicate God's plans through himself in an intensely personalized language and imagery, as does Finster.

Visionaries appear all along the spectrum of normal (that is, "reasonable") and abnormal (that is, "irrational") behavior. Some act beyond the protective web of organized religion and behavior shared by their audiences; others have greater or less ability to function adequately in daily society. Inevitably, those who constitute the normative usually determine how the visions and visionaries are received. An individual who readily speaks of his or her visual and auditory "visions" of non-corporeal beings or states that he or she is a visitor from another world might easily be labeled a psychotically disturbed "outsider." But to those familiar with the premises of evangelical Christianity as practiced across the South and throughout America, such a figure is not especially uncommon. The sociologist Frédéric Allamel has observed: "In Europe, an artistic career originating in visionary and auditory stimuli . . . would be noteworthy; here, however, it conforms to the norm."[9]

Indeed, despite Finster's flamboyant self-mythologizing as a visionary from another planet, he remained fully within a recognizable religious tradition. Finster's conception of God and his belief that one can communicate directly with him and hear his voice is so common to the culture that Finster declared only those who did not know God could consider him insane: "How could I expect anybody not to think I was crazy when they don't know nothing about what I'm talking about? . . . Nobody is crazy that communicates with God Almighty, the engineer of the earth's planet. Nobody is crazy that God Almighty would employ and use as an instrument. Nobody is crazy that tells the world what I'm telling 'em. There is nothing mental about me."[10]

Fully grounded in a regional evangelical tradition that expected, even required, public testimony of his personal salvation and relationship to the Holy Spirit, Finster felt authorized as a visionary artist to proclaim his unique visions. Yet his religion also demanded of him a submission to a set of received images and narratives found in the Bible. Finster created works of imaginative genius and creative fervency

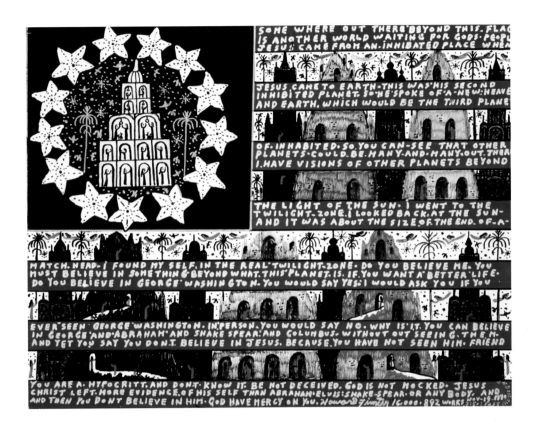

married to long-established dogma. His work tends to cast depictions of common dogma in new forms, often by incorporating imagery of a decidedly populist and secular culture. In his works, Finster exuded the fervency of the outsider and the naiveté of the homespun folk artist, informed by the self-assurance of the showman.

Visions of Other Planets #16000,892 (1990; fig. 8), for instance, presents a celestial flag, modeled on that of the United States, on which Finster wrote, in part:

I WENT TO THE TWILIGHT-ZONE. I LOOKED BACK. AT THE SUN—AND IT WAS ABOUT THE SIZE OF THE END-OF-A-MATCH.HEAD. I FOUND MYSELF IN THE REAL TWILIGHT-ZONE. DO YOU BELIEVE ME. YOU MUST BELIEVE IN SOMETHING BEYOND WHAT THIS PLANET IS. IF YOU WANT A BETTER LIFE.

Divine visions that speak of other planets slip easily into references to the then-popular science fiction television show *The Twilight Zone*. References to Christ, God, Abraham [Lincoln], George Washington, Shakespeare, and Elvis are called up to deliver a conventional fundamentalist lesson. This self-described visionary from another planet located himself firmly in the heart of popular culture. Like many contemporary "folk" artists, Finster can surprise us by his willful indulgence of pop cultural clichés, even kitsch, in his work. But

FIG. 8. Howard Finster, *Visions of Other Planets #16000,892*, 1990. Enamel on wood, 18¾ x 24 in. (47.6 x 61 cm). Collection William C. Paley

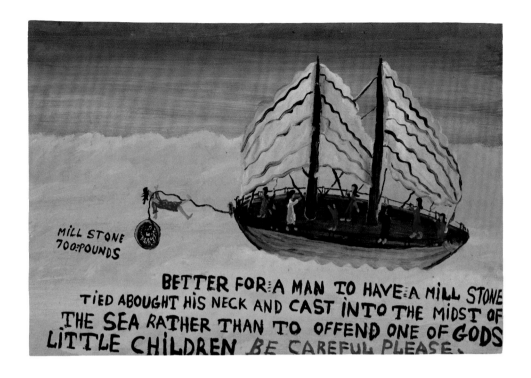

that is precisely his intent. He believed the Bible's message does not change, and its lesson is cataclysmic when suddenly revealed and fully accepted. For this populist evangelist, the challenge was to make that message evident in the commonly known terms of immediate experience, where one lives and may least expect it.

Finster was as likely to find proof of God's presence on television as in an extraterrestrial vision: "I have to look at the TV to see what's going on in the world, and then I have to look at my visions and see if my visions compare with what's going on in the world. Afterwards, I write messages on the paintings about predictions in the Bible that I've seen on TV."[11] In this dance of the divine and the quotidian, Finster tested his sacred visions by the "reality" presented on the television screen, and as he watched television he was spurred to paint "predictions" based on it *and* the Bible. The television and the Bible jointly authorize the art.

Finster's media viewing seems somewhat selective, however. His art rarely mentions serious social issues, except to cast the Cold War as a battle of "two super powers" in end-time terms. While he castigated common evils such as lying politicians and high taxes, he never addressed the great social conflict of his culture—the civil rights struggle. There is barely any mention of African Americans and no acknowledgment of the southern white church's complicity in segregation. Instead, Finster's works abide by a specific cultural framework: a southern, white, evangelical Christianity focused entirely on individual sin and salvation. His message is at times delivered with the directness of a Sunday School homily in colorful, fanciful, if literal images, as in *Better for a Man to Have a Mill Stone. . .* (1968; fig. 9). Or it may marshal the colorful, comic-book figures to represent a vision of the hell that awaits sinners who ignore the warnings of "God's last red light" (see *Vision of a Great Gulf on Planet Hell*, 1980; fig. 10).

Finster was not the only warning light trying to catch the attention of wayward sinners. Thousands of self-appointed evangelical ministers have walked into the streets accosting passersby, have constructed their own missions or churches

FIG. 9. Howard Finster, *Better for a Man to Have a Mill Stone Tied about His Neck and Cast into the Midst of the Sea Rather than to Offend one of God's Little Children. Be Careful Please*, 1968. Paint on wood, 15 x 21⅞ in. (38.1 x 55.6 cm). American Folk Art Museum, New York; Blanchard-Hill Collection, gift of M. Anne Hill and Edward V. Blanchard, Jr. (1998.10.22)

OPPOSITE: FIG. 10. Howard Finster, *Vision of a Great Gulf on Planet Hell*, 1980. Enamel on plywood with painted frame: panel: 35⅜ x 18⅝ in. (90 x 47.2 cm). Smithsonian American Art Museum, Washington, D.C.; Gift of Herbert Waide Hemphill, Jr. (1988.74.5)

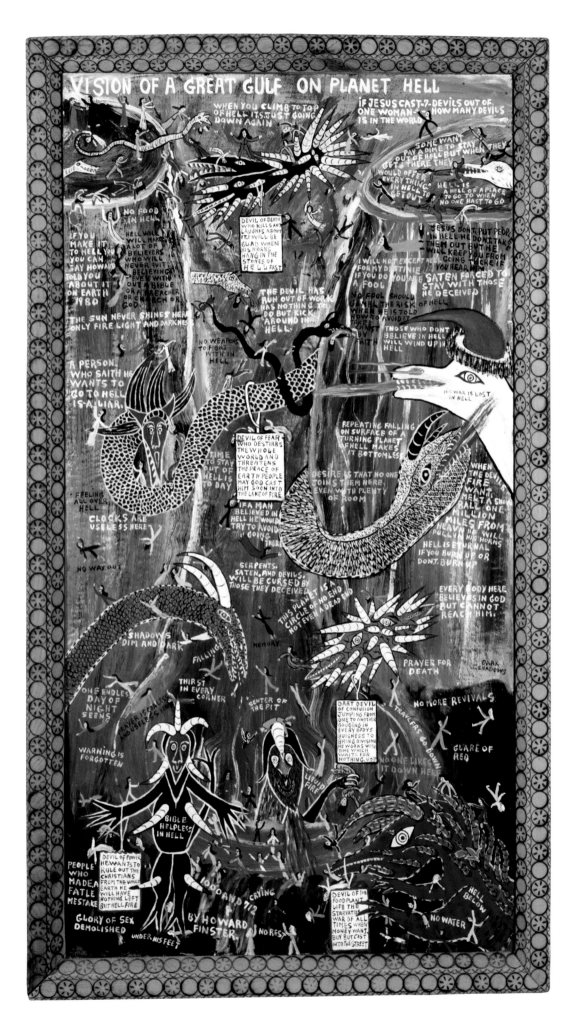

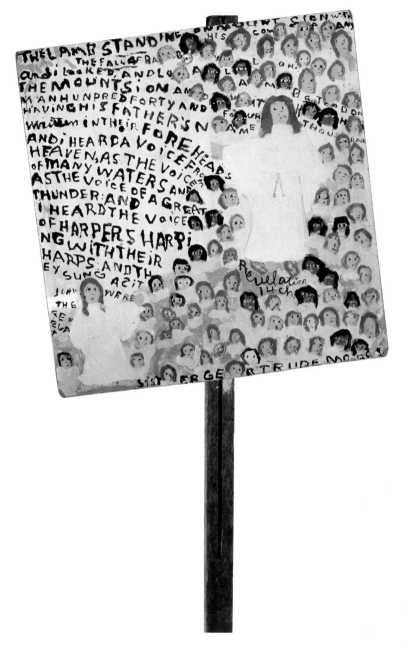

to bring in sinner and saved alike, or have broadcast their messages of sin and salvation by any media available. Many have embellished their message through original works of visual art.

Called by the spirit to preach when she was in her mid-thirties, Sister Gertrude Morgan (1900–1980) moved in 1939 to New Orleans, the "headquarters of sin." With the help of two other African American women, she founded a mission, a day-care center, and an orphanage, all of which they supported through their street preaching and singing. In her mid-fifties, she began drawing as supplemental to her preaching and steadily developed as an artist for the next twenty years. Most of her works combine biblical text, most often from the Book of Revelations, and imagery illustrating or inspired by the holy words. She quickly received recognition from a dealer, collectors, and museums, but regarded her evangelical work as far more important than art-world appreciation.

The Lamb Standing on Mount Sion with His Company (c. 1973; fig. 11) is a sign to be carried while preaching. Its message, drawn from Revelations, tells of a vision of the Lamb of God and a host of 144,000 believers with him. Although Morgan was primarily a woman of the Word—a preacher, singer, and poet—she began the composition by painting the many faces and white-robed bodies of the blessed. Some of the believers stand on a green expanse; others rise into the white air that becomes the open ground onto which she then painted the text, weaving the words though the crowd above. Text and image intertwine throughout Morgan's works—the brightly hued images structuring the composition; the words providing a subtle but constant reward for close attention. Unlike the work of many self-taught artist-preachers, Morgan's paintings focus mostly on the heavenly future announced in Revelations, particularly the descent from heaven of a New Jerusalem.

William Alvin Blayney's *Church and State* (1970–71; fig. 12) also serves as a preaching tool, but here the sermon is

FIG. 11. Sister Gertrude Morgan, *The Lamb Standing on Mount Sion with His Company* (recto), c. 1973. Acrylic and/or tempera and pencil on Masonite with wood post and metal wing nuts; sign, without post: 23¾ x 23¾ in. (60.3 x 60.3 cm). Collection of the Jaffe Family

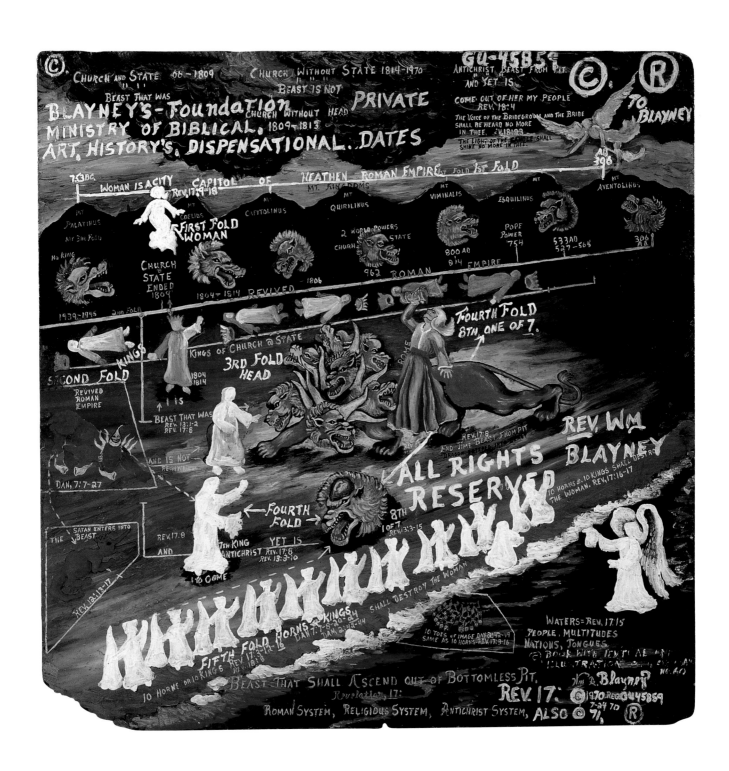

FIG. 12. William A. Blayney, *Church and State*, 1970–72. Oil on Masonite, 24¼ x 24 in. (61.6 x 61 cm). American Folk Art Museum, New York; Blanchard-Hill Collection, gift of M. Anne Hill and Edward V. Blanchard, Jr.

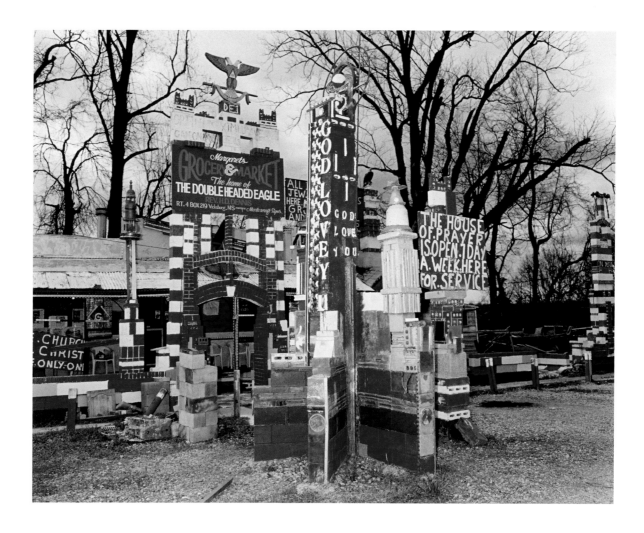

decidedly frightening. It presents a lesson in end-time trials and depicts the beast of the apocalypse at its center. But while it is also grounded in the Book of Revelations, Blayney's vision departs from biblical text to offer interpretive instruction.

Blayney (1917–1986) was a Pentacostal minister who in his late forties abandoned his wife and job to start up a roadside ministry in Oklahoma. He believed a literal interpretation of the Bible could provide a dependable reading of humanity's spiritual history and future, and prophesy the coming apocalypse, Last Judgment, and eventual establishment of the New Jerusalem. He appears to have adopted—more likely, adapted—a widespread Christian fundamentalist belief in dispensational pre-millennialism, which holds that God's plan for humanity's sacred history is divided into distinct "dispensations," or time periods, leading to the end-time.[12] Blayney's work purports to explain that plan in systemized text and illustration (see fig. 12). Unlike Morgan's work and many of Finster's paintings, which are direct transcriptions of biblical texts or easily understood parabolic images, Blayney's chart requires explanation that can only be provided by the artist-preacher, for many of the signs, symbols, and figurative images seem to be solely of his own interpretive system. Perhaps sensing the importance of his singular vision, Blayney liberally scattered copyright and trademark signs across his works.

FIG. 13. Margaret and Reverend H. D. Dennis's Margaret's Grocery, Vicksburg, Miss.

Just as Finster built his Paradise Garden to attract people to his holy message, in 1979 the Reverend H. D. Dennis (born 1916) began converting his new wife Margaret's run-down grocery store in Vicksburg, Mississippi, into a place of prayer and biblical instruction where he would be available to preach to shoppers and passersby. To attract travelers, he constructed brightly painted cinder-block towers, walls, and latticework grids running some one hundred feet along the road (see fig. 13). Large red-and-white signs proclaim the place a House of Prayer welcoming Jews and Gentiles, blacks and whites alike to "Margaret's Grocery and Market: The Home of the Double-Headed Eagle." Indeed, a wood two-headed eagle astride a festooned sword rises above the gro-cery store at the top of the tallest tower. Other plastic eagles and found objects decorate the yard, and Masonic symbols and other religious messages are affixed to the window shutters. A rarely used, ornately decorated "preaching bus" with pulpit and pews has at times stood by the grocery for the announced weekly services.

Like many vernacular "roadside attractions" spread across the American landscape, Reverend Dennis's site is an expression of a single individual's committed vision announc-ing itself to a passing and largely indifferent world. People might come to the grocery for their daily bread and possibly find their salvation, but Margaret's Grocery and Market largely attracted instead the attention of the aficionados of self-taught and outsider creative genius.

Notes

1. J. F. Turner, *Howard Finster: Man of Visions* (New York: Knopf, 1989), p. 101.
2. Charles Reagan Wilson, *Judgment and Grace in Dixie: Southern Faiths from Faulkner to Elvis* (Athens: University of Georgia Press, 1995), pp. 8–9, quoted in Carol Crown, "More than Meets the Eye: Visions of the Sacred in Southern Self-Taught Art," in *Sacred and Profane: Voice and Vision in Southern Self-Taught Art*, ed. Carol Crown and Charles Russell (Jackson: University Press of Mississippi, 2007), p. 52.
3. Charles Reagan Wilson, "Self-Taught Art, the Bible, and Southern Creativity," in *Sacred and Profane* (note 2), p. 7.
4. Thelma Finster Bradshaw, *Howard Finster: The Early Years; A Private Portrait of America's Premier Folk Artist* (Birmingham, AL: Crane Hill, 2001), p. 18.
5. Howard Finster, quoted in Turner (note 1), p. 4.
6. Tom Patterson, *Howard Finster: Stranger from Another World; Man of Visions Now on This Earth* (New York: Abbeville, 1989), p. 133.
7. Herbert Waide Hemphill, Jr., quoted in John Michael Vlach, *Plain Painters: Making Sense of American Folk Art* (Washington, D.C.: Smithsonian Institution Press, 1988), p. 165.
8. See Henry Glassie, *Pattern in the Material Folk Culture of the Eastern United States* (Philadelphia: University of Pennsylvania Press, 1968), passim, and John Michael Vlach, "'Properly Speaking': The Need for Plain Talk about Folk Art," *Folk Art and Art Worlds*, ed. John Michael Vlach and Simon J. Bronner (Ann Arbor: UMI Research Press, 1986), pp. 13–26.
9. Frédéric Allamel, "Sacred Spaces and Mythmaking: A Sociological Perspective on Southern Environmental Art," in *Sacred and Profane* (note 2), p. 32.
10. Turner (note 1), p. 84.
11. Ibid., pp. 135–36.
12. See Crown (note 2), pp. 47–50.

Thornton Dial

ost people don't understand art. Most people don't understand *my* art, the art of the Negroes, because most people don't understand *me*, don't understand the Negroes at all."[1] The art of Thornton Dial (born 1928), like that of every artist in this book, emerges from the margins of society to articulate what has been unknown, ignored, or repressed. Dial's exclusion was not an issue of mental condition, however, but one of class and race. Born in the deep South, Dial grew up during an era in which not only was he assumed not to have a voice but also was actively denied one. To develop an art that addresses the personal, cultural, and historical issues as he has is an unexpected and inherently political act. His work is indeed political and presents us with a vision of a life and culture at once distant from and yet of our common historical moment.

Throughout his more than two-decade-long career as an artist, Dial has used a wide range of materials and methods, freely developing and appropriating formal languages and imagery to articulate his ideas. Often depicting figurative images or incorporating referential metaphors, his works are marked as well by strongly expressive gestural abstraction. Usually, both abstract and representational languages join in his dense and complex creations imbued with strong personal and collective cultural meaning.

Dial's 2002 work *Looking Out the Windows* (fig. 1) is an imposing vertical construction over eight feet high and four feet wide. A densely packed assemblage relief, it juts out more than a foot toward the viewer. Within its frame a jumble of strips of cloth, rope, plastic dollhouse furniture,

children's dolls, and teddy bears is barely constrained by a web of cords that keeps the objects from tumbling out of the work. Several of the items project from within the mass, while others, peering downward, seem poised for free fall. Throughout the entire work, marks of red, white, and blue paint are slathered across the objects and materials; the edges of the work are delineated almost completely in red.

The work is from a series of more than a dozen paintings, drawings, sculptures, and reliefs Dial created in response to the 9/11 assault on the World Trade Center. It can be read as a horrific depiction of the individuals trapped in the upper stories of the burning towers looking out at their doom. The clutter of the torn and painted materials suggests the utter chaos of the moment, and the predominance of red calls up the bloody horror of the event. Dial's choice of children's toys to represent the trapped people—an estimated two hundred of whom chose to leap out of the windows to their deaths—suggests a tone of sentiment for their lives cut short and may also connote a state of innocence assaulted, and perhaps ended, that day. The prevalence of the colors of the American flag throughout the work emphasizes the national political resonance of that assault but may also render problematic the notion of "innocence." Are we meant to empathize with the individual victims, reflect on the guilelessness of the American public, or explore darker, more ironic thoughts on the delusion of national innocence prior to the attack?[2]

Whichever interpretation we lean toward, we recognize that every element of the work—the specific imagery, the formalist structural strategies, the materials, the range of color,

and the expressive mark—has been consciously infused with meaning. With similar concentration, Dial's works are often as emotionally charged, visually complex, and politically ambiguous as *Looking Out the Windows*.

The 1992 painting *Graveyard Traveler/Selma Bridge* (fig. 2), for instance, offers an allegorical representation of the life and death of Dr. Martin Luther King, Jr., focusing on his participation in the 1965 civil rights confrontation at the Edmund Pettus Bridge in Selma, Alabama; the urban world he served and where he would be assassinated; and the graveyard to which he—and all of us—are destined. The composition is meant to be read from right to left and then back downward to the right as our eyes follow the yellow path arching over the turbulent blue Alabama River and then curving into a darkened landscape and pointing toward the cemetery at the lower right. A figure representing Dr. King stands at the far right edge the bridge, poised to cross one of the many rivers of his life's journey. Other figures join him on the

bridge, while birds, which to Dial represent the spirit of freedom, perch on its cables. At the far left, Dr. King has been transformed into a tiger—Dial's iconic figure for the black male—who will soon encounter around the bend a horse rider signifying the white police force that brutally attacked the freedom marchers. The work derives much power from the dense swirl of the bound and entwined materials: braided carpet, bunched burlap, electrical conduit, rubber hoses, and rope, the last of which suggests police violence and lynch mob action. While a depiction of a specific political and historical event, the painting resonates with broader existential significance, as Dial subsequently observed: "As a man live, he is a graveyard traveler. Every move he make, death will move with him. Martin Luther King had to cross Selma bridge. Every man got to take that same trip."[3]

A reticent man, Dial rarely provides such explicit interpretations. Subjects are suggested in part by his works' titles, but even they have often been assigned by others based on

FIG. 1. Thornton Dial, *Looking Out the Windows*, 2002. Metal grating, fabric, plastic toys, stuffed animals, rope carpet, wire fencing, carpet scraps, metal, corrugated metal, metal screening, wire, nails, paint cans, Splash Zone compound, enamel, and spray paint on carpet on wood, 100 x 50 x 13 in. (254 x 127 x 33 cm). Collection of the Souls Grown Deep Foundation

FIG. 2. Thornton Dial, *Graveyard Traveler/Selma Bridge*, 1992. Mixed mediums, 85½ x 146 x 6 in. (217.2 x 370.8 x 15.2 cm). Collection of the Souls Grown Deep Foundation

descriptive comments Dial has made. In general, our understanding develops through the repeated viewing of Dial's iconic imagery, the recurring associations of visual elements, the expressive handling of the medium, and the formal order within the construction. Because narrative and personal statement are so fundamental to Dial, figuration is prevalent across most of his works.

The figurative impulse is most evident in many early works that establish a personal iconography of humans and animals (tiger, fish, bird, monkey, mule, deer, and snake) interacting within narrative terrains at once archetypal (the jungle, the city) and historical (Birmingham, Selma, New York). The range of imagery allows the paintings to serve simultaneously as fable and political commentary, as traditional folk tale and modern allegory. The flat planes and figures in profile in Dial's early paintings recall figurative strategies typical of much folk art. This is particularly apparent in a series of works from 1988 through 1992, in which the figure

of a tiger provides the visual focus, around which other formal and thematic elements are arrayed.[4] *When the Tiger Cat Leaves the Jungle He Gets a Monkey on His Back* (1988; fig. 3), for example, uses the vernacular adage of drug addiction being a "monkey on one's back" to offer a cautionary message about blacks leaving—or being taken from—their home environment, whether Africa or another protective community. The painting reads as a direct illustration of its message, which is transmitted by clearly defined, centrally placed, balanced, figurative forms. Its visual power is asserted by the rough tactile surface of the carpet fabric that composes the tiger and monkey and by the boldly painted gestural marks of the tiger's stripes and the animated jungle ground. In subsequent paintings, the folklike figuration gives way to a thematically more complex interaction of dense materiality of prepared ground, expressive gestural marks, and figurative references.

Dial has always affixed rough-surfaced materials (braided rugs, burlap bags, strips of metal, and ropes) and found

FIG. 3. Thornton Dial, *When the Tiger Cat Leaves the Jungle He Gets a Monkey on His Back*, 1988. Oil, wood, carpet, Bondo, and industrial sealing compound on wood, 49 x 101 x 5 in. (124.5 x 256.5 x 12.7 cm). Private collection

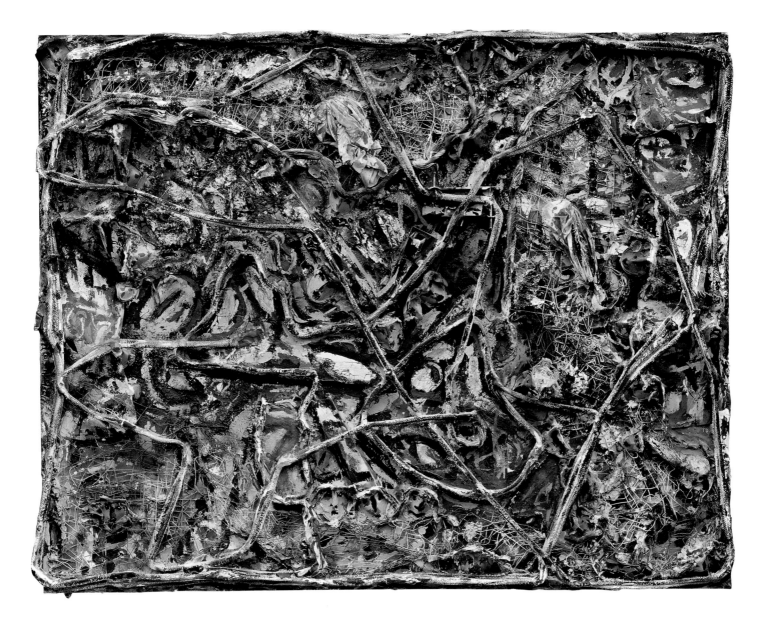

objects (dolls, toys, desiccated goat and cat skins, plastic flowers) to his painting grounds both to structure the compositions and to extend their thematic referentiality. He then covers the works with multiple layers of paint, creating thick, encrusted surfaces that seem at times more like assemblage reliefs than paintings. The overall interweaving of assemblage elements and layers of paint frequently obscures the figurative images, essentially producing abstractions of brute expressive power. The result at times is overwhelming, verging on confusion. Thomas McEvilley has referred to a "perilous boundary between order and chaos" in the works,[5] yet Dial brings meaning out of turbulence, finding significance in his manipulation of material. In the massive *City Lines* (1994), for instance, a complex web of twisted rope, metal fencing, and cloth appears simultaneously to bind together a mass of densely embedded materials on a heavily painted ground

FIG. 4. Thornton Dial, *City Lines*, 1994. Rope, paint can lids, metal fencing, cloth, wood, metal, plastic, toy truck, paint, and industrial sealing compound on canvas on wood, 82 x 107 x 10 in. (208.3 x 271.8 x 25.4 cm). Collection of the Souls Grown Deep Foundation

and to provide an energetic, if subtly lyric structure to the entire composition. The flowing movement of the lines establishes an overall abstract and gestural expressionism. We also observe, however, representational elements. Bent paint-can lids are painted to resemble faces throughout the work, peering out of the thick weave of materials; a toy truck adhered to the surface with industrial sealing compound makes reference to an urban landscape. The title references a visit by Dial to New York City, and the painting can be read as an aerial view of the traffic arteries running through the city. But it is also a confrontational depiction of myriad homeless people barely noticed, perhaps willfully-ignored, but ever-present on the streets of the urban jungle.

Throughout his career, Dial has employed abstraction and figuration in fluid and always-productive relationship to each other. He has created starkly representational pieces in short succession to works that appear to be almost pure abstractions. Mostly, however, his oeuvre incorporates representational images within densely constructed and materially rich abstracted grounds that bear deep associative meanings. *In Honor* (2002; fig. 5), for example, is an homage to the women quilters of Gee's Bend, Alabama, and to generations of African American women in general. It is created out of scraps of materials typically used by Dial or quilters, which the artist patched across an all-over ground suggestive — but not imitative — of the syncopated, asymmetrical patterns of an

FIG. 5. Thornton Dial, *In Honor*, 2002. Clothing, bedding, carpet, plastic twine, enamel, and spray paint on canvas on wood, 73 x 108 x 3 in. (185.4 x 274.3 x 7.6 cm). Collection of the Souls Grown Deep Foundation

African American quilt. Many of the scraps are stapled—rather than sewn—onto the armature in patterns that suggest the faces of a group of quilters. When light strikes the surface at certain angles, the staples glint and eyes, noses, and mouths appear. The work pays tribute to a group of southern African American women who have struggled for decades against poverty, oppression, and historical neglect yet have sustained a community and a vital aesthetic and craft tradition that only recently has achieved national renown. Dial honors them as artists, but he also testifies through his art to the crucial support women have given him throughout his life, especially during his difficult childhood.

Thornton Dial was born in 1928 to an unwed teenage mother, Mattie Bell, in the rural crossroads town of Emelle in west-central Alabama. He was raised for his first ten years primarily by his great-grandmother and the extended Dial family of sharecroppers whose name he was given. He grew up in a close-knit African American community under the reign of segregationist Jim Crow laws during the Great Depression, picking cotton and doing farm chores. Dial received little schooling, never learned to write, and had few opportunities for self-advancement in the racist South.

At age thirteen, he moved to the industrial city of Bessemer to live with his great-aunt. He spent most of his life there, working many jobs, often several concurrently. Dial knew himself as a working man, a provider for his family, having married at age twenty-two and raising five children with his wife, Clara. For some thirty years, he built railroad boxcars for the Pullman-Standard Company until the local factory closed in 1983 when he was fifty-five. With his sons, also workers at Pullman, he formed a small business making painted steel furniture. It is from this period that his first extant works of art originate.

Dial had always made "objects," as he called them—he is said to have never heard the word *art* or considered his

creations artworks until he was sixty.[6] Like many self-taught artists who begin creating late in life, Dial (once he had his own shop and place to work) found in making objects a means to reflect on his experiences and the world he knew. Familiar with the tradition of the yard show or "dressed yard," in which rural and urban African Americans decorate their home environments with symbolic constructions of used or found objects, Dial placed his works around his and his aunt's homes. He also destroyed or buried many, in part for lack of space, but in larger part out of fear of attracting unwanted attention from white people, the "authorities" who, he assumed, would require he have a license to do such work and probably tax them. He also suspected they might recognize the weighted political meanings within the works. One early sculpture that was not destroyed and certainly could be easily understood is *Slave Ship* (1987; fig. 6). In this depiction of the Middle Passage, chained figures fill the body of the ship, while under an American flag a white man rapes a black woman.

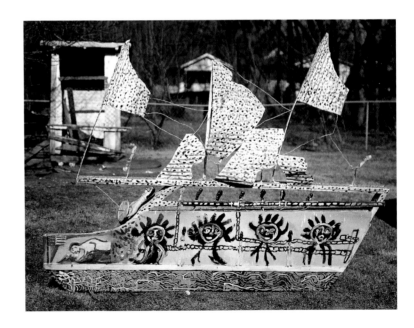

FIG. 6. Thornton Dial, *Slave Ship*, 1987. Wood, metal, tin, wire, Bondo, and paint, 72 x 102 x 16 in. (182.9 x 259.1 x 40.6 cm). Collection of the Souls Grown Deep Foundation

Few people saw Dial's creations, and presumably no white person, until he was approached in 1987 by William Arnett, who was brought to Dial's doorstep by Lonnie Holley, a younger black self-taught artist and a great admirer of Dial's work. A passionate collector and former art dealer, Arnett had, since the early 1980s, collected almost exclusively self-taught, southern African American art. Arnett immediately recognized Dial's strength, gained his trust, and supported him. He provided Dial with a monthly stipend, purchased many of his works, established a foundation for him (that bought him his house), and served as his exclusive agent. Arnett is Dial's patron; he encourages the artist to create as much as he wants and in any manner he wishes. He supplies him with a range of fine art materials rarely used by vernacular artists—canvases, brushes, watercolors, graphite, acid-free papers—though Dial generally gathers his own media, preferring found, commercial and industrial strength materials for his paintings and constructions.

Whatever specific effect this encouragement has had, Dial's growth as an artist has been rapid, constant, and self-directed for more than twenty years. His career has reflected a steady expansion of format, from painting and sculpture to works on paper, and a rapid mastery of media, from oil, acrylic, and spray paint to pastel, graphite, and watercolor. From the early flat-plane representational tiger paintings, he quickly moved through a range of abstract and expressive styles in painting and sculpture. He has displayed a remarkable ability to shift at will from creating dense, three-dimensional constructions to delicate, lyrical works on paper, many of which celebrate the attraction and power of women and embrace the play of sexuality and love (see fig. 7).

The range of Dial's visual strategies bespeaks the scope of his vision and his willingness to address a complexity of personal, ethnic, historical, and global issues. Although his art has looked back to the historic drama of slavery, segregation, economic struggle, and civil rights in America, it also confronts current events and pop-culture phenomena encountered through the modern media, including war and the global politics of oil, wildfires, the O. J. Simpson spectacle, and the death and public frenzy over Princess Diana.

Dial's immense productivity and visual ambition, championed assertively by Arnett and his sons, resulted in early successes in the art worlds. A bit like Howard Finster, who was embraced by folk and outsider art circles and found fame in the popular media, Dial seemed a sudden sensation. But unlike Finster, who straddled folk and popular art, Dial has attempted to navigate the folk and mainstream art worlds, a much more problematic venture because it challenges each realm's conception of itself. Initially, he appeared to have succeeded. He had concurrent exhibitions at the New Museum and the Museum of American Folk Art (now the American Folk Art Museum) in New York; he had representation at several galleries specializing in self-taught art; and his work was included in the 2000 Whitney Biennial, usually a sign of mainstream acceptance. Nonetheless, despite major exhibitions at national museums in Houston (2005) and Indianapolis (2011), Dial's work has been denied general approval of the mainstream art world, which is unable to place it within the dominant art dialogue and is suspicious of his unconventional rise independent of the institutions of the art market and its attendant critical discourse.

Dial, excluded from the academy, is not ignorant of this world. He is aware of it and would just as soon be recognized by it, but he also asserts the validity of his art and his closest audience on their own terms. He evokes this dichotomy in *The Art of Alabama* (2004; fig. 8), in which a flamboyant exemplar of African American yard assemblage rises splendidly above a garishly painted concrete replica of a classical statue placed ingloriously on a box pedestal of found wood. Although Dial has made a few works that respond to the art he has observed on occasional visits to museums, art history and his place within it are not major concerns for

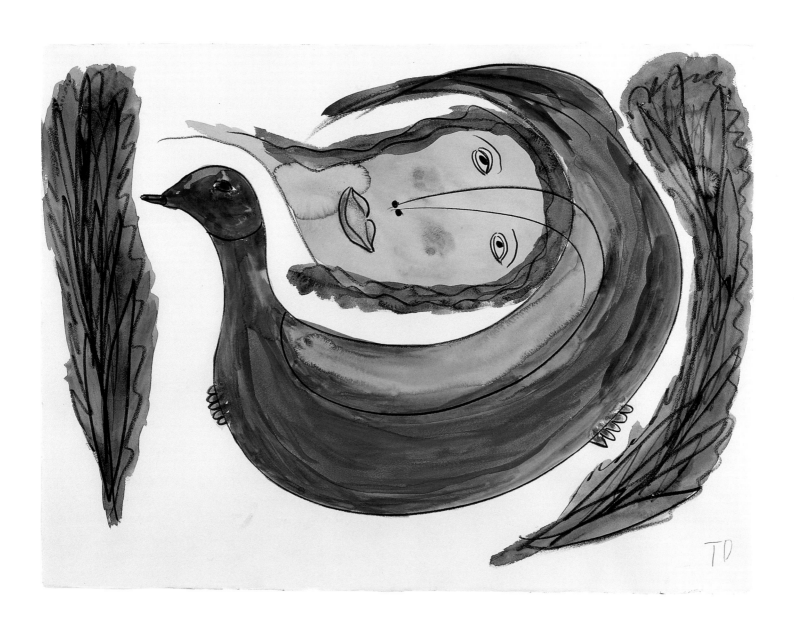

FIG. 7. Thornton Dial, *Lady Holds the Bird*, 1991. Watercolor on paper, 22¼ x 30 in. (56.5 x 76.2 cm). American Folk Art Museum, New York; Gift of Ron and June Shelp

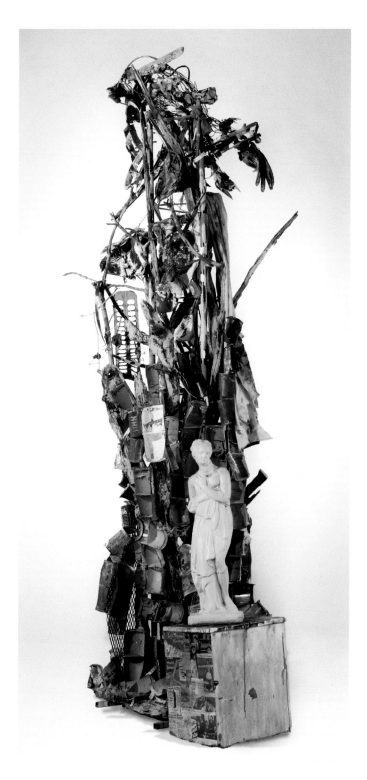

him. Rather, it is history in the broadest sense that engages him.

In this engagement, Dial should be seen as representative of a contemporary vernacular African American culture that is both local in origin and global in awareness, one through which nonacademic artists speak to and participate in political, historical, and cultural discourses by the production of visually significant objects. The manifest behavioral and material forms of African American vernacular culture find their roots in a history of exclusion from, but coexistence within, a hostile white society and combine still-vital remnants of African religious, philosophical, and aesthetic beliefs with developing artistic forms, practices, and media adapted from Euro-American society and global cultures. Situated outside the academic art world, vernacular visual culture has developed sophisticated forms of expression that address subjects of personal and collective significance.

The work of African American vernacular artists has become increasingly visible and political in the post–civil rights era. Liberated from the threat of white violence, these artists have given public voice to an expansive vision of personal identity and collective experience. The model of contemporary art that results is at once individually significant, visually inventive, and culturally embedded. Dial's work is among the most expansive in statement. His is a moral, political, and spiritual voice, at once personal and communal, biographical and historical, particular and epic. In short, it is greatly ambitious and self-aware.

Dial's assemblage paintings can be intensely personal, yet depict a condition and sensibility universally recognized. *Construction of the Victory* (1997; fig. 9) commemorates his survival of a near-fatal bout with hepatitis. The brilliant, red-soaked, stretched and tied fabric denotes the blood of life—and the fluids and life nearly lost. Embedded flowers connote the signs of hospital well wishes and foreseen memorials. The center star-flower form suspended below the

FIG. 8. Thornton Dial, *The Art of Alabama*, 2004. Wood, steel, clothing, concrete sculpture, wire, oilcans, bottles, glove, license plate, found metal, paper collage, enamel, spray paint, and Splash Zone compound, 129 x 40 x 66 in. (327.7 x 101.6 x 167.6 cm). Collection of the Souls Grown Deep Foundation

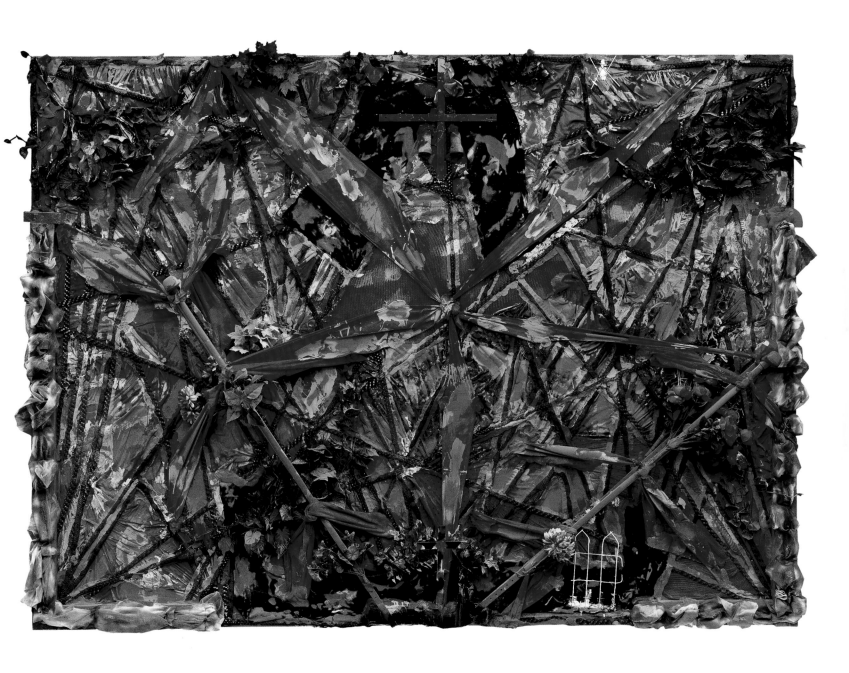

FIG. 9. Thornton Dial, *Construction of the Victory*, 1997. Artificial flowers and plants, crutches, fabric, clothing, rope carpet, wood, window screen, found metal, wire, oil, enamel, spray paint, and Splash Zone compound on canvas on wood, 83½ x 114 x 13 in. (212.1 x 289.6 x 33 cm). Collection of the Souls Grown Deep Foundation

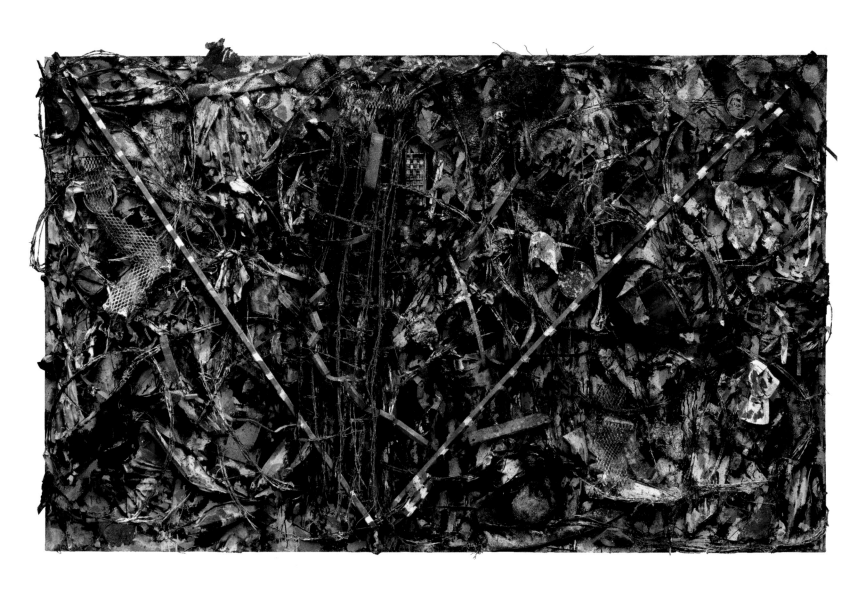

FIG. 10. Thornton Dial, *Victory in Iraq*, 2004. Mannequin head, barbed wire, steel, metal grating, clothing, tin, electrical wire, wheels, stuffed animals, toy cars and figurines, plastic spoon, wood, basket, oil, enamel, spray paint, and Splash Zone compound on canvas on wood, 83½ x 135 x 16½ in. (212.1 x 343 x 83.8 cm). Collection of the Souls Grown Deep Foundation

blood-red cross symbolically binds all elements together, holding a pair of crutches that rise in a triumphant *V* shape. A similarly placed *V* dominates *Victory in Iraq* (2004; fig. 10), a more somber and decidedly less optimistic painting. Here, the metal bars of the flag-colored *V* barely constrain the jumbled mass of barbwire, tangled metals, and electrical wires, in which stuffed animals, children's toys, and a severed head of a mannequin are embedded. The spots of red on torn clothes refer to blood, but not necessarily to life triumphant. Whenever the victory announced in the work's title is actually proclaimed, Dial presciently offered a grave portrait of what it would entail.

These works do not display the sensibility of a "timeless" folk art. They are the creations of a historically engaged individual, speaking to culture at large through a personal vision grounded in a vernacular aesthetic. Dial is no "outsider," though he and many self-taught African American artists emerge from a culture little known to many. But he makes it abundantly clear that he and African American vernacular artists are from within the heart of American culture—and world culture—and that their objects, their art, speak to both their and our placement within a common culture and history. Dial proves himself to be as much a contemporary artist as any within the mainstream. He exemplifies those "untutored" artists, of whom Russell Bowman has spoken, who "incorporate a powerful and original formal vocabulary to express the artists' cultural or personal ideals," and though they are "nonparticipants in the dialectical history of what defines art, they do participate in the dialectics of the broader culture."[7]

Like many trained artists, Dial responds to the world he sees and experiences by creating personally shaped and visually inventive objects. By operating within the frame of vernacular creativity, however, Dial has created an "original" language from the visible terms of culture that need not be validated by the terms of art history. Rather, Dial's work is to be understood—and judged—as an individual vision and

statement within the cultural dynamics that challenge and shape us all, and of which "art" history is but a subsidiary component.

Dial is not unique. Many untrained, black artists of the American South have created richly inventive objects and environments that articulate their personal and racial experiences. Artists such as Lonnie Holley, Joe Minter, and Purvis Young have filled their immediate environments with artworks that bear witness to the history and condition of black people in American society. Their works are manifestations of both the worldwide phenomenon of the vernacular and outsider constructed environment and, more specifically, the African American cultural tradition of the yard show. The works and built environments of these artists share a common vision: they are expressions of a formidable sense of self; they present the existential interaction between the individual and the physical, natural surround, which the artist seeks to shape and imbue with personal meaning; and they reveal the dynamics of the artist's relationship with the immediate social community. They engage the psychological, spiritual, and communal or political dimensions of experience, expressed through aesthetic action. But although the works and environments are frequently beautiful, they are more likely to inspire awe because they bear more than aesthetic significance. Art, for creators such as Joe Minter, has an existential function: "Art is the one way man can have a common thread that would connect the hearts of all people. Art is for universal understanding."[8]

Joe Minter (born 1943) constructed his *African Village in America*—a quarter-acre, densely packed environment in Birmingham, Alabama—from dozens of rough-hewn sculptures and installations commemorating four hundred years of African American history (see fig. 11). The site testifies to the endurance of Africans through centuries of slavery and racism in America and is filled with political and religious lessons, which are told primarily through sculpture, although written

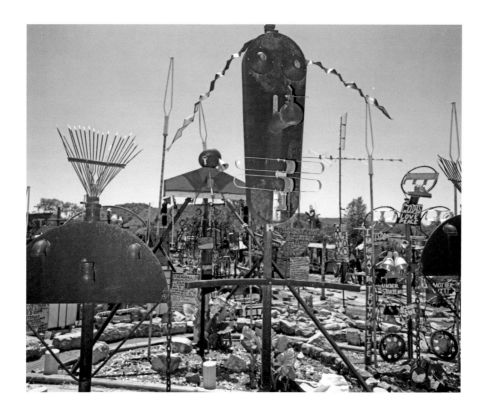

texts are evident throughout the site. Minter's sculptures and assemblages bear witness to the history of slave and peonage labor, the black soldiers who fought for their country, and key moments in the civil rights movement: the Montgomery bus boycott; the 1963 church bombing in Birmingham; and the march over the Edmund Pettus Bridge in Selma.

Minter constructs the works from found objects, reclaimed metal, and inexpensive materials acquired at outlet stores. The art is often strongly representational and literal, as when a manikin wearing an Alabama State Trooper helmet is crouched over black baby dolls in a depiction of the Selma confrontation. More frequently, a few visual clues and painted words invoke specific moments or historical conditions. The materials themselves carry a message, especially the ubiquitous old, rusty tools and chains that Minter frequently uses.

The tools call forth memories of their original users. They are often combined in imposing abstract testimonials to slave labor. Minter argues that if the tools he gathers were allowed to rust and be lost, the lives of all who had touched them—slave or wage laborer—could no longer inform the present. Similarly, the chains are both brutal reminders of slavery and metaphorical links to connect the past to the contemporary viewer in an act of reclamation and healing.

In the early 1970s, Purvis Young (1943–2010) transformed a section of the Overtown area of Miami into an extended "yard." He created a street-long mural on the walls of abandoned buildings, comprising hundreds of paintings depicting the street life and culture of the neighborhood. Young's project was inspired by Chicago's *Wall of Respect* (1967), a collaborative work of public art commemorating historical and

FIG. 11. Joe Minter, *African Village in America*, Birmingham, Al., begun 1989

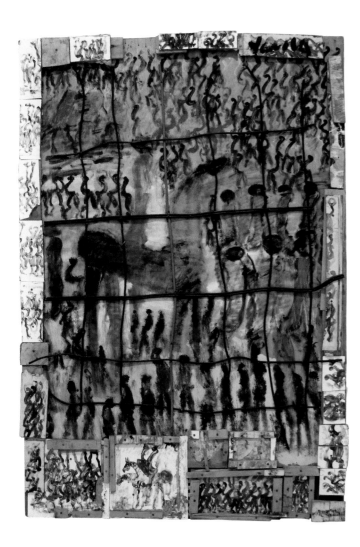

FIG. 12. Purvis Young, *Problems People Behind Bars*, 1995. Latex house paint, plastic coated wire on plywood, 70 x 48 in. (177.8 x 121.9 cm)

popular figures of African American culture. The life Young celebrated was one he observed around him and knew from the media. A decade of street protests and marches for civil rights, as well as demonstrations against the Vietnam War, found its way into images of marchers and people walking through Overtown's streets. The cycles of life and death are represented by images of pregnant women, men and women dancing, and funerals and graveyards. Angels descend over the funerals and the streets of the community, blessing those who have passed and supporting those who remain (see fig. 12). The heads of the angels are encircled by yellow halos, a convention Young had first noticed in the art books he studied in local libraries, where he often went to teach himself about art and history.

Young had first learned about art and how to paint while in jail for breaking and entering when he was a teenager. Once released in the mid-1960s, he began painting prolifically on thousands of stray sheets of paper, which he glued into found magazines and books. His works quickly received acclaim, were exhibited in local libraries and galleries, and many were purchased, enabling Young to establish a career as a professional artist, though he continued to live a somewhat marginal and vulnerable life in his community.

Like Young, Lonnie Holley (born 1950), who first introduced William Arnett to Dial, is an immensely prolific artist who has gained significant renown yet has led a fragile existence. A sculptor, painter, and creator of complex and extended assemblages and yard environments, Holley conceives his works as pedagogical opportunities. Each piece has a story and a message told through the conjunction of disparate associative images from found objects. Similar to Minter and many African American assemblage artists, Holley serves as a griot of the discarded lives of his materials, spinning cautionary tales and observations on contemporary life. *African in a Cage Suffering for Air* (1988; fig. 13) presents a dashiki and a gas mask constrained by a wire cage. The

FIG. 13. Lonnie Holley, *African in a Cage Suffering for Air*, 1988. Mixed mediums, 40½ x 31 x 19 in. (102.9 x 78.7 x 48.3). Private collection

traditional African garment serves as an emblem of 1960s black power, while the mask recalls the violence directed on African Americans by the white police. Enclosed within a wire cell, the implied figure is both suffocated by and protected from life's assault.

As an artist, Holley has not found protection from life's assaults. In the late 1990s, the City of Birmingham bulldozed his dense, art-filled yard to make space for an expansion of its airport. Nevertheless, the same city gave him significant acclaim when in 2003–04, Holley was commissioned by the Birmingham Museum of Art to be an artist in residence, turning an installation of junkyard materials in the museum's courtyard into a disquisition on modern communications technology. A concurrent exhibition within the museum also traveled to Birmingham, England.

Notes

1. Thornton Dial, "Mr. Dial," in *Souls Grown Deep: African American Vernacular Art of the South*, ed. Paul Arnett and William Arnett, vol. 2, *Once That River Starts to Flow* (Atlanta: Tinwood Books, 2001), p. 221.
2. See Amei Wallach, "Thornton Dial at Ground Zero: To Build Means to Destroy," in Paul Arnett, Joanne Cubbs, and Eugene E. Metcalf, Jr., *Thornton Dial in the Twenty-first Century*, exh. cat. (Atlanta: Tinwood Books/Houston: Museum of Fine Arts, 2005), pp. 242–43.
3. Thomas McEvilley and Amiri Baraka, *Thornton Dial: Image of the Tiger*, exh. cat. (New York: Harry N. Abrams/Museum of American Folk Art, 1993), p. 150.
4. For examples of this compositional strategy, see ibid., pp. 66–67, 78–79.
5. Thomas McEvilley, "Proud-Stepping Tiger: History as Struggle in the Work of Thornton Dial," in McEvilley and Baraka (note 3), p. 26.
6. Paul Arnett, "The Strategy of Thornton Dial," in *Thornton Dial: Strategy of the World*, exh. cat. (Jamaica, NY: Southern Queens Park Association, 1990), p. 5.
7. Russell Bowman, "Introduction: A Synthetic Approach to Folk Art," in Jeffrey Russell Hayes, Lucy R. Lippard, and Kenneth L. Ames, *Common Ground/Uncommon Vision: The Michael and Julie Hall Collection of American Folk Art*, exh. cat. (Milwaukee: Milwaukee Art Museum, 1993), p. 18.
8. Joe Minter, "Joe Minter: Peacemaker," in *Souls Grown Deep* (note 1), p. 504.

Michel Nedjar

The life and oeuvre of Michel Nedjar (born 1947) are haunted by a constant confrontation with the mysteries of existence and the mutability of being, whether actively sought or suddenly imposed. His works are grounded in personal biography and collective history yet offer a vision of identity that transcends individuality and culture.

Born in the aftermath of the Holocaust and a member of a countercultural generation of global vagabonds, Nedjar knows the shock of existential displacement and the freedom of rootlessness. A world traveler who realizes the most disturbing and enlightening journeys are those within oneself, he has created an art in which rituals of personal dissolution lead through chaos to a communion with the living and the dead.

Nedjar's early dolls (*poupées*) confront us like creatures of the night—the dark night of our dreams, our nightmares, our souls. They hover or crouch before us as if our familiars, perhaps ourselves in another state, recalling to us secrets long known that we keep hidden within—and from—ourselves. They seem simultaneously to have emerged from within and arrived from without, and in the ambiguity of their sources they upset the presumed stability of our balance.

Who is this creature (fig. 1)? Or rather, *what* is this creature? Its head might be human, or may have been human at some moment, but the beaklike nose and gaping mouth suggest some reptilian or avian hybrid that turns to us to speak, to be fed, or perhaps to devour (see fig. 2). Its oversize head is attached to a barely formed body, shrunken and armless, with two hanging appendages that suggest atrophied, possibly decayed, legs. Indeed, the wizened face and desiccated

OPPOSITE: Detail of Michel Nedjar's *Untitled* from the Travel Doll series (fig. 9)

FIG. 1. Michel Nedjar, *Untitled*, 1980–85. Cloth and mixed mediums, 24⅜ x 10¼ x 78¾ in. (62 x 26 x 31 cm). Kunstmuseum des Kantons Thurgau, Warth, Switzerland

tesques," whose pedigree stretches across the Western imaginary back to the sixteenth century. As Wolfgang Kayser has observed: "The grotesque world is—and is not—our own world. The ambiguous way in which we are affected by it results from our awareness that the familiar and apparently harmonious world is alienated under the impact of abysmal forces, which break it up and shatter its coherence."[1] In the grotesque world, incompatible, often-opposing properties from heretofore-distinct taxonomies challenge the given order. Boundaries are transgressed; hybridity flourishes; confusion reigns.

We experience the grotesque as a liminal realm where the borders of the human order seem suddenly porous, and our universe is opened to powerful forces and unanticipated realities at once deeply familiar yet profoundly alien. We undergo a state of disorientation and unease, desperate for the return of ordinary life yet struck by how uncannily appropriate, even recognizable, is the horrific world we have glimpsed. We are drawn toward the impending figures seeking to make sense of what they mean, but each step into the realm of the grotesque takes us further into unstable ground and greater ambiguity. We encounter a thrilling and unsettling state of intensified awareness and profound mystery. The *poupées'* brute presence imposes itself as absolute fact in all its strangeness. One doll—bound by blood- and mud-stained rags, mouth agape (see fig. 3)—arrives as if a messenger from a repressed or forgotten realm demanding acknowledgment: "Consider me; recognize me; shudder and be silent."

However compelling the dolls' physical statement, we seek terms that might comprehend what we have encountered. The dolls intimate absolute states of alterity (see fig. 4) and embody aberrant moments within processes of gestation or decay; they also suggest haunting narratives of eros and thanatos (see fig. 5). Especially mysterious are the dolls and drawings where figures emerge out of other bodies. Heads

body may have arisen not merely from the night but from the grave. Still, is it not possible to see in that gaping face the hunger of an infant, a barely formed creature—human or not—arrived perhaps too soon, a helpless and needy mutant?

Our wonder and confusion in the face of these "dolls" are stirred by our inability to quite identify them even though they seem so imminently recognizable. Often, they *are* mutants, hybrids of animal and human forms, but also of vegetal and mineral realms. They are contemporary "gro-

FIG. 2. Michel Nedjar, *Untitled*, 1980–85 (detail)

FIG. 3. Michel Nedjar, *Untitled*, 1980–85. Cloth and mixed mediums, 26¾ x 11 x 12¼ in. (68 x 28 x 31cm)

FIG. 4. Michel Nedjar, *Untitled*, 1980–85. Cloth and mixed mediums, 15 x 8⅝ x 10¼ in. (38 x 22 x 26 cm)

project from the side of heads, out of a torso, or arise phal-liclike from the hips (see fig. 6). The works suggest states of birth and death, bonding and absorbing, consuming and excreting. Each figure is singular and plural, isolate and con-joined—within itself and to us.

While Nedjar's *poupées* invoke other dimensions of exis-tence, their stark facticity spurs our own physical awareness. They are, after all, sculptural objects that impose their physi-cal immediacy within our presence, forcing both a conceptual and a corporeal response. Much more than a two-dimensional artwork on a wall, which is primarily ocular and conceptual, sculpture evokes a phenomenological reaction that engages a distinct type of knowledge. The dolls are strong visceral presences. Their dense materiality bears meaning as fully as do their figurative associations.

Nedjar's medium is richly organic; the dolls are con-structed primarily out of pieces of old cloth that are sewn, tied, and bundled around masses of straw, raffia, and sticks. He has incorporated scraps of clothing and shoes for figura-tive as well as structural elements. Zippers have shaped mouths and suggested teeth (see fig. 4); shoes have served as ears, horns, and phalluses (see fig. 6). Many of the dolls were bathed in a mixture of water and dye, mud, or blood, the latter two of which contribute to their organic presence and their aged mien.

Whatever personal associations and imaginative reso-nances stirred in us by the *poupées*, they suggest other uses and different eras and cultures. We imagine that they might well serve as personal or tribal fetishes, masks and religious vessels, or vodou dolls and power objects of rites and rituals unknown. In these questions, we stand once again at another porous boundary between the supposed rational, secular world and the nonrational dimensions of the symbolic, the spiritual, the religious, and the so-called primitive, unsure whether the affinities arise from within our disturbed subconscious or are perceived darkly at an unknown, perhaps fantasized, distance.

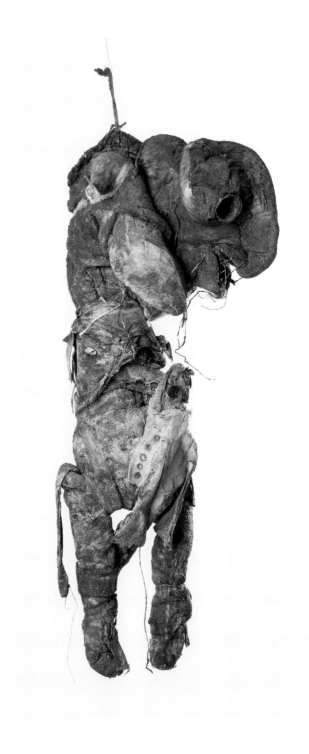

OPPOSITE: FIG. 5. Michel Nedjar, *Untitled*, 1995–97. Cloth and mixed mediums, 39⅜ x 17¾ x 10⅞ in. (100 x 45 x 27.5 cm)

FIG. 6. Michel Nedjar, *Untitled*, 1998. Cloth and mixed mediums, 28⅜ x 10⅝ x 11⅞ in. (72 x 27 x 30 cm)

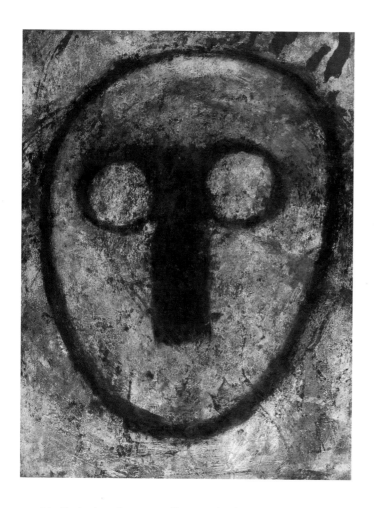

Nedjar's drawn faces seem impersonal and unknowable, showing little emotion but asserting their silent presence. They have no mouths, either to speak or to betray feeling or thought. Rather, the eyes dominate the visage, although those eyes are blank and empty, without pupils. They indicate no inner self that we can surmise, or that we might humanize. At times, their emptiness suggests the vacant sockets of a skull; at others, the impenetrability of a mask (see fig. 7). Arising from dense or smudged grounds, the figures have an ambiguous relation to our plane of vision. We remain unsure of where they reside, either outside us, just beyond the surface of the visible world, or within us, a fragment of our memory just below the thin veil of consciousness. Alternately, we may find ourselves asking, "the face, the mask looking directly at us, is it a mirror image?"

Similarly, Nedjar's dense, blocklike paintings of humans or animals have an impassive yet imposing presence, and they too expand on the themes and materiality of the dolls. If not nearly as grotesque as the *poupées*, they nonetheless conjoin disparate bodily parts, most often faces emerging from torsos or animal forms — birds, snakes, bulls, or goats imprinted on or consanguineous with the human body (see fig. 8). The world we dimly perceive through them is as primal and mutable as that of the dolls. Fraught with symbolic resonances, both present in the immediacy of their hand-worked medium and archaic in their figurative associations, they keep us at a remove even as they draw us in. They forbid perceptual and psychic stability. They are meant to unbalance us yet entrance us by the dream of a more primal grounding.

Nedjar's drawings tantalize, as do the *poupées*, with intimations of other dimensions just beyond the known boundaries of our daily existence. Mysterious, incompletely articulated faces and figures emerge from the dense grounds, seemingly ready to either invade our space or invite us into some deep dimension behind them. The drawings have a thick materiality. Accreted layers of graphite, ink, paint, and wax, usually applied directly by hand, are melted by the passage of a hot pressing iron, which partially uncovers — or, as Nedjar has said, "unburies,"[2] — what was previously painted and covered over in successive layers.

FIG. 7. Michel Nedjar, *Untitled*, 1989. Mixed mediums on paper, 25⅝ x 19¾ in. (65 x 50 cm)

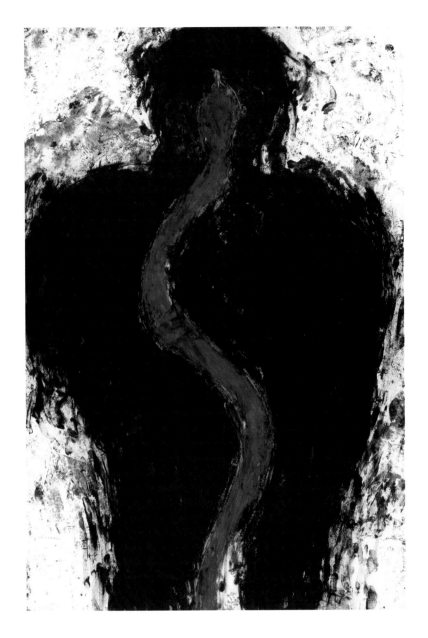

FIG. 8. Michel Nedjar, *Untitled*, 1994. Mixed mediums on cardboard, 47¼ x 31½ in. (120 x 80 cm)

Michel Nedjar was born in 1947 in the village of Soisy-sous-Montmorency, near Paris. His parents were Jews who had immigrated to France in the 1920s, his father from Algeria, his mother and grandmother from Poland, fleeing pogroms. Mother and grandmother once again had to flee the German occupation of France by hiding in Brittany. Although they and Nedjar's father survived the war, much of his father's family and most of his mother's died in the Shoah.

Nedjar's father was a tailor with a prosperous business; his grandmother had a flea market stall where she primarily sold used clothes and rags—*schmattas*. As a child who was close to neither his domineering father nor his three brothers, Nedjar preferred the company of his three sisters. Attracted to materials and clothing, he developed a facility for sewing clothes for their dolls. Desiring to play with dolls himself but aware of the prohibition against boys engaging in such feminine pleasures, he surreptitiously created his own dolls out of his sisters' broken and discarded ones or out of sticks wrapped in pieces of cloth. His skills in sewing did not go unobserved, and when, a poor student, he withdrew from school at age fourteen, it was determined that he should enter his father's profession. Nedjar was apprenticed to a Polish tailor in Paris and attended a school for fashion and design. His love of cloth and clothing was nurtured most, however, by his grandmother, whose stall he frequently visited and at which he would periodically work for years.

From an early age, Nedjar sensed that he was different from his father, brothers, and classmates at school. In 1960, however, he suffered a fundamental shock of separation and difference when he viewed Alain Resnais's film on the Holocaust, *Night and Fog*, on television. Although he had been told of the Shoah by two aunts who managed to return, the horror of the extermination camps and treatment of the Jews became disturbingly real through the visual image and film medium. Nedjar recalled: "Everything collapsed within me. The paradise of my childhood, all the magic were suddenly

destroyed because I now knew that the *other* could kill me. I identified with the corpses. I felt the violence."[3]

Although he continued working with tailors and began thinking about a career as a designer, Nedjar remained unsettled. After a desultory experience in the army and an episode of tuberculosis that sent him to a sanitarium for nearly a year and impressed on him his mortality, Nedjar broke with the course laid out for him and began a period of global vagabondage. From 1970 to 1975, largely in the company of the Mexican filmmaker Téo Hernandez, Nedjar traveled throughout northern Africa, Asia, and Central America. He lived in an ashram in India and spent a year and a half with Hernandez in Mexico, Guatemala, and Belize. In Mexico Nedjar experienced shamanism, ingested hallucinogenic mushrooms, and was entranced by the Day of the Dead culture, as well as by the colorful vernacular dolls. Upon returning to Paris in 1976, he participated briefly in communes where gays and straights sought to live together, recently commenting, "It really sounds like all the clichés of that period."[4]

Back in France, he faced the challenge of reconciling the charged memories of his European past—both the love of materials and dolls associated with his grandmother and sisters and the horror of the Shoah—with the mystery and beauty he discovered during his voyages outside the West. He now sought the terms of self-formation and articulation not as a designer and tailor, but as an artist. His point of aesthetic departure took the form of the doll, conjoining his childhood fascination and training with the psychic resonance he sensed in Mexican dolls. Initially comprising fine and discarded cloths and notions, his early pieces seem rather like exotic evocations of a gypsy, countercultural, third-world rag-doll aesthetic. Although a second face emerges presciently from the some of the dolls' midriffs, these early creations fail to fully plumb the psychic depths he felt within himself or those intimated by religious and vernacular objects he encountered in the third-world cultures he visited.

In the late 1970s, during a two-year period of extreme depression, Nedjar began creating his dark and foreboding *poupées*. Eschewing fine cloth and material, he gathered up rags and clothes found in his grandmother's flea market stall to construct his dolls. Stuffing, sewing, and binding the rough material into vaguely figurative forms, he immersed them in baths of mud, dye, and blood and then hung them up to shrivel and dry.

For Nedjar, the creative process is intensely physical and especially visceral. Making the *poupées*, he grapples with the doll bodies as he stuffs, binds, and sews them, immersing them with his hands and arms into the mire of blood and mud and then pulling them forth as new and ancient creatures of life and death. Creation becomes a personal ritual of birth, which serves the creator as well as the creation. Nedjar often speaks of entering a trance as he draws and creates his dolls: "During the act of creating I leave my own identity behind. I touch upon the male as well as the female; I outgrow even the androgynous, the fauna and flora." Nedjar feels pulled far into and beyond himself in quest of "the hidden," something sensed—an "intuition, a presentiment" of another state of being.[5]

In the trance, he leaves his identity behind and approaches the condition of the abject, the state where the borders between self and not-self threaten to collapse and we confront the brute reality of existence from which we strive to distinguish ourselves but into which we can and must fall. It is the encounter most forcefully experienced in the presence of the corpse and of the bodily fluids or excretions that announce the breakdown of our desired differentiation between ourselves and dead materiality. As Julia Kristeva has envisioned: "without makeup or masks, refuse and corpses *show me* what I permanently thrust aside in order to live. These body fluids, this defilement, this shit are what life withstands, hardly and with difficulty, on the part of death. There, I am at the border of my condition as a living being."[6]

What emerges from Nedjar's ritualistic baths of blood and mud is physical and symbolic. The rags and the muck that take figurative form are visceral representations of the primal organic and inorganic conditions of self and not-self, ultimately, of life and death. For Nedjar, creating the dolls has been the means through which personally felt difference and displacement may be overcome in acknowledgment of the universal vulnerability to life and death. Yet the entities he has shaped not only symbolize his personal connection to the transindividual but also tie him directly to others tragically located within recent history. The bodies of others could well be his own. The embodied self of the *poupée* is the personal and collective self that is threatened by the other, by death, by the Shoah. The *schmattas* amassed from the flea market stall recall the mounds of clothes found in the extermination camps, and the *poupees* built from them evoke the piles of bodies from which the clothes had been stripped. Nevertheless, the emergence of the *poupée* from the viscous bath also enacts a birth and enlightens the artist and the viewer, no matter how grotesque the creature or how dire its message.

However primal and ritualistic Nedjar's personal involvement with the creative process, he presented the *poupées* as works of art. Nedjar saw himself as an artist and sought recognition by the art world, which in the 1970s was a seemingly open but narrowly configured community oriented increasingly toward minimalist abstract languages, new technological media, and neo-conceptual and discourse-oriented cultural critique. Neither a naive nor an isolate artist, Nedjar was nonetheless largely unique in seeking to articulate a sense of deeper, hidden reality within personal and collective experience.

Nedjar found greatest reception outside the mainstream. Long aware of the nonacademic art termed *art singulier* and *art hors-les-normes,* Nedjar began exhibiting in 1976 at the Atelier Jacob, Paris, and by 1979 his work was included in the groundbreaking exhibition *Outsiders*, at the Hayward Gallery in London. In 1980 Jean Dubuffet bought several *poupées* for the Collection de l'Art Brut, and Nedjar, already an "outsider," was anointed an art brut artist. Simultaneously, however, his dolls were purchased by Daniel Cordier, a collector of surrealist and mainstream art and a supporter of the Centre National d'Art et de Culture Georges Pompidou, into which Nedjar's works were placed. Hence Nedjar found himself in the "schizophrenic" position of having works in collections within and outside the mainstream. Nonetheless, he is mostly exhibited within the outsider art world, which is sufficiently established to allow him regular sales at prices significant enough to sustain him as an artist and support his love of global travel.

Nedjar has periodically made short films; he draws and paints profusely, and he continues to make dolls, though by the late 1990s the dolls lost much of their horrific, primal resonance and began to reflect an equanimity and delight that the maturing artist had discovered. In 1998 he began creating a series of "travel dolls," which he composed of detritus collected on his extensive travels. At times, Nedjar appended metaphoric texts on scraps of paper to evoke the artwork's sources, as in *Untitled* (from the Travel Doll series, New York City, 2005; fig. 9), which is constructed around a broken umbrella and references a storm that swept the city: "everywhere dead umbrellas on the sidewalks, landscape of destruction."

The travel dolls signal Nedjar's continued exploration of the world but no longer recall the horror of the collective body of death that haunted him for decades: "I didn't know what it meant to be Jewish. I identified with all the dead, the corpses, which a truck dumped into a hole in the ground. I also fell into that black hole, and it took me a long time to escape from that black hole, that chaos, that destruction."[7] His emergence from the horror is evidenced by the Purim dolls he made for the Musée d'art et d'histoire du Judaïsme in 2009. Neither an observant Jew nor entirely familiar with the meaning of Purim, Nedjar rediscovered the childhood

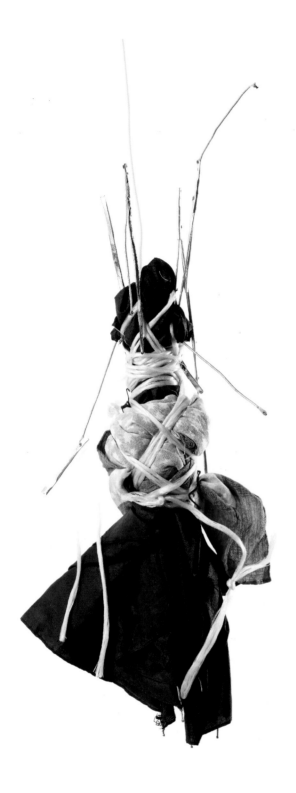

delight that had been destroyed by his discovery of the Shoah: "I had tears in my eyes when I was working on the dolls for Purim because I rediscovered the dolls of my childhood. . . . This work opened up something which I had forgotten but which had been there all along. I only had to unearth it."[8] Purim, the biblical-based Jewish celebration of life after the threat of slaughter, is a festival of reversal and transformation, of costumes, and of revelation. *Untitled* (fig. 10) — a work that specifically refers to the first dolls Nedjar had seen in Mexico — similarly embraces birth and rebirth, in part as parody, always as mystery. With the Purim dolls, Nedjar has moved from summoner of darkness to celebrant of life.

"The Shoah, the travels, Mexico, magic, my dolls, my childhood — all those are linked together, woven into my work."[9] Nedjar's life as an artist began with his sense of personal difference, displacement, and vulnerability within family, gender and social roles, and racial-religious identity — the cultural expectations that threatened to constrain, deny, and possibly exterminate him. As with the work of generations of modern artists before him, Nedjar's art embodies a search across cultures and eras for ways of knowing, acting, and being, through which an unformed but intuited selfhood is sculpted. His quest was a crucial personal matter, but however intensely personal their gestation, the works that have emerged from his journeys speak to the broader culture.

Befitting their origin in the primal existential passion that characterizes the works of so many art brut artists, Nedjar's creations found their initial home within the outsider art world. Yet in his emergence as an artist who has recognized his intimate and fated connections to the history of his people and society, Nedjar explicitly engages the broader culture as few outsiders do. His works raise, once again, the questions we face when confronting art produced by the self-taught and outsider, as well as that of the mainstream: who speaks for the culture? And how?

FIG. 9. Michel Nedjar, *Untitled*, from the Travel Doll series, New York City, 2005. Cloth and mixed mediums, h. 17 in. (43 cm). Lille Metropole Musée d'art moderne d'art contemporain et d'art brut, France

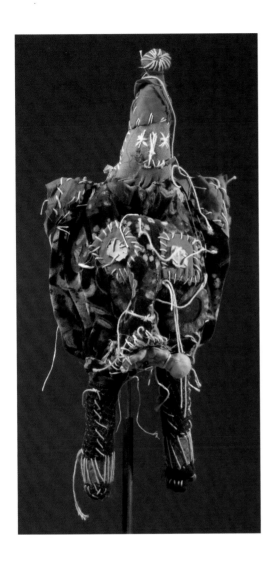

artistic consciousness. In 1972, as he made plans for his massive Collection de l'Art Brut, Dubuffet—the great polemicist—determined that some twelve hundred of the more than forty-three hundred works he had collected did not meet the strict definition he had established. To protect the purity of the original concept, he removed these twelve hundred works to a separate section designated as the Annex Collection, which he still hoped to exhibit as a distinct form of anticultural art. In 1982 the Annex Collection was given the more positive title Neuve Invention by then-director Michel Thévoz, who described the art as "works that do not arise from the radical psychological rupture found in creators of Art Brut . . . but that are independent enough from the fine arts system to create their own kind of unorthodox position and a kind of cultural and institutional protest."[10]

The struggle of this terminology makes evident once again the difficulty of encompassing the wide range of creative expressions, each a separate rivulet heading toward the great stream of art, to recall Hans Prinzhorn's metaphor. Fortunately, few outside of Lausanne have taken up *neuve invention* as a useful term, and Dubuffet's struggle to precisely delineate degrees of anticultural purity has raised a larger, more important, issue: namely, that a vast amount of strong self-taught art produced outside the academy has equal claim to speak for the culture at large *and* still challenge the visual authority of the mainstream. Nedjar's work is exemplary of this duality.

Dubuffet embraced Nedjar as an art brut artist well after the announcement of the Annex Collection, which spoke in part to Nedjar's apparent independence from the established art world and his marginal cultural status. Yet Dubuffet must have recognized in Nedjar's passionate struggle with the *poupées'* materiality an echo of his own long-abiding engagement with the determining voice of his materials, as well as the power of monstrous figuration in Nedjar's dolls and Dubuffet's driftwood, crumpled foil, and papier-mâché figures

Although designated an art brut artist by Dubuffet, Nedjar is not one who speaks without knowledge or regard for the culture of which he is a part. Returning from years exploring cultures outside the West, he chose to act in society, as an artist, a decision that renders his identification with the world of art brut problematic. Dubuffet had already recognized that art brut as he had proclaimed it represented an extreme and ideal pole on a spectrum of cultural embeddedness and

FIG. 10. Michel Nedjar, *Untitled*, 2005. Cloth and mixed mediums, h. 15¾ in. (40 cm). Musée d'art et histoire du Judaïsme, Paris

of 1959–60. Other members of the art brut community believe, however, that Nedjar has been too receptive of or influenced by "culture" and "*art culturel.*" Although Nedjar's work has remained on continuous exhibit at the Collection de l'Art Brut through the decisions of Michel Thévoz and current director, Lucienne Peiry,[11] some advocates of art brut as a mode of radical cultural rejection have argued—as did Bruno Decharme, founder of the abcd art brut collection in Paris—that Nedjar has "progressively evolved" away from art brut and no longer has any connection to it.[12] A more problematic critique by Laurent Danchin pitted the issue of the valued authenticity of the true art brut artist's visual inventions against the acculturated artist's adoption of well-recognized visual languages of non-Western peoples to articulate an inner awareness.

Danchin wrote of Nedjar's "idiosyncratic *neo-tribal* universe," and placed him among other outsider artists "who *regress* to the roots of figuration and, struggling with *pseudo-archaic* matter, instinctively *mimic* the art of primitive cultures in an effort to provide a new mythology, new rituals and a new sense of the sacred to a hypermodern state of civilization."[13] Danchin's suggestion that the works are imitative of "primitive cultures" raises the question of whether Nedjar is primarily appropriating aesthetic forms of other cultures, though Danchin's description of an *instinctive* mimicry allows that the creative process might replicate universal, hence accessible, archaic behavior. If the former, Nedjar would be a postmodern appropriationist. If, instead, Nedjar's art touches an *instinctive* sensibility, the "mimicry" of the primitive is not merely an appropriation of archaic forms but rather a response to the presence of the primitive within oneself and, perhaps, within one's own culture.

Certainly, as a self-aware artist who travels to third-world cultures and visits anthropological and cultural museums, Nedjar is well exposed to many visual vocabularies. He admits that he is not trying to invent anything new and rejects the mainstream art world's self-reflexive idolatry of the succession of aesthetic trends. Rather, he finds in many visual languages and personal experiences the necessary mediums and imagery of his work. The form and emotive power of the doll have been known to him since childhood, were rediscovered by him in cultures as separate as Mexico and Tibet, and were made anew to him—personal and timeless—through his transformation of needlework into a ritual of binding. In its expressive and grotesque figuration, the doll is an abstraction of and a return to the human body experienced in its abject state and as a historical specter of the Holocaust.

Nedjar is largely alone seeking a means to articulate a sense of hidden primitive reality within personal and collective experience. His strategies are far distant from the appropriationist manipulation of ritual, ironic uses of the contemporary grotesque, neo-conceptual disquisitions on the abject, or the tasteful evocations of the Holocaust typical of mainstream art. There are few references to the primal or demonic in art today. While Nedjar might recognize distant cousins in Joseph Beuys's self-mythologizing pedagogic rituals of fat and felt, or Ana Mendieta's submersion of the feminine body in plant life and earth, neither of them directly engages the visceral and irrational dimension of self-knowledge. Similarly, the grotesque—when it is invoked—is usually presented through media-based, self-reflexive images, such as Cindy Sherman's, or used for comic neo-adolescent transgressive theater, as does Paul McCarthy. And although in 1993 the Whitney Museum of American Art mounted an entire exhibition on abject art (with appropriate references to Kristeva), little of the work was particularly visceral or treated the abject as more than a conceptual challenge to dominant cultural discourse. Furthermore, most references to the Holocaust in mainstream art filter it through the prism of receding historical memory and absence, such as Christian Boltanski's elegant and poignant, if sentimental and highly mediated, evocations of mourning and melancholia stirred by, but not necessarily explicitly referencing, the Shoah.

Nedjar's discovery of the Shoah was personal: "The *other* could kill me." Nedjar's work is personal; it is his physical knowing of the boundaries of being and identity. The Shoah is cultural; it testifies to the collective frenzy of fear and hatred at the service of the state. Nedjar's dolls are also cultural; they embody a universal awareness of psychological formation and threat and testify to collective crime.

For Nedjar, the immersed and emergent dolls are both self and not-self; the *poupées* are the others who have gone before him into the camps and their deaths, and they are the others whose aura animates the beings he brings into existence. The rituals of death and creation that he shapes are not pale imitations of third-world "primitivism." They respond to and are empowered by the very real memory of twentieth-century Western blood primitivism—the mass tribal frenzy of racial scapegoating and slaughter that was the Holocaust.

Nedjar believes that at least for him the process of creation and the works that emerged were transformative: "The dolls saved me."[14] The descent into self and collective memory to confront the personal and cultural reality of abjection was an act of healing—of himself and, by extension, of others who will engage with the artworks that emerge from and are themselves agents of the healing ritual.

As have artists across time and cultures, Nedjar found in the articulation of his contemporary grotesque a means of confronting and subduing horror: "In spite of all the helplessness and horror inspired by the dark forces which lurk in and behind our world and have power to estrange it, the truly artistic portrayal effects a secret liberation. The darkness has been sighted, the ominous powers discovered, the incomprehensible forces challenged. And thus we arrive at a final interpretation of the grotesque: *an attempt to invoke and subdue the demonic aspects of the world*."[15] The ritual of the grotesque, however "primitive," is an act of art making, an assertion of meaning, an establishment of the symbolic realm that

affirms the artist's cultural role of giving voice to the experience of limits and the transcendence of them.

Born eight years before Nedjar, Rosemarie Koczÿ (1939–2007) experienced the demonic aspects of the world personally. At the age of three, she was deported with her German-Jewish parents to the Traunstein concentration camp and then to the Ottenhausen camp. Her father and much of her family died in the camps; after the war, Koczÿ lived primarily in Catholic orphanages until age twenty. In 1961 she moved to Switzerland to study at the École des Arts Décoratifs in Geneva, where she received a classical four-year training before receiving her diploma. For the next two decades, Koczÿ established an international reputation as a tapestry maker, but in 1975 she began making finely drawn, densely worked, ink drawings of her memories of the concentration camps (see fig. 11).

FIG. 11. Rosemarie Koczÿ, *Untitled*, 1988. Ink on paper, 17 x 13¾ in. (43.2 x 34.9 cm). Milwaukee Art Museum; Promised gift of Anthony Petullo

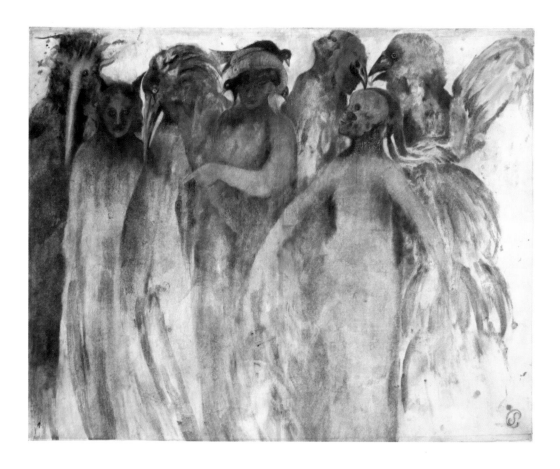

The drawings of skeletal, twisted figures barely emerging from or sinking into finely hatched and often-dark grounds are expressions of those who died in or lived through the Holocaust. She wrote *"Je vous tisse un linceul"* ("I am weaving you a shroud") on the backs of the drawings—mourning, honoring, and preserving in memory those who did not survive and those "brutalized for life" by the experience.[16] Koczÿ completed several thousand drawings, in addition to paintings and wood sculptures. Despite the cultural resonance of her work, she has stated that it seeks no place in culture: "The image of culture leaves me completely indifferent! It speaks only of aestheticism. Myself, I cry the truth, that's all

that matters to me; and justice for the victims."[17] A raw and unrelenting cry of the living memory of horror and loss, this art stands outside the conventional art world and has instead found a home in the galleries and museums associated with self-taught and outsider art. Dubuffet encouraged her to work from her life experiences and gave her a solo exhibition inaugurating the Annex Collection, signaling his recognition that authentic art can arise from the depths of the souls of those who embody an aspect of the larger culture.

Like Nedjar, Christine Sefolosha (born 1955) has been drawn since youth to the cultural expressions of non-Western peoples. Her young adulthood took her to South Africa,

FIG. 12. Christine Sefolosha, *Grande Procession*, 2002.
Oil on canvas, 77¼ x 62 in. (196.2 x 157.5 cm)

where she lived for some twenty years, initially in the company of her first husband, a white South African veterinarian with whom she worked as an assistant. While there, she began painting and she became attracted by African music circulated within the black communities, where she met her next husband, the musician Sefolosha. Harried by apartheid, the new couple moved to Montreaux, Switzerland, Christine's childhood home. A few years later, she committed herself to painting, inspired largely by her African experiences.

The world Sefolosha depicts evokes mythic tales of constant metamorphosis where humans and animals merge and mutate, and boundaries between the self and the natural world are ever porous (see fig. 12). Creatures with claws and horns seem threatening, yet any sense of danger is muted by the softened, murky forms, as if we are perceiving them through the screen of a distant memory or dream. The figures seem present in our world, but they also call out from some mythic dimension, or rather from ancient scenes of a collective unconscious. We recognize, as we do in Nedjar's works, primal images from other moments in art history. Beasts drawn with her hands dipped in a mixture of tar, dirt, and paint seem descendants of cave paintings, though Sefolosha has infused them with a personal sentiment that makes them her own. The horses she knew as a child equestrian and veterinarian's partner have totemic resonance through her consciously primitivistic style.

Notes

1. Wolfgang Johannes Kayser, *The Grotesque in Art and Literature*, trans. Ulrich Weisstein (New York: McGraw-Hill, 1966), p. 37.
2. Markus Landert, "Michel Nedjar," in *Michel Nedjar: animo.!*, ed. Johann Feilacher (Vienna: Springer-Verlag, 2008), p. 45.
3. Sylvia Kummer, "Michel Nedjar, Who Are You?," in *animo.!* (note 2), p. 17.
4. Laurent Danchin, "My Dolls Saved Me," *Raw Vision* 63 (Summer 2007), p. 39.
5. Kummer (note 3), p. 11.
6. Julia Kristeva, *Powers of Horror: An Essay on Abjection*, trans. Leon S. Roudiez (New York: Columbia University Press, 1982), p. 3.
7. Kummer (note 3), p. 33.
8. Ibid., p. 29.
9. Ibid., p. 27.
10. Lucienne Peiry, *Art Brut: The Origins of Outsider Art*, trans. James Frank (Paris: Flammarion, 2001), p. 215 and Michel Thévoz, *Art Brut* (Geneva: Skira, 1995), p. 8.
11. Thévoz has stated that Nedjar would not be accepted into the Collection de L'Art Brut today, even though he also admitted that in essence Nedjar's work has not changed. Michel Thévoz, conversation with author, June 2009.
12. Bruno Decharme, "The Two Topics of Jean Dubuffet," abcd art brut, 2009, http://www.abcd-artbrut.org/spip.php?article729.
13. Danchin (note 4), p. 41 (emphasis mine).
14. Ibid., p. 39.
15. Kayser (note 1), p. 188.
16. Jeanine Rivas, "I Am Weaving You a Shroud: Interview with Rosemarie Koczÿ," *Raw Vision* 25 (Winter 1998–99), p. 37.
17. Ibid., p. 38.

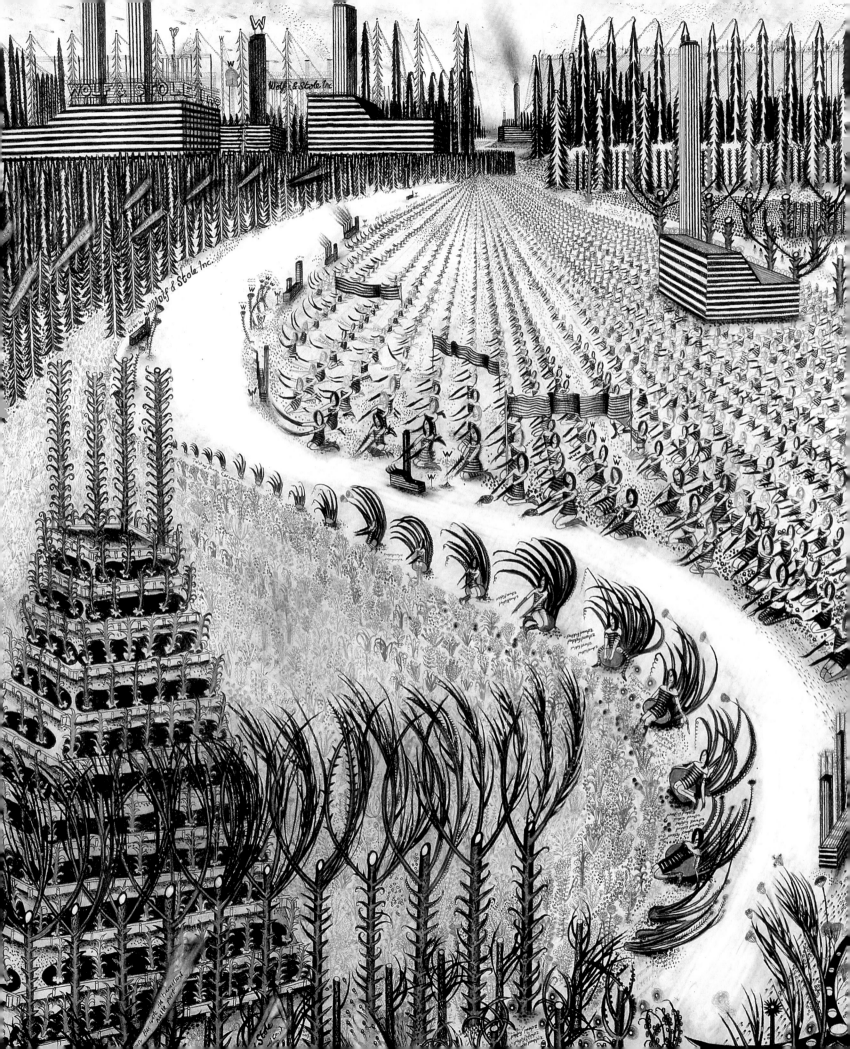

The Great Stream of Art in the Twenty-first Century

Throughout a century of discovery of powerful art by self-taught and often marginalized individuals, we recognize that creative genius, however seemingly sui generis and idiosyncratic, is manifest across all parts of our culture. What we have been calling self-taught and outsider art merely suggests the broadest patterns of distinctive artistic behavior. Indeed, the many other terms applied to the work of untrained artists—art brut, folk, naive, outsider, vernacular, visionary, and so on—provide a larger sense of the breadth and variety of expressions of creative genius. No one name serves to define the behavior because it is not one form. In lieu of definitions and categories, we turn to metaphor to envision the scope. Hans Prinzhorn's poetic words return:

> The creative process, as realized in a contemporary work of art, is nourished by very different psychic springs, which do not always have to coalesce. . . . As groundwater seeps to the surface and flows toward the stream in many rivulets, many expressive impulses run in many creative paths into the great stream of art. Neither historically nor according to psychological theory does there exist a beginning point. Instead there are many springs which finally transcend all life.[1]

In the works of the self-taught and outsider artists of the past century and today, we experience the expression of those sources, the groundwaters of creativity that flowing together create—but do not define or constrain—the great stream of art.

We call what we experience in these visual creations *art*, even though we have discovered that for many of the creators their work was not meant to be art, or it was meant to be much more than art. And in the latter case, we confront the reality that art as defined and enshrined in contemporary culture both excludes consideration of these many rivulets and in many cases has lesser expectations for itself than does the work of the outsiders. The artists we call "outsiders" sometimes are merely outside the institutionalized art world, which calls itself the "mainstream," a culturally constructed and more navigable channel of the much greater stream of art.

But even though the mainstream has too many locks to allow the free flow of creativity and only recognizes tributaries that pay tribute to it (both within and without the academic tradition), artists and impassioned, freethinking viewers of art have recognized for over a century now that what the self-taught create is *art*. Russell Bowman's succinct criterion for art is appropriate: "Because they incorporate a powerful and original formal vocabulary to express the artist's cultural or personal ideals, they are art."[2] Here he is speaking of the self-taught, but he is describing what all serious and successful artists do.

We are drawn to the work of the self-taught and outsider for the experience of art. They allow us to encounter again

the basic human urge for personal expression and assertion of meaning. Self-taught artists respond to the visual world around them with a fervency known to all artists, trained or untrained. They share a recognition of the power of visual elements to bear meaning, and, in their particular selection and manipulation of those elements, they establish a realm of struggle and an achievement of symbolic order. Through their unique and personally meaningful visual languages and strategies, they locate themselves in the world and shape a formal response to, if not a degree of psychological control over, it. Their works may comment on or illuminate aspects of their immediate environment; they may respond to, and carve out a place in, culture and history.

But often, perhaps primarily, we turn to the work of the outsider and self-taught because of the special degree of passion evident in their art. Much more frequently than in mainstream art, we encounter here work that is striking because it is the result of compulsion. As Walter Morgenthaler said of Adolf Wölfli's art, it has "a character of necessity, of urgency."[3] Within the works, we sense a greater depth of existential awareness and psychological need than we do in many contemporary works of the art-historical tradition. Although we recognize the foundations of modern art in an idealist philosophy that asserts the separation of the aesthetic from contingent social values, we also understand, as did Michel Thévoz, that vaunted aesthetic autonomy has also severed art's roots in "the sacred, magical, mythological, religious, political, therapeutic, [and] metaphysical."[4] In distinct contrast, the work of many self-taught and outsider artists is rooted in these dimensions of imaginative being. This is especially evident among the artists discussed in this book, whether in the unfolding of fictive epic narratives; private prayers and evangelical preaching; communication with spirits and gods of another dimension; elaborate psychological and philosophic systems of universal order; naive academicism; close observation and personal commentary; passionate inward quests

and exuberant self-display; or wistful evocations of lost or utopian states of being.

Because the work so often arises out of private, impassioned psychic necessity, it appears to us nakedly, unguarded, and barely mediated with a force that transgresses the boundaries of customary social behavior and expression. Indeed, outsider and self-taught art inherently challenges neat conceptual categories and borders between viewer and artist and between traditional expectations of creative activity and primal behavior. One of the greatest gifts of outsider art is that it can make us experience someone or something believed to be so distant as if it were very near, or even inside, us. The behavior of the most extreme outsider can appear uncannily familiar; the most raw of creations can move us with the force of the most masterful work of art. Again, we find profound and disturbing insight in another observation of Hans Prinzhorn: "neither the extremes of sick or healthy nor those of art and nonart are clearly distinguishable except dialectically."[5] We can only judge our position relative to the other, but the power of art is to unsettle any assumption of a secure perspective. However different it at first appears, it lives close to us and speaks to something we already sense, if not know, within and around us. And to the extent that the "outsider," self-taught artists respond to and act within our common, local and global realm, their works participate in and contribute to the "dialectic" of the culture through which we speak and by which we are spoken.

We encounter such works today created by self-taught artists who find in the creative process, as did their predecessors and as will those who follow, the means by which personal life can be focused and made meaningful and by which the world they inhabit can be given order. The artists take up whatever medium necessary and adopt all visual languages possible, from the culture around them, from personal experiences, from their dreams and insistent unconscious.

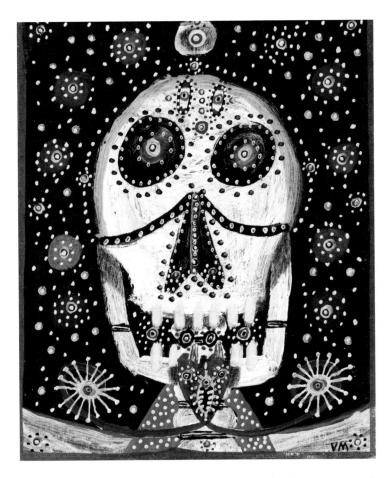

Often, outsider imagery reflects a passionate engagement with a tormented psyche found as much in the visage of the other as within oneself. The face—and its haunting armature, the skull—stares back at the artist and out at the viewer, at once a supremely personal and recognizable universal. In the works of Gregory Van Maanen (born 1947), we are confronted by a bejeweled, skull-like head that floats within a psyche-delic dimension, as if it were already celebrating our arrival in its home ground (see fig. 1). Van Maanen may not have needed to be wounded in Vietnam to glimpse this necessary encounter, but the war brought him a very personal and enduring vision. In his years of healing and discovery since,

he has learned how universal is our species' precognition of the other side. Perhaps these talisman-like works crafted within *our* home ground can display and contain both what is now and not-yet.

Sometimes the visage we observe in the mirror of art is our own and that of others who are not us, but might well be. As Rimbaud said, to each several other lives are due.[6] Sometimes we seek them out in the life or art of others; sometimes they come pouring in, welcomed or not. With the mixed-media collage paintings and expressionistic books of portraits by West Coast artist Anne Grgich (born 1961), we are never quite sure whether to admit and welcome them or to

FIG. 1. Gregory Van Maanen, *Untitled*, November 3, 2008.
Acrylic on board, 3¼ x 4 in. (8.3 x 10.2 cm)

For many, the surge of organic life within combines with the seeming chaotic tumult of the surrounding world to inform us just how little we can control. Fragile or courageous, the artist may engage the turmoil, perhaps unsure whether its origins lie within or without, emerging with a hard-earned and certainly hard-worked vision of transcendent order found, at least in part, on the semantic field of the artwork. The self-conscious, personally controlled artifice provides respite, clarity, and possible evidence of containment or barrier against the chaos.

The mixed-media drawings of Tennessee artist George Widener (born 1962) appear to triumph over the flow of time and the certainty of disaster within it, but in doing so, they heighten his and our awareness of that certainty (see fig. 4). An autistic savant who carries thousands of historical dates in his memory and is able to calculate precise dates across centuries, Widener constructs exacting and orderly geometric charts focused on recurring patterns through history. His

keep them at a safe remove—if such a space exists, which her works seem to strongly deny (see fig. 2).

There is no safe space; we are as invaded from within as without, even at the heights of the most intimate pleasure. The passion of being knows eros and thanatos alternately and simultaneously. The wave of life envisions its crest and dying turbulence at the peak of passion. In the work of Ody (Odette) Saban (born 1953), a Turkish artist of Jewish descent, we are pulled into the embrace of the body we could not escape if we wanted to, discovering not only ourselves and the needed other, but also the loss of personal identity to the life force that lives us then discards our remains as it moves on (see fig. 3). Yet located here in the moment that we experience, life takes consciousness of itself and finds its reflection in the art of one particular instance known to us as Ody Saban.

FIG. 2. Anne Grgich, *Watermarked*, 1998. Mixed mediums on canvas, 48 x 48 in. (121.9 x 121.9 cm). Collection of Zymogenetics, Seattle

FIG. 3. Ody Saban, *Un rituel de mains amoureuses*, 2000. Acrylic on canvas, (92 x 65 cm)

preference for recording disasters, such as the sinking of the Titanic, suggests the necessity and frailty of the aesthetic realm.

The artist expresses, but also constructs, selfhood by engaging the medium to discern and shape significant form and to establish a meaningful conceptual and perceptual field. In the creation of sculpture, the artist feels the resistant and responsive presence of the inanimate matter that lays claim to his or her physical space. For the French artist

A.C.M. (born 1951), the meticulous and multiphase construction of his complex, intricate, and delicate architectural miniatures also involves an extended temporal cycle of reclamation, restoration, destruction, and recomposition. His personal history of near self-destruction and re-creation is seemingly reenacted in his laborious renovation of a dilapidated building. A.C.M. gathers found materials—such as electronic and typewriter parts—conscientiously cleaning, restoring, and painting them before submitting them to baths

FIG. 4. George Widener, *2 and 1 Robot Teaching Calendar*, 2009. Mixed mediums on paper, 32 x 54 in. (81.3 x 137.2). Private collection

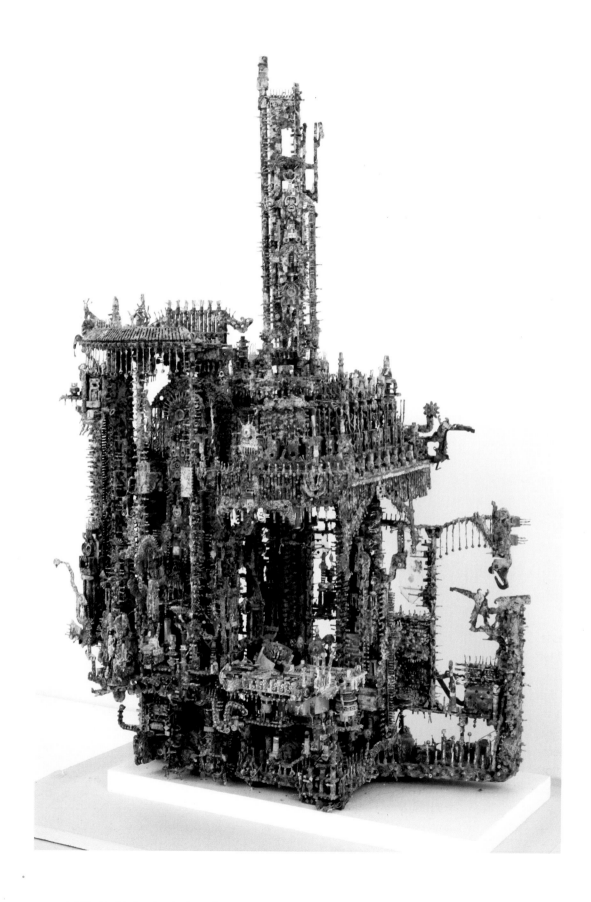

FIG. 5. A.C.M., *Untitled*, n.d. Mixed mediums, 26 x 13½ x 17 in.
(66 x 34.3 x 43.2 cm)

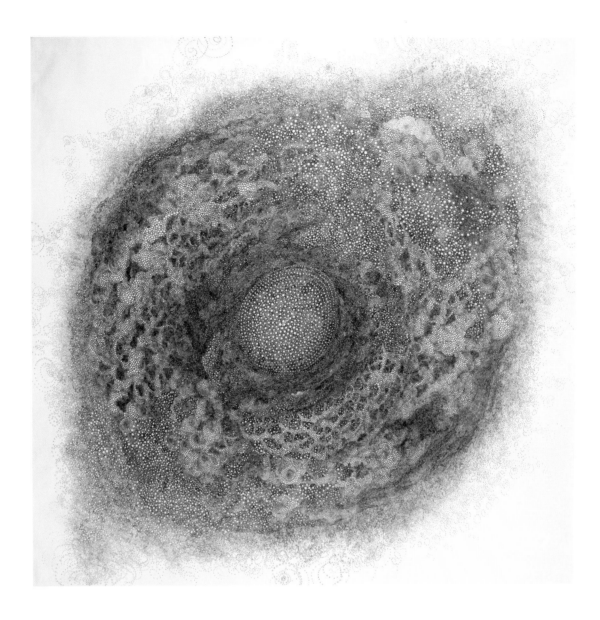

of acid and processes of rusting, only to bring them back to life within assemblages that have the integrity of carefully composed, delicate universes unto themselves (see fig. 5).

The meditative process of slow creation can lead to both a centering of the self and a release of the self into the demands of the work and all it represents. Abstracted forms and intricate patterns can resonate with expansive, multivalent meaning and order into which the artist is merged or can

flow from the artist's hand and mind (see fig. 6). For the Japanese artist Hiroyuki Doi (born 1946), the slow, rigorous process of drawing thousands of small, lyrical circles in ink on handmade paper provides a sense of relief, a giving over to something larger than himself that allows him to feel at one with the cosmos. He began drawing the circles in the 1970s following the death of his brother, initially finding peace with the process of reflecting on the transmigration of souls. Today

FIG. 6. Hiroyuki Doi, *Soul III, HD 2610*, 2006. Ink on washi paper, 38¼ x 37 in. (97.2 x 94 cm). Private collection

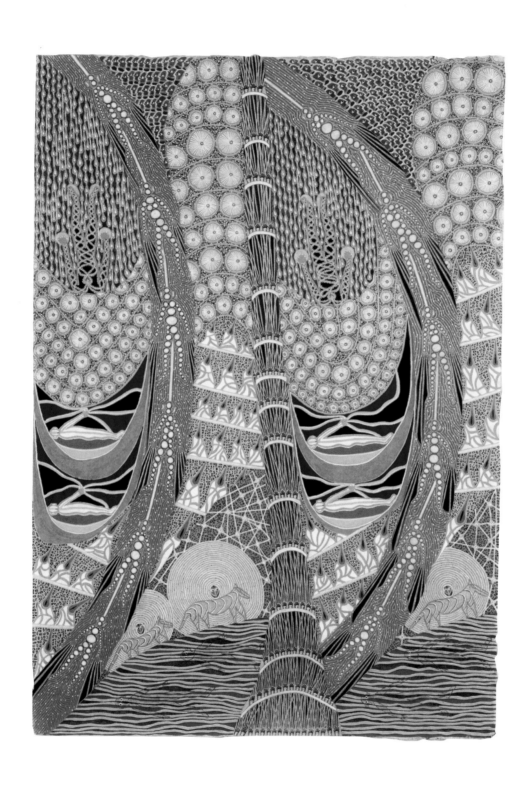

FIG. 7. Domenico Zindato, *Untitled*, 2009. Ink and pastel on paper,
25⅝ x 18 in. (65.1 x 45.7 cm). Private collection

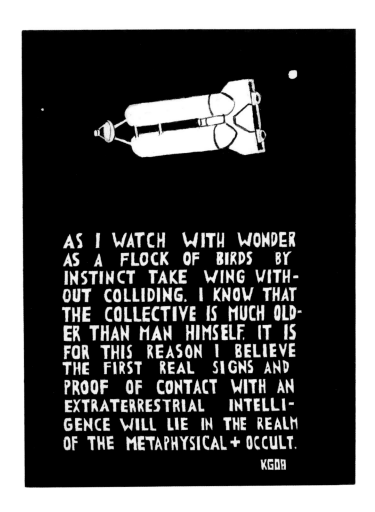

AS I WATCH WITH WONDER
AS A FLOCK OF BIRDS BY
INSTINCT TAKE WING WITH-
OUT COLLIDING. I KNOW THAT
THE COLLECTIVE IS MUCH OLD-
ER THAN MAN HIMSELF. IT IS
FOR THIS REASON I BELIEVE
THE FIRST REAL SIGNS AND
PROOF OF CONTACT WITH AN
EXTRATERRESTRIAL INTELLI-
GENCE WILL LIE IN THE REALM
OF THE METAPHYSICAL + OCCULT.
KG08

he continues by metaphorically connecting each circle with the life of a creature brought into being by every stroke of his pen.

Like Doi, Domenico Zindato (born 1966) is aware of the trancelike state he enters when creating his minutely worked, richly hued, vibrant pastel and ink drawings (see fig. 7). But whereas Doi's pure, empty circles invoke a release into either the void or the transcendent consciousness, Zindato's bright, intuitive abstractions of exotic mutant creatures suggest primordial mythic beings and sensuous dimensions much closer to corporeal existence. Born in Italy, Zindato's peripatetic life led him through Italy, India, and Germany, before he made Mexico his home. His aesthetic, influenced by his travels, expresses the pleasures of a self-presence that spurs a discovery of imaginative truths within and beauty without.

The world we live in is not always so brightly hued or suggestively inviting into another realm of being. It can easily be exactly the opposite. For Ken Grimes (born 1947), the mysterious presence he senses seems far from benign. Fully immersed in the beliefs of millions of Americans in the possibility of extraterrestrial encounters, Grimes is convinced that an observant eye, inquisitive mind, and researcher's dedication to discovery will establish the truth of alien presence (see fig. 8). The truth is to be delivered in black and white by

FIG. 8. Ken Grimes, *Untitled (As I Watch with Wonder)* from the Probe Series, 2008. Acrylic on Masonite, 48 x 36 in. (121.9 x 91.4 cm)

FIG. 9. Chris Hipkiss, *Wolfe and Stole, Inc.*, 2010. Graphite on paper, 23½ x 33¾ in. (59.7 x 85.7 cm)

his stark paintings of symbols and signs, which illustrate mysterious occurrences, troubling questions, or speculative arguments about extraterrestrial phenomena in his private experience and in the public record. Art, for Grimes, centers the self by radically de-centering humanity's sense of its privileged place in the universe.

If Grimes envisions a monochromatic world of imminent revelation and cosmic estrangement, self-taught English artist Chris Hipkiss (born 1964) considers the world a place of extreme if visionary clarity, of precisely defined landscapes of looming animate presence (see fig. 9). All objects—factories, feminine androgynous figures, blades of grass or forms of vegetation and insect life—are drawn with a seemingly impossible exactitude. Like a surrealistic painting in which every element is presented with an equal intensity, the familiar becomes uncanny and the bizarre is made quotidian. Factories dominate landscapes in which vegetal and insect life appear to be industrialized mutations. The drawings suggest scenes from some unknown but imaginable personal and mythic narrative of political and sexual import. It is a world we know, yet it exists in a dimension we would rather not enter.

The drawings of Kevin Sampson (born 1954) have a similar brutal lucidity and political spirit, which is not surprising given Sampson's history as a former police sketch artist. But it is his sculptures made from found and rough materials, delicately combined and formed into emblematic shapes, that most effectively reflect the life experiences of an African American in contemporary America (see fig. 10). Each sculpture bears a story, a message, a truth. His work serves as political and social commentary and as a means of salvaging order.

Although all of the creators consider themselves artists and have found professional representation within the portion of the art world that supports self-taught and outsider art in its many forms, their efforts extend beyond the conventions of contemporary art. They speak to a cultural dynamic

Art of self-taught and outsider artists will ceaselessly flow forth in the future from sources unknown and unexpected, in forms and media we cannot predict. Most likely new terms will attempt to identify its psychic springs. It may even occur that the art will be recognized by the dominant art world of its time, but that would merely be a sign of changes in the operating premises of the academy, most likely responding to larger changes within the dialectics of the culture.

Whatever its institutional reception, the art will continue to be created by individual artists speaking their greatest need, and we will experience it and attempt to come to terms with it, perhaps guided by the terms provided by the then-existing art world(s), but primarily through our own empathetic responses and openness to whatever drives us in desire, fear, delight, or awe.

Notes

1. Hans Prinzhorn, *Artistry of the Mentally Ill*, trans. Eric von Brockdorff, 2nd. ed. (New York: Springer-Verlag, 1995), p. 15.
2. Russell Bowman, "Introduction: A Synthetic Approach to Folk Art," in Jeffrey Russell Hayes, Lucy R. Lippard, and Kenneth L. Ames, *Common Ground/Uncommon Vision: The Michael and Julie Hall Collection of American Folk Art*, exh. cat. (Milwaukee: Milwaukee Art Museum, 1993), p. 18.
3. Walter Morgenthaler, *Madness and Art: The Life and Works of Adolf Wölfli*, trans. Aaron H. Esman (Lincoln: University of Nebraska, 1992), p. 90.
4. Michel Thévoz, untitled letter, in Leo Navratil, *August Walla: Sein Leben und Seine Kunst (August Walla: His Life and Art)* (Nördlingen: Greno, 1988), p. 6.
5. Prinzhorn (note 1), p. 4.
6. The complete quote, "To each being it seemed to me that several *other* lives were due," comes from Rimbaud's *A Season in Hell*. See Arthur Rimbaud, *Complete Works, Selected Letters*, trans. Wallace Fowlie (Chicago: University of Chicago Press, 1966), p. 201.
7. Bowman (note 2), p. 18.

through the languages of art, but they are not concerned with the dominant discourse of the mainstream art world. Again, we find Russell Bowman's judgment apt: "Despite being non-participants in the dialectical history of what defines art, they do participate in the dialectics of the broader culture and deserve to be seen on a par with any meaningful artistic expression."[7] It is here in the broad culture in which we live that the work of self-taught artists is made known, and through their art the lives of the artists and ourselves and the culture we share are illuminated.

FIG. 10. Kevin Sampson, *Wall Street*, 2007. Mixed mediums, 14 x 18 x 6½ in. (35.6 x 45.7 x 16.5 cm).

Bibliography

General Texts

Arnheim, Rudolf. *Art and Visual Perception: A Psychology of the Creative Eye*. "The New Version," rev. ed. Berkeley: University of California Press, 1974.

Cardinal, Roger. *Outsider Art*. New York: Praeger, 1972.

Carlano, Annie, ed. *Vernacular Visionaries: International Outsider Art.* Sante Fe: The Museum of International Folk Art and Yale UP, 2003.

Carr, Simon, Betsy Wells Farber, Sam Farber, Allen S. Weiss, eds. *Portraits from the Outside: Figurative Expression in Outsider Art*. New York: Parsons School of Design Gallery/ Groegfeax Publishing, 1990.

Dubuffet, Jean. *Prospectus et tous écrits suivants*. Vol. 1. Paris: Gallimard, 1967.

Geertz, Clifford. *Local Knowledge: Further Essays in Interpretive Anthropology*. 3rd ed. New York: Basic Books, 2000.

Gombrich, Ernst H. *The Sense of Order: A Study in the Psychology of Decorative Art*. 2nd ed. London: Phaidon, 1984.

Hall, Michael D. and Eugene W. Metcalf, Jr., eds. *The Artist Outsider: Creativity and the Boundaries of Culture*. Washington, D.C.: Smithsonian Institution, 1994.

Hayes, Jeffrey Russell, Lucy R. Lippard, and Kenneth L. Ames. *Common Ground/Uncommon Vision: The Michael and Julie Hall Collection of American Folk Art*. Milwaukee: Milwaukee Art Museum, 1993.

Kandinsky, Wassily. *Concerning the Spiritual in Art*. Translated by M.T.H. Sadler. New York: Dover, 1977.

Kandinsky, Wassily and Franz Marc. *The Blaue Reiter Almanac*. Edited by Klaus Lankheit. New York: Viking, 1974.

MacGregor, John M. *The Discovery of the Art of the Insane*. Princeton: Princeton University Press, 1989.

Maclagan, David. *Outsider Art: From the Margins to the Marketplace*. London: Reaktion Books, 2009.

Maizels, John. *Raw Creation: Outsider Art and Beyond*. London: Phaidon, 1996.

Martin, Jean-Hubert. *Dubuffet und Art Brut: Im Rausch der Kunst*. Düsseldorf: Museum Kunst Palast, 2005.

Naives and Visionaries. New York: E.P. Dutton and Walker Art Center, 1974.

Oakes, John. *In the Realms of the Unreal: "Insane" Writings*. New York: Four Walls, 1991.

Peiry, Lucienne. *Art Brut: The Origins of Outsider Art*. Translated by James Frank. Paris: Flammarion, 2001.

Peiry, Lucienne, ed. *écriture en délire*. Lausanne: Collection de l'Art Brut, 2004.

Prinzhorn, Hans. *Artistry of the Mentally Ill*, 2nd edition. Translated by Eric von Brockdorff. New York: Springer-Verlag, 1995.

Rexer, Lyle. *How to Look at Outsider Art*. New York: Harry N. Abrams, 2005.

Rhodes, Colin. *Outsider Art: Spontaneous Alternatives*. London: Thames and Hudson, 2000.

——. *Primitivism and Modern Art*. London: Thames and Hudson, 1994.

——. *Private Worlds: Outsider and Visionary Art*. Loughborough University and Orleans House Gallery, 2001.

Rose, Barbara. *American Art Since 1900*. New York: Praeger, 1975.

Russell, Charles, ed. *Self-Taught Art: The Culture and Aesthetics of American Vernacular Art*. Jackson: University Press of Mississippi, 2001.

Šafářová, Barbara and Terezie Zamánková. *art brut: collection abcd*. Prague: abcd collection, 2006.

Spira, Anthony. *Inner Worlds Outside: A Supplement*. London: Whitechapel Gallery, 2006.

Thévoz, Michel. *Art Brut*. Geneva: Skira, 1995.

Thévoz, Michel. *The Art Brut Collection Lausanne*. Zurich: Swiss Institute for Art Research, 2001.

Tuchman, Maurice and Judi Freeman. *The Spiritual in Art: Abstract Painting 1890–1985*. Los Angeles: Los Angeles County Museum of Art, 1986.

Tuchman, Maurice and Carol S. Eliel. *Parallel Visions: Modern Artists and Outsider Art*. Princeton: Princeton University Press & Los Angeles County Museum of Art, 1992.

Turner, John and Deborah Klochko. *Create and Be Recognized: Photography on the Edge*. San Francisco: Chronicle Books, 2004.

Umberger, Leslie. *Sublime Spaces and Visionary Worlds: Built Environments of Vernacular Artists*. Princeton: Princeton Architectural Press and John Michael Kohler Arts Center, 2007.

Weinhart, Martina and Max Hollein. *World Transformers: The Art of the Outsiders*. Frankfurt: Schirn Kunsthalle, 2010.

Worringer, Wilhelm. *Abstraction and Empathy*. Translated by Michael Bullock. Chicago: Ivan R. Dee, Elephant Paperbacks, 1997.

Nek Chand

Bandyopadhyay, Soumyen and Iain Jackson. *The Collection, the Ruin and the Theatre: Architecture, sculpture and landscape in Nek Chand's Rock Garden, Chandigarh*. Liverpool: Liverpool University Press, 2007.

Bhatti, S. S. "The Rock Garden of Chandigarh." *Raw Vision* 1 (1989; reprint edition *Raw Vision 1-2-3*): 28–37.

Cheval, Ferdinand. "The Story of the Palais Idéal, Hautrives" *Raw Vision* 38 (Spring, 2002): 24–33.

Goldstone, Bud and Arloa Paquin Goldstone. *The Los Angeles Watts Towers*. Los Angeles: Getty Conservation Institute and the J. Paul Getty Museum, 1997.

Jackson, Iain. "Documenting Nek Chand's Rock Garden: Interpretations of Stones & Castles." *Taking the Road Less Traveled: Built Environments of Vernacular Artists*. Sheboygan, WI: John Michael Kohler Arts Center, 2007: 21–48.

Maizels, John. "Nek Chand: 25 Years of the Rock Garden." *Raw Vision* 35 (Summer, 2001): 22–31.

Maizels, John and Deidi von Schwaewen. *Fantasy Worlds*. Edited by Angelika Taschen. Cologne: Taschen, 2007.

Manley, Roger and Mark Sloan. *Self-Made Worlds: Visionary Folk Art Environments*. New York: Aperture, 1997.

Peiry, Lucienne, ed. *Nek Chand's Outsider Art: The Rock Garden of Chandigarh*. Paris: Flammarion, 2005.

Reeve, Philip. "A Visit with the Master: The Creative Genius of Nek Chand." *Raw Vision* 9 (Summer, 1994): 34–42.

Umberger, Leslie. *Nek Chand: Healing Properties*. Sheboygan, WI: John Michael Kohler Arts Center, 2001.

Aloïse Corbaz

Aloïse (Corbaz). *facsimilé 2*. Lausanne: Collection de l'Art Brut, 1993.

——. *facsimilé 4*. Paris: abcd, 2003.

——. *Peinture et musique au théâtre*. facsimile. Innsbruck: Galerie Krinzinger, n.d.

Dubuffet, Jean. *Asphyxiating Culture and Other Writings*. Translated by Carol Volk. New York: Four Walls Eight Windows, 1988.

Farrimond, Melanie. "Alternative Worlds: Utopia and Madness in the Work of Cixous, Aloïse and Vivien." In *The Impossible Space: Explorations of Utopia in French Writing*. Strathclyde Modern Language Studies, No. 6. Edited by Angela Kershaw, Pamela Moores, and Hélène Stafford. Glasgow: University of Strathclyde, 2004: 42–51.

Greer, Germaine. *The Obstacle Race: The Fortunes of Women Painters and Their Work*. New York: Farrar Straus Giroux, 1979.

MacGregor, John, M. "Art Brut Chez Dubuffet." *Raw Vision 7* (Summer, 1993): 40–51.

Porret-Forel, Jacqueline. *Aloïse*. Publications de la Compagnie L'Art Brut, Fascicule 7. Paris: Compagnie de L'Art Brut, 1966; second edition, Lausanne, 1989.

——. *Aloïse "comme un papillon sur elle."* Shiga, Japan: Haretari-Kumottari, 2009.

——. *"La Cloisonné de Théâtre*: Aloïse Corbaz." *Raw Vision 57* (Winter, 2006): 46–53.

——. *La voleuse de mappemonde: Les écrits d'Aloïse*. Geneva: Éditions Zoé, 2004.

Selz, Peter. *The Work of Jean Dubuffet*. New York: Museum of Modern Art, 1962.

Henry Darger

Anderson, Brooke Davis, ed. *Darger: The Henry Darger Collection at the American Folk Art Museum*. New York: American Folk Art Museum, in association with Harry N. Abrams, Inc., 2001.

Biesenbach, Klaus. *Henry Darger*. New York: Prestel, 2009.

Bonesteel, Michael, ed. *Henry Darger: Art and Selected Writings*. New York: Rizzoli, 2000.

Gómez, Edward Madrid. "The Singular Life and Art of Henry Darger." In *Sound and Fury: The Art of Henry Darger*, 2nd ed. New York: Andrew Edlin Gallery, 2008.

MacGregor, John M. *Henry J. Darger: Dans les Royaumes de l'Irréel*. Lausanne: Collection de l'Art Brut, 1995.

——. "Art by Adoption." *Raw Vision 13* (Winter, 1995–1996): 26–35.

——. *Henry Darger: In the Realms of the Unreal*. New York: Delano Greenidge Editions, 2002.

Longhauser, Elsa and Harald Szeemann, curators. *Self-Taught Artists of the 20th Century: An American Anthology*. New York: American Folk Art Museum; San Francisco: Chronicle Books, 1998.

Thornton Dial

Arnett, Paul. "The Strategy of Thornton Dial." In *Thornton Dial: Strategy of the World*. Jamaica, NY: Southern Queens Park Association,1990: 5–9.

Arnett, Paul, Joanne Cubbs, and Eugene E. Metcalf, Jr., eds. *Thornton Dial in the Twenty-first Century*. Atlanta: Tinwood Books/Houston: Museum of Fine Arts, 2005.

Arnett, Paul and William Arnett, eds. *Souls Grown Deep: African American Vernacular Art of the South* v. 1. *The Tree Gave the Dove a Leaf*. Atlanta: Tinwood Books, 2000.

——, eds. *Souls Grown Deep: African American Vernacular Art of the South* v. 2. *Once That River Starts to Flow*. Atlanta: Tinwood Books, 2001.

Crown, Carol and Charles Russell, eds. *Sacred and Profane: Voice and Vision in Southern Self-Taught Art*. Jackson, MS: University Press of Mississippi, 2007.

Cubbs, Joanna and Eugene Metcalf, eds. *Hard Truths: The Art of Thornton Dial*. New York: Indianapolis Museum of Art and Delmonico Books, Prestel: 2011.

Griffin, Roberta T. "Abstraction in the Art of Thornton Dial." In *Abstraction in the Art of Thornton Dial*. Marietta, GA: Kennesaw State College, 1995: 9–25.

Gundaker, Grey, ed. *Keep Your Head to the Sky: Interpreting African American Home Ground*. Charlottesville: University Press of Virginia, 1998.

Kraskin, Sandra. *Wrestling with History: A Celebration of African American Self-Taught Artists*. New York: Sidney Mishkin Gallery, Baruch College, 1996.

McEvilley, Thomas. "Brinksman." *Thornton Dial*. New York: Ricco/Maresca Gallery, 1998: 3–5.

McEvilley, Thomas and Amiri Baraka. Thornton *Dial: Image of the Tiger*. New York: Harry N. Abrams/Museum of American Folk Art, 1993.

Minter, Joe. *To You Through Me: The Beginning of a Link of a Journey of 400 Years*. Birmingham, AL: self-published, n.d.

Howard Finster

Bradshaw, Thelma Finster. *Howard Finster, The Early Years. A Private Portrait of America's Premier Folk Artist*. Birmingham, AL: Crane Hill Publishers, 2001.

Crown, Carol, ed. *Coming Home: Self-Taught Artists, the Bible and the American South*. Jackson: University Press of Mississippi, 2004.

Davies, Glen C., ed. *Stranger in Paradise: The Works of Reverend Howard Finster*. Urbana/Champaign: Krannert Art Museum, 2010.

Finster, Howard. *Howard Finster Man of Visions*. Atlanta: Peachtree Publications, 1989.

——. *Howard Finster's Vision of 1982*. Sumerville, Georgia: self-published, 1982.

Giradot, Norman, *Howard Finster (1916–2001)*. Bethlehem, PA: Leigh University Art Galleries, 2004.

——. "Howard Finster's Shamanistic Christianity: *The Vision of 1982*." *Raw Vision* 63 (Summer, 2007): 28–35.

Glassie, Henry. *Pattern in the Material Folk Culture of the Eastern United States*. Philadelphia: University of Pennsylvania Press, 1968.

Patterson, Tom. *Howard Finster: Stranger from Another World, Man of Visions Now on The Earth*. New York: Abbeville, 1989.

——. "Paradise Garden Before and After the Fall." *Raw Vision* 35 (Summer, 2001): 42–51.

Peacock, Robert, with Annibel Jenkins. *Paradise Garden: A Trip through Howard Finster's Visionary World*. San Francisco: Chronicle Books, 1996.

Turner, J.F. *Howard Finster: A Man of Visions*. NY: Knopf, 1989.

——. "Paradise Garden: Howard Finster Man of Visions," *Raw Vision* 2 [reprint edition] 1-2-3: 70–77.

Turner, John. "When Allen Ginsberg Met Howard Finster." *Raw Vision* 67 (Fall/Autumn, 2009): 42–44.

Vlach, John Michael. *Plain Painters: Making Sense of American Folk Art*. Washington, D.C.: Smithsonian Institution Press, 1988.

Vlach, John Michael and Simon Bronner. *Folk Art and Art Worlds*. Ann Arbor: UMI Research Press, 1986.

Madge Gill

L'Art Brut, Fascicule 9. Paris: Compagne de L'Art Brut, 1973.

Breton, Andre. *Manifestoes of Surrealism*. Ann Arbor: University of Michigan Press, 1972.

Breton, Andre. *Les Pas perdus*. New edition. Paris: Gallimard, 1969.

Cardinal, Roger. "The Art of Entrancement." *Raw Vision, 2*, reprint edition *Raw Vision 1-2-3*, 84–93.

Cardinal, Roger and Martine Lusardy, eds. *Art spirite médiumnique et visionnaire: messages d'outre-monde*. Paris: Hoëbeke, 1999.

Morris Hirshfield

Apollinaire, Guillaume. *Apollinaire on Art: Essays and Reviews 1902–1918*. Edited by Leroy C. Breunig. Translated by Susan Suleiman. New York: Viking Press, 1972.

Bihalji-Merin, Oto. *Masters of Naïve Painting*. New York: Harry N. Abrams, 1959.

Bishop, Robert. *Folk Painters of America*. New York: Greenwich House, 1979.

Breton, André. *Surrealism and Painting*. Translated by Simon Watson Taylor. New York: Harper & Row, 1972.

Cahill, Holger. *American Folk Art*. New York: Museum of Modern Art, 1932.

Cardinal, Roger. *Primitive Painters*. New York: St Martin's Press, 1979.

Hemphill, Herbert W., Jr. and Julia Weissman. *Twentieth-Century American Folk Art and Artists*. New York: E.P. Dutton, 1974.

Morris Hirshfield, 1872–1946, American Primitive Painter. New York: Sidney Janis Gallery, 1965.

Janis, Sidney. *They Taught Themselves: American Primitive Painters of the 20th Century*. New York: Dial, 1942.

Kallir, Jane. *The Folk Art Tradition: Naïve Painting in Europe and the United States*. New York: Viking Press, 1981.

Lipman, Jean and Thomas Armstrong. *American Folk Painters of Three Centuries*. New York: Hudson Hills Press in association with the Whitney Museum of American Art, 1980.

Lipman Jean and Alice Winchester. *The Flowering of American Folk Art (1776–1876)*. Philadelphia: Courage Books and the Whitney Museum, 1974.

Rumford, Beatrice T. and Carolyn J. Weekley. *Treasures of American Folk Art*. Boston: Little, Brown, 1989.

Saroyan, William. *Morris Hirshfield*. Milan: Franco Maria Ricci, 1976.

Schapiro, Meyer. "Significance of modern naive painting." Unpublished note Meyer Schapiro collection, Columbia University Rare Book and Manuscript Library.

Michel Nedjar

Michel Nedjar: Bezauberte Körper. Köln: Galerie Suzanne Zander, 1994.

Michel Nedjar: Les ongles en deuil. Köln: Galerie Suzanne Zander, 1995.

Cardinal, Roger. "Michel Nedjar, "*L'Art Brut, Fascicule 16*. Lausanne: Publications de la Collection de l'Art Brut, 1990: 72–99.

Danchin, Laurent. "My Dolls Saved Me." *Raw Vision 63* (Summer, 2007): 36–43.

Feilacher, Johann, ed. *animo.!*. Vienna: Springer-Verlag, 2008.

Kayser, Wolfgang Johannes. *The Grotesque in Art and Literature*. Translated by Ulrich Weisstein. New York: McGraw-Hill, 1966.

Kristeva, Julia. *Powers of Horror: An Essay on Abjection*. Translated by Leon S. Roudiez. New York: Columbia University Press, 1982.

Monnin, Françoise. *Michel Nedjar envelopes*. Paris: Iconofolio, 2006.

Nedjar, Michel. *Poupées Pourim*. Paris: Gallimard Jeunesse, 2008.

Rivas, Jeanine. "I Am Weaving You a Shroud." Interview with Rosemarie Koczÿ. *Raw Vision, 25* (Winter 1998–99): 31–39.

Sondheim, Alan, ed. *Individuals: Post-Movement Art in America*. New York: E. P. Dutton, 1977.

Weiss, Allen S. *Shattered Forms: Art Brut, Phantasms, Modernism*. Albany: State University of New York Press, 1992.

Martín Ramírez

Anderson, Brooke Davis, ed. *Martín Ramírez*. Seattle: Marquand Books/New York: American Folk Art Museum, 2007.

——, ed. *Martín Ramírez, The Last Works*. San Francisco: Pomegranate, 2008.

Cooke, Lynne. *Martín Ramírez: Reframing Confinement*. Madrid: Museo Reina Sofía/Munich: Prestel, 2010.

Kind, Phyllis. "Martín Ramírez Under Scrutiny." In *Visions from the Left Coast: California Self-Taught Artists*. Santa Barbara: Contemporary Arts Forum, 1995: 24–27.

Morris, Randall. "Martin Ramírez." *Folk Art*, 20, 4 (Winter 1995/1996): 36–45.

Bill Traylor

Bill Traylor 1854–1947. New York: Hirshl and Adler Modern, 1988.

Bill Traylor Drawings from the Collection of Joe and Pat Wilkinson. New York: Sotheby's, 1997.

Bill Traylor, High Singing Blue. New York: Hirschl and Adler Modern, 1997.

Bill Traylor, Observing Life. New York: Ricco/Maresca Gallery, 1997.

Helfenstein, Josef and Roman Kurzmeyer. *Bill Traylor 1854–1949 Deep Blues*. New Haven: Yale University Press, 1999.

Helfenstein, Josef and Roxanne Stanulis. *Bill Traylor, William Edmondson and the Modern Impulse*. Urbana-Champaign: University of Illinois Krannert Art Museum, 2004.

Kuyk, Betty M. *African Voices in the African American Heritage*. Bloomington: Indiana University Press, 2003.

Livingston, Jane and John Beardsley. *Black Folk Art in America 1930–1980*. Jackson: University Press of Mississippi, 1982.

Lovett, Bobby L. "From Plantation to City: William Edmondson and the African-American Community." *The Art of William Edmondson*. Nashville: Cheekwood Museum of Art: 15–32.

Maresca, Frank and Roger Ricco. *Bill Traylor: His Art–His Life*. New York: Knopf, 1991.

Sobel, Mechal. *Painting a Hidden Life: The Art of Bill Traylor*. Baton Rouge: Louisiana State University Press, 2009.

Stigliano, Phyllis, ed. *Bill Traylor: Exhibition History, Public Collections, Selected Bibliography*. New York: Luise Ross Gallery, 1990.

Weld, Alison. "Dream Singers, Story Tellers: An African American Presence." In Alison Weld and Sadao Serikawa. *Dream Singers, Story Tellers: An African American Presence*. Fukui, Japan & Trenton, NJ: Fukui Fine Arts Museum & New Jersey State Museum, 1992: 39–58.

August Walla

Feilacher, Johann. *blug: Gugging–ein ort der kunst*. Vienna: Christian Brandstätter, 2006.

——. "Classics of Outsider Art: Johann Hauser." *Raw Vision*, 22 (Spring, 1998): 19.

Feilacher, Johann, ed. *Das rote Zebra: Zeichnungen von Oswald Tschirtner*. Vienna: Christian Brandstätter Verlag, 1997.

Feilacher, Johann, ed. *Sovären: Das Haus der Künstler in Gugging*. Heidelberg: Edition Braus in Wachter, 2004.

Gugging, L'Art Brut, Fascicule 12. Lausanne: Collection de l'Art Brut, 1983.

Maizels, John. "Interview: Dr. Leo Navratil." *Raw Vision 34* (Spring 2001): 42–48.

MacGregor, John, M. *Metamorphosis: The Fiber Art of Judith Scott*. Oakland, CA: Creative Growth Art Center, 1999.

Navratil, Leo. "Art Brut and Psychiatry." *Raw Vision 15* (Summer 1996): 40–47.

——. *August Walla: Sein Leben und Seine Kunst*. Nördlingen: Greno, 1988.

Schreiner, Gérard, ed. *European Outsiders: The Gérard A. Schreiner and John L. Notter Collection*. Vol. 1. Vienna: The Gérard A. Schreiner and John L. Notter Collection, 1986; also published New York: Rosa Esman Gallery, 1986.

Adolf Wölfli

Arnheim, Rudolf. "The Artistry of Psychotics." *To the Rescue of Art: Twenty-six Essays*. Berkeley: University of California Press, 1992: 144–154.

Baumann, Daniel, ed. *Adolf Wölfli Universum*. Berne: Museum of Fine Arts Berne, 2008.

——. "Classics of Outsider Art: Adolf Wölfli." *Raw Vision 23* (Summer, 1998): 22.

Baumann, Daniel and Therese Bhattacharya-Stettier. *Albert Anker—Adolf Wölfli. Parallele Welten*. Berne: Museum of Fine Arts Berne, 1999.

Beyond Reason: Art and Psychosis: Works from the Prinzhorn Collection. London: Hayward Gallery, 1997.

Brand-Claussen, Bettina and Viola Michely. *Irre ist weiblich: Künstlerische Interventionen von Frauen in der Psychiatrie um 1900*. Heidelberg: Verlag Das Wunderhorn & Sammlung Prinzhorn, 2004.

Hunger, Bertina, et. al. *Porträt eines produktiven Unfalls: Adolf Wölfli, Dokumente und Recherchen*. Frankfurt am Main: Stroemfeld/Nexus, 1993.

Jádi, Inge. *Leb wohl sagt mein Genie Ordugele muss sein: Texte aus der Prinzhorn Sammlung*. Heidelberg: Verlag Das Wunderhorn, 1985.

Luchsinger, Katrin, ed. *Werke aus psychiatrischen Kliniken in der Schweiz 1850–1920*. Zurich: Chronos Verlag, 2008.

Morgenthaler, Walter. *Madness and Art: The Life and Works of Adolf Wölfli*. Translated by Aaron H. Esman. Lincoln: University of Nebraska Press, 1992.

Sass, Louis, A. *Madness and Modernism*. New York: Basic Books, 1992.

Spoerri, Elka. *Adolf Wölfli Draftsman Writer Poet Composer*. Ithaca: Cornell University Press, 1997.

Spoerri, Elsa and Daniel Baumann. *The Art of Adolf Wölfli: St. Adolf-Giant-Creation*. New York: American Folk Art Museum, 2003.

Spoerri, Elsa and Jürgen Glaesemer. *Adolf Wölfli*. Berne: Adolf Wölfli Foundation, Museum of Fine Arts Berne, 1976.

Wölfli, Adolf. *>>o Grad o/ooo: Entbrantt von Liebes, = Flammen<<: Gedichte*. Frankfurt am Main: Fischer Verlag, 1996.

——. *Der Engel des Herrn im Küchenschurz: Über Adolf Wölfli*. Edited by Elsa Spoerri. Frankfurt am Main: Fischer Verlag, 1987.

——. *Geographisches Heft No. 11 Schriften 1912–1913*. Stuttgart: Verlag Gerd Hatje, 1991.

de Zegher, Catherine. *The Prinzhorn Collection: Traces upon the "Wunderblock."* New York: The Drawing Center, 2000.

Index

Illustration Credits